Warriors of the Plains

The Arts of Plains Indian Warfare

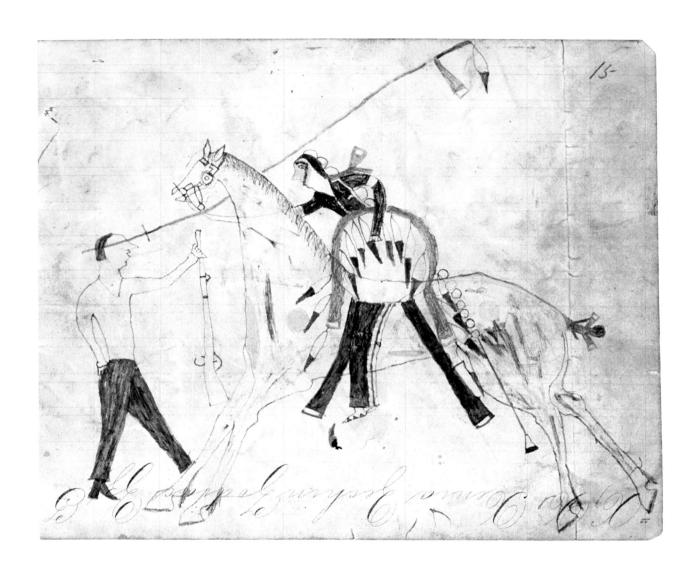

Warriors of the Plains
The Arts of Plains Indian Warfare

Max Carocci

McGill-Queen's University Press
Montreal & Kingston • Ithaca

© 2012 The Trustees of the British Museum

Max Carocci has asserted the right to be identified
as the author of this work.

ISBN 978-0-7735-4004-0

Legal deposit first quarter 2012
Bibliothèque nationale du Québec

First published simultaneously in 2012 outside North America by
The British Museum Press, a division of The British Museum Company Ltd.

McGill-Queen's University Press acknowledges the financial support of the
Government of Canada through the Canada Book Fund for its activities.

Library and Archives Canada Cataloguing in Publication

Carocci, Max
 Warriors of the Plains : the arts of Plains Indian warfare / Max
Carocci ; with a preface by Stephanie Pratt.

Includes index.
ISBN 978-0-7735-4004-0

 1. Indians of North America--Warfare--Great Plains. I. Title.

E78.G73C374 2012 978.004'97 C2011-907056-1

Photography by the British Museum Department
of Photography and Imaging

Designed by John Hawkins Design
Printed and bound in Hong Kong by Printing Express Ltd

The papers used in this book are recyclable products and the
manufacturing processes are expected to conform to the environmental
regulations of the country of origin.

A note on objects illustrated: unless otherwise stated all objects featured
in this book are from the collection of the British Museum. Their museum
registration numbers are listed in the image captions. Further information
about the Museum and its collection can be found at
www.britishmuseum.org.

Frontispiece: *Mounted warrior counting coup on an American man*
by Tall Bear, Sioux (Oglala Lakota), 1874. *Drawing on paper,
H 17.5 cm, W 21 cm (Am2006,Drg.1).*

Contents

Preface

It is a welcome pleasure and indeed a great honour to have been asked by Max Carocci to write the preface for *Warriors of the Plains*. As a Native American woman of Dakota ancestry and heritage, I consider its topic of utmost importance historically, both for the museum-going public and for present and future indigenous warriors and their communities.

Max Carocci reminds us that British or European visitors to exhibitions about Plains Indian cultures have too often understood these groups or individuals stereotypically via the war-bonneted Plains Indian brave, who stands for indigenous separation from or resistance to white settlement. This clichéd image has been elaborated over the last 150 years by artists, performers, photographers and film-makers including such notable figures as George Catlin, William Cody (Buffalo Bill), Edward Curtis and John Ford who between them formalized a romanticized Plains Indian identity. Max Carocci's primary intentions in his several publications, and the exhibition he curated at the British Museum in 2010 on this same theme, are to explode such myths and stereotypes, to get beyond the romanticized projections and to gain an insight into actual Plains Indian societies and cultures. Far from there being one kind of Native American warrior, Max Carocci alerts us to the many individual identities, with all their specificity and unique purpose, held within their larger groups of clan, tribe and nation. He looks not only at war-making but also at its vital corollary, peace-making. He explores the warrior tradition in its historical context as well as its evolution up to the present-day.

Carocci's practice as an anthropologist, art historian and indigenous studies scholar has provided him with a wide range of expertise and, importantly, he has made it an over-riding purpose to place indigenous knowledge and indigenous understanding at the centre of his analysis and interpretation. He has unique personal experiences from which to draw. He worked from an early age as a political activist alongside his Italian mother, providing European-based support to the American Indian activist movements of the 1970s and 1980s. He lobbied for Native North American tribes to be recognized by the United Nations in the Forum for Indigenous Peoples in Geneva in the 1980s, activism which eventually bore fruit as the World Indigenous Rights declaration of 2007. Its

influential statements set out the precise ethical nature of those working alongside indigenous knowledge-holders and cultural advisors. These are values that have been held by Carocci throughout his working life.

Thousands of indigenous objects were collected by hundreds of Europeans and settler-newcomer Americans in the American West from early contact until the twentieth century. Max Carocci shows how the Western Anglo-European world has often termed an 'object' a mere 'thing', but what we see in many collections is in fact much more than this when viewed from an indigenous North American perspective. Carocci helps us come to terms with the true significance of these items. As this book reveals, these objects are socially coded and often carry metaphysical meanings.

He also gives rightful attention to the ways that martial matters crossed the gender divide in Plains Indian societies and gives recognition to the involvement of women in all aspects of the cultures which produced these items. Women produced items such as shirts for members of their families and these shirts gained further power when worn by successful warriors and leaders. Women were crucially involved in the cleaning, scraping and preparation of the hides, which they then beaded in intricate designs. These designs were created for the specific individual and held within them protective forces to help the wearer. Women were also very much involved in warfare itself, taking part in dancing and other ceremonials of preparation; some became members of female war societies, thus emerging at times as active combatants. This is as true today as it was long ago.

Growing up as an indigenous person in the 1960s and 1970s in California I was caught up in the impetus towards 'self-determination', which meant that we took pride in being 'warriors' of our own indigenousness, holding out against encroaching assimilation or Christianization even as it took its effects across my own American Indian extended family. We were privileged to own a number of Native American objects, some of ceremonial importance, such as a painted war drum with a thunderbird motif made on the reservation in the 1960s. These things were not merely part of a personal or family collection but stood for connectedness and a hope

for recovery and reintegration in some future time when American Indian culture might be recognized for its own importance and history. The opening in 2004 of the National Museum of the American Indian in Washington, DC was a huge step towards such recognition by Native American peoples and the United States of America.

In many ways the term 'heirloom', used in this book, amply sums up what an indigenous person might think about the objects from the past held in both museum and private collections today. My own understanding of how Native Americans valued such things as a Dakota warrior or leader's eagle-feather bonnet came through my family's ownership of a modern-made example of such, purchased by my Dakota father on his own reservation in South Dakota during the 1960s. It held pride of place, alongside our war drum, in the family home resting on the mantelpiece for many years. It was gifted to my brother at my father's passing and is now held in reverence by him and his children, an American Indian family living far away from their Dakota roots but able nevertheless to reconnect to their culture and traditions through the possession of items like these.

Objects of material culture, in other words, whether in private collections or museum displays are potent things. All of us who see them can respond to their superb qualities of design and manufacture and, thanks to scholars like Max Carocci, we can also understand how material culture is not merely material. These objects speak of beliefs, behaviours and ways of being that have not been extinguished.

Stephanie Pratt

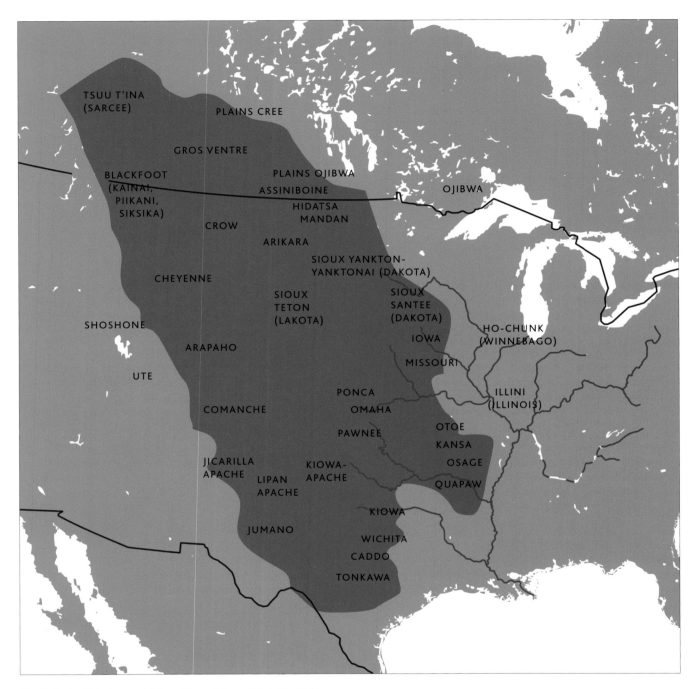

Map illustrating Plains tribes and their most immediate neighbours cited in the text. Please note that tribal boundaries have changed over time. Map locations are indicative of the approximate area occupied by these tribes throughout the nineteenth century.

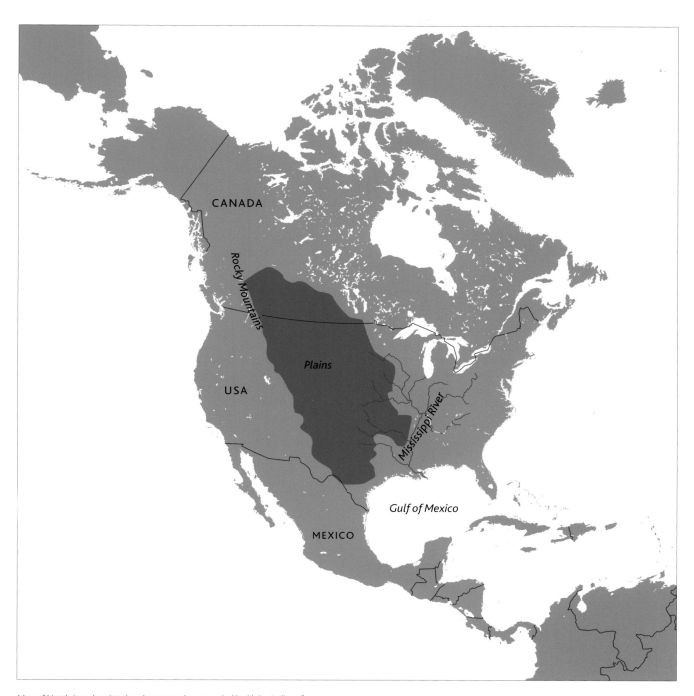

Map of North America showing the vast region occupied by Plains Indians for thousands of years. The area stretches from the Mississppi River to the Rocky Mountains and from the Canadian Plains to the Gulf of Mexico.

Map | 9

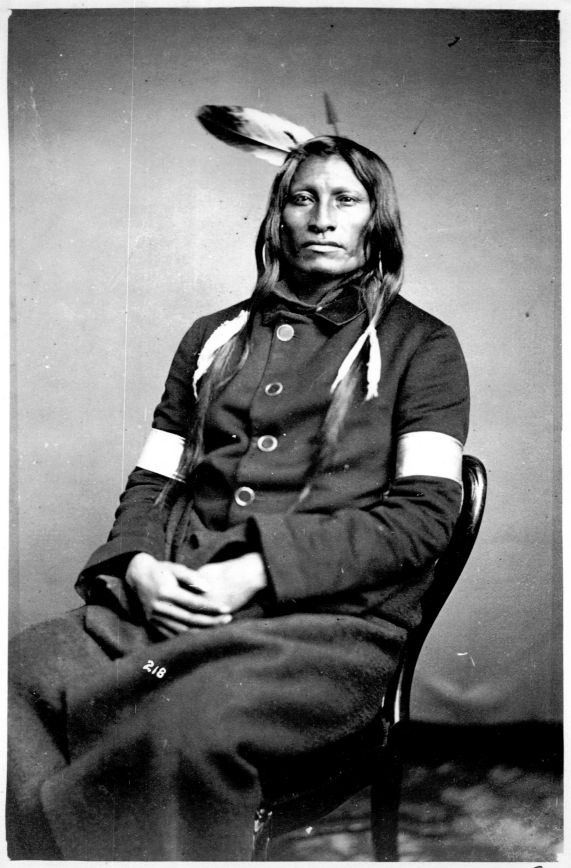

Yankton Dakota Jumping Thunder

218

1060

Chapter 1

Contextualizing the arts of Plains Indian warfare

Introduction

In January 2010 four representatives of the Kiowa and Dakota tribes of North America opened the exhibition *Warriors of the Plains: 200 Years of Native North American Ritual and Honour* held at the British Museum, in London. Two of them, proudly representing the Black Leggings, one of the revived warrior societies of the Kiowa, escorted the military regalia of one of their deceased members to be put on display in the exhibition. During a private ceremony that preceded the official opening, they talked about the objects in the cases as 'ancestors'. The evident connection established by the delegation between themselves and their long-gone forebears was enabled by an elaborate discursive preamble that blurred the fine line which in other circumstances would have separated objects from people and living beings from the dead. Their explicit reference to objects as people indicated that, for the delegates, those two categories were one and the same. This was no exceptional occurrence, however. For thousands of years, objects similar to the ones displayed in the exhibition, and now the focus of this book, have been thought to have their own life force and power much as people do, a notion that continues to be central to Plains Indians' understanding of objects, individuals and warfare today. It is the aim of this book to examine the meanings embedded in the production and usage of war-related objects among Plains Indians in order to re-evaluate their cultural significance for the peoples who made and used them. Largely based on the research conducted in preparation for the exhibition opened by the Native American delegates, the book also looks at the changes in warfare and its associated practices among Plains Indians to examine the sustained relevance of warfare meanings in the maintenance of ethnic and national identities (Fig. 1).

Plains Indians is a collective term describing historical and contemporary peoples who live in the area known as the Great Plains; the region of grasslands that divides the North American continent from north to south across Canada, the United States and Mexico. This area sits between the Rocky Mountains in the west and the Great Lakes in the east, between the subarctic north and the arid southern drylands of Texas and the American Southwest (see Map, pp. 8–9). Other more general terms are used interchangeably to describe the aboriginal inhabitants of this part of the continent, independent of their citizenship. In common parlance and scholarly texts, however, terms such as 'Native North American' and 'Indigenous North American', and adjectives such as 'indigenous', 'native', 'Indian' and 'aboriginal', are often used as synonyms, and in this text will be employed in this way to describe inclusively those tribes that occupy both Canada and the United States. The term Native American generally only applies to indigenous peoples of the United States, whereas First Nations are the aboriginal peoples of Canada. The current Canadian constitution recognizes three categories of aboriginal person: First Nations, Inuit groups of northern Canada and *Métis*. The last is a distinct ethnic group made up of mixed-descent people from aboriginal and European, particularly French and Scottish, backgrounds.

Whether because nations living in this region were the last to resist colonization before the reservation period, or because historically they based much of their social life around the business of war, Plains Indians have become almost emblematic of the Native North American warrior, mounted on a horse ready for battle in his imposing feather bonnet. This book unpacks this popular image to reveal interesting aspects of the lives of Plains warriors that at first may seem unconnected to battles and fighting. The following examination of objects usually associated with warfare will reveal that aspects of Plains Indian life such as identity, ritual and ceremony are crucial to an understanding of what it means to become a warrior. This perspective brings a discussion about war and warfare closer to how it might have been experienced by those involved. Indeed, an analysis of the connections that exist between war, ritual and identity highlights their relevance

Fig. 1 *Psicha Wakinyan, Jumping Thunder, Sioux Yankton (Dakota), photograph by Zeno Schindler, 1858. Albumen print, H 14.5 cm, W 12.5 cm. (RAI 1069).*
This image encapsulates the ideology of Plains Indian warfare for which the absorption of external forces to augment one's personal power is central. Note the arrow worn in the hair, the quintessential symbol of masculinity.

for an appreciation of Native North Americans' longstanding association with the American and Canadian armies, despite a troubled history with their respective governments. The rich North American collections housed in the British Museum offer a perfect opportunity to tease out the complexities and apparent contradictions embedded in this ongoing relationship from the nineteenth through to the twenty-first century.

Men and women from Native North American tribes have been employed to fight alongside European, Canadian, Euro-American and Afro-American soldiers since the beginnings of colonization. They fought during the colonial wars and the American Civil War as well as all the major conflicts in which the United States and Canada have been involved over the last century. They served as scouts, messengers, diplomats, mounted riflemen, soldiers, captains and nurses (Fig. 2). In

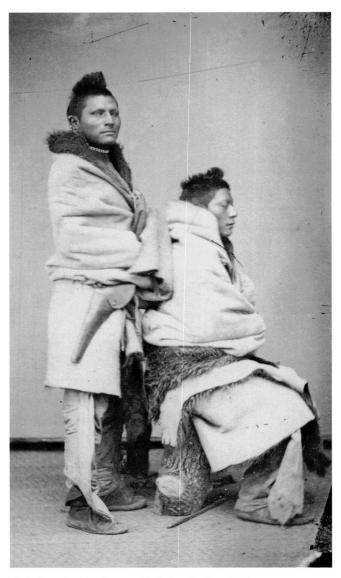

Fig. 2 *Carte-de-visite photograph by Jackson Brothers, 1800s. Albumen print, H 10.1 cm, W 6.1 cm (Am,A9.126).*
This studio photograph from the nineteenth century shows two Pawnee men. Pawnee frequently found employment in the American army as scouts and guides.

world conflicts, they represented the largest non-European volunteer group employed as part of American troops. During the Second World War, more than 3,000 indigenous soldiers served in the Canadian forces. That Indians have been so well-represented in the US and Canadian military forces should not be surprising, however. In many parts of North America indigenous peoples have been warriors since prehistory. Archaeological and ethno-historical records show extensive use by Plains Indians of both offensive and protective weapons and prove intertribal conflict and extensive belligerent and defensive confrontations. For centuries much of their social, moral and philosophical life revolved around the practice of war, although the ideas underpinning this notion have changed considerably over time.

Because the objects associated with war and warfare are so heavily charged with meaning, they ought to be understood as more than simple instruments. Like any other material product they are laden with cultural significance, historical depth and often religious symbolism which deserve proper contextualization. When seen in this broader framework, the objects discussed in this book come closer to new interpretations of Native North American material culture that exceed canonical definitions of indigenously produced articles either as simply ethnographic objects or as art. Over the last twenty-five years there has been an increasing move towards recognizing the social significance of objects produced or used in non-Western cultures from the perspectives provided by their makers (Appadurai 1986; Tilley 1999). This new theoretical stance and its novel methodological reformulations have been vigorously championed by a growing number of indigenous scholars, artists and anthropologists as well as non-indigenous anthropologists, for whom the existing categories of analysis fall short of comprehending the deep cultural connotations of objects produced by indigenous, aboriginal and native peoples around the world (Dobkins 2008; Tuhiwai Smith 1999; Young Man 1991). In the British Museum, in particular, this perspective is reflected in a long series of exhibitions, conferences and other activities that directly involve consultation and advice of indigenous North American peoples (King 2005; Londoño Sulkin 2003). Exhibitions such as *Living Arctic* (1987), *Rain* (1997), *Ancestors* (2002) and the most recent *Warriors of the Plains* (2010) highlighted how collaborations of this kind can generate fruitful and productive dialogues between museum practitioners and source communities (Carocci 1997b; Ingold 1988; Lee and Graburn 1988; Oberholtzer 2000; Peers 2000).

These advances in the scholarship of Native 'arts' have encouraged theoretical perspectives and innovative research that have generated culturally sensitive and more informed accounts of the repertoire of objects and practices that in the United States has been comprehensively called 'Native American expressive culture' (Biolsi 2008; Hill 1994a). This expression stretches the boundaries provided by art historical and ethnographic frameworks to encompass the multidimensional and dynamic interplay of a variety of forms

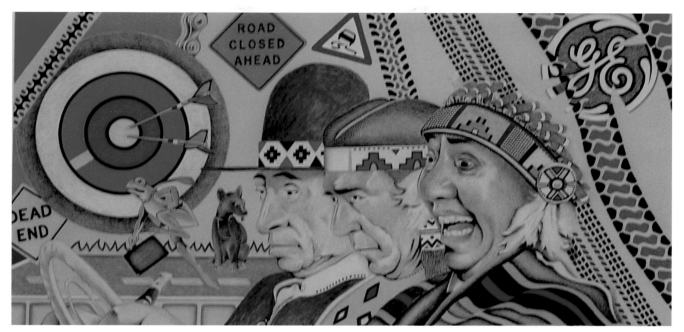

Fig. 3 *Taking the Short Cut 2007 by Star Wallowing Bull (Ojibwa/Arapaho) 2007. Prisma colour pencil on paper, H 28 cm, W 56 cm (2008,2005.1 Purchased with support from The Sosland Foundation).* The chromatic exuberance and deceivingly light-hearted nature of the characters in this drawing hint at twentieth-century representations of Native Americans as subjects of amusement and entertainment. The image also alludes to the cultural experiences of indigenous peoples in that era through the use of textual puns.

of cultural expression that have long been kept separate under self-contained headings and classifications such as decorative arts, fine arts, crafts, painting etc. In adopting this terminology and theoretical framework this book contributes to a more nuanced understanding of the complexity of the processes, experiences and perceptions of Native-made objects as extensions of body, spirituality and identity outlined by some Native scholars (e.g. Her Many Horses 2007). In revealing the importance of the implicit meanings embedded in the production, usage and perception of objects, these scholars seem to meet the theoretical parameters developed within recent anthropological research on material culture, which by definition includes the study of what is normally perceived as 'art'. This body of work, too, has reiterated the importance of contextualization in the study of objects, which involves more complex engagements with how things are experienced and theorized among the people who used or originate them. In much the same way as a new strand of indigenous scholarship that maintains as paramount a close analysis of local meanings, material culture theory exposes the implicit connotations embedded in the materiality of things or, in other words, all that falls 'outside the discursive realm' (Buchli 2002: p. 19). This perspective is particularly relevant for a deeper comprehension of Plains Indian objects associated with warfare because it stresses the sustained importance of objects as means of communication between humans and intangible realities (Schiffer 1999). This concept is at the core of most Native North American belief systems and cosmologies, as clearly demonstrated in the respect and admiration shown by Native American delegates towards the objects on display in the exhibition *Warriors of the Plains* at the British Museum.

Recent scholarship about the material culture of warfare, in particular, explicitly engages with the idea that objects as well as natural phenomena are active agents in the deployment of social life and action (Nielsen and Walker 2009). This theoretical stance resonates with the arguments put forward by anthropologists such as Alfred Gell (1998) and Fernando Santos-Granero (2009), among others, who posit that objects are often perceived as being as alive as people. As such they have the potential to engender a variety of effects on social relations that are reflected in their treatment and perception by human agents. This notion can be pertinently applied to Native North American peoples who see objects as living entities imbued with powers associated with animals, ancestors and enemies, as well as personal and cosmic forces (Gelo and Jones 2009; Pauketat 2008; Pauketat and Emerson 2008). Their use establishes a relationship between humans and other-than-human beings that is integral to what it means to be a person in all the distinctive permutations of roles and responsibilities. Insomuch as objects are mediators between tangible and intangible forces, their use facilitates potential connections to unseen beings and powers pertaining to other realms of existence. As such, objects can effectively be considered 'technologies of the intangible'; in other words, they are a means to rendering visible unseen forces and powers.

Evaluating the significance of these connections through the study of material culture associated with warfare among Plains Indians enables us to see how the intrinsic vitality inherent in objects can have an effect upon reality. For example, this can be appreciated in the value attributed by Plains peoples to weapons, shields and shirts that actively transmit power to their owner. Attitudes towards items

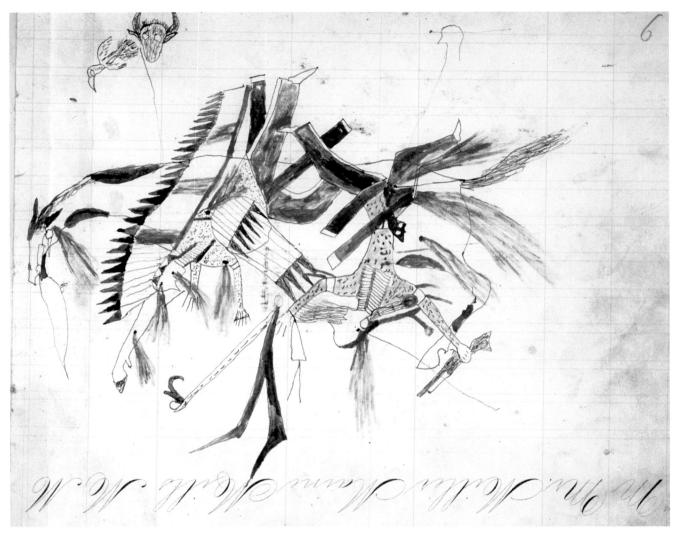

Fig. 4 *Ledger drawing by Tall Bear, Sioux (Oglala Lakota), 1874.*
Pencil or crayon on paper, H 17.5 cm, W 21 cm (Am2006,Drg.5).
References to past lifestyles are common in ledger art of the Plains, which
developed after the establishment of reservations in the latter part of the
nineteenth century. In this image two warriors, Eagle Bull and Bullet in
the Head, engage in fierce hand-to-hand combat realistically rendered
by the position of the figures and the red marks that represent blood.
Note the name glyphs at the top of the page.

related to war and warfare analysed from this perspective
can help us explain the reverence and care shown in their
preparation, handling and disposal among both historical and
contemporary groups. What is more, the following analysis of
Plains Indians' attention to objects related to warfare reveals
a number of concerns beyond their involvement in belligerent
activities. Indeed, today only few of these objects are directly
used in war. Rather they are used in ceremonies and rituals
of martial nature that are deeply underpinned by religious
and spiritual significance. The respect displayed towards such
objects is in fact akin to the care with which religious objects
may be treated. If, as often reiterated in anthropological
literature, spiritual meanings underpin notions of ethnic
and national identity, such objects can rightfully qualify as
the material articulation of religious, spiritual, social and
cultural meanings that sustain ethnic and national identity
for contemporary Native North American tribes. In fact,
interpretations and contextual readings, anecdotes and
stories provided about these objects by indigenous makers

and cultural experts show a concern about issues such as
customs, traditions and ceremonies that for many Native
North American peoples are pivotal concepts articulating
and reproducing their community identity. With regard to
this point Tuscarora art historian and curator Richard W.
Hill reflectively remarks that 'art ... is another form of
storytelling by which each succeeding generation adds its
experiences to the collective consciousness' (Hill 1994b:
p. 78). While objects have an intrinsically evocative power
associated with stories, they can also be appreciated in their
more tangible qualities such as smell, touch and sound.
Together these characteristics contribute to complete the
full experience of the object, which can no longer be seen
as simple, inert matter. Both the material and intangible
qualities of things can therefore transmit meanings across
the generations, adding value and social significance to
objects. As a result, they become material vehicles for
the ever-changing reproduction and adaptation of social
relations that articulate identity (Fig. 3).

This book delineates the contours of Plains Indian societies and their relationship to war and ritual from the nineteenth century to the present through material and photographic collections in the British Museum's Department of Africa, Oceania and the Americas. Most of the material in the British Museum's Plains Indian collections is from the nineteenth century, which was characterized by a series of wars between indigenous groups and colonizers. Mostly concentrated in the United States area of the Plains, and generally known as Indian Wars, these conflicts resulted from the resistance of Native North Americans to pioneers' territorial claims, the establishment of railways and the opening of new routes that facilitated colonial enterprises and the exploitation of resources such as gold mining in California (see pages 112–13). Intensification of intertribal wars and conflicts with colonizers encouraged the strengthening of the organizations associated with war generally known as 'warrior societies'. The nineteenth century was a period of vibrant ferment that was mirrored in the exuberant production of shirts, shields, weapons and accoutrements used in battle as well as in war ceremonials. This same century, however, also saw the decline of such societies soon after the end of the historic Indian Wars, symbolically marked by the infamous massacre of more than two hundred Lakota Sioux at Wounded Knee in 1890. After this the role of warrior societies in tribal life began to change in radical ways. As opportunities to fight were no longer available, men started producing pictorial accounts of their former days as valiant warriors. Some of these narratives were recorded on paper in 'ledger art', a term which refers to the use of accountants' ledgers in place of buffalo and other animal hides. Examples from the British Museum collection of these pictorial renderings of biographical events related to battles and combat have been included in this volume to illustrate the transitional period in which warriors' lives became a memory of bygone eras (Fig. 4). During this time, ritual and ceremonial life connected to warfare offered former warriors an opportunity to maintain a steady continuity with the past. Dances and social events formerly organized by warrior societies became regular features of tribal and intertribal gatherings. At these events identities were affirmed and negotiated and new forms of cultural expression emerged.

One of these new cultural expressions is the contemporary powwow. This term describes social gatherings at which dances originating in the ceremonies of warrior societies are performed by men, women and children. Contemporary photographs in the British Museum by Kiowa photographer Milton Paddlety show how old symbols and warrior dances, for example, have become a feature of modern celebrations organized as a tribute to war veterans. Clothing and ornaments worn by today's dancers also bear witness to old warrior roots. In them are encrypted forms, shapes and meanings associated with war and warfare that can only be appreciated by carefully examining their symbolism, historically developed and shared between martial, ceremonial and ritual contexts (Fig. 5).

If powwow has today become a very visible aspect of the legacy of warrior societies, the spiritual relationship that connects contemporary Native American soldiers to a former war ethos can be appreciated in the more intimate beliefs and practices associated with going to battle: for example, in soldiers' common habits of praying, purifying themselves and

Fig. 5 *Anadarko ceremonial grounds, Oklahoma by Milton Paddlety, Kiowa, October 1996. (Am,Paddlety,F.N.2330 Donated by Milton Paddlety).* American and Native American cultural elements sit side-by-side during celebrations for victorious war veterans from the Kiowa tribe. The juxtaposition of martial symbols from two distinct military traditions reveals the importance of the simultaneous allegiance to both tribe and nation.

wearing leather pouches containing protective items that are very similar to the old 'medicine bundles' carried in battle by selected members of the various warrior societies (Fig. 6).

The following discussion of what will be called the 'material' and 'expressive' culture of Plains Indian warfare shows that objects considered here can variously belong to one or more spheres of social interaction, such as religion or war, according to their use over their life span. Because of the context of their uses and the meanings attributed to them, objects cross and blur commonly perceived boundaries between what constitutes war, belief or art in a multiplicity of intersecting ways. For analytical clarity, however, the book has been divided into parts that separately deal with ritual and war. This division reflects the original narrative structure of the exhibition upon which this book is based.

The present chapter continues with an explanation of the framework used in this research to examine Plains Indian expressive cultures as they historically developed at the crossroads between popular perceptions, academic discussions on their status as 'art', and broader issues of classification and representation.

Chapter 2 presents a bird's-eye view of the social life and beliefs shared by peoples living in the Great Plains in the nineteenth century. A discussion of modes of subsistence, trade networks and community arrangements gives a framework to understand warfare through the changes that affected proto-historic and historic periods.

Chapter 3 is dedicated to the associations called warrior societies. Objects used in their rituals and dances illustrate the deep cultural and spiritual relevance of these men's clubs for the transfer of knowledge and power across the generations. An examination of objects such as drums, rattles and whips, extensively used as society property and emblems, reveals the importance of these items for the preservation of oral traditions and, at the same time, exposes the religious meanings associated with war and individual potency.

Fig. 6 *Purification kit by Ken Harper (Cherokee); Christopher Scott Gomora (Ojibwa); and Jack Flores (Yakima/Cherokee), 2002. Ritual fan: turkey and goose feathers, leather, horse hair, glass beads, deer skin and bone, L 115 cm, W 18 cm. Abalone shell: L 18 cm, W 16 cm, diam. 6 cm. Herb bundles: wild sage (Artemisia tridentata) bound with yellow thread, L 14.5 cm, diam. 6 cm. Braided sweetgrass (Hierocloe odorata), L 40 cm, W 2 cm. Twisted tobacco, L 17cm, W 6 cm. String with cotton bundles containing tobacco and angelica root: L 360 cm (Am2002,12.4).*

Contemporary purification kits usually consist of a fan to waft the incense's smoke around the person, herbs for burning and an abalone shell to collect the ashes. The incense positions a person between air, fire, earth and water, which are signified by smoke from the burning herbs, their ashes and the marine shell. The coloured bundles contain tobacco and angelica root; they are individual prayers left as offerings at sacred sites.

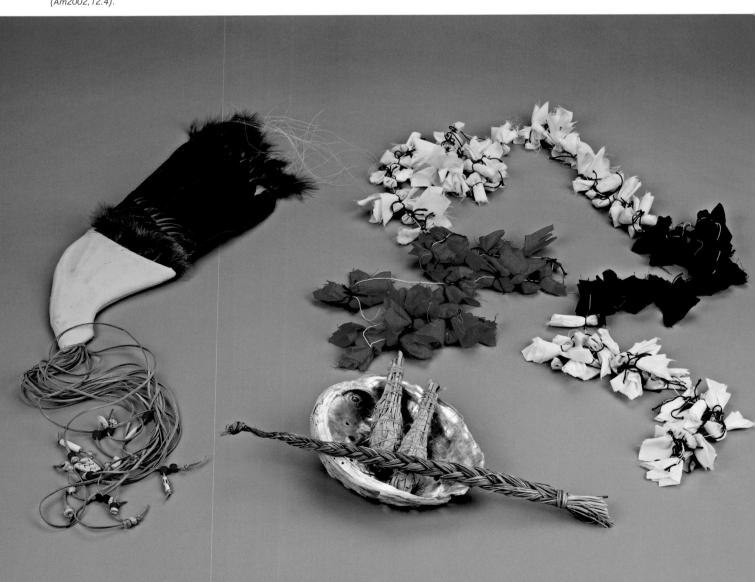

Chapter 4 explores technologies of warfare as a means to discuss the intangible powers needed by warriors to pursue a successful career. It looks at the ways in which warriors enhanced their personal potency and how they rose in rank and status by means of supernatural guidance. In this section inter-ethnic relations are examined through a discussion of objects such as pipes and tomahawks that played an important role in diplomatic transactions, treaty making, peace processes and intertribal alliances. Objects more closely related to combat, such as clubs and armour, are examined with a particular emphasis on the ritualistic aspect of combat as a reflection of moral principles tied to spiritual beliefs.

In Chapter 5, the two sections on Native Americans in war and powwow will examine how old meanings and customs were adapted to rapidly changing predicaments and how these changes are today mirrored in two separate yet complementary contexts that are equally important to the preservation and continuation of Plains Indian culture and identity. The chapter concludes with a discussion about the ways in which the objects examined here can be equally seen as objects of ceremony and religion as well as objects of war and secular life. Hopefully this final evaluation of the complexities of the meanings and practices associated with war and warfare will encourage further analysis of the rich and elaborate material and expressive cultures developed by Native North Americans of the Great Plains over their long and intricate history.

Plains Indian objects: perceptions and representations

Knowledge of Plains Indian cultures among Europeans and Euro-Americans is derived from sources such as museum displays, movies, literature, and to a lesser extent first-hand experiences. Over time the constituent elements of this corpus have mutually reinforced each other and at times created as well as discarded ideas, stereotypes and classifications of Plains Indians and their modes of expression among a variety of audiences. Whereas the systematic study of Plains Indian material culture initiated by anthropologists at the end of the nineteenth century created a type of knowledge firmly shaped by theoretical discussions about cultural traits, symbolism, function, usage and style of objects, over the years museography, art history and popular culture have similarly constructed their own discourses about, and representations of, Plains Indian material culture. The legacy of this long intellectual history can still be appreciated in the ways in which academics and professionals as well as the wider public deal differently with this body of knowledge. Because the objects collected here are part of ethnographic collections, it is therefore essential to locate the present discussion in the context of museum practice as a starting point for further examination of Plains Indian material and expressive cultures.

Museums play an important role in the study and dissemination of knowledge about peoples throughout the world and their material cultures. Source communities,

however, have often disapproved of the ways in which they were represented in museums, offering alternative narratives to official interpretations and objecting to the display of sacred items not made for public consumption (Peers and Brown 2003). Mounting criticism and increasingly vocal disagreements about the ethics of display eventually forced museum practitioners to consider more carefully the range of issues involved in the treatment of ethnographic objects. Following on from these arguments, local communities, elders and intellectuals have become more involved in museum consultations over interpretation and display (Cobb 2005; Mithlo 2004a; Rickard 2007). Objects kept and exhibited in museums have often offered the opportunity to establish fruitful dialogues between museum practitioners, scholars and communities represented in museums through their material culture. More recently, the relationship between museum practitioners and indigenous peoples has been greatly enriched by research carried out within the emerging interdisciplinary field of World Arts studies. Indigenous cultural critics, artists and practitioners have been fundamental in shaping new directions of research by proposing arguments in favour of a greater cultural sensitivity towards their cultural heritage exhibited in museums. Its pedagogy, centred around material and visual cultures and their representations in museums and other contexts of cultural production, examines the ways in which objects and images have become increasingly central to the pressing need for re-evaluating the power dynamics historically established between indigenous and non-Western peoples, colonial and postcolonial powers (McMaster 1999; Mithlo 2004b; Phillips 1994; Thomas 1999; Venbrux et al. 2006). One of the main concerns among scholars researching in this field is precisely the examination of the role played by material and visual cultures of non-Western peoples in establishing power hierarchies based on perceptions derived from preconceptions, theoretical frameworks and notions from Western intellectual history. The very division between art and artefact applied to non-Western objects is, for example, deeply indebted to notions of high and folk art that have strong European intellectual roots (Fig. 7). The present work fully embraces the theoretical parameters proposed by a World Arts framework, because it places the issues of classification and aesthetics in the context of power relations that shaped the ways in which Plains Indian cultures have been perceived, classified and constructed through objects, representations and visual culture over the long time span bridging colonial and postcolonial periods.

In Europe, in particular, objects are frequently the only means by which people can directly experience Plains Indian cultures. The paucity of opportunities to see live performances of indigenous dance troupes or theatre companies is inversely proportional to the diffusion of films and books popularly marketed as entertainment or leisure. Repositories of ethnographic objects such as museums, however, offer unique opportunities to see and learn about different cultures by way of material and visual culture in the form of displays, handling

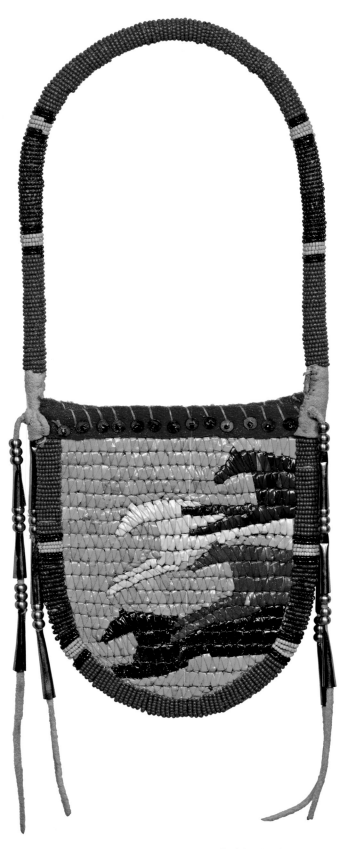

Fig. 7 *Quilled pouch by Dorothy Brave Eagle, Sioux (Oglala Lakota), 2008. Skin, dyed porcupine quills, brass, sinew, W 14.4 cm, H 34 cm (2009,2004.10).* Native North American expressive cultures have recently been the subject of intense debates about what constitutes art. Ongoing discussions between professionals, museum ethnographers, art historians and the art market have highlighted the uneasy relationship between incommensurable systems of classifications.

sessions, photographs and the screening of documentary films. Ethnographic artefacts can be perceived as tangible effigies that embody distant realities. Audiences, however, perceive and interpret them through pre-existing categories that are often shaped by misguided, partial, biased or inaccurate knowledge. The discrepancy between lived experience and imagination can therefore be problematic in the evaluation of Plains Indian ethnographic artefacts.

Material and visual expressions are just one aspect of the complex picture drawn by the multiple intersections between films, literature and real-life experiences. Objects nonetheless constitute a fruitful point of departure for an examination of the intricate web of mutual references that make up the large repertoire of representations associated with Plains Indians. Objects made and used by Plains Indians, and in particular those most clearly associated with war and warfare, have played a significant role in establishing the lens through which Europeans and North Americans perceive the peoples living in this vast region. From early ethnographic collections to representations found in leisure, fashion and entertainment, Plains Indian visual and material culture has been the focus of academic and popular musings about ancient lifestyles, the beginnings of art, and 'primitive' humans' resistance to the encroachment of civilization. Indeed, the fascination for European audiences of Plains Indian shields, bows, arrows, tomahawks and feather headdresses is the result of a long and frequently troubled relationship between Plains Indian peoples and colonizers that dates back to the earliest historical contacts.

Objects produced by peoples inhabiting the Great Plains of North America started reaching European and non-indigenous museums, private collections and learned institutions as soon as European travellers, explorers and governmental agents began making contact with the peoples living west of the Mississippi River. Up until the eighteenth century, objects coming from this vast area were limited to items produced or used by peoples living at the fringes of the Plains, such as the Osage, Quapaw and Illinois (Fig. 8). Surviving items collected among them include, for example, painted robes and hides now in French national museums (Horse Capture *et al.* 1993). At first, these objects from distant lands ended up in royal and presidential cabinets of curiosity in both Europe and North America, but with the establishment of national museums these so-called 'exotica' or 'artificial curiosities' (that is, man-made), once the patrimony of elite classes, became available to larger viewing publics.

The British Museum collection is different to those in other museums in the United States and Canada and in European cities such as Hamburg and Berlin. Until the end of the twentieth century the British Museum did not collect by field collecting; instead it relied on the acquisitions of historic materials. The Department of Africa, Oceania and the Americas houses some 27,000 objects from North America. Of these, five hundred items have been identified as coming from the Great Plains, western states and the western Great Lakes. Historically, objects were often given or sold to the Museum

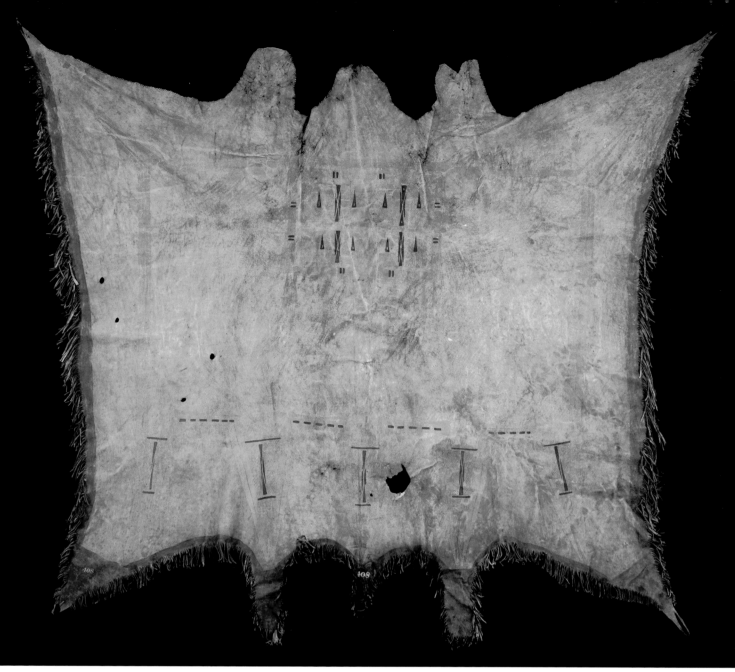

Fig. 8 *Robe, unknown creator, tribe or date. Hide, natural pigments, L 180 cm, W 150 cm (Am1944,02.219).*
Early Plains objects were collected by travellers and brought to Europe as curiosities. The age of items such as this robe, possibly from the Illini tribe (formerly Illinois), can be inferred by the pictorial style that was common in the eighteenth century among the tribes of the Midwest and the Western Great Lakes.

by explorers and colonial officials. Some of the earliest objects reached the British Museum via expeditions and individuals who travelled across the Plains as surveyors, adventurers or erudite eclectic voyagers, such as Duke Paul Wilhem of Württemberg, whose collection of Plains Indian objects is now in the British Museum (Gibbs 1982; but see also Württemberg and Dyer 1998). The items he gathered over four distinct travels in North America between 1822 and 1857 are some of the earliest examples of Plains Indian material culture in the British Museum (Fig. 9). Often, exceedingly rare specimens of Plains Indian material culture, such as horse-hide armour used by horse riders of the southern Plains, ended up in European collections as donations from entrepreneurs such as the Irishman John Mullanphy (1758–1833) (see Fig. 87). He emigrated to Missouri and became a successful cotton trader.

He subsequently left his collection to Stonyhurst College in Lancashire, northern England, though it was eventually integrated into the British Museum's early ethnographic collections (King and Archambault 2003).

There are few eighteenth-century Plains Indian objects in European and North American collections because contacts between Plains Indian tribes and Europeans only became increasingly frequent when colonization efforts were implemented by American and Canadian governments after the mid-nineteenth century. Popular curiosity about objects coming from the Great Plains grew with the spread of news about the conflicts between colonists and Native North American tribes. Some of the objects that have now become part of museums' ethnographic collections were either diplomatic gifts, exchanged during peace negotiations

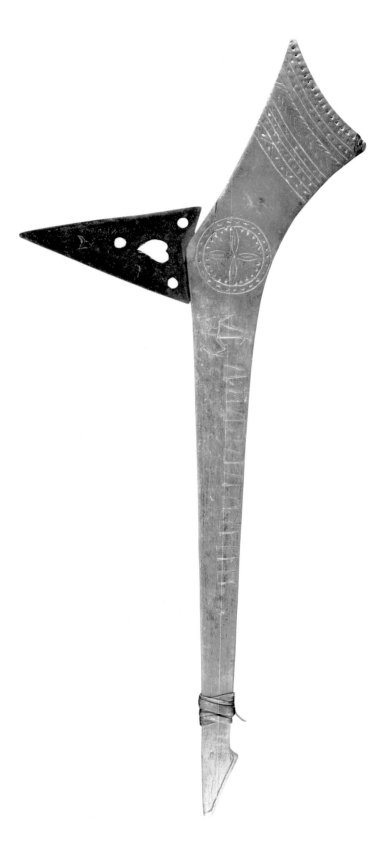

between indigenous groups and Europeans, Americans and Canadians, or were collected by generals and other army officials during military campaigns in various parts of this vast region.

Diffusion of travel writing, diaries and field accounts further facilitated the dissemination of information about Plains Indians in the nineteenth century, both in North America and in Europe. This corpus of knowledge, in addition to more frequent visits of indigenous diplomatic delegations to European and North American cities, or as part of pageants such as Buffalo Bill's Wild West Show in the mid-nineteenth century, contributed to the construction of popular conceptions of Plains Indians that, over time, became the typical archetype of all North American tribes. Although these representations were biased, prejudiced and in many cases inaccurate, they nonetheless had a significant impact in creating the popular image of the doomed warrior succumbing to Euro-American civilization. Adding to this perception was the implementation in both Canada and the United States after the 1870s and 1880s of vigorous government policies aimed at the total assimilation of indigenous peoples into mainstream culture, and efforts to convert Native North Americans directly on the lands set aside for their use in both countries (called reserves in Canada and reservations in the United States).

In this context, government agents – who often spent years in close contact with indigenous populations – accumulated large collections that were integrated ultimately into museums at home and abroad. One such example which contains Plains Indian objects is the Frederick and Maude Deane-Freeman collection, now held jointly between the British Museum in the United Kingdom and the Royal Ontario Museum in Canada. It includes material acquired from the Kainai/Blood division of the Blackfoot at the beginning of the twentieth century (Brownstone 2002; Soop 2002). Along with many items of clothing, it also includes horse trappings and dance objects that testify to the changing lifestyles experienced by Plains Indians at the turn of the century (Fig. 10).

In the period between the late nineteenth and early twentieth century the great poverty experienced by Plains Indians after their confinement to reserves and reservations, and the subsequent demise of their traditional subsistence economies, led many families to sell precious heirlooms. Additionally, much-needed revenue was generated through the production and sale of items purposely made for non-indigenous markets. This situation resulted in an increase of collecting of Plains Indian items by tourists and art amateurs as well as anthropologists, who wanted to preserve the cultures of endangered peoples. Many of the items in North American museum collections were acquired in the attempt to make a comprehensive inventory of every form of material culture ever produced by Native American and First Nations peoples with the intent of classifying and storing it for future generations. Although ethnographers continued to gather a diverse array of Plains Indian objects for their museums for study and research, by the early twentieth century private

Fig. 9 *Club, early 1800s. Wood, metal and hide, L 62 cm (Am2003,19.2).* This club collected by Duke Paul Wilhelm in the early nineteenth century was common among Plains, Midwestern and eastern tribes. Figures carved on the handle often represented captives taken or enemies killed.

collectors and tourists had shifted their attention towards typologies of objects that more closely resonated with Western art references, taste and sensibilities. During this period the opening of new tourist markets generated new strands of interest in Native North American cultures and arts that then competed with the arts of the Plains. Large-scale enterprises in long-distance travel by train and boat in areas such as the southwestern United States and the Northwest coast of Canada paved the way for the establishment of commercial ventures and the collecting of items specifically made to appeal to Euro-American and Canadian customers. Peoples living in the Southwest and the Northwest coast produced arts that clearly echoed modernist aesthetics, mannerisms and designs produced by non-indigenous artists of the 1920s and 1930s. Unique among Plains Indians is the case of some Oklahoma artists who became famous for their vibrant yet mannerist watercolours depicting scenes of traditional life in a style attuned to the Art Deco aesthetics of the time (Fig. 11) (see also Chapter 5). Although historically significant, this group of artists, later known as the 'Kiowa Five', was more the exception than the rule. The development of an art market for Plains Indian artists in the first two decades of the twentieth century was largely based on the implicit premise that objects traditionally produced with hides, furs, feathers, beads and skins were too cumbersome and awkward to appeal to educated and discerning collectors of Native North American arts. These materials evoked images of primitivism that were absent from the highly polished, streamlined and sinuous forms of Pueblo plates and pots, Navajo jewellery, Haida carvings and Tsimshian boxes. Objects made by Plains peoples generally did not conform to the expectations of patrons and collectors whose ideas of fine art were determined by classical divisions such as painting and sculpture. In consequence, with the exception of a limited number of artists whose style was largely influenced by American patrons, Plains Indian expressive culture, in comparison to that of other areas, mostly retained its place in museum storage as the testimony of lifestyles that were perceived to have ended with the last bouts of resistance from tribes such as the Sioux, Cheyenne, Arapaho, Kiowa and Comanche (Errington 1998).

Early twentieth-century Canadian and North American public opinion preferred to glide over the uncomfortable effects of traumatic conflicts with Plains Indian nations of earlier decades. At the same time, commercial and tourist relations with peoples of the Southwest and the Northwest coast helped to redirect public attention towards the less emotionally charged economic transactions between sellers and buyers. Although many such transactions may have been mediated by humanitarian and, not infrequently, patronizing attitudes, it was not until the end of the 1960s that Plains Indian material culture re-emerged in the public domain with a powerful emotional force conveyed through media images of Native North American civil rights struggles. The confrontational stance staged by indigenous activists during public displays aimed at drawing attention to their causes and rights during the 1960s and 1970s made strategic

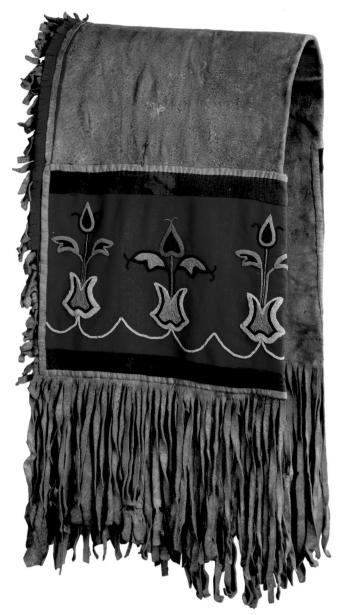

Fig. 10 *Saddle blanket, Blackfoot (Kainai), late 1800s.*
Wool, glass and skin, L 195 cm, W 45 cm (Am1903,-.76.a4).
Items, such as this saddle blanket, made between the late nineteenth and the early twentieth century were often created for public display. Other objects now in museum collections were used as part of pageants that travelled Europe and North America.

use of the warrior aesthetic articulated through the use of war chants and drumming, feather headdresses and other regalia. In numerous public appearances, demonstrations, takeovers and political rallies, Plains Indians once again reappeared in the public consciousness as the quintessentially rebellious, belligerent warriors, a representation that further anchored all Native North Americans to culturally entrenched stereotypes. One of the most publicized political actions that represented Plains Indians in this light was the Wounded Knee takeover in 1973.

If the stereotype of the Plains warrior is still very popular in both Europe and North America, current debates in

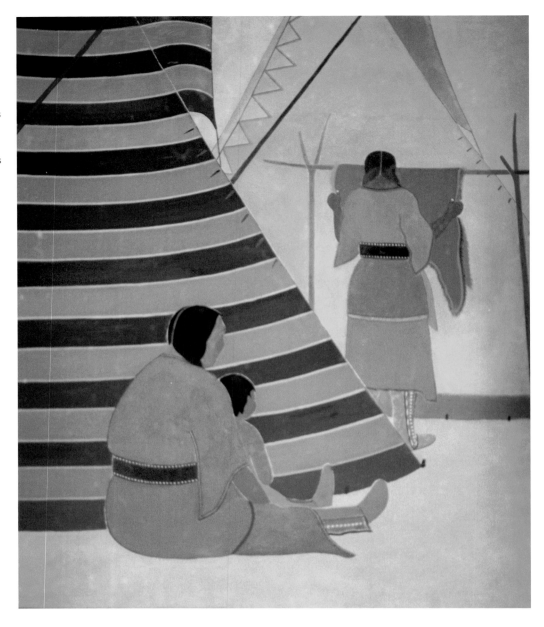

Fig. 11 *Mural painting in the Anadarko post office, Oklahoma, by Stephen Mopope, early 1900s. Photograph by Milton Paddlety, Kiowa, 1996. (Am,Paddlety,F.N.2970 Donated by Milton Paddlety).* Stephen Mopope, Kiowa (1898–1974) was among the few Plains Indian artists who became famous in the early twentieth century due to a personal style that fitted in with the aesthetics of the time.

the media about the treatment of indigenous peoples are beginning to question the ethics of such representations precisely by addressing the cultural meanings invested in objects evoked or shown in popularly consumed iconography. The recent furore over the pop group OutKast's inappropriate use of Plains Indian feather bonnets in one of their music videos, for example, has been highlighted in the United States media by indigenous intellectuals, who argued that their actions were symptomatic of the ways in which objects can epitomize strongly held views about cultural meanings and their significance for indigenous peoples (Adams 2004a, b; Jennings 2004). All over North America, indigenous peoples are actively re-evaluating their material culture to give it proper contextualization so as to make the wider public aware of the cultural connotations of the items in which they recognize themselves. This process entails a reassessment

of the tone and modalities in which indigenous expressive cultures can convey to audiences who are alien to Native North American cultures those messages that reflect culturally appropriate meanings and alternative readings of otherwise misunderstood objects so central to the continuation of their identity.

The expressive cultures of Plains Indian warfare
The items discussed in this book are very diverse. Photographs, drawings, garments, ritual accoutrements and mementos, among other objects, have been included here as a means to illustrate Plains Indian expressive cultures associated with warfare. One of the issues the book addresses is that the diversity of these objects can be ordered according to classification systems that historically changed according to

different contexts of perception and representation. Museums, art markets, auction houses, cultural institutions and academia each have their language to describe and present objects produced and used by indigenous peoples. The current treatment of the British Museum's Plains Indian collections as one corpus is both a challenge and a statement of intent.

The present book brings together museological, ethnographic and art historical practices and premises with indigenous meanings, interpretations and frameworks. Indeed, the arguments brought forth by the following discussion are aimed at expanding the often too rigid boundaries established by canonical definitions and paradigms generally applied to Native North American art by art historians, collectors, museum ethnographers and anthropologists.

Simultaneously, the book shows that indigenous perspectives can reveal additional layers of meaning existing between objects that may not be apparent from a purely aesthetic appreciation of their formal qualities. While indigenous aesthetic meanings may play a role in the skilful production of objects, this is by no means the only perspective from which one can appreciate Native North American material and expressive cultures. Perhaps a more fruitful approach to this issue is to examine the ways in which objects in indigenous contexts engender and transmit meanings beyond aesthetics.

In Native North American cultures meaning is created and actively reproduced in the interstitial space generated by the relationship between objects and people. This is a process that is often more important than the appearance of objects. An analysis of the history and use of some of the material illustrated here teaches us that frequently what from a Western perspective may appear unassuming items are, in fact, incredibly important complements to elaborate ritual kits without which other objects have neither meaning nor purpose. Indigenous North American 'arts', as we are often reminded by indigenous practitioners, belong to an integrated whole, of which material objects are only a fragment. Items described as art cannot be seen in isolation, nor is it advisable to interpret them outside modalities of expression and contingent articulations of their meanings, lest we risk misinterpreting their cultural relevance and uses. Indigenous intellectuals often reiterate that items of material culture are in dialogue with one another in a dynamic dialectic expressed through the practical employment of objects in real life. For example, the power of objects can lay dormant for variable periods of time, and can only be revived in special circumstances by proper ceremonial procedures that require invocations, prayers and the use of complementary implements, without which they remain inert. Human action, often ritual or more broadly ceremonial, is thus essential in activating the powers that reflect the meaning and purpose of objects. In Native North America objects have the function of enhancing the power of a person or group by activating their inherent potential. Powerful objects effectively make people more powerful. So objects establish power relations and negotiate the place individuals have in broader cosmological schemes reflected in social life.

More specifically, an object's power is made up of the sum of the powers contained in its constituent elements. For example, significant connections can be drawn between objects containing special materials. While whole items may perform important religious, political or social functions, it is the additional relationship between their parts that further establishes a web of often invisible connections between seemingly unrelated things. So, for instance, objects that include owl feathers partially partake of the owl's powers. This characteristic aligns them alongside other objects or contexts in which the same material is used. As such they can constitute a class of objects that are connected by the same power, intentionality and function. An awareness of the multiplicity of connections established between things from this viewpoint can potentially generate new and fruitful discussions about the nature and role of material culture between anthropologists, museum professionals, artists and art traders who work with and through objects.

The classification of the objects included in this book according to typologies such as photography, mementos, ethnographic artefacts or art is as subjective as it is to some extent alien to the meanings that may originally have been attributed to them by their makers. Native North American-made objects have often been classified according to the language and canons derived from the art historical study of material culture according to medium, technique or styles (Feest 1999). While attempts to expand the interpretative language that can describe Native North American expressive cultures have included alternative frameworks such as cosmology or identity that cut across geographical regions and historic periods (Berlo and Phillips 1998), the prevailing interpretative templates are still offered by anthropological and art historical matrices based on well-established classifications and discourses such as, for example, the notion of 'culture area' (Driver 1962; Kroeber 1939). In this paradigm, North America can be divided into eco/geographical areas whose inhabitants share specific cultural characteristics. Historically, this model has proven to be a popular and useful shorthand, with definite disadvantages in the sense of reducing complex difference to a single culture type, in the definition of Native North American art styles, typologies and diffusion of themes and designs. Despite obvious shortcomings and limitations, however, it still provides a well-accepted approach to anthropological and art historical studies of indigenous North Americans' cultural production (Carocci 1995). While the notion of the 'Plains' as a cultural area is here taken as the departure point for the present evaluation of objects in the British Museum collections, it is nonetheless a framework that rarely reflects some of the old and more recent artists' multiple engagements with various expressive registers that trespass strict geographical boundaries. This is particularly evident in the range of cultural borrowings between regions that can be noticed in stylistic influences displayed in several objects, such as different uses of colours, combination of motifs and frequency of designs. Floral patterns matched with geometric

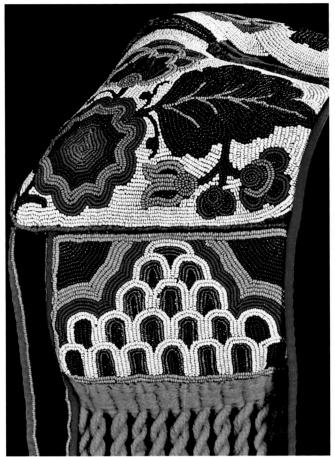

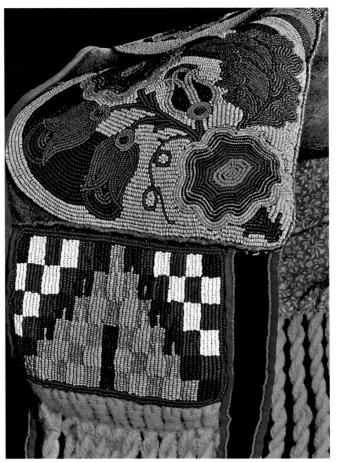

Fig. 12 *Parade Saddle (two details), Blackfoot or Plains Cree, late 1800s–early 1900s (?). Leather, wool, glass and wood, L 47 cm, H 27 cm (Am1983,Q.254).* Blackfoot and other northern Plains groups integrated different influences in

their cultural expressions. A variety of styles and techniques can be seen in the beadwork on items such as this saddle, which displays both geometric and floral motifs developed in the subarctic areas of Canada.

decorations found among the Blackfoot, for example, reveal historical contacts with subarctic populations living beyond the geographical confines of the Plains culture area (Fig. 12). Similarly, eastern Sioux aesthetics can be said to reflect the influence of their woodlands neighbours more than that of other Plains tribes (Fig. 13).

Perhaps one of the most productive engagements with existing classificatory frameworks in the study of Plains Indian expressive cultures is offered by the critical dialogue opened between anthropologists, museum and art professionals with the indigenous perspectives that this book endorses. Taking Native North American epistemologies as a starting point, it becomes clear that classes of objects conventionally presented as belonging to specific art traditions, areas or genres may be interpreted according to classificatory schemes very different from the ones utilized in canonical texts about Native North American art. Native standpoints tend to downplay the pre-eminence of geographically binding frameworks or schemes provided by classic medium-led interpretative models, thus challenging established authority. As we have seen earlier, objects made in indigenous contexts may be divided according to their inherent power content; alternatively they can be classified

according to whether or not they are used on the body, or if they are exclusively used in ritual or social situations (Clifford 1992).

In recent years, novel interpretative frameworks produced by indigenous-led research have greatly benefited from the input of scholars engaged in exploratory examinations of their ancestors' expressive cultures. Some of the most recent work carried out on Native North American museum collections tends to transcend predictable typologies and classifications by highlighting shared meanings between objects generally separated by the imposition of alien theoretical models (Cobb 2005; Her Many Horses 2007; Hill and Hill 1994; Horse

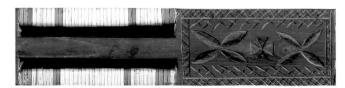

Fig. 13 *Carved wooden pipe (detail), Sioux (Dakota), c. 1850. Wood, horse hair and porcupine quill, L 16 cm (Am.2564.a Donated by Henry Christy).* Eastern bands of the Sioux confederacy brought themes and designs derived from their original homelands in the woodlands onto the Plains. Woodlands tribes were, and still are, very fond of floral motifs that they carve and bead on a variety of items.

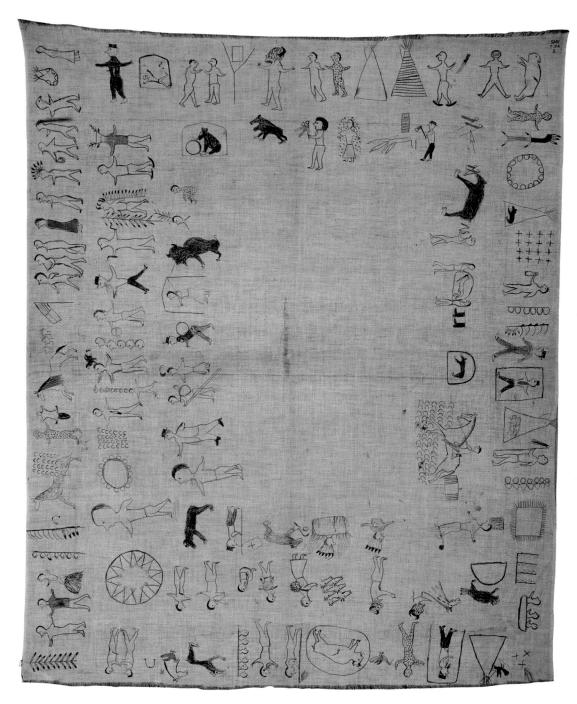

Fig. 14 *Winter count, Sioux Yankton-Yanktonai (Dakota), early 1900s. Ink on calico, L 90 cm, W 112 cm (Am1942,07.2 Donated by Miss. Smee).* Winter counts drawn on calico are the continuation of a pictorial tradition that dates back to prehistory. Retelling of important events in tribal and personal histories is still a common practice among all Plains peoples.

Capture and Horse Capture 2001; Walters 1989). The present juxtaposition of diverse objects under the theme of war and warfare aims to encourage readings of Plains Indian material culture along these lines so as to enable new connections that can expand our understanding of the role played by objects in indigenous Americans' modes of expression.

Some of the objects included in this book were deliberately created as records of or commentaries about memory and history. This class of objects can include visual accounts of memorable facts that reveal a conscious reflection upon

the importance of specific actions for the maintenance of individual and group identity, shared values and ideologies. The British Museum's winter count, ledger drawings, personal visual records of war exploits painted on hide or muslin and, lately, contemporary photographs, collectively express the desire to document what is deemed important and worth remembering in a conscious effort to freeze in time significant events or cultural practices of an individual or group (Fig. 14). While they are undoubtedly important records of historical moments or biographies, these representations also constitute

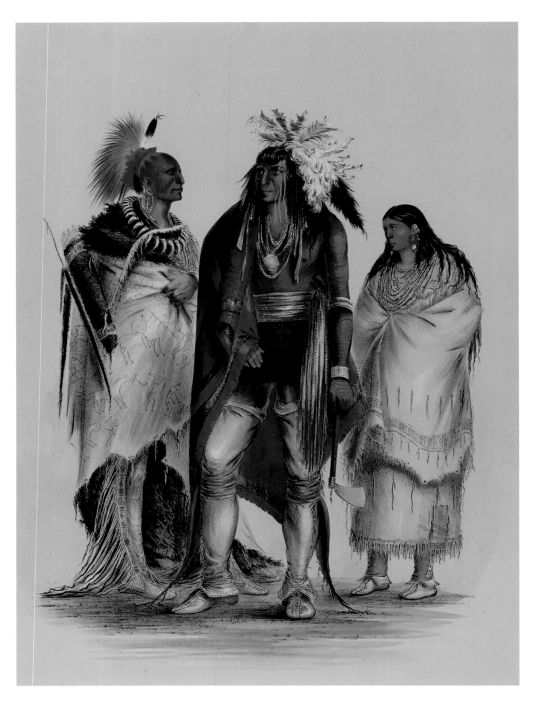

Fig. 15 *Portrait of three men from 'Souvenir of North American Indians', George Catlin, 1845. Lithograph, H 45.5 cm, W 31.5 cm (AOA F Kub [Cat-] M33161 Plate 1).* Over his long career, artist George Catlin produced hundreds of portraits of Native American men and women. Catlin developed his own artistic conventions to depict items such as leggings and pictographs. As a result they are not always accurate renditions of the things he saw.

a typology of artefacts that reify relationships between individuals and seemingly inert materials such as paper, used in both ledgers and photographs. In indigenous contexts the relationship between people and things is always mediated by the inherent meanings attributed to the characteristics associated with specific materials as well as invisible forces. The ability of paper or hide to convey or conceal messages, for example, can be said to have the capacity to transmit something of the power of the person represented. Often esoteric meanings are encoded in designs and motifs only known to the makers. The secrecy that surrounded them enhanced and preserved their hidden power. If we consider that writing and drawing in indigenous terms are analogous

operations, it should not be surprising that picture writing, the form of message transmission by way of semi-realistic images, icons and signs, historically developed from ritual and ceremonial activities (Keyser 2004, Sundstrom 2004).

Objects cannot be detached from the actions that accompany them. Things and acts inform each other and act synergically to generate, mediate or transmit the power of both things and beings. In the case of paper, for instance, a person's power is transmitted by means of his or her voice conveyed via the written word, or a realistic image of his or her essence, as in the case of photographs or painted portraits. Personal essence is always present in objects that contain much of the vital force, agency and intentionality of

the makers, as Gros Ventre anthropologist and art historian George P. Horse Capture reminds us (Horse Capture and Horse Capture 2001: p. 29). Historical indigenous North Americans' responses to the printed word, early paintings and, later, photographs indeed show the true meaning of the expression 'technologies of the intangible', because their mediatory function enables a direct communication between humans and invisible powers. As artist George Catlin reported among the Mandan in the early nineteenth century, paintings were alive for them: that is, they contained vital essence because they made people appear in two places. Anyone capable of achieving this by way of the skilful use of particular technologies such as paper or paint was associated with great spiritual power, which in this tribe granted the painter the nickname *Te-ho-pe-nee Wash-ee*, that is, 'Medicine White Man' (Catlin 1974, I: pp. 106–7) (Fig. 15). Visual representations and images are important snapshots of both Plains Indian history and current customs, but they also indicate a distinctive sense of reverence for outstanding individuals and actions that reveals a deep concern with values and moral conditions shaped by beliefs about unseen and intangible forces at work in seemingly mundane objects or activities.

The working of intangible forces upon the tangible world is a significant trait that characterizes all those objects illustrated in this book that intentionally open up a connection between humans and unseen energies and powers. This relationship is more generally expressed through the production and use of items employed by warriors and their military societies. These include ceremonial rattles, drums, sashes, headgear, shirts, shields and weapons that contain powers crucial in protecting warriors on the warpath, or that ensure a safe return home. This class of objects, irrespective of medium or material, constitutes the core of the British Museum collections presented here. With the exception of a few items collected in the early eighteenth century, such as a rare scalp from the Sloane collection (the original founding collection of the British Museum) (Fig. 16), most of the objects in this book were collected between the nineteenth and early twentieth century. This period has often been characterized as the end of the classic equestrian phase of Plains Indian cultures, one that coincides with the end of nomadic lifestyles and the beginning of the reservation era in the late nineteenth century. While a portion of these objects were probably only used in war-related activities such as dances and ceremonies and may never have been used in real battles, their sustained use in the reservation era testifies to a vibrant tradition that continued well into the early twentieth century when intertribal warfare and confrontations with both Canadian and United States armies had long since ceased. The importance of these objects for contemporary indigenous groups is paramount, however, as they embody the connection between modern people and their ancestors. This is a valued relationship that plays a crucial role in articulating and maintaining ethnic and national consciousness for many indigenous groups in North America. These forms of identity are strongly predicated upon the spiritual meanings embedded in objects that represent both

a heartfelt connection with the past and an investment for future generations.

A further class of objects is constituted by all those items made in the late twentieth and early twenty-first centuries (see p. 28). Specimens in this class epitomize current issues about the status of contemporary indigenous material and expressive culture in museum and art contexts. While some of these objects would normally be classified as 'art', for example the work made by Linda Haukaas and Don Tenoso, other items, such as the Black Leggings regalia made by a number of skilled people of the Kiowa tribe, have a more ambiguous status in the current classificatory systems of art historians, museum ethnographers and art traders. These objects in particular elicit interesting questions about the changing nature of Native North American expressive cultures at the crossroads between classificatory systems embedded in false

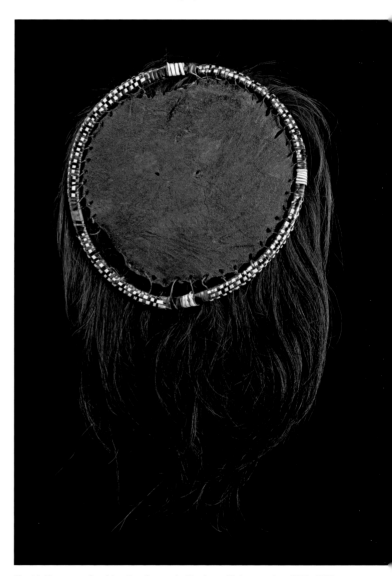

Fig. 16 *Human scalp with painted portrait, Northeast Plains peoples, 1750–1850. Human scalp, wood and porcupine quill, L 20.5 cm (Am1978,Q.39).*
The custom of painting faces on the flesh side of human scalps derives from the notion that these items were equivalent to human persons and took the place of a dead relative. The old-style quillwork that decorates the hoop may date this scalp to the early eighteenth century.

Contemporary Plains objects in the British Museum

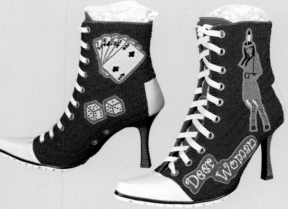

Fig. 17 *Beaded stiletto boots by Teri Greeves (Kiowa) 2004. Plastic, nylon, glass and cotton, H 23 cm, L 27 cm, W 9 cm (Am2004,02.1.a-b Purchased with support from The Sosland Foundation).*
The references to playing cards and dice that appear on this pair of beaded stiletto heels by Teri Greeves directly refer to the popular appeal of casinos. The image of Deer Woman symbolizes the ambivalence of appearances and warns the viewer about the attractive yet deceiving nature of gambling.

The contemporary objects of the Plains Indians in the British Museum's collection reveal an intense cross-fertilization between a wide range of technical innovations that have had an impact on the manufacture of arts and crafts by Native North American peoples over the last hundred years. The makers of these objects deliberately blend modern techniques and themes with older media and iconographies. This reflects a self-conscious approach to art that is typical of the most recent production of many indigenous expressive cultures around the world. Modern and contemporary objects produced by Plains artists and craft specialists mirror the emergence of new contexts in which indigenous peoples are progressively more connected both between themselves and to international networks. Honed in response to evolving economic circumstances, such as the growth of tourism, art markets, auctions and fairs, Native creativity today gives a voice to indigenous concerns about cultural self-determination and identity.

Collectively these objects show an increased blurring of the boundaries that divide art from craft, a canonical separation that has distinguished Euro-Americans' and Canadians' consumption of Native arts since the early twentieth century. The mid-twentieth-century objects in the British Museum, for example, are a classic case of how old crafts were turned into commodities under the influence of Euro-American patrons and market demands. As a result of some of these changes, accomplished craftspeople are now being exhibited alongside artists who produce objects to be sold on the art market using customary techniques such as beadwork or ribbon-work, generally considered within the scope of decorative arts. Contemporary beaded stiletto heels by Kiowa artist Teri Greeves (Fig. 17), for instance, are an example of a process by which everyday objects are transformed into what some people consider fully fledged works of art. Plains peoples have been decorating everyday objects such as parasols or bags since the early twentieth century. While these beaded stilettos indirectly call to mind such historical developments, they also show the instability of strict canonical categories in the definitions of Native North American expressive cultures today. Contemporary indigenous peoples' critical assessment of the placement of their work in museums highlights concerns about the redefinition of both the boundaries and canons of what constitutes art.

Teri Greeves' stilettos and other modern and contemporary objects made by Plains artists reflect aspects of Native North American peoples' social, cultural and political life between the twentieth and twenty-first centuries. In powwow regalia by Dennis Zotigh (Kiowa) one can find reference to the emergence of intertribal realities, whereas warrior insignia commissioned from Lyndreth Palmer (Kiowa) reveal the sustained importance of martial life in the maintenance of customary continuity and tradition. The rich journalistic reportages by Milton Paddlety (Kiowa) show us facets of Plains Indians' contemporary life with its concerns and contradictions. Artwork by Star Wallowing Bull (Ojibwa/ Arapaho) or Don Tenoso (Sioux) reflect upon indigenous history and identity with the suggestive irony of the tricksters at the core of traditional storytelling, whereas healing objects made by San Francisco's intertribal communities to respond to the AIDS crisis expose how culturally sensitive messages have become paramount in addressing health issues in Native North America (see Figs 2, 4, 17 and 18) . The diversity of these objects, now part of the British Museum's Plains Indian collections, mirrors the heterogeneity of artists' multiple engagements with issues that characterize Native North Americans' contemporary lives. Additional items from the twentieth and twenty-first centuries range from contemporary clothing to dance regalia, photography, decorated articles and paintings. All these items collectively represent the various media of expression recently adopted by Plains artists and craftspeople. They all show vibrant and multifaceted approaches to both indigenous and cosmopolitan aesthetics, as well as the adoption of new artistic conventions and experimental visual idioms (see Fig. 7).

The significance of these objects in the British Museum lies in their role in representing and interpreting living cultures, which can potentially contribute to fruitful comparisons with the current cultural production of other non-Western peoples equally well-represented in the Museum collections. As institutions dedicated to the development of public culture and education, museums are becoming places for expressions of identity and community as well as being showcases for political agendas and the articulation of intercultural dialogues. Museum practitioners' explicit commitment to addressing these topical concerns, in both their relationship with source communities and the display of their objects, can not only contribute to inclusion of Native North Americans' diverse modes of expression in museums, but also to a re-evaluation of perceptions and representations of indigenous peoples in the modern world (Jessup and Bagg 2002; Mithlo 2004a; Rickard 2007).

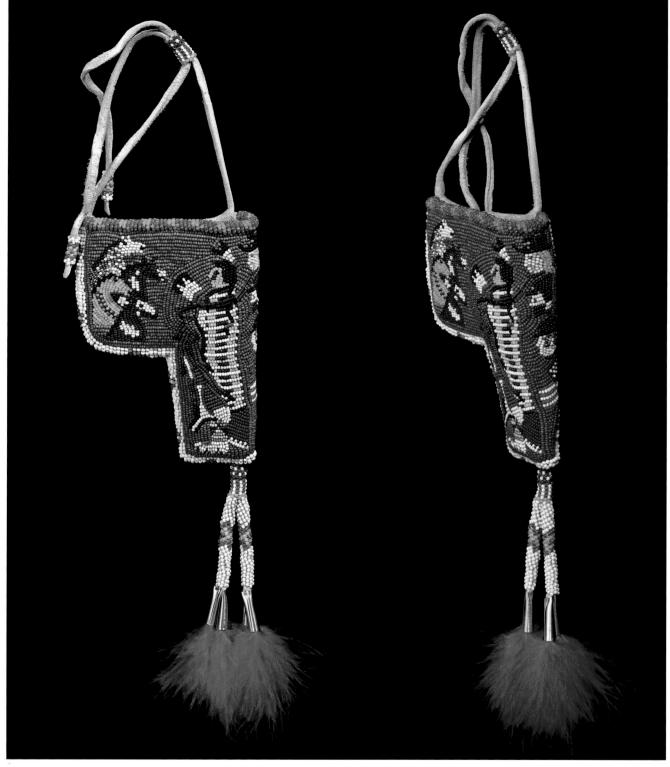

Fig. 18 *Replica beaded holster by Don Tenoso, Sioux (Hunkpapa Lakota), 2006. Leather, glass, metal and feather, L 26 cm, W 9 cm (Am2006,04.1).* In this work, the artist represents with trenchant satire defeated soldiers from the 7th cavalry looking at a warrior who possesses a powerful medicine. Reduced to little more than faces, the American soldiers are spectators of a scene in which Indians are the heroes.

dichotomies such as art versus artefact, ethnographic objects and collectibles, fine art versus decorative art, etc.

The items produced by Haukaas and Tenoso clearly mirror a recent reflective stance in the history of Native American self-representations, one that has adopted expressive idioms familiar to art curators and historians, collectors and gallerists accustomed to subtle satire and the irony of postmodern pastiches (Figs 18, 19). The media in which Haukaas and Tenoso choose to express themselves straddle artistic idioms and traditions in a way that eludes easy classifications solely based on techniques. Neither can their work be easily slotted into existing categories such as fine art or decorative art. Although the media in which they work may be associated with objects typically classified under headings such as beadwork or drawing, the premises upon which they work set them apart from art pieces made for either aesthetic contemplation and personal expression or mere decoration. Picture writing used in two very different ways in Haukaas'

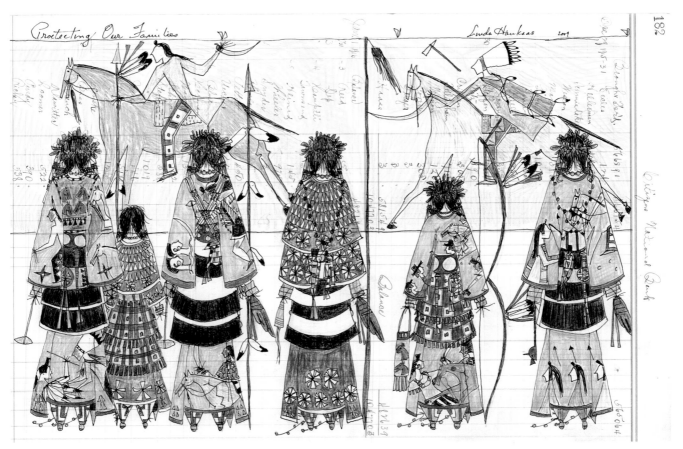

Fig. 19 *Protecting Our Families, Linda Haukaas, Sioux (Sicangu Lakota), 2009. Drawing on paper, H 29 cm, W 45 cm (2010,2005.1 Presented in part by Estelle and Morton Sosland).*

In this ledger drawing by Linda Haukaas, women in full regalia celebrate the return of warriors. This scene is timeless, as celebrations of this kind still happen today across the Plains.

ledger drawings and Tenoso's beadwork, for example, directly engages the public in a dialogue centred round postcolonial issues of identity which is at the core of much of today's indigenous discursive currency. Identity is indeed a useful analytical term through which we can begin to unravel the meanings underpinning both Haukaas' and Tenoso's work. In its multifaceted and polymorphous constitution, identity can be approached from different angles that reflect the complexities of attributing self-ascribed or socially negotiated labels to individuals and groups among contemporary indigenous constituencies. The difficulty of associating any of their work with pre-existing identity categories, such as artist or artisan, traditionalist or progressive, commonly used by present-day indigenous people highlights how their creative practices are articulating new expressive parameters that echo new cultural and social predicaments. While some individuals consciously choose to practice their skills within the parameters established by custom, others such as Haukaas and Tenoso base their work on traditional techniques yet extend and trespass the limits of what may normally be considered 'traditional'. Both of them, for example, blur conventional gender roles in the production of objects made according to old-style techniques. While technological expertise ensures continuity with customary practice, the fact that a man may

produce beadwork on a holster and a woman may draw scenes of war-related ceremonies on a ledger could be seen as a rupture with what most people consider tradition. As a result, by straddling categories these objects open exciting new dialogues between the specialized languages of art and anthropology.

Other objects in this book implicitly express cultural principles through ever changing visual idioms that elude the limitations of canonical categories derived from academic disciplines. Placing them in preconceived categories may risk limiting their expressive potential and the possible linkages that can be drawn between them along the theme of war and warfare. These objects force us to re-evaluate the parameters through which, for example, we may compare an American army uniform produced by government factories with contemporary warrior society regalia made by tribal people. A simple juxtaposition of these two items locates them challengingly in an ambiguous status between ethnographic artefacts, art objects and culturally relevant items that do not neatly fit under any of these headings. How can we talk about them to make sense of the significantly different contingencies in which they were produced and from which they were collected? What is their place in ethnographic museums? On what bases can they be considered similar or different? These

questions force us to examine the role played by objects in the cultural articulations of implicit meanings above and beyond the standard concerns with provenance and authenticity. Indeed, the apparent cultural distance between a soldier's uniform and Indian meanings evident in warrior regalia may only be superficial. Objects constantly change contexts and take on local meanings that highlight different connotations engendered by their use over time (Appadurai 1986) (Fig. 20). These questions invite us to think about the importance attributed to geographical origins in determining what exactly constitutes an indigenous object, or what might rightfully belong to ethnographic collections exhibited in museums. These issues are germane to much of the current debate about Native North American as well as other indigenous arts in ethnographic collections and, more generally, the role of objects in intangible cultural expression such as festivals, memorial services, diplomatic visits, rituals, ceremonies and performances, which is increasingly prominent in museum practice around the world (Wingfield 2007). Just as with army uniforms, objects such as pipe tomahawks or glass beads are not originally native to North America, yet they have become intrinsically indigenous objects insomuch as their use is mediated by the experience of being Native North American in

particular moments of history. What it means to be indigenous may have changed over time, but the role of objects in the maintenance and reproduction of collective identity remains a constant throughout the centuries.

The present examination of arts associated with Plains Indian warfare tells us that collective identities around the world are conveyed through shared cultural idioms cemented by the use of objects irrespective of provenance and history. Once an object is successfully integrated as part and parcel of a group's cultural repertoire, it begins to perform its role as conveyer of culturally encoded messages necessary to bind relationships in social life. Understanding how much cultural and social significance indigenous peoples attribute to objects underlines material culture's crucial role in the dynamic rearticulation of collective identities in time and space. Archaeologist Christopher Tilley has argued that 'things create people as much as people make them' (Tilley 1999: p. 76). The resonance of this axiom with the indigenous tenet that 'powerful things make powerful men' opens up promising prospects not only for a better understanding of Plains Indian material and expressive cultures, but to the elaboration of novel languages that can inform future dialogues between indigenous artists, craftspeople, intellectuals, academics and the wider public.

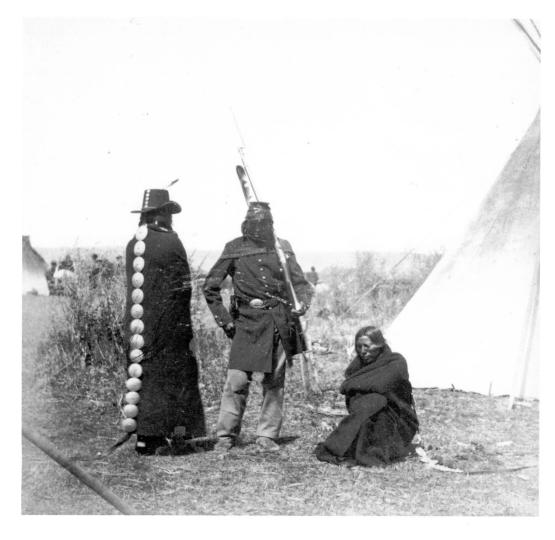

Fig. 20 *Photograph of a group of Sioux (Oglala?) men next to a tipi, mid-1800s. Albumen print, H 7 cm, W 7.2 cm (Am,A38.45).*
Plains Indians attributed new meanings to imported items, which originally may have been made for different purposes. Items such as German silver buttons became fashionable among most tribes that used them as decoration on hats and blankets, drops such as the one in the picture, and occasionally strung them onto belts.

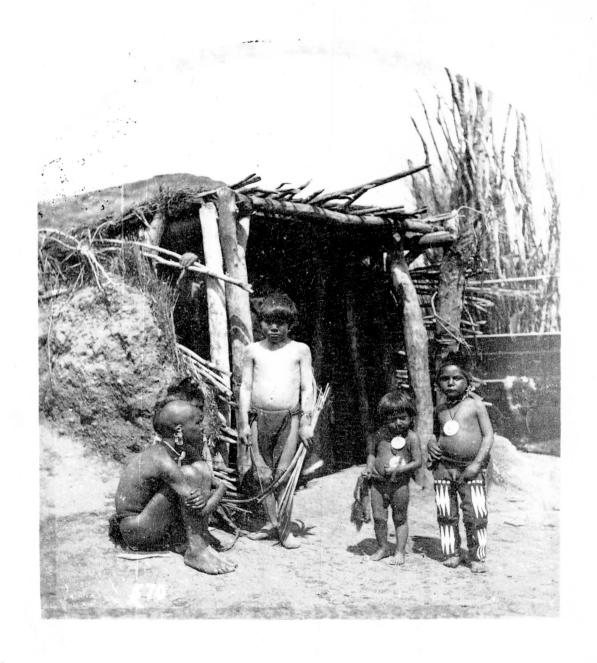

Pawnee Pappooses
1905

Chapter 2

Historic Plains cultures before the twentieth century

Plains peoples

Native peoples say that they have lived on the Plains since time began, or as archaeologists would put it, since prehistory. Peopling of the area has been dated to around 10,000 years ago, when hunters followed large game mammals on foot down the Rocky Mountains through the Great Plains. Some of the ancestors of today's Plains Indian nations reached this region more recently, however. Local peoples' oral traditions about their ancestors' migrations to the Plains reveal substantial connections with pre-Columbian matrices rooted in Late Archaic (3000–1000 BC), Woodland (1000 BC–AD 1000) and Mississippian (c. AD 1000–1700) period cultures that have deeply shaped historical Plains Indian ideologies and culture. The Mississippian period's societies in particular had a lasting impact upon subsequent cultural developments of the Plains, given that their descendants occupied strategic positions from which ideas, goods and people travelled extensively. By the twelfth century AD Mississippian influences had reached the northern Plains via the Siouan-speaking peoples of the Oneota complex of Minnesota and Wisconsin, and in the south via the important Caddoan ceremonial centres such as Spiro in Oklahoma (Fagan 1995; Reilly and Garber 2007; Townsend 2004).

Reasons for the gradual movements of people across the area over time are diverse. Changes in political strategies and economic pressures had a significant impact on historic Plains peoples. The northward spread of wild horses, originally left free on the southern Plains by the Spanish in the early seventeenth century, for example, engendered new alliances around this important new resource. Tribal movements also followed trade routes and markets where European trade goods and firearms could be bought and sold from

the eighteenth century. Consequently historical territorial boundaries and areas of cultural influence have changed over time, resulting in mutual influences and stimuli. Northern groups such as the Plains Cree and the Plains Ojibwa, encouraged by the arrival of the horse, moved on to the Plains from their northern and eastern homelands around the eighteenth century. Sioux bands, meanwhile, were pushed on to the Plains as late as the eighteenth century due to warfare with their Ojibwa neighbours around the Great Lakes and conflicts with Europeans. Other newcomers to the Plains were the nomadic Apachean tribes who slowly moved south after gradually separating from an original branch in Canada and Alaska, today's Athapaskan-speaking groups such as the Dene and Gwich'in. Large bands of these nomads eventually settled in the Southwest between the fourteenth and fifteenth centuries and developed lifestyles that combined hunting and raiding with minimal forms of horticulture. Some of their divisions, such as the Kiowa Apache, the Jicarilla and the southernmost Lipan, adopted many cultural traits developed by their Plains neighbours.

In truth, the cultural boundaries of this immense region have always been permeable. Ideas, people and goods have crossed the Plains with steady regularity since antiquity. Early Spanish, French and English travellers soon recognized the importance of indigenous exchange networks and trading sites as well as the role played by groups acting as middlemen, such as the village-dwelling Caddo, Wichita, Mandan and Osage, or the nomadic Jumano encountered by Spanish crossing the southern Plains in the seventeenth century. This intense interaction between peoples has contributed to the vitality of Plains Indian cultures that, in addition to their own creativity and resourcefulness, have also benefited from the human, ideological and material input of peoples living in areas as far away as the Pacific coast and the Gulf of Mexico. Goods such as shells and furs were traded from the Pacific Coast; corn and cultivated plant products were traded for hides, and arrow points and pigments were exchanged both during seasonal

Fig. 21 *Pawnee children in front of an earth lodge, Loup Fork village, Nebraska, photograph by W.H. Jackson(?), 1871. Albumen print, H 14.5 cm, W 10 cm (RAI 1285).* Earth lodges were common among semi-sedentary groups living west of the Mississippi and around the Missouri river.

fairs and around permanent settlements such as those of the Mandan horticulturists of the upper Missouri River or the Wichita in Texas (Wood 1980). Humans were traded too across the Great Plains (Barr 2007; Donald 1997; Eckberg 2007; Wedel 1973; Wiegers 1988) (Fig 22). Captive-taking was a common practice among Plains peoples, who left evidence of this custom in the rock and pictographic art they produced across the Plains. Early pictographic art is quite explicit about the practice of stealing women between groups living in the Plains and Plateau (Greer and Keyser 2008; Keyser *et al.* 2006). Captives, most frequently women, were adopted into the tribe of their captors as spouses and kin. As newcomers they contributed to the exchange of ideas between Plains nations and often introduced new techniques and styles in the production of clothing, pottery and domestic implements. While these exchanges brought innovations in the material life of Plains peoples, they simultaneously contributed to an increased and widespread cultural and ideological homogeneity that, by the nineteenth century, cut across both linguistic and cultural boundaries. Although integration of strangers into new social groups was a common practice throughout the nineteenth century, the exchange of peoples more often occurred by way of marriage between individuals of different clans belonging to linguistically related groups.

Plains Indian social units were either divided into moieties (descent groups), large social subdivisions composed of more than one clan, or alternatively they could be organized according to clans that had a clear identity, normally associated with ritual objects such as bundles that contained sacred items with supernatural or mythical origins. Clans and villages (frequently co-terminus social units) regulated marriage in addition to managing social and religious functions. Clans and sub-clans dealt with specific ceremonial tasks and were assigned a particular place in the camp. Distinct villages, as in the case of the Pawnee, descended from a common ancestor and looked after the sacred bundles that represented their powers. Up until the nineteenth century, Plains groups were variously organized in bands and villages that gathered related families in often complex kinship arrangements. Because regular hunting required a great degree of mobility, most Plains groups seasonally split into autonomous smaller bands for long periods of the year, only to reunite with other communities for ceremonials or, in the case of semi-sedentary groups, during the planting season.

Politically, Plains societies were very diverse. By and large, most groups were led by councils of elders who were also religious specialists who managed the group's ritual life. The organization of large groups into societies, of which warrior clubs were one type, curbed social conflict by prescribing

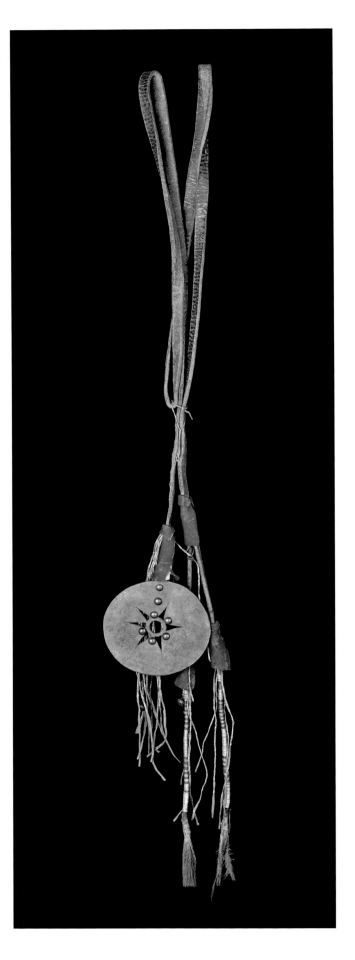

Fig. 22 *String, Pawnee, early 1800s. Wool, porcupine quill, leather, feather and brass, L 128 cm (Am.5199 Donated by Sir Augustus Wollaston Franks).*
Among the Pawnee strings such as this one were given to former captives to indicate their freedom. Duke Paul Wilhelm remarked on this in a note in his diaries. Pawnee were subject to slave raids to such an extent that the French adopted the name Pani (from Pawnee) to describe Native individuals from west of the Mississippi river who were sold in their slave markets.

roles and responsibilities for women and men through an institutionalized system of competition based on the value put on male and female activities and skills. Social roles were articulated around ideas of status that depended as much on spiritual power, personal achievements, wealth and property as on belonging to particular clans, lineages or societies. Clubs, sodalities and societies existed for both men and women, and they included adolescents, adults and elderly people. As will be discussed in more detail in the next chapter, these social units were a way to structure the group's social life, established duties, the transfer of rights, and the transmission of customs and moral teachings conveyed through myths, dances and ceremonies in which objects played an important part. Horticultural societies, such as those of the Mandan and Hidatsa, were organized through an elaborate system of societies that managed women's work in the fields and craft production as well as inter and intra group relations and ceremonial duties (Bowers 1950, 1992; Carocci 1997a).

Since antiquity, the Great Plains have been populated by nations with very different languages from several linguistic groups. Some languages have disappeared, many are still spoken with different degrees of fluency, and others are on the verge of extinction. Although English is almost universally spoken in the whole area, efforts to revitalize indigenous languages have succeeded among several tribal communities in both Canada and the United States. Algic, one of North America's most widespread language stocks, is spoken in a variety of regional dialects by Blackfoot (which includes Siksika, Piikani and Kainai), Cheyenne, Arapaho, Gros Ventre, Plains Ojibwa and Plains Cree. The less widespread Caddoan is spoken by Wichita, Pawnee and Arikara, who live respectively in the southern, central and northern Plains. Different dialects of Siouan largely feature in the northern Plains and are spoken by Dakota peoples (Lakota, Nakota and Dakota proper, collectively also called Sioux), Hidatsa, Crow, Assiniboine and Mandan. Siouan languages are also spoken by groups living at the boundaries of the southeast-central Plains. These are the once semi-nomadic Otoe, Osage, Omaha, Iowa, Missouri, Quapaw, Ponca and Kansa who used to live in semi-permanent settlements just west of the Mississippi River. In the west-southwest of this vast region, Uto-Aztecan is the linguistic group of the Shoshone of the westernmost fringes of the Plains and the Comanche inhabiting the region's southern portion. Languages of the Athapaskan division are spoken by the northern Tsuu T'ina, as well as the Kiowa Apache. An Athapaskan language was also spoken by the Lipan of the southern part of the region that borders Mexico; over time this tribe's members became integrated into other Apachean groups. The isolated Kiowa Tanoan is limited to the Kiowa in the south-central part of the area, and the almost extinct Tonkawa was the language of the tribe of the same name. Because of their high level of intercultural exchange, Plains peoples in the past were often multilingual and, when languages were mutually unintelligible, they communicated in a conventional sign language whose local variations were understood across the region (Goddard 1996).

Plains peoples' incredible linguistic diversity is mirrored in the degrees of variation of similar beliefs and cultural traits. Minor differences between groups' cultural practices can be partially explained by the fact that some of those groups that later became known as distinct nations stemmed from common ancestors: for example, the Hidatsa and Crow, Sioux and Assiniboine, Pawnee and Arikara, and (possibly) the Arapaho and Gros Ventre. Shared cultural roots and linguistic homogeneity may account for similarities between groups with a common origin, although regional distinctions eventually developed due to the simultaneous separation from the primitive matrices and the contact with customs and traditions of peoples belonging to different language branches. Despite regional and local differences, there was and is a degree of cultural homogeneity between all the peoples who inhabit this area that enabled scholars to talk confidently about a generally recognizable Plains Indian culture (DeMallie 2001). This cultural homogeneity can be seen in a number of traits shared by Plains peoples.

One of the features that characterized groups living in this large area during the nineteenth century was their long-standing dependence on the buffalo, once the most common animal roaming the widespread grasslands of the Great Plains. Not all groups settled on the Plains exclusively depended on this animal, however. At the eastern and southern frontiers of the area, groups such as the Pawnee, Wichita, Caddo, Arikara, Mandan, Hidatsa, Iowa, Kansa, Omaha and Osage practiced indigenous forms of horticulture. They cultivated beans and squash, pumpkins, sunflowers and, among many other plants, the life-sustaining maize (corn). Corn was as important for these horticultural groups as buffalo was for hunters, although this division is somewhat arbitrary. Horticulturists also valued the buffalo greatly and had many ceremonies to invoke its power and piety, or to give thanks for allowing them to hunt it. Emblematic of the equal importance given to plants and animals by horticulturists is the Evening Star bundle, one of the Pawnee's spring ceremony wrappers that comprises a buffalo skin enveloping symbolic ears of maize which stand for the figure of the Mother of Corn (Murie 1981: pp. 52–3).

Conversely, groups who sustained themselves primarily by hunting also augmented their diet with plant foods through exchange or gathering wild vegetables, berries and roots. Some of these tribes adopted buffalo hunting relatively recently in their history and even after moving on to the Great Plains retained much of their horticultural past encoded in rituals and beliefs about the plants that they brought with them during their migrations (Carocci 1997a; Harrod 1995; Holder 1970). Although not all Plains Indians lived exclusively on buffalo, the animal was essential for the social, cultural and economic life of all the groups living on the Plains. The buffalo was considered one of the most important creatures and it was revered with great respect and wonder. The buffalo appears as an important ancestor in much of the Plains Indian oral traditions. It emerges from the earth bringing gifts to humankind such as, for example, the sacred pipe among the Sioux, a ritual object that was essential in the religious life

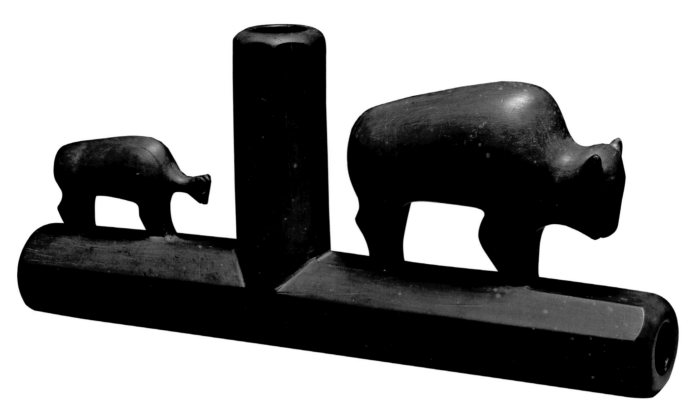

Fig. 23 *Pipe bowl (Pawnee) c. 1860. Catlinite and metal, L 25.4 cm (Am,Dc.86.a).* Plains Indians today continue to greatly respect the buffalo. Following the reduction in numbers of buffalo due to excessive hunting in the nineteenth century the American bison is now experiencing a comeback. Native-run buffalo farms are becoming a popular means to continue the sacred relationship that ties Plains peoples to this animal.

of many groups (Fig. 23). Buffalo ceremonialism is found across the region. In it are encoded complex messages about prosperity, well-being and wealth that are sometimes conveyed through explicit sexual imagery and the importance of fertility. The buffalo's role in the lives of Plains Indians cannot be underestimated, as it offered much of the material that was once used for dwelling, cooking and clothing (Fig. 24).

Before the horse arrived in the area with the first Europeans, Plains groups hunted buffalo on foot. The horse brought dramatic changes in the nomadic hunters' lifestyles. Plains-dwelling peoples' responses to this animal, alongside the increasing presence of Europeans and the consequential diffusion of new technologies, engendered a series of cultural, social and political adaptations that developed into what is generally known as the Plains Indians' 'equestrian period', which lasted until the late nineteenth century. The dependence on the horse for hunting, transportation, war and social life is another trait that all Plains peoples have in common. Horses allowed greater and faster mobility and enabled skilled raiders to hunt more effectively. Horses soon became a valued item of exchange and gradually became a symbol of prestige and wealth among all Great Plains tribes. Horses were revered and represented in a variety of different media. From wooden effigies to paintings, from rock art to beaded representations, no other animal has received as much iconographic exposure among the Plains peoples as the horse (Her Many Horses and Horse Capture 2006) (Fig. 25).

A man's social prestige was measured in part by the number of horses he owned. Whereas warriors always had the best horses, smaller, weaker and slower horses were generally used for domestic chores or transportation. As a result of this ranking, warriors were always searching for new and better horses to possess and to give away to show their wealth. For this reason, up until the late nineteenth century raids were organized simply with the aim of capturing large numbers of these precious animals. Understanding horse stealing only in terms of gaining prestige and wealth is, however, limiting and somewhat misleading, as horses were revered as almost supernatural creatures. In some native languages, the words used for 'horse' can translate into 'awesome dog'. The pursuit of horses should thus also be understood as a way to augment one's spiritual potential.

The importance of the buffalo and horse for Plains Indians is a reflection of the widespread approach to the relationship between humans and animals that is rooted in ancient ideologies. Animals were hunted for their skins and pelts, their meat, and for other materials such as horn, antler, hooves, bristles, teeth, claws and sinew. This relationship, however, was not limited to pure subsistence. Both hunting and ownership of animals were regulated by ceremonial obligations, offerings and invocations, because all animals were considered beings that helped and protected humans in return for prayers and reciprocal respect. In Plains Indian ideology, animals are the equal of humans, as other-than-

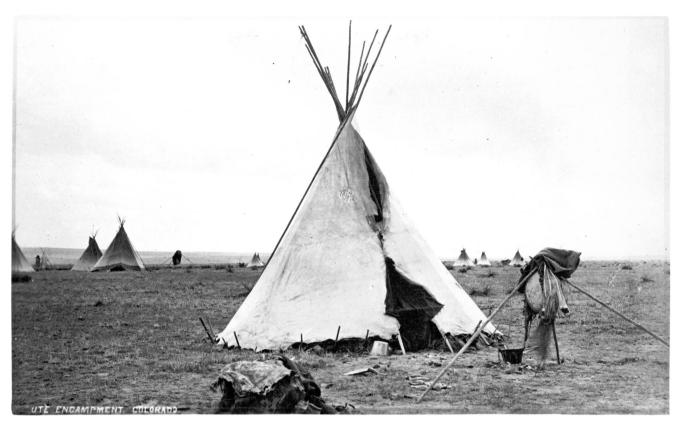

Fig. 24 *Ute encampment, photograph by W.H. Jackson (?), mid–late 1800s. Albumen print, H 12.5 cm, W 18.5 cm (RAI 1424).*
Before the availability of canvas, buffalo hides were used to make mobile dwellings generically called tipi, a Siouan term for domestic dwelling. Tipis could vary in size depending on the wealth of the owner and his wife's tanning skills. Utes adopted Plains style tipis after the introduction of horses.

Fig. 25 *Horse, by Tall Bear, Sioux (Oglala Lakota), 1874. Pencil on paper, H 17.5 cm, W 21 cm (Am2006,Drg.12).*
The particular attention given to detailed visual representations of horses in ledger drawings shows the care Plains Indians had for this animal.

human beings who similarly display volition, agency, emotions and intelligence. But they also have other specific powers that humans seek.

Cosmology and ideologies of power

The search for protection that could be provided by animals and other cosmic forces constitutes a very important feature shared by all Plains nations that made the quest for 'power', alternatively translated as 'medicine', a distinctive trait of their ideology. Both are facets of a fundamental concept at the core of Plains Indian beliefs as they are the physical manifestation of spiritual forces that operate in the universe. Different linguistic groups have specific terms that define these forces: *Manitou* among some Algic speakers, *Daudau* among the Kiowa, or *Wakonda* among the Siouan-speaking peoples. They describe what is at once numinous, awesome, mysterious, and all permeating. No translation can make sense of these complex concepts that simultaneously encompass ideas of spirit, energy, force, strength and vitality present in all

things. Such forces can be found in natural elements, animals, plants and minerals, and can be used both as collective and as individual protection. Humans too, like other beings, share this pervasive power.

Supernatural power is often perceived to be unequally distributed among beings and substances. Some beings have more power than others, and Plains people recognize this in the variety of ways in which animals and humans relate to each other. This model, in which unequal powers are in a constant dynamic relationship, is a framework that informs

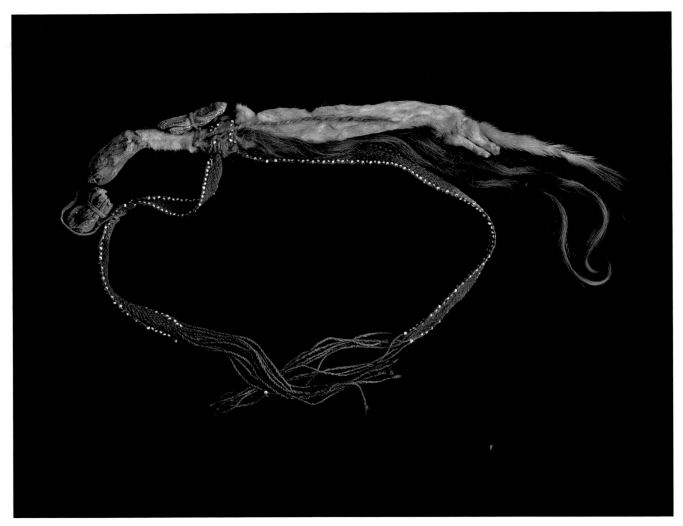

Fig. 26 *Charm, Blackfoot, 1800s (?). Weasel skin, buffalo hair, bladder, wool, human hair, glass and tobacco leaf, L 61 cm (Am1949,22.174).*

Skins, such as this ermine pelt, were used to seal pacts between men and animals. The owner of this item vowed to respect this animal in exchange for some of its power.

how Plains Indians understand war and conflict. Political and social status result from the ownership of powerful things one acquires. As a consequence a man has to gather power as a means to enhance his position, and this is eventually mirrored in the shared value accorded to particular substances, objects or animals.

Searching for the aid of animals, invisible beings and natural forces is the expression of a desire to harness vital forces and partake in cosmic powers that result in healthy, wealthy and balanced life. This existential pursuit was, and is still, done during vision quests. Through this means people seek supernatural guidance and connection with powers displayed by animals or contained in a variety of different materials. The practice of seeking a vision is not unique to Plains societies, but over the centuries peoples of this region have perfected this ritual seclusion in a complex set of ceremonial requirements that both sustain and complement a widespread ideological framework based on the quest for power. A successful quest requires days of fasting, praying and self-sacrifice. After a period of seclusion, often supervised by

older men or women, the young person would re-emerge with a personal set of instructions to be followed in order to have a successful and honourable life. During the vision, and often spontaneously in dreams, spirit guides in the form of ancestors or animals, plants or natural elements would teach the initiate how to handle his or her protective 'medicine'. This could be any number of things ranging from stones, feathers and stalks to twigs, claws, horns, antlers, animal skins or other materials. After the vision, the medicine would be wrapped in a neat package that was to be carried on the person as supernatural protection, and the perennial reminder of the connection established between humans and the spirit world (Fig. 26).

An individual who had received a vision was qualified to participate fully in the ritual and ceremonial life of the group. For males in particular, it marked the passage from puberty to adulthood and in so doing validated individual agency and bestowed social responsibilities upon the newly initiated. Visions effectively guaranteed that young men would safely face the perils of life aided by supernatural endorsement, help and assistance. Using medicines taken from the natural

world to one's advantage promised defence against opposing forces, established health, provided moral guidance and simultaneously ensured offensive efficacy in combat. Because of their capacity to affect positively human action, powers were sought as means to warrant protection and to enhance individual strength or any number of abilities considered desirable in both war and personal life.

In Plains Indian belief, power is limited. It can, however, be transferred to restore balance in both individuals and groups. Although this power is invisible, it can take different forms and can be found in substances that humans recognize as at once both dangerous and beneficial, polluting and numinous. Humans are also aware that spiritual power ought to be preserved and should never be wasted. Symptomatically, warriors ready to go on the warpath observed a period of sexual abstinence so as to store up the male power necessary to face the enemy (Dorsey 1894: p. 444; Hoebel 1978: p. 83). Mandan and Hidatsa warriors, for example, were aware of the risks involved in the quick depletion of stored spiritual power. They sought it through ceremonial sexual intercourse with women who functioned as vehicles for its transfer from highly regarded spiritual men. This practice was common among several tribes of the northern Plains in various permutations, and in more or less attenuated forms appeared in cyclical tribal rituals as a reference to the intimate relationship that Plains Indians saw between warfare and fertility (Kehoe 1970). Spiritual power was also believed to reside in body fluids such as saliva, tears and mucus. These substances were smeared on guests during calumet ceremonies (see Chapter 4) to signify the hosts' subordination to their guests in accordance with the belief that potentially harmful actions against individuals made use of body effluvia (Hall 1997: p. 4).

Hunting ceremonialism and beliefs of many Plains peoples reveal that cosmic powers manifested in all things and beings must be acknowledged as a means to maintain equilibrium through reciprocal exchange. Any animal killed, for example, required a ceremony that confirmed the gratitude of the hunter to his prey and re-established the balance broken by the loss of life. This notion has striking parallels with war ceremonialism and beliefs of many Plains nations. Every time power is lost it must be regained or replaced with something of equal value. This concept can be appreciated in the reported case of the historical Kansa, among whom the death of a tribal member had to follow the death of an enemy (Skinner 1915a: p. 749). In customary belief, loss of human life in raids and battles required a constant rebalancing of powers that in some cases mirrors hunting practices and the respectful treatment of dead animals. Among the Osage, for example, the old rite called 'Mourning for the Slain Enemy' was aimed at empathizing with enemies killed in battle in much the same way as prayers, gratitude and sympathy went to the killed prey (La Flesche 1939: p. 138–9). Loss of human life generated a perpetual necessity for new power that could substitute for what would otherwise be irretrievably lost. This preoccupation with the loss of power shows a concern with disharmony and instability that humans must always avoid. This feature is

clearly epitomized in the Cheyenne's renewal of the sacred medicine arrows, brought to them by the culture hero Sweet Medicine, every time a death that involved blood occurred in the nation. In this case, the renewal of the arrows turns into a prayer to the sacred powers that is rendered necessary by the instability generated by death or misfortune (Grinnell 1972, I: p. 353, n. 4; II: p. 53; Powell 1969). Adoption ceremonies, common among Plains peoples, are also an example of the social staging of rituals of power substitution and renewal that ensure the acquisition of new vital forces (Fletcher and La Flesche 1911: pp. 61–2; Powell 1969; Powers 1982: pp. 100–1). The ritualized practice of integrating outsiders into the social group is akin to scalp taking and revenge raids. Both these practices, although seemingly incommensurable, can be understood as a means to restore balance by replacing human life and depletion of power with newly acquired vital forces (see pp. 40–1 and Chapter 4).

Ethnographic texts, oral traditions, personal narratives and observations collected among Plains peoples in the nineteenth century reveal their deep concern with the place humans occupy in the cosmological design. Human behaviour is guided by an acute awareness of the responsibility that humans have towards the cosmos and its inhabitants. This concern is most crucially epitomized in the fundamental principle of harmony, which is reflected in common dualisms and oppositions. This principle can be explained through the metaphor of complementary forces, expressed in terms of equilibrium engendered via reciprocity. Common to all Plains peoples' cosmologies is the notion of 'balance', sought in every sphere of social interaction and essential in directing ritual life. In this latter context in particular, this notion appears in the diffused use of figures of speech, as well as in visual and linguistic metaphors. These mirror ideological oppositions generally manifested in the use of colours, substances, objects and ideas thought to represent divergent extremes of a power continuum of which humans take part. Plains Indians' notion of balance has a very long history, tracing its origins to pre-Columbian times, and is rooted in the ideologies of power associated with chiefdoms of the Mississippian period as well as later regional cultures developed in the northwestern Plains. In historic times Caddoan-, Siouan- and Algic-speaking descendants of these early archaeological and proto-historic cultures displayed thematic, aesthetic and ideological continuity with ancient belief systems encoded in iconographies and ceremonial practices that confirm this lasting historical link (Bailey 2004; Hall 1997; Howard 1953; Kehoe 2007; Keyser 1977) (see pages 80–1).

Women and men, alongside male and female animals, are the most visible manifestation of the notion of balance of complementary powers central to Plains Indian belief. Roles assigned to different sexes defined, constructed and maintained cosmic balance by way of gender identity that among Plains peoples was largely determined by what people did in their daily life. Warfare-related activities established and maintained gender identities in accordance with the roles

Scalps

The use and significance of scalps among historical Plains Indians far exceeds the gruesome and sensationalistic accounts produced by colonists and explorers. Native North Americans gave particular attention to hair, which they decorated and cut in a variety of ways to denote clan, tribal or society affiliation. Among many tribes the ritual cutting of hair marked the passage from childhood to manhood and irrevocably turned the young boy into a warrior. Irrespective of regional and local differences, Plains Indians took special care of the central part of the skull. This area was marked by placing a feather, attaching personal protective amulets and bells, or neatly braiding it into a long plait. Some tribes emphasized it by shaving the whole head, leaving just a tuft of hair that was decorated with elaborate deer-hair ornaments or porcupine quills. This is known as the scalp lock, and it is the part of the human scalp that past warriors were after.

In general, Plains Indians believed that human hair possessed the qualities of the individual. As such it was considered to be a powerful substances and was given particular symbolic significance. The value attributed to hair can be seen in the frequency with which it is mentioned in oral traditions, where its metaphorical associations indicate a strong connection with rain and, more generally, with the notion of vital force, which is widespread across the Americas. Plains warriors valued scalps because possession of someone's hair ultimately enhanced one's own power. Scalp taking was therefore a way to accumulate spiritual power. Crucially, once taken, scalps had to be ritually handled and purified to neutralize their potential harm. Each tribe had its procedures to do this through particular liturgies, songs, prayers and ritual preparation.

Although scalping enemies is strongly associated with warfare practices, the inclusion of scalps in ritual bundles, the ceremonial use of human hair and its decorative functions on many personal items reveal an ideological and religious importance whose origins can be traced in prehistory. Depictions of human scalps appear on ritual objects used since the twelfth century by Plains Indians' predecessors, although the practice of scalping dates back to ancient times. Both realistic and abstract renditions of scalps are visible on

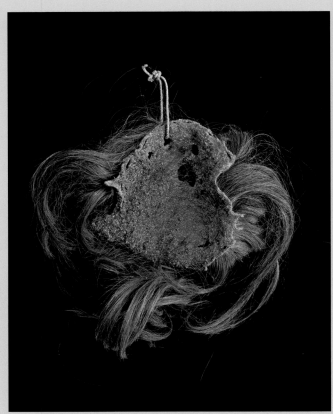

Fig. 27 *Studio portrait of Chief Johnson, a Ute leader, holding a wooden pole with two human scalps on it, photograph by W.G. Chamberlain, 1868. Albumen print, H 20.4, W 13.6 cm. (Am,A8.24).*
Scalps were displayed on sticks and paraded as a sign of victory among most tribes.

Fig. 28 *Human scalp, Northeast Plains Peoples (?), 1764. Human tissue, natural pigment and rope, H 10 cm, W 9 cm (Am1986,Q.13).*
This scalp is painted in red and black. Tribes differed in their treatment of scalps, but red or black pigments were used to convey victory as these colours were associated with blood and the charred remains of destruction.

painted vessels, engraved whelk shells and ceremonial monolithic maces used by warrior chiefs who managed important warfare rituals. In its most realistic visual rendition, the human scalp is commonly depicted stretched on a circular hoop with dangling locks trailing behind (Fig. 27). This is how most tribes prepared scalps so that they could be publicly displayed and used in dances. Scalps prepared this way were often decorated with beads, porcupine quills and other ornaments. They could also be painted on the flesh side in various colours, most notably black and red, and in some rare cases human faces were painted to give the object a human character (Figs 16 and 28). Scalps symbolically brought new life to the group and among many tribes they were often treated as substitutes for lost relatives and friends.

Variations on the theme of the scalp stretched on the hoop frequently appear in precolonial iconography as carrot-shaped appendages, keyhole-looking outlines and elongated drops. These shapes have been retained in the decorated bone tablet that kept in place a warrior dancer's head ornament made of dyed deer hair and called a roach. Such head ornaments are also popularly used in powwow dances today (Figs 29 and 94).

In ancient iconographies scalps can be found as isolated motifs, but frequently they are integrated as elements of complex narrative scenes representing dances, ceremonies or mythical episodes. Men bearing staffs decorated by scalps, or wearing them attached to the waistband, are common motifs that have direct correspondence with the historical use of human hair in rites and ceremonies. Scalps, for example, were strung to long poles by women at the return of victorious warriors and carried in parade in dances that celebrated their accomplishments, a practice that among some tribes continues to this day. As can be seen in old iconography, ancient warriors from the eastern Plains used to dance with scalps attached to their belts. This practice was later replaced by the use of bunches of grass that mimicked hair, giving rise to what eventually came to be known as the Grass Dance (Laubin and Laubin 1977: 217 plate 24; Riggs 1893: p. 227).

Historically, full human scalps were not kept except on rare occasions where they became part of ceremonial wrappings and were regarded as special items. More often, parts of scalps were employed to decorate weapons and shirts, leggings, horse bridles, shields and tomahawks. While they were an important visual reminder of the warrior's courage and bravery in combat, these decorative scalp locks simultaneously enhanced a man's prestige, imbuing him, his accoutrements and weapons with the spiritual forces attributed to human hair.

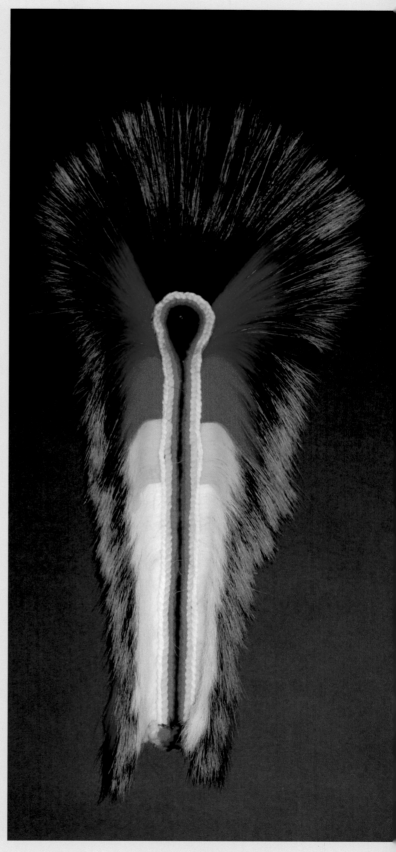

Fig. 29 *Roach headdress, designed by Dennis Zotigh, Kiowa, made by Larry Kincer, Kiowa (Tewa Santee), 2009. Dyed deer hair, wool and cotton thread, L 72 cm, W 33 cm (2010,2028.1.a).*
The base of this roach shows continuity with ancient iconography, depicting scalps stretched on a hoop with trailing locks.

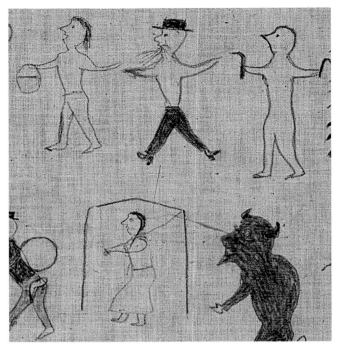

Fig. 30 *Detail of Fig. 14.*
In the winter count now in the British Museum's collection, the year 1891 is known as the 'man-woman suicide winter'. Here a figure in a dress is shown hanging from a roof beam, the method of suicide typical of males who adopted women's roles.

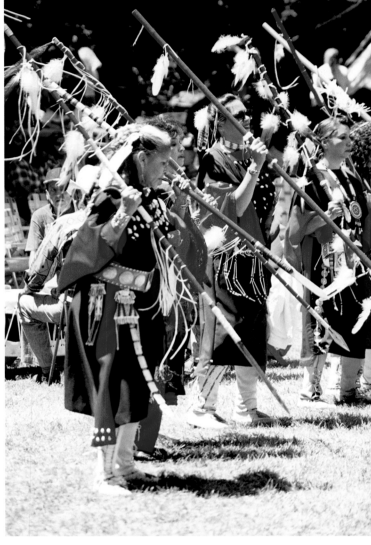

Fig. 31 *Scalp or victory dance at the Anadarko ceremonial grounds, Oklahoma, photograph by Milton Paddlety (Kiowa), 1996. (Am,Paddlety,F.N.2225 Donated by Milton Paddlety).*
The Kiowa women performing are holding lances tipped with scalps while dancing toward the centre of the arena in defiance of invisible enemies.

assigned to males and females as well as additional classes of people who crossed or blended the spiritual, or more rarely physical, attributes of both. These were the men who acted like women or women who acted and talked like men (Lang 1998) (Fig. 30). By and large, the division of labour was quite distinct with regard to warfare activities. Ethnographies, visual records and eyewitness accounts report the almost universal association of men with war. It has been noted, however, that women, and not infrequently males and females of different genders, also went to war (Carocci 2009; Ewers 1997; Keyser *et al.* 2006; Mallery 1893; Medicine 1983; Roscoe 1990; Thomas 2000) (see pp. 60–1).

By and large, socialization into gender roles began at an early age. Plains Indian males were generally encouraged to become warriors, whereas females took on domestic chores and craft production. The Lakota informant Bushotter recalled that his father expected him to become a warrior from when he was a child. He reported that his whole preoccupation was to be brave, the essential quality of the Plains Indian male (DeMallie 1983: p. 248). Acts of courage and bravery materialized the masculine character of military prowess. Females who displayed these characteristics would be associated with the male sphere. In some cases these women formed a distinct class, as with the Blackfoot who called them 'manly hearted women' (Lewis 1941; Zuyderhoudt 2002). This is because a Plains woman's life was centred around domestic affairs while public matters were generally a man's concern.

Although women and men were usually associated with different spheres of social life, and their respective ritual objects and activities were to a certain extent kept separate, with regard to war-related activities male and female worlds met in a number of occasions. Ritual and ceremonial life included various complementary roles played by husband and wife. A clear example of this is the so-called 'victory dance' staged by both historic and contemporary peoples. Widespread across the Plains and even beyond its geographical boundaries, victory dances were, and still are, staged at the return of warriors and soldiers from the battlefield. While overwhelmingly celebratory in nature, these dances embed much of the ethos, values and principles such as balance that are at the core of Plains Indians' social organization and gender ideologies (Carocci 1999). Women and men join the dance arena to honour successful warriors. Whether joyful, quasi-carnivalesque expressions of joy and

pride or conventionally choreographed dances, women in the past generally donned their husbands' regalia or carried their weapons while dancing and singing the praise of the successful war party. In a particular version of these dances called 'scalp dances', women carried poles to which were attached the scalps and hair locks taken from enemies by their spouses. This dance is still performed among many tribes who include it as an integral part of their celebrations in honour of veterans and soldiers during powwows or annual celebrations such as those staged by the Black Leggings warrior society of the Kiowa in Oklahoma (Fig. 31). These dances root group identity into the moral principles of honour and bravery while highlighting the co-operation of male and female in articulating Plains Indian social life and organization.

Gender roles in social affairs and ritual calendars metaphorically represent the maintenance of cosmic equilibrium. Men and women still co-operate in the running of the ceremonial calendar, which involves a variety of ceremonies that can benefit either the whole tribe, clans and particular lineages, or individual societies. Complex and frequently lengthy tribal rituals draw together important symbols that convey tribal ethos and values. Customarily, large seasonal ceremonials aim at maintaining or restoring cosmic balance. This is the function of ritual cycles such as the *Massaum* among the Cheyenne, *Naxpike* of the Hidatsa, the *Okipa* among the Mandan, the all-women *Mo'tokiiksi* ceremonies of the historic Blackfoot, the bundle renewal ceremonies of many Plains nations, and the universal Sun Dance. All these seasonal ceremonies stress the importance of stability and reciprocity, and are centred round the concept of cyclical renewal necessary to keep the cosmos in place and periodically to regenerate its all-permeating vital forces (Hall 1997; Harrod 1995; Hultkrantz 1980; Taylor 1996).

The ritual regeneration of powers frequently makes use of sexual and fertility symbolism, or implicitly refers to the mutually sustaining co-operation between men and women in this endeavour. Explicitly sexual figures attached by Siouan-speakers to the central pole in the Sun Dance, for example, reiterate the connection between masculine forces, sun and warfare more widely expressed in the complex performative staging of cosmic renewals, most notably among the Mandan (Dorsey 1894: pp. 456–7; Ewers 1987: pp. 178–81; Taylor 1996) (Fig. 32) and the Omaha (Fletcher and La Flesche 1911; Ridington and Hastings 1997: p. 155). Male and female symbolism characterizes the allegories and metaphors materially rendered in ceremonial paraphernalia, regalia and designs utilized in these cyclical rituals. Male power designs associated with Cheyenne sacred objects used in cyclical rituals, for example, literally bring together the connection between spirituality, prowess, masculinity, protection and vitality epitomized by the masculine nature of the sacred arrows and pipe at the centre of the *Mahuts* renewal ceremonies (Powell 1969: p. 438).

Cosmic symbols and sacred geography are evoked, or concretely reproduced, in the spatial arrangement of dance arenas, ceremonial stages, secluded areas, altars

and choreographies. Circular enclosures of the Sun Dance, *Naxpike*, *Mo'tokiiksi* and *Okipa*, for example, tend to stress the inclusive nature of these stages upon which ritual performances take place. In the past, all large communal rituals included dances, public ceremonies, invocations and the ritual handling of objects in which particularly powerful cosmic forces resided. Each tribe, and within it smaller subdivisions such as clans and individual societies, owned sacred items that were regarded as the embodiment of the power bestowed upon the group. As such they epitomized national or group identity. Important objects given to the tribe by mythic ancestors, such as the Sacred Buffalo Hat of the Cheyenne, the Sacred Pole of the Omaha, the Sacred Buffalo Calf pipe of the Sioux among others, still function as catalysts for collective identity. These objects cannot be transferred, sold or bartered because they are collectively owned by the tribe. Should loss or damage occur to them or any of their constituent parts, it would be a calamity that could affect the whole group to which they belong. Because of their awesome inherent power these sacred objects are vigilantly cared for, and the utmost attention is given to their handling and storage. The treatment of tribal sacred objects is in the hands of the ritual specialists (sometimes a man and his wife) who

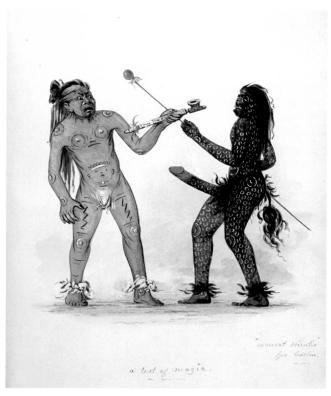

Fig. 32 *Mandan Ceremonies by George Catlin, 1864. Drawing on paper, H 29.5 cm, W 22 cm (Am2006,Drg.126.pl 2).*
O_ke_hee_dee *The Owl* or *Evil Spirit*, was a character that appeared in the O-kee-pa, a Mandan renewal festival. These two figures appeared among other male characters and interacted with women onlookers. Overt sexual themes dramatized the co-operation of male and female forces and the dialectic tension between good and evil.

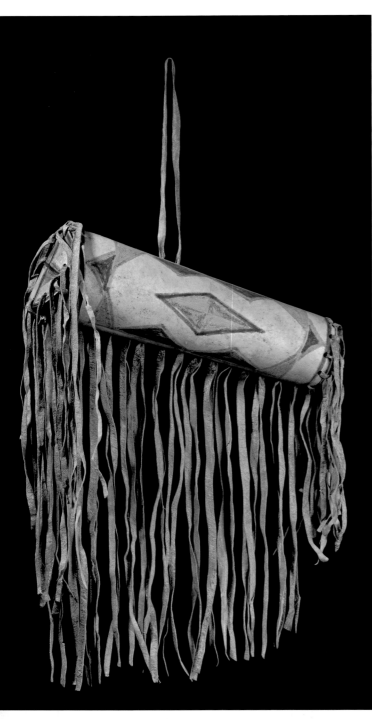

Fig. 33 *Parfleche, Blackfoot (Kainai), late 1800s. Rawhide and natural pigments, L 70 cm, D 15 cm (Am1903,-.106).*
Tubular rawhide containers such as this one were used to store headdresses and other ritual objects. Such cases had different shapes and some painted designs might have had symbolic significance. Styles changed according to tribal aesthetics.

look after them with a deep sense of responsibility. Handling such sacred items requires long training and ritual expertise that can only be acquired after years of apprenticeship among wise and virtuous men and women. These are individuals who have led an exemplary life according to the strictest values and moral standards set for the people by their

ancestors, ancient prophets and mystic heroes. Among the men, praiseworthy individuals often reach this position after retiring from a successful warrior career. Indeed, as discussed in more detail in the next chapters, it is upon warrior societies' bravest and most honourable men that the responsibility falls of performing the most sacred ceremonies associated with symbols and objects originally transferred to the tribe by culture heroes and cult initiators.

Frequently, the handling of these important objects necessitates the use of additional items contained in medicine bundles. Use of medicine bundles is very old on the Plains. As with pre-Columbian iconographies and symbolism, the employment of medicine bundles is found in the archaeological record and has been further confirmed by ethnographic comparisons among Plains peoples and their predecessors. This typology of objects is akin to a portable altar or a ritual kit containing the items necessary to carry out specific rites. For example, they are essential to the liturgies of both seasonal and renewal rituals. Medicine bundles are composite items made up of a variable number of covers tightly wrapped around one or more objects so as to conceal and preserve their power. Medicine bundles can contain animal parts, stones, feathers and man-made objects that are believed to store powerful forces which can benefit the group that cares for them. Medicine bundles are normally kept safely in the hands of special classes of people called 'bundle keepers'. Occasionally, they can also be exhibited or opened up for display as part of ceremonial procedures. Because they are imbued with much spiritual power, medicine bundles are often talked about as humans, and are treated as such.

Smaller packages and sachets that contain protective materials received in dreams or visions that are carried by individuals for personal use are also considered to be bundles. Each bundle comes with a set of prescriptions about how to handle, open and store it. Some of these bundles are so sacred that special places are allocated for their preservation. In numerous cases sacred bundles are placed in special lodges. More frequently, personal medicines and bundles are put in hard rawhide cases, conventionally known under the generic term *parfleche* (from the French word for shield), that hang from tripods outside a warrior's tipi. This precaution eliminates the risk of potential harm to those who do not know how, or are not entitled, to touch the sacred items (Fig. 33).

Individual bundles have names, stories and songs attached to them, and their ownership is regulated by a set of rules that determine the rights of transfer, prices and duties. Often, caring for particular bundles includes the right to wear special items, or may also entail the responsibility of looking after the tipi that contains them, and the mandatory usage of accoutrements such as belts, sashes or necklaces while handling them. Both society and individual bundles contain powerful objects received by individuals in dreams or visions in historic times. Their use is limited to members of a particular society and gives protection only to them. Articles that have proved successful in war could also be regarded as medicine bundles (Ewers 1958: p. 165). Critically,

this connection shows the intimate relationship that Plains Indians saw between war and the spiritual world as two sides of the same reality, simultaneously comprising disruption and conflict alongside balance and harmony.

Visual and material renditions of power

There is no doubt that Plains peoples have been engaged in warfare since before Europeans arrived. Pictorial records produced by Native groups of the Plains and Plateau since prehistory indicate a great deal of belligerent activities (Keyser 1977; Keyser and Klassen 2001; Sundstrom 2004). Rock incisions, stone etchings, pecked images on boulders and under rock shelters, and to a lesser extent mural paintings, vividly illustrate actions and symbolism associated with war and combat. Apart from being a useful record of Plains Indians' cultural and artistic variation, these depictions are important to contextualize the convergence of military exploits with supernatural powers in places of great spiritual significance. Boulders and flat rock surfaces that feature this art form were, and in some cases still are, sites of pilgrimage where warriors not only invoked powerful cosmic forces by leaving offerings to invisible beings, but also sought visions and contact with ancestors by way of fasting and prayers.

Interestingly, during the early period of a long tradition identified as the earliest phase of Plains Indian rock art called Ceremonial (prehistory to c. AD 1700), shield-bearing male warriors and other warfare scenes frequently appear juxtaposed to supernatural elements, indicating a close connection between war, masculinity and spirituality. They can be found beside images of female genitalia, and in turn, scenes of a sexual nature appear combined with icons related to animal and supernatural power such as bears, thunderbirds and other beings invoked as guides and protectors of warriors throughout historic times (Keyser and Klassen 2001). These early depictions were produced in places that held particular spiritual significance for the acquisition and enhancement of masculine powers connected to war medicine and supernatural assistance. The common figure of the shield-bearing warrior, found in many rock art sites across the north-western Plains, for example, in some cases displays streaks tearing down the cheeks that denote his crying during visions in pursuit of spiritual guidance (Keyser 2004: 66–7; Kaiser et al. 2010). This is a convention that continued to be used in later visual renditions of Plains ritual pledgers engaged in activities such as the Sun Dance (Harris 1989: p. 81).

Depictions of war-related themes and battles scenes in early rock art are supported by the presence of mass graves in the archaeological record, and evidence of physical violence in numerous sites shows that intertribal rivalry predates historical conflicts caused by migrations of several groups on to the Plains. Precolonial intertribal warfare has been variously explained as a result of competition over ecological and technological resources. These interpretations, however, fall short of explaining the complex levels of interdependence established between groups in terms of reciprocity, exchange

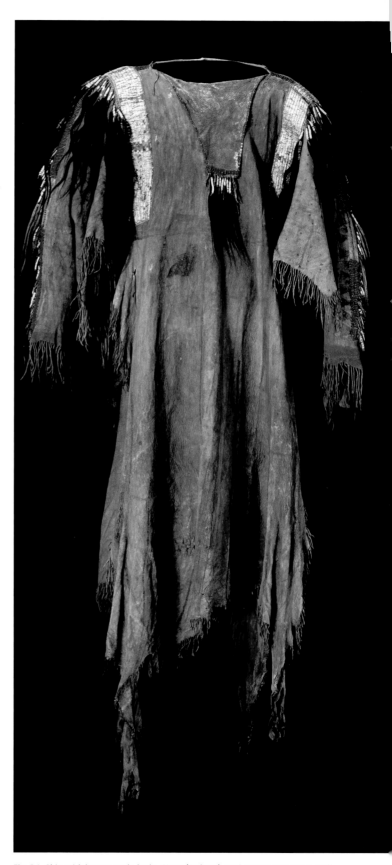

Fig. 34 *Shirt with human scalp locks, Sioux (Dakota), mid-1800s. Porcupine quill, leather, horse hair, glass and fur, H 150 cm (Am.9063 Donated by John Davidson).* Human scalps were used to decorate war shirts among many Plains tribes. While the number of locks conveyed the extent of the owner's bravery, they also added to the shirt's potency through vital forces derived from hair.

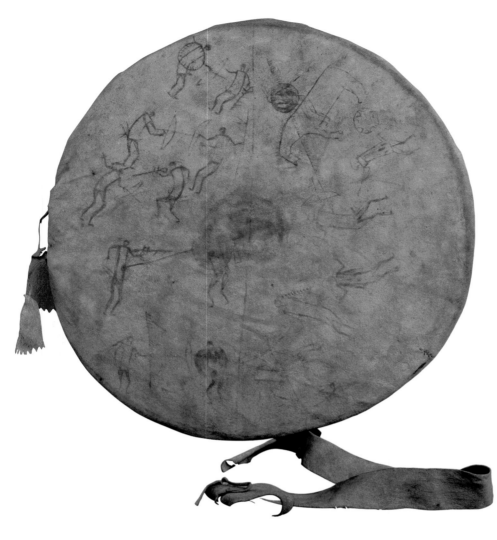

Fig. 35 *Shield cover, Pawnee, early 1800s (?). Buckskin and natural pigments, diam. 59.8 cm (Am.5202.b Donated by Sir Augustus Wollaston Franks).*
This shield cover, possibly made among the Pawnee in the early nineteenth century, is illustrated with distinct episodes from the martial career of a warrior. Often the composition of such depictions has a non-chronological sequence, which can be very difficult to interpret.

and ceremonial co-operation (Albers 1993; Jablow 1951). Analysis of these contexts can illuminate further the nature of nineteenth-century Plains Indians' warfare that was informed historically by particular types of diplomatic relations, in which adoption ceremonies, barter and trade determined alliances and enmities across the region. In this framework, warfare emerges as part of more complex dynamics of inter-ethnic relations in which social, economic and cultural practices mediated competition over access to both material goods and intangible resources, such as spiritual power.

This framework may be useful to explain why pre-contact mass raiding appears to have been relatively rare. In comparison to the equestrian period, the frequency and scale of war parties were greatly limited by the absence of the horse (Klein 1993). Although it is not possible to identify with certainty one single reason for precolonial conflicts, it is likely that a combination of causes such as retaliation, theft, vengeance and quest for social prestige may have contributed to episodic instances of intertribal violence. In addition to this conventional interpretation, current research on warfare in the Americas suggests that supernatural or non-human agents had a significant role in the staging of precolonial conflicts (Nielsen and Walker 2009; Pauketat 2009). Evidence from the early Ceremonial tradition of the north-western Plains, as well as Mississippian period art from regions such as the Midwest

and eastern Plains, shows a distinct concern with ideologies of supernatural power and ideas of generation/regeneration embedded in trophy taking and scalping, with clear mythical references (Chacon and Dye 2007; Reilly and Garber 2007; Sundstrom 2004). Particularly significant in this regard are the examples of cut marks found on prehistoric Plains skulls that indicate scalping (Miller 1994; Neumann 1940). These findings, alongside a rich repertoire of iconographic references to heads and scalps, reveal the antiquity of a preoccupation with appropriating vital forces contained in human hair that continued well into the historic period with the inclusion of scalps in the war bundles and ceremonies of many Plains peoples(Bowers 1992; Fletcher and La Flesche 1911; Murie 1981; Powell 1969; Skinner 1915a) (Fig. 34). Although scalping should be interpreted neither as the sole nor the main reason for precolonial intertribal conflict, it is not an incidental practice within the larger warfare complex; it is, rather, a fundamental element that ties together ideas at the core of Plains Indian ideology of war as a manly pursuit of social prestige and power that reinforces concepts of balance and reciprocity at the core of intertribal exchange, trade and co-operation.

With the advent of the horse, the increase in belligerent activities coincided with new forms of pictorial styles that refined visual languages of realism, offering crucial details

about the social and spiritual life of Plains warriors. The study of what has been called the Biographic tradition, which gradually replaced the Ceremonial tradition by the mid-eighteenth century, has greatly enhanced our understanding of the activities that historic Plains peoples considered significant enough to record in visual form (Keyser 2004; Keyser and Klassen 2001). In this genre warriors appear brandishing weapons, staffs and military insignia, bundles, unique accoutrements and shields. They also appear touching or taking women captives, an action that counted towards a warrior's social standing (Greer and Keyser 2008; Keyser *et al.* 2006; Risch 2003) (see pp. 60–1).

Thematically, Biographic tradition imagery represents facts and events in which warriors are the protagonists of hand-to-hand combat, battles, horse capture, scouting, killing, scalping, taking captives and touching enemies. Narrated through a visual idiom articulated on a spectrum that goes from the crude abstract rendition of bodies to fully fledged realistic portraiture, Biographic tradition imagery shows the relevance of warfare activities for the enhancement of a warrior's status within the group, which was based on accomplishments and exceptional deeds performed in battle (Fig. 35). Insignia, weapons and special badges are often clearly represented to show the warrior's position in the ranking system, or his belonging to specific societies or grades within men's many prestigious and exclusive martial

clubs. Headdresses, feather banners, sashes or recognizable objects such as harnesses and halters can identify the wearer's affiliation to distinct warrior societies whose exclusive use of specific items set them apart from other clubs.

Stylistically, visual records that appear in rock art sites associated with the Biographic tradition across the Plains pave the way for later developments in warriors' pictorial styles that utilized different media to record both individual and collective events relevant to tribal histories and cultural memory. Plains Indian artists' realist visual language, developed in this long tradition, extended to the production of collective histories called 'winter counts'. This type of history keeping seems to have started as early as the mid-eighteenth century. Winter counts were produced by Kiowa, Mandan, Blackfoot and most Dakota subdivisions. Historical events featured in winter counts were recorded in a form of picture writing that condensed in one image a prominent fact that gave name to the year in which it happened (see Figs 14 and 30). Thematically they are very diverse, although the great majority of events depicted are related to war, battles, diplomatic encounters, treaties and peace negotiations. Special men were dedicated to keeping these pictorial records, which furnished a mnemonic device for the cyclical retelling of tribal histories. Much in the same way as the regular retelling of war deeds by individual warriors, winter counts were recounted orally and performed in front of the tribe.

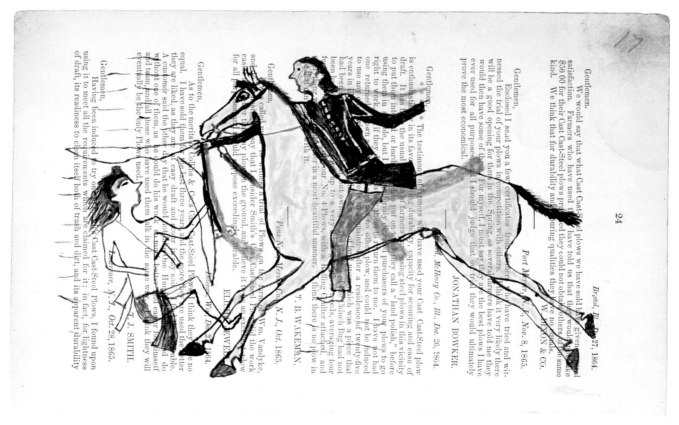

Fig. 36 *Ledger drawing, Good Bear, Sioux (Oglala Lakota), 1874. Pencil or crayon on paper, H 14.2 cm, W 22.4 cm (Am2006,Drg.36).*
Good Bear's ledger drawings encapsulate the martial ethos of Plains Indians at

a moment of radical change. This scene, which represents the author striking a Crow enemy, may refer to past episodes that were immortalized in pictures.

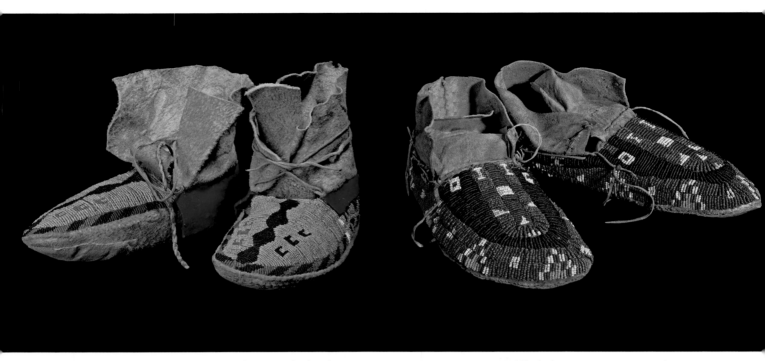

Fig. 37 *Moccasins Left: Assiniboine or Crow, early 1900s. Hide, skin, glass sinew and wool, L 27 cm, W 10 cm (Am1983,Q.197.a-b). Right: Crow, c. 1930. Skin, glass and sinew, L 25 cm, W 9.5 cm (Am1930,-.18.a-b).*

Decorations on moccasins could be both a means to convey a man's accomplishments or be based on the maker's visions or dreams. In the pair seen here on the left, the 'U' signs decorating the surface signify the tracks of the horses captured by the owner.

By the early nineteenth century, collective visual histories recorded in winter counts and warriors' biographic accounts were established pictorial traditions, painted on hides, skins, shirts, muslin, shields and, not infrequently, on tipis (Rosoff 2011).

The Biographic tradition continued well into the twentieth century during many instances of war captivity and the establishment of reservations. This more recent period is characterized by a gradual shift from the public retelling of war deeds aided by pictures to a more intimate, self-reflective and conscious mode of visual expression in which accounts of warriors' accomplishments, dances and ceremonials were drawn on paper. This visual tradition is better known as 'ledger art', from the practice of using crayons on ledgers acquired from Euro-Americans (Afton *et al*. 2000; Berlo 2000; Brizee Bowen 2002; Earenfight 2007; Greene and Thornton 2007; Petersen 1971; Szabo 2007). This form of visual expression quickly replaced old forms of picture writing yet maintained the spirit and ethos of warriors' former lives, now dramatically ended by the rapidly changing historical circumstances (Fig. 36). Both in early and later forms, however, Biographic warrior tradition retains deep spiritual connotations shown by a juxtaposition of facts with abstract symbolism and the depiction of ceremonies evoking notions of supernatural agency, protection and guidance. Whether biographic accounts of personal deeds or visual records of historical facts, these elaborate forms of expression collectively informed and maintained identity at all levels. Together, Ceremonial and Biographic tradition, picture writing, winter counts and ledger art paint a complex

picture of warriors' life on the Plains that contextualizes the oral histories collected by anthropologists and ethnographers throughout the twentieth century (Krupat 1992; McCoy 1992; Szabo 1994a; Vestal 1962). While they established a narrative framework for tribal identities, they also provided complementary reminders of masculine versions of the fundamental notions of power, honour and prestige shared by all in their societies. For men at least, both public reciting of past events and ledgers' biographic vignettes reinforced individual belonging to the warrior societies that managed both tribal affairs and intertribal politics. Their responsibilities in public affairs were visually conveyed through a variety of exuberant and vibrant repertoires of realistic representations that stand in sharp contrast to more abstract expressions of esoteric, and often secret, meanings imbued in objects produced by, or in collaboration with, women.

Women and men often contributed to making objects and clothes used in war. This practice also mirrored the widespread notion of complementary powers common across the whole area. A popular adage among Plains Indians clearly epitomizes this idea: 'When women are making moccasins a conflict is imminent'. This expression stems from the fact that men going to war needed moccasins for the warpath; expeditions could be long, and spare footwear was a necessary part of the warriors' kit (Fig. 37).

Historic Plains Indian women adopted a unique visual idiom very different from that of men (Kroeber 1901; Lowie 1909; Lyford 1940; Wissler 1904, 1927). Women's decorative style is largely characterized by abstract forms and geometric figures whose rights of ownership belonged to the maker. Such

designs shared conventional motifs whose basic units were differently assembled in a variety of creative combinations. Because most of these designs belonged to the individual artists, it is not always possible to infer their inherent meanings, if and when they exist. Some designs were widely recognized by name and denoted a conceptual grouping of thematic and iconographic motifs that were used to decorate both domestic and ritual objects. Furthermore, spiritual meanings, aimed at protecting wearers from potential dangers or misfortune, are embedded in these designs. Abstract forms generally used by Plains Indian women in the decoration of moccasins, shirts and blankets used by men, as well as many ceremonial objects made for the sole use of warriors, visually materialized prayers or concepts through symbols of great spiritual significance aimed at transmitting the purest essence of power (Coleman 1998; Dorsey 1894:

451; Kostelnik 2009; Taylor 1999). Among the Arapaho, for example, particular motifs embroidered by specially trained women quillworkers on circular hide cutouts called 'rosettes' were abstract renditions of beings such as Whirlwind Woman that were sewn to the back of tents to ensure protection and maintain order (Anderson 2000; Kroeber 1902–7). Beaded or quilled rosettes derived from this practice were also sewn on hides, blankets, shirts and baby cradles, each having a specific function and meaning. Among the Sioux, for example, blanket strips that included rosettes were applied along the central axis of a buffalo hide. This decoration may have marked particular episodes in the life of the warrior who owned the blanket in accordance with the conventional use of lines and circles to express the passing of winters in their pictographic writing system (Mallery 1893: p. 265; Taylor 1994: p. 184) (Figs. 38, 39).

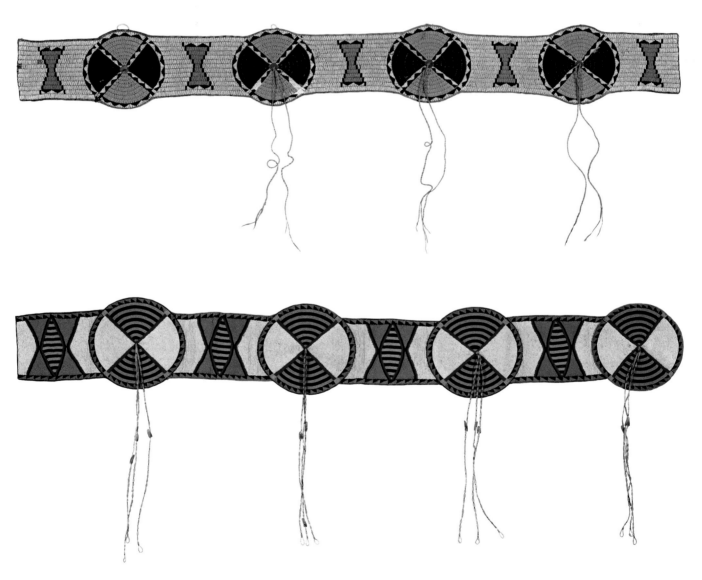

Fig. 38 *Blanket bands. Above: Crow, 1800s. Skin, beads, porcupine quill and claw, L 160 cm, W 22.5 cm (Am1937,0617.2). Below: Cheyenne or Arapaho, mid-1800s. Skin, beads and cloth, L 145.5 cm, W 18.2 cm (Am 1944,02.225 Donated by Irene Marguerite Beasley).*

Blanket strips or bands were produced by women and traded as separate items. Decorations, styles, and beading techniques travelled along exchange networks that predated the arrival of Europeans.

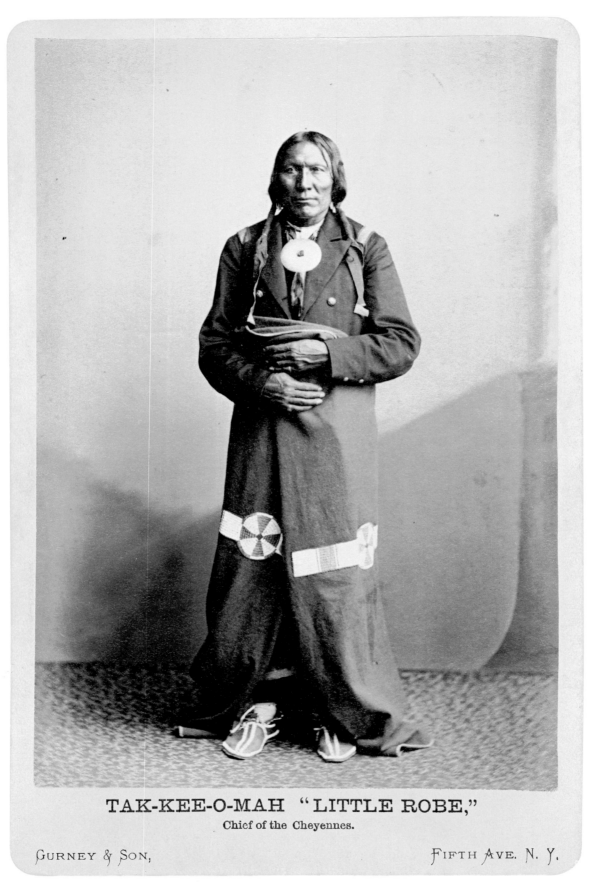

TAK-KEE-O-MAH "LITTLE ROBE,"

Chief of the Cheyennes.

GURNEY & SON, FIFTH AVE. N. Y.

Fig. 39 *Tak-kee-o-mah (Little Robe), photograph by Gurney Studio, 1871.*
Albumen print, H 14.4 cm, W 9.7 cm (Am,B32.4).

Cheyenne leader Tak-kee-o-mah is shown here wearing a commercial blanket
in the fashion of Plains warriors, who would wrap this garment around the hips
when horse riding.

In historic Plains tribes women generally made the necessary items of clothing, as well as some amulets and protective devices used in war rituals and ceremonies. Among some tribes, special classes of women endowed with the power of making potent protective amulets formed societies. For example, until the early twentieth century among the Oglala, a division of the Sioux nation, a selected group of women prepared shields and war medicines that they gave to warriors going on the warpath (Wissler 1912). Other special classes of women, often belonging to societies, were also entitled to bless warriors, without providing particular objects such as shields or charms. Nevertheless, the mediation of sacred items was paramount. Among the Kiowa, for example, the Bear Women society was associated with the ten sacred tribal medicine bundles. Their association with these items ensured that these women could transfer their power to warriors by way of blessings and prayers. The society consisted of ten elderly women who controlled bear power during their secret meetings. They could, however, be summoned by warriors going to war who wanted their blessing for a safe return. Should a warrior come back victorious, he vowed to sponsor a feast for the society (Lowie 1916; Meadows 2010).

Universally across the Plains, women made the clothing worn by warriors. They lavishly decorated these garments with elaborate strips woven from porcupine quills or wrapped long bundles of horse hair with the quills. When glass beads became readily available, women embellished shirts and leggings with precise geometric designs in addition to or in place of quilled strips. Skilled women who learned the art of beading and quilling gathered in societies that effectively performed the same function as those of men (Carocci 1997a). They guaranteed prestige and social standing in ways akin to men's way of gaining status recognition by retelling their accomplishments. Beading and quilling societies held regular meetings in which women recounted their own achievements, such as the number of objects decorated in one season (Anderson 2000; Grinnell 1972, I: p. 161; Hassrick 1964: p. 43). Societies of hide tanners had a unique system for measuring prestige: they incised a dot for every hide tanned on their bone scraper. This method of recounting deeds paralleled the ranking system of men who, in similarly performative fashion, rehearsed their accomplishments in front of their comrades. These two systems not only defined gender roles and responsibilities, but also offered independent systems for individual recognition.

Women's technological and aesthetic skills complemented men's own decorations on items of great importance such as shirts. Cosmic balance kept in place by complementary roles is evident in the production of war shirts worn by warriors. This typology of items used by prominent honourable men in ceremonial occasions clearly shows how women's craft expertise, men's spiritual symbols and warfare actions could benefit both makers and wearers in different ways. While makers boasted of their technical accomplishments among themselves, wearers displayed objects enveloped in spiritual

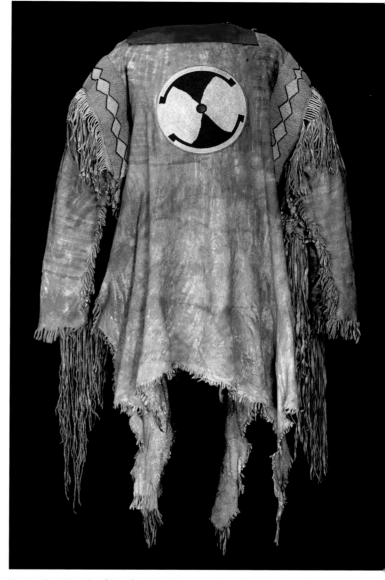

Fig. 40 *Shirt, Blackfoot (Kainai), 1880s. Skin, porcupine quills, glass, natural pigments and wool, L 100 cm, W 164 cm. (Am1983,Q.288).*
The hourglass shape decorating this shirt, which once belonged to the Blackfoot leader Red Crow (Kainai, c. 1830–90), has been interpreted as depicting the mighty thunderbird. This common iconographic convention used to represent the thunderbird originated in the eastern woodlands.

power that granted protection. Many early war shirts were decorated by men with protective designs that came in dreams. Some recognizable designs recur over the whole area, for example stylized tadpoles, cocoons, hail, morning star, thunderbirds, bears, eagles and many other important other-than-human beings (Fig. 40). In addition to protective motifs, warriors could decorate their shirts with male symbols such as the sun, lightning or arrows (Fig. 41). These designs reinforced ideas of masculine power that were most dramatically expressed through the performance of warfare deeds. Brave exploits and symbols mutually sustained and informed each other in gendered performances that established divisions between men, women and other genders. Dragonflies, for example, which among some Plains tribes

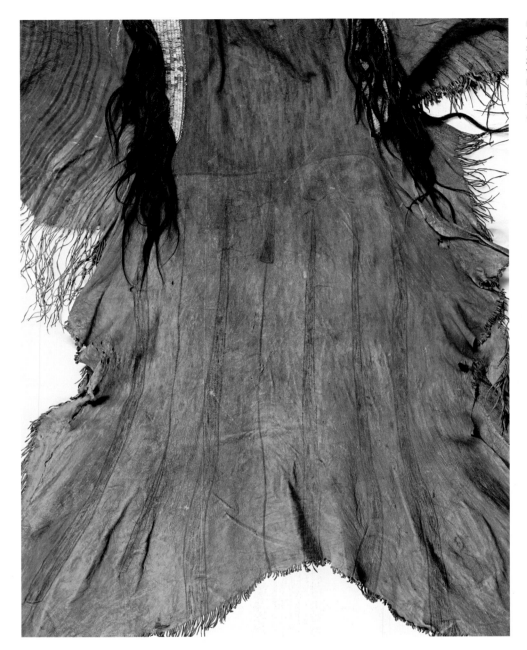

Fig. 41 *Detail of Fig. 34.*
Arrows motifs painted on this Sioux shirt are very similar to conventional geometric designs that appear in warrior tattoos and on old robes and hides (see also Fig. 8). Arrows are a symbol of male energy, a metaphor for lightning and the striking power of thunder.

such as the Cheyenne were associated with transformation, appear on war items collected by men-women. This symbol represented their gendered position as in between males and females (Coleman 2003).

In addition to recognizable symbols, men put their personal touch on the shirts made by their wives by adding pigments and protective items on the front, back and sleeves. In some cases, particular colours would convey conventional messages: for instance, among the Sioux, the use of blue for the sky and yellow for the earth could respectively cover the upper and the lower part of the shirt (Wissler 1904: p. 200). It is not always possible to determine the meanings of some of the designs on war shirts because warriors, like women in their designs, frequently tended to personalize their shirts with highly individual references to intimate personal experiences with other-than-human beings and intangible

cosmic forces. More easily recognizable are conventional pictograms that denote scalps, horse tracks, guns or human figures, which were codified according to a familiar visual lexicon widespread throughout the Plains (Petersen 1971) (see Fig. 35). Pictorial examples from the British Museum collections show the variety of icons used to denote particular concepts or things. One shirt, for example, displays several guns that the wearer stole from his enemies (Fig. 42). As well as being social conveyors of male power and prowess, war shirts were very personal items that simultaneously identified warriors with their life history, spiritual experiences and individual essence, rooted in ideas of power and masculinity. These ideas conceptually sustained social institutions such as warrior societies that ultimately managed the political and ritual life of the many groups that populated the North American Plains.

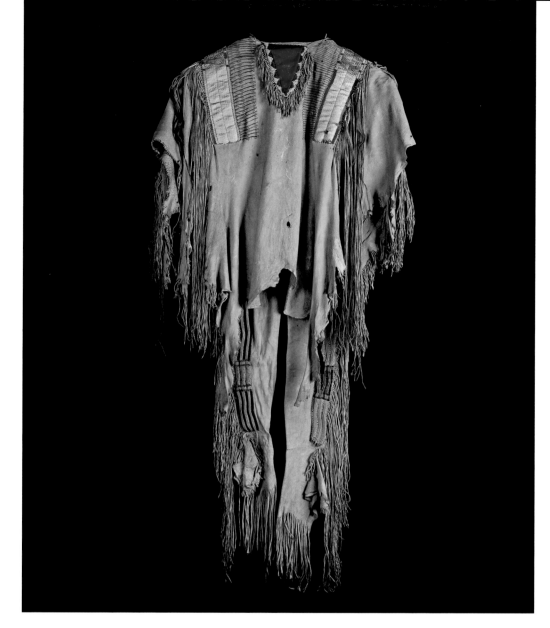

Fig. 42 Left and detail below
*War shirt, Crow or Hidatsa,
early 1800s. Skin, porcupine
quills, horse hair and natural
pigments. Shirt
L 95 cm, leggings L 140 cm.
(Am1924,1009.1 Donated by
Miss Romaine).*
In the same way as robes
and moccasins, war
shirts were canvases that
publicized a man's valour
by showing the number
of his accomplishments.
Drawings made on them
covered the wearer with the
power obtained through the
captured objects. Numerous
guns can be seen drawn on
the front of this war shirt.

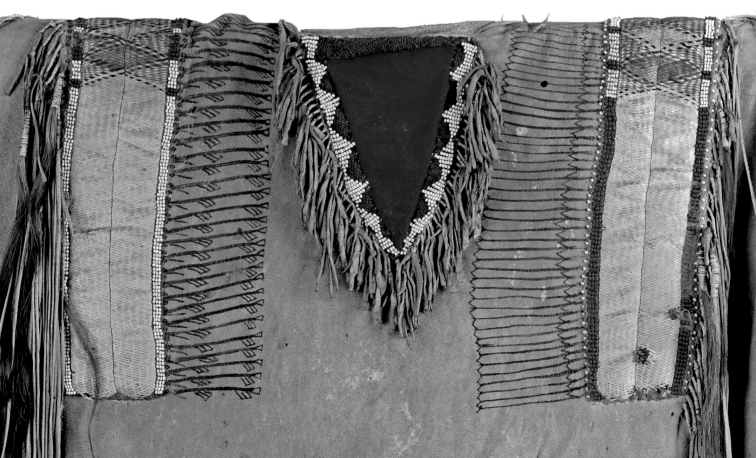

534 Pawnee Sun Chief

Chapter 3

Warrior societies and ceremonial life

Theorizing warrior societies

What struck us most was an institution, peculiar to them, and to the Kite [i.e. Arapaho] *Indians further to the westward, from whom it is said to have been copied. It is an association of most active and brave young men who are bound to each other by attachment, secured by a vow, never to retreat before any danger, or give way to their enemies . . . these young men sit, and encamp, and dance together, distinct from the rest of the nation; they are generally about thirty or thirty five years old; and such is the deference paid to courage that their seat in council are superior to those of the chiefs, and the persons more respected.* 31 August 1804
(Lewis and Clark 1905)

With these words the American explorers Meriwether Lewis and William Clark described in their diaries their first encounter with a society of warriors among the Dakota. This early account of what they called a 'peculiar institution' is the record of one of the many societies of men that organized and managed social, ceremonial and political affairs among Plains groups throughout the nineteenth century and, in some cases, continue to do so today (Fig. 44)

In one of the earliest academic studies about this particular form of social arrangement, so popular among Native American nations in the nineteenth century, the eminent anthropologist Alfred Kroeber highlighted differences and similarities between such societies. One of the things he regretted he could never do in this study was to ascertain positively whether the societies' main function was civil, military or religious (Kroeber 1907: p. 63). Kroeber acknowledged the relative importance that all these aspects had in the activities performed by the various societies. His preoccupation with the societies' origins and function seems today to limit this early twentieth-century discussion to a less than fruitful concern with definitions and factual accuracy whose 'scientific' premises can be seen by contemporary

Fig. 43 *La-roo-chuck-a-la-shar (Sun Chief), Pawnee, photograph by W.H. Jackson (?), 1868. Albumen print, H 18.5 cm, W 12.5 cm (RAI 1232).*
The son of famous leader Pet-la-sha-ra, Sun Chief was head chief of the Chaui band and leader of the councils. He is wearing a robe decorated with stars, an important cosmological theme in Pawnee ideology and religion. Note the James Buchanan Medal of 1857 worn around his neck.

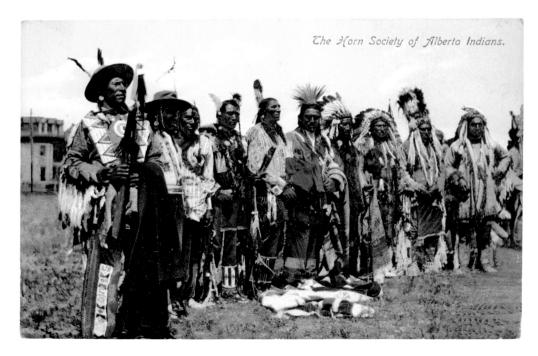

Fig. 44 *Blackfoot members of the Horn Society of Alberta Indians in full ceremonial regalia, Canada, 1907. Colour postcard, H 9 cm, W 14 cm (Am,B41.16).*

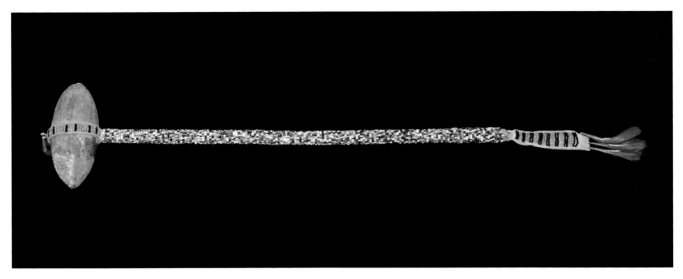

Fig. 45 *Club or coup-stick, Northern Plains, late 1900s. Skin, stone, metal, fibre, beads and horse hair, L 44 cm (Am1981,12.29 Donated by Wellcome Institute for the History of Medicine).*

anthropology as overly deterministic, and positivistic. Marxist, feminist and postmodern anthropology have later criticized this early search for objective reality by offering new interpretative tools that formulated new frameworks for the contextual study of institutions such as warrior societies.

Current anthropological approaches to the study of cultural life interpret social behaviours and practices as a visible rendering of ideologies and beliefs through socially shared meanings. These meanings are in continuous states of flux, and are reconfigured in contingent permutations engendered by responses to ever-changing economic and political predicaments. Socially shared meanings cut across spheres of interaction, and as a consequence they ought to be examined as context dependent. Meanings can simultaneously refer to areas that we classify as religion, war or civil society which early anthropologists characterized as unambiguous, and clearly bounded. A new interpretive framework adopted in the present study provides a contrast to this early perspective. Here notions such as honour, for example, cannot be solely understood in terms of social standing; they also have to be analysed in relation to moral and ethical principles at the basis of Native spirituality, beliefs and, ultimately, religious practice. Equally, customs practised by Plains Indians in battle, such as scalping, touching living or dead enemies and trophy taking, ought to be understood with reference to deeply rooted beliefs about the person, soul, power, property, gender and other areas of social life. As a consequence, we begin to see warrior societies as permeable and flexible areas of social interaction in which shared meanings can have implications for locally understood notions of what constitutes, for example, spirituality or conflict, which bridge interlocking and overlapping spheres such as religion, politics and civil and social life.

While the current definition of warrior societies highlights the belligerent aspect of this social institution, we ought to consider that Plains Indian warfare cannot be understood only in terms of conflict management and competition. The existing literature on warrior societies generally highlights the martial connotations of these clubs, yet in order to fully understand their social significance it is crucial to examine the religious meanings underpinning their creation and existence. There is no doubt that many Plains Indian men's clubs organized raids and were concerned with fighting and combat; however, warrior societies were also implicated in the running of ritual, religious and ceremonial calendars. They were a mechanism for maintaining for the whole society moral values and principles that, in turn, were at the core of historic Plains Indians' offensive and defensive practices, with clear political and economic ramifications.

At the same time, war and warfare among nineteenth-century Plains Indians ought to be understood as forms of social interaction that exceed intergroup contacts, broadly defined as politics, ethnic relations and diplomacy. Meanings associated with conflict, ideas of death, and the management and transfer of power indeed stem from beliefs that are visibly articulated through warrior societies' ritual, religious and ceremonial life. This intricate interplay between religion, politics, social arrangements and civil and moral duties, expressed through the regimented and ritualized organization of men's societies' practices and values, adds subtlety to the canonical description of Plains warfare in terms of a 'war complex', generally limited to the explanation for horse stealing, raiding and scalping in terms of economic or political drive (Smith 1938). As anthropologist Patricia Albers has eloquently argued, social phenomena such as nineteenth-century Plains warfare are not static, but rather are contingent rearticulations of beliefs

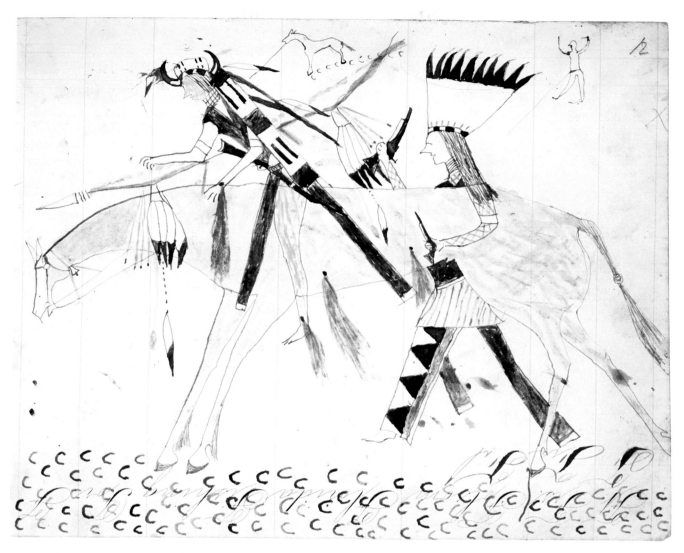

Fig. 46 *Ledger drawing by Tall Bear, Sioux (Oglala Lakota), 1874. Pencil or crayon on paper, H 17.5, W 21 cm (Am2006,Drg6).*

The wounded warrior on the left of the drawing, identified by the name glyph as White Horse, is holding a bow lance, the distinctive insignia of contrary warriors, while the standing warrior brandishes two colt revolvers.

(e.g. transfer of power during ceremonial exchange) and practices (e.g. gift-giving, alliance) that are contextually renegotiated through time (Albers 1993). Undeniably, Plains Indian warfare and intertribal relations changed over a period of more than two hundred years and, as a consequence, so did the implicit meanings that gave them cultural significance for so many groups.

The prominence of warrior societies among nineteenth-century Plains Indians is indeed tied to changes in meanings and practices associated with warfare and intergroup relations through time. Archaeological excavations aided by interpretations of indigenously produced rock art show that intergroup fighting was a common occurrence in the life of early Plains Indians. On what ideological premise intergroup hostility was carried out in the deep past can only be conjectural, but for prehistoric and proto-historic times it can be inferred by comparative analysis and explained via ethnographic parallels. However, during the proto-historic period (between *c.* AD 1050 and 1600), a rich body of recent

anthropological and archaeological research on warfare and trophy taking among pre-horse cultures of the Midwest and southern plains has revealed an intimate connection between religious beliefs and warfare.

While most of the historic Plains and Midwestern tribes had warrior societies, not all the tribes occupying this large region organized warfare in the same fashion. War-related activities and ceremonialism among some nations were managed by clans, and often by the whole tribe. Tribes such as the Osage and Kansa, for example, did not have societies of warriors like those of the great majority of Plains nations. In these tribes, different clans were in charge of war bundles, the wrappings that guaranteed collective protection and war success.

The situation on the Plains in the early historic period (generally considered to coincide with the arrival of the first substantial number of Europeans on the Plains by the late eighteenth century) is further described by travellers, traders and explorers. They left in diaries and accounts

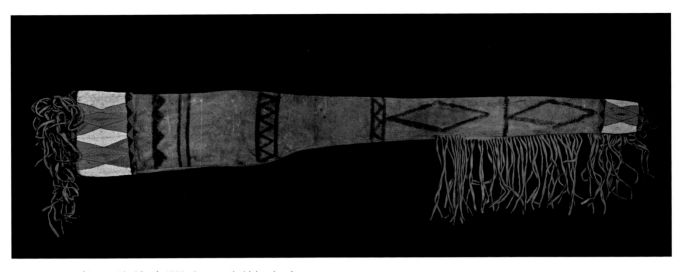

Fig. 47 *Gun case (Crow or Blackfoot), 1800s. Decorated with beadwork and natural pigment, L 115 cm (Am1981,Q.1934).*

limited, if precious, information about at least some Plains societies. Indigenous belligerence was frequently remarked upon by early explorers and commentators who happened to observe Native fighting. Yet these observers also realized that Native American warfare was significantly different from their own understanding of what war was about. Accounts of Plains Indian battles and raid parties describe a variety of motivations for aggressive behaviour between the nations that could range from revenge to supernatural sanction. Territorial defence, competition over horse pastures, supremacy over trade networks and controversies over hunting grounds may have also triggered intergroup fighting. Chains of endless retaliations were generally carried out through small raids against enemies that seldom ended with many dead. One of the things that most impressed early European explorers and commentators about Plains Indian warfare, however, was an almost total disregard for inflicting losses upon the foes. The symbolic importance of 'counting *coup*' (loosely translated from the French as 'counting the strikes'), in order to access enemies' power, sets Native North American warfare apart from familiar Euro–American fighting practices (Fig. 45). If a major distinction between Indian early historic fighting and the European-American combat ethos could be drawn, it was Native Americans' preoccupation with elevating a warrior's social status through acts of bravery, and not by the killing of enemies. Rather, it could be said that men went to war not to kill, but to risk being killed. A famous Dakota song from the Kit-Fox military society, collected in the early twentieth century, symptomatically reads: 'I am a Fox. I am supposed to die. If there is anything difficult, if there is anything dangerous, that is mine to do' (Lowie 1954: p. 101). Warriors put more emphasis on scorning the possibility of death than causing it in the first place, unless this was required for retaliation, vengeance, or the appeasing of a dead person's soul (Fig. 46). Historical evidence confirms that carefully orchestrated large-

scale war raids in search of scalps, women and trade items (including captives and, in some areas, slaves) intensified with the arrival of Europeans and the introduction of new technologies and horses. Until then warfare involved matters that frequently could be dealt with by members of a society or a small war party, and large-scale battles were rare before the period described by Euro-American historians as the Indian Wars (*c.* 1830–90) (see pp. 112–3).

It should be noted that much of the first-hand non-indigenous information about warrior societies was collected in the period immediately before the institutionalization of professional ethnography in the early twentieth century. Knowledge produced by early anthropological studies severely limited the understanding of additional social, civil and religious connotations of these societies in the life of their nations. Diplomatic and trade relationships between colonists and indigenous nations of the Plains were generally managed by men throughout the nineteenth century. Often based on simple notes in passing, superficial remarks, or a preoccupation with tactics, strategy and losses, these sources cannot give us a full sense of the social relevance of warrior societies in their entirety, that is, both in war and during times of peace. European comments about Plains Indian warfare did not contextualize it in a broader regional picture, and what is more, they were unable to appreciate the subtle changes occurring between nations and their warrior societies in a historical perspective. This body of information about Plains Indians partially reflects a Eurocentric male bias fuelled by a colonial and somewhat romantic mentality; yet, in its partiality, it mirrors a situation of rapid change in which the increase of large-scale warfare due to the availability of guns and horses had a significant impact on the war complex (Hämäläinen 2003) (Fig. 47).

The nature of Plains Indians intergroup hostility indeed mutated over time and, as a consequence, changed the nature of men's societies and war clubs. Most economic and

political anthropologists' assessments of this area between the late seventeenth and nineteenth centuries suggest that the introduction of horses, gunpowder and European trade goods, and the growing displacement of groups due to colonial conflicts, slave networks and epidemics, may have collectively exacerbated both the defensive and the aggressive nature of men's societies. As Native nations adapted to a political economy of combat triggered by new technologies and forms of exchange, societies of warriors increasingly became more important than other types of social clubs (Albers 1993; Haines 1976; Klein 1980, 1983). In some cases warrior societies substituted for elderly chiefs in the running of ceremonial affairs. Among the Cheyenne, for instance, warrior societies took executive decisions about tribal bundles and sacred ceremonial items after the decline in power of tribal leaders (Powell 1969: p. 357). At the same time, the former symbolic and ritual efficacy of Plains Indian women' societies rapidly declined in favour of male-dominated clubs that, despite the overwhelming emphasis on war and honour in the political sphere, retained some of the former ritual and ceremonial duties and implicit meanings (Carocci 1997a). As a result, by the time anthropologists started collecting information about Plains Indians social arrangements in the late nineteenth century, this radical shift was mirrored in male informants' biographical narratives, personal memories and collective recollection of historical facts in which battles and combats played an extensive role.

It took the labour-intensive data collection and comparative work of early ethnographers and anthropologists to produce a more complete understanding of the sketchy information contained in early accounts of warrior societies made by explorers such as Lewis and Clark. The systematic classification of Plains Indian men's societies initiated by anthropologists such as Alfred Kroeber, Robert Lowie, Clark Wissler and Alanson Skinner, alongside the invaluable work of Native American ethnographers such as James Murie, David Duvall and Francis La Flesche, offers a precious, if unprecedented, insight into the cultural and social relevance of these institutions for nineteenth-century Plains Indians.

While in most cases clubs of men were frequently concerned with warfare and battles, a closer analysis of the practices and meanings associated with what Lewis and Clark called a 'peculiar institution' reveals that war was but one, albeit important, aspect among the many that characterized this social arrangement of Plains communities. Warrior societies were also involved in the organization of rituals and festivals and performed major functions in policing and organizing large communal hunts and collective seasonal camp movements. Women too frequently played a role in similar societies and, not infrequently, in war (Albers and Medicine 1983; Carocci 1997a; Ewers 1997; Keyser *et al.* 2006; Thomas 2000). Women's war-related activities included active engagement in the preparation and running of societies' meetings and ceremonies, singing, cooking, assisting warriors during and after the warpath and occasionally fighting (see pp. 60–1).

In the monumental 'Societies of the Plains Indians', Clark Wissler (1912–16) concentrated some of the most detailed accounts available at that time of the societies found among the nations of the Plains. This work gathers ethnographic data from fourteen nations compiled by five anthropologists, and clearly shows that warrior societies shared with other social groups a number of traits that, over their history, often put them in an intermediary position between dancing associations, cults, private clubs and military regiments. Indeed, as originally remarked upon by Kroeber in his frustrated confession, also shared by his contemporary Robert Lowie, warrior societies were, and perhaps exceeded, all of these. Looking at the origins and typologies of these societies can illustrate their complex and ever-shifting nature throughout a long history of continuity, changes and adaptations.

Origins and types of societies

As a social institution warrior societies ought to be examined within the context of the widespread Plains Indian practice of establishing clubs, social and religious groups, cults and associations that cut across the basic social structure of tribes, bands, clans and moieties. While many of these associations were short-lived and their practices only partially involved religious and ceremonial aspects, the fact that the great majority of warrior societies functioned in simultaneous and multidimensional ways across several areas of Plains Indian life can account for their endurance and popularity.

With reference to their origin as a social institution, anthropologist Robert Lowie pointed out how Plains nations were caught between western peoples who lacked this tradition and eastern groups that featured secret societies (Lowie 1916: p. 953). This interesting cultural/geographical positioning triggered a series of questions about the origins and functions of the institution and the spread of beliefs underpinning men's and women's societies across the Plains. In his lengthy theoretical elaboration on cross-cultural comparisons between different types of societies, clubs and cults, Lowie addressed the distinction between societies for mature men, young adults and boys. He concluded that at least the northern Plains age-graded societies of the Blackfoot, Arapaho and Gros Ventre derived from an original matrix associated with the Missouri villagers the Mandan and Hidatsa (Lowie 1916: p. 954). Although he may have found the geographical origin of this particular type of society, he nevertheless remained silent about the reasons why such institutions should emerge in the first place.

More recent scholarship has proposed that the emergence of warrior societies can be understood in the context of economic activities such as large buffalo hunts, in which groups of men co-ordinated all the stages of chase, hunt and butchering of the animals. Indeed this remained a function of some warrior societies during the historic period. Societies that performed this type of policing took the name Akicita, derived from the Dakota language. Akicita societies

Plains Indian women and war

Although women generally did not go on war expeditions to fight, some individuals achieved warrior status and public recognition because of their fighting abilities (Ewers 1997; Medicine 1983; Thomas 2000). One of the most famous cases among women warriors is that of a nineteenth-century Crow woman called *Bar-chee-am-pe* (Pine Leaf, *c*. 1820–?) who led successful war parties and was skilled in manly occupations. Another nineteenth-century Crow was The-Other-Magpie (?–?), who became a warrior to avenge the death of her brother. She went on the warpath alongside men of her tribe, painting herself like a warrior and wearing a stuffed woodpecker on her head as war medicine (Linderman 1972). Revenge also motivated Blackfoot Running Eagle (*c*. 1800–?) to become a warrior. She led successful war parties after receiving power from the sun (Roscoe 1998). Women warriors were reported also among the Cheyenne and Dakota (Landes 1968; Medicine 1983). As a result of their war deeds some women were officially recognized by male warriors as braves and were allowed to sit among them. However, this did not always imply crossing gender boundaries, although in some cases women warriors took wives, such as the famous Woman Chief of the Crow (*c*. 1800–?) (Medicine 1983: pp. 273–4).

Unfortunately, to date only a few rare pictorial examples of women warriors have been recovered. Two such images are found on a ledger that represents a Cheyenne woman stripped to her breech cloth and brandishing a gun ready for battle (Ewers 1997: p. 192; Roscoe 1998: frontispiece). Another woman warrior was identified in a petroglyph at Large Bluffs in Wyoming. She appears holding a crooked lance. It is supposed to be the only recorded image of a woman warrior in rock art (Keyser *et al.* 2006: p. 62). Women on the warpath counted coup, killed enemies, took scalps, captured horses and defended themselves and their families with forceful determination and bravery. Among the Omaha, they were also responsible for building defensive earthworks around the village in case of imminent danger (Fletcher and La Flesche 1911: p. 426). Wives more frequently accompanied their husbands on the warpath to look after the horses, cook or give moral support (Bad Heart Bull *et al.* 1967; Ewers 1997).

In pictorial depictions women most frequently appear as subjects of war raids (Fig. 48). They could be taken as war captives, counted coup upon, and even killed (Ewers 1997; Greer and Keyser 2008; Horse Capture *et al.* 1993: pp. 85, 101; Risch 2003; Sundstrom 2008).

Women have continued supporting warriors and co-ordinating war-related ritual activities to this day. Modern scalp and victory dances performed by women of different tribes give recognition to returning victorious soldiers at powwows, anniversaries and other memorial celebrations among nations such as the Kiowa, Comanche and Tonkawa. Among the Kiowa, Mandan and Dakota women still wear special dresses called 'battle dresses' at these events (Her Many Horses 2007; Jennings 2004) (Fig 49). In the past, these garments displayed pictures of the exploits of the woman's relatives and frequently included the positions of their wounds on the body. The deceased's male relatives would paint battle scenes on the dress that the woman would wear. Battle dresses could also be worn by males who acted like women but went to battle much in the same way as men (see Chapter 2). For example, Osch-Tisch (Finds-Them-and-Kills-Them, 1854–1929), a Crow *boté* (man–woman), fought together with The-Other-Magpie in the battle of the Rosebud Creek (1876) against the Cheyenne and Lakota.

Women's custom of wearing warriors' regalia in honouring dances is as common as it is old. Early European explorers of the Great Plains recorded celebrations during which women would wear their husbands' feather headdresses while brandishing their weapons (Carocci 1999). Among the Osage, Omaha and Ponca, wives or daughters of the prominent warriors responsible for tribal war bundles wore signs of their male relatives' distinction permanently marked on their bodies. These tattoos represented stars and life-giving winds and were called *xtehxe* ('mark of

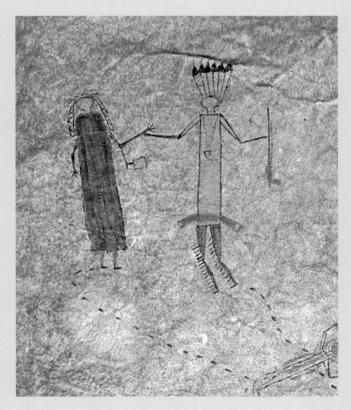

Fig. 48 *Detail of painted robe, see Fig. 99.*
Touching or killing a woman in battle counted as a war coup. Women were more often captured than killed and they frequently became second wives to prominent leaders.

honour'). They inscribed on the woman's body symbols that reinforced the complementary roles of males and females in ensuring, through valour, mutual support and industriousness, the preservation and prosperity of their society (Fletcher and La Flesche 1911: pp. 503–9). Today women still publicly carry or display men's symbols of valour during social events. Contemporary battle dresses worn at honouring dances, for example, always include insignia such as patches, medals, flags and other items of recognition related to the military accomplishments of a woman's husband or son.

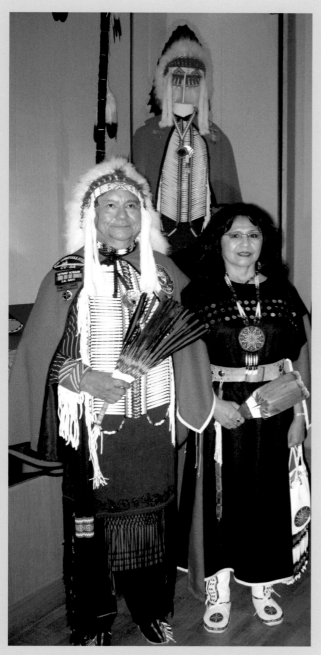

Fig. 49 *Lana Palmer (Apache), wearing a Battle Dress in the Kiowa tradition of her husband Lyndreth L. Palmer, photograph by the author, 2010.* Battle dresses are worn today by the wives of prominent soldiers and veterans in their honour and are decorated with the insignia from the soldier's career.

overlooked communal hunts and maintained order during seasonal migration to hunting grounds, monitoring anti-social behaviour and recalcitrant individuals and punishing people who resisted collective decisions.

However, on the basis of reported evidence of the antiquity of so-called 'contrary societies', it is perhaps from these that historic warrior societies may have developed (Meadows 1999: pp. 369–70). Contrary societies are found across the Plains in various degrees of organization. They are particularly interesting because in them spiritually sanctioned behaviours converge with social and political meanings that became prominent in nineteenth-century warrior societies. Members of contrary societies were expected to act by opposites. They were most specifically associated with thunder and utilized designs and implements that represented the power of this element or being. This characteristic points to a deeply rooted set of beliefs that stem from precolonial cosmologies and ideologies of power based on cultural matrices developed before AD 1600 among eastern woodlands peoples. Universally across the Plains, thunder beings and the power of lightning are connected to masculine force and war activities. Thunder beings are the patrons of war, and their explicit or hidden symbolism is ubiquitous. In thunderbird iconography the concept of supernatural force clearly converges with a notion of social and political power over enemies and their vital energies.

Because early European sources report the existence of warrior societies among the tribes living on the western edge of the woodlands, it is reasonable to suggest that there is cultural continuity between precolonial beliefs about war and the early colonial warrior societies engaged in warfare activities and ceremonialism as described in textual sources. Historical origins of the war beliefs underpinning practices linked to these early woodlands societies suggest that this type of institution may have developed among Siouan- and Algic-speaking peoples occupying eastern and Midwestern areas of the north-central regions of the Great Plains since the fourteenth century. These social forms eventually evolved into distinct regional variations over time as they spread north to south and reached groups such as Numic-speaking Comanche, Tanoan-speaking Kiowa and Athapaskan-speaking Kiowa Apache living in the southern Plains during the historic period (Lowie 1916; but also Meadows 1999).

Collectively, this body of evidence suggests that Plains warrior societies were more complex than the depictions of early ethnographers and anthropologists implied. The original questions posed by Alfred Kroeber and Robert Lowie about the nature of this institution can be more fruitfully answered by examining how the roles and functions of warrior societies cut across more than one area of social interaction. It is rather more useful to see Plains Indian typologies of clubs and associations as part of a continuum in which spiritual, political and social aspects interlock in a multiplicity of ways through a notion of power that simply eludes a straightforward application of terms such as social or religious.

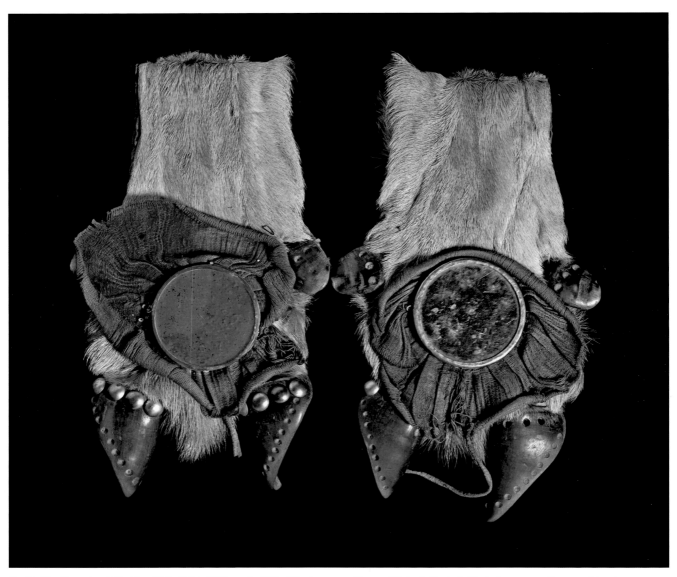

Fig. 50 *Elk-skin armband, Blackfoot (Kainai), late 1800s–early 1900s. Silk, glass, deer hoof, cotton and brass, L 21 cm, W 12 cm (Am1903,-.56.a–b).* The combination of elk skin and mirror on these objects may refer to the widespread Plains Indian belief that elks possessed love medicine. Among Siouan speakers, such as the Sioux Lakota, there was a society of people who dreamt of elks and therefore could benefit from the animal's power.

Typically, warrior societies share with other types of associations characteristic origin narratives that are widespread across the Plains and the Midwest. Native traditions attribute the birth of particular societies to culture heroes who established the rituals, ceremonies and dances among their people in the deep past. However, customary knowledge also indicates that societies and clubs often were instituted as a result of individual dreams. Among Plains Indians, people who dreamt of the same animal or natural phenomena grouped together to form a distinct club (Fig. 50). That societies of warriors should follow a similar pattern would not be surprising, although, over time, access to particular societies was not necessarily legitimized by dreams. By and large, the institution of new dances and the acquisition of supernatural power and medicine were spiritually sanctioned, and it is not unusual to read in the ethnographic

literature that new associations are frequently said to have originated from the encounters of individuals with talking animals and other creatures. This common pattern may have been the basis upon which warrior societies developed over time. Anthropologist Robert Lowie, for example, reports that the Crow tribe's Kit-Fox society was initiated by a man who dreamt of foxes that gave him special fox songs (Lowie 1913b). Similar stories are found among Mandan, Hidatsa, Sioux and several other groups with reference to other societies and clubs. In some cases animals would instruct particular individuals to use part of their fur or feathers in a special way. The dreamer's responsibility and moral obligation was then to institute a club in honour of these animals or any other being they dreamt of, so that incoming members of the newly established society could benefit from their teachings, powers and medicines. Whether instructing through spontaneous

dreams, direct encounters with supernatural beings or during vision quests, the non-human patrons of warrior societies would clearly tell humans how to manage their medicine in ritually appropriate ways. This would establish the norms, taboos and responsibilities required from each of the members, as well as, very frequently, the structure of the association.

The structure, complexity and function of warrior societies changed greatly according to tribal tradition. Every tribe had a set of warrior societies that differed with regard to the age of participants and the degree to which ceremonial, political and social roles intersected. Generally, however, societies always included singers, drummers and various ritual specialists, with helpers whose responsibilities were diversified according to their position within the club. The common basic formation of prominent warrior societies included leaders, drum keepers, whip bearers, pipe keepers, scouts, lance bearers, food helpers and, not infrequently, female singers and other ceremonial assistants.

While individual warriors were encouraged to excel in their bravery, camaraderie and mutual aid were expected among members of the same society. Normally, the reciprocal help established between comrades during war raids and battles resulted in special bonds of friendship between two members that lasted their whole life. These bonds were formally recognized and guaranteed that no member

of the society would ever be left without aid under any circumstances. Helping one's comrade meant rescuing him in battle, but also looking after each other during times of hardship. This often resulted in mutual economic security for both comrades (Fig. 51).

Warrior societies of the nineteenth century could either be age-graded or not. Male age-graded societies existed for the three Blackfoot divisions (Siksika, Piikani, Kainai), Arikara, Mandan, Arapaho, Gros Ventre and Hidatsa. Boys as old as fifteen would be encouraged to belong to the lower grades of men's societies, such as the Doves and Mosquitoes among the Blackfoot, or the Rabbits among the Kiowa. In some cases, for example among the Cheyenne, young men generally joined their father's society. As they gained more experience they would then be allowed access to the higher ranks, following a prescribed path of social mobility that depended upon wealth and the status derived from performing praiseworthy deeds in combat. As young men proceeded to become junior combatants, then experienced warriors, and finally prominent leaders, their reputation increased, as did their responsibilities and obligations towards their peers, seniors and the whole tribe. Belonging to the most exclusive warrior clubs resulted in reaching the highest level of social status. This also meant upholding the moral standards considered desirable for honourable men which distinguished them from the rest of

Fig. 51 *Ledger drawing by Good Bear, Sioux (Oglala Lakota), 1874. Pencil or crayon on paper, H 13.8, W 21.5 cm (Am2006,Drg.17).* The scene depicted here by Good Bear may refer to the rescue of a comrade during combat. The lucky pair presumably managed to escape the rain of bullets shown flying around them. Mutual obligation between society comrades lasted a lifetime.

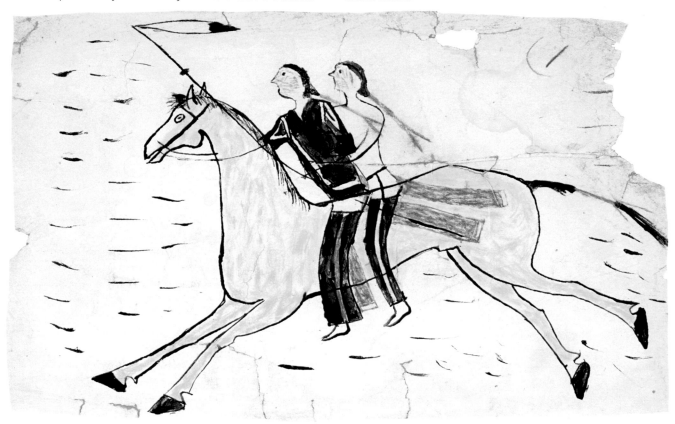

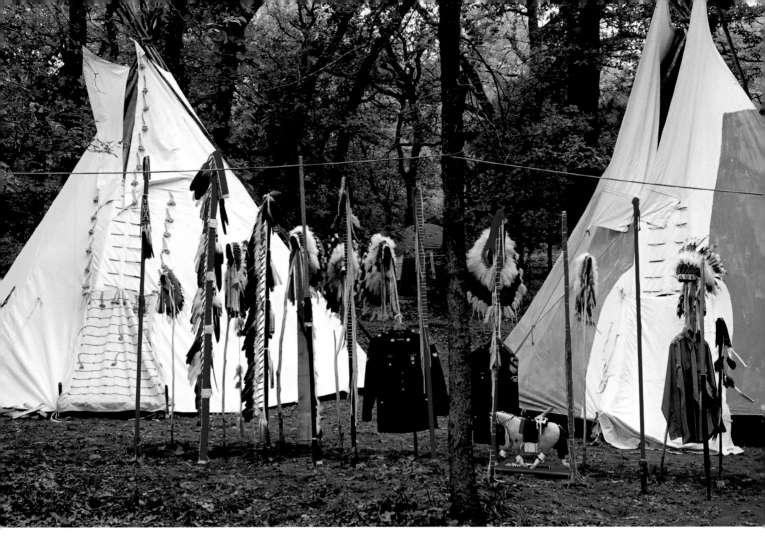

Fig. 52 *Tipis pitched at the Anadarko ceremonial grounds during the yearly celebrations in honour of veterans held by the Kiowa Black Leggings. Photograph by Ian Taylor, 2009.*

Warrior insignia are visibly displayed alongside military uniforms and war headdresses.

the tribe. Social consensus was paramount with regard to decisions about the recruitment of potential new members. Novices had to earn the right and privilege to belong to a men's club. While some societies required a price of admission, having the right price did not guarantee automatic entry into the circle of the selected few. Performing admirable deeds was crucial in securing entry to the most exclusive warrior clubs, societies and dance associations, but what constituted an honourable deed varied greatly between societies. Each had a highly codified set of rules and requirements for membership.

Like items, ideas and technologies that travelled across the Plains, societies were borrowed, sold and bought, either completely or partially, between groups. At times, dances or songs belonging to a particular society were imported; in some cases, headdresses and other types of regalia would inspire locally elaborated versions of distant originals. This explains why there are several versions of similar societies in different parts of the Plains. The Kit-Fox society, for example, was one of the most widespread. It was found among twelve distinct language groups. The Dog Soldiers were equally prevalent, and so were the Crazy Dogs and the Bull society.

Each society adopted distinct features to mark its character and identity and used different accoutrements or variations of the same objects to do so. The most important items used to indicate society membership were lances, staffs, headdresses, belts, sashes, rattles, quirts and whips. Shapes and forms were standard, with different materials and colours to distinguish them from those of equivalent societies of other tribes. Each material, colour and shape had significant associations with other-than-human patrons, such as animals or thunder beings, which reflected a deep concern with spiritual protection and supernatural assistance.

Societies and warrior regalia

Evidence for the existence of warrior societies before the historic period can be seen in early pictographic depictions made in proto-historic times by groups that inhabited the northern Plains before AD 1700. Sites such as Bear Gulch in the United States and Writing on Stone in Canada, among many others, testify to the prior use of some of the weapons and insignia later found among historic warrior societies. In these depictions, one can appreciate frequently recurring iconographic markers that indicate warriors' functions as scouts, party leaders, combatants or sentinels. Wolves, universally considered to be animals that can see everything with their sharp sight, were associated with scouting; many depictions of warriors wearing wolf-skin hats are found in

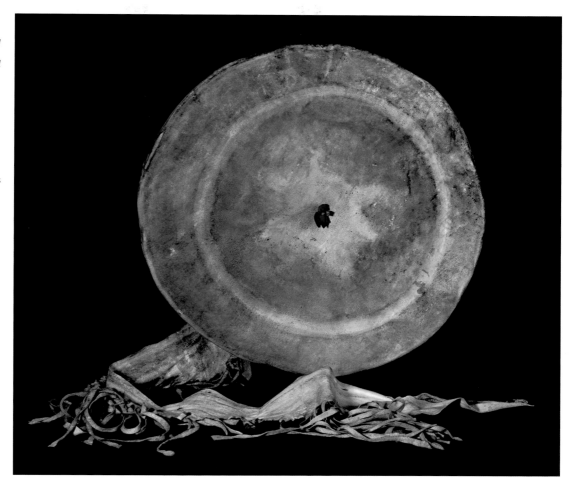

Fig. 53 *Painted shield with turtle image and medicine bundle hanging from the centre, Sioux, early 1800s. Skin, natural pigments, cotton, undisclosed protective materials, D 57 cm, L 110 cm (Am2003,19.7).* Shields and other weapons lost their efficacy should they not have spiritual sanction. Often protective designs were placed on the back of shields and the inner part of bonnets to be closer to the wearer.

the rock art at such sites (Keyser 2007). Given that many warrior functions, such as scout, sentinel and staff bearer, were characterized by the use of specific items including headdresses or banners, it has been possible to identify in rock art the predecessors of these historic items. Ethnographic sources from the nineteenth and early twentieth century, for example, systematically recorded the shape, colour and materials of banners used by distinctive warrior societies among all Plains tribes (Wissler 1912–16). Detailed analyses of some of these banners in rock art indicate that the presence of particular shapes of feathers could refer to early examples of a system of ranking war deeds that matches later descriptions given by warriors to ethnographers and other Euro-American commentators. Historic tribes had a very elaborate system for ranking war deeds that used feathers as markers for particular accomplishments. The shape, distinctive trim or split of the feathers might denote grades of recognition associated with different levels of accomplishment. These subtle variations were conveyed by the use of particular flags and banners shared by men of the same society (Fossati *et al.* 2010). The use of the crooked staff of these earlier times has been retained as the traditional banner for a number of warrior societies that even today parade it in honour of veterans and in celebratory victory dances (Fig. 52).

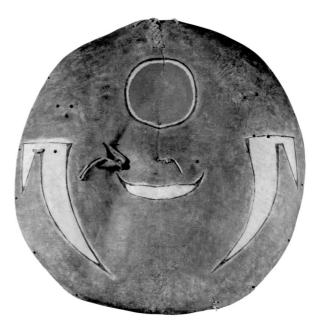

Fig. 54 *Shield, Pawnee, early 1800s. Leather and natural pigments, D 58 cm (Am.5202.a Donated by Sir Augustus Wollaston Franks).*

Whereas in rock art positive attribution of specific banners to particular societies can be complicated due to difficulties in determining the type of feathers used on flags and staffs,

a clearer picture emerges from the study of shield motifs that further links historic examples to old traditions. Some of the earliest depictions in rock art show warriors on foot bearing large decorated shields on which one can discern the outlines of protective designs, medicine bundles, feathers and other items that clearly prove historical continuity with later similarly decorated specimens (Fig. 53). Shield designs were not associated with either particular grades or distinctive societies. In fact, they were highly personal objects that each warrior decorated with unique items derived from his intimate encounters with other-than-human beings.

Shields produced throughout the historic period may also include designs of battle scenes or episodes that marked the owner as a valiant warrior. An example of this type of decoration can be seen on the cover of a shield probably made around 1820 by a Pawnee warrior that is part of the Duke Paul Wilhelm collection at the British Museum. The shield's round buckskin covering shows a series of warriors engaged in one-to-one combat drawn in the conventional Plains pictographic style derived from earlier rock art (see Figs 35 and 103). The geometric figures stand in stark contrast to the realistic rendition of battles. The imagery also shows a crescent and a circle flanked by two horn-like appendages that are difficult to interpret. Surely these bold designs may refer to personal esoteric meanings attributed by the owner to personal protective powers. Despite difficulties in interpreting individual designs, a comparison with shield motifs found in the rock art of South Dakota's Black Hills suggests that it may depict buffalo horns (Sundstrom 2004: pp. 112–13) (Fig. 54).

Although one can detect differences in the variety of designs found on shields, there is a certain degree of regularity in the occurrence of distinctive designs or figures that denote the importance of particular animals and beings for war activities. Some of the most common animals found on war shields are bears, wolves, buffaloes and hawks. Animal powers were invoked or transferred to people and objects by wearing items made with the skins, pelts, feathers and claws of the animals concerned. Headdresses, sashes, belts and ponchos made of animal parts were believed to transmit to the warrior who wore them their inherent qualities. These were inferred by a chain of associations between their colours, behaviour and the role they played in oral histories, myths and stories. Feathers, claws and other body parts signified particular ideas that were implicit in these associations. Owl feathers, for example, were generally associated with death and ghosts. They were regularly used by members of several Plains societies for headdresses as well as decorations for war insignia and shields. Ermines and weasels, equally important as animal harbingers of death, were employed because of their cunning and swiftness in attacking their opponents. Their skins were used extensively by northern Plains peoples such as the Blackfoot in warrior society regalia, most crucially as headdresses and as decorations of ceremonial shirts that required this animal's widely recognized fighting abilities. Among the Omaha the same animal signified alertness and skill in evading pursuit (Figs 55, 56, 57). Swallows, for the

same tribe, were associated with the arrival of the thunder gods, hawks with destruction caused by storms, and crows with the devastating forces of war beings.

Thunder and thunder beings are commonly found in the decorated items of warrior societies. They appear as birds such as eagles or hawks that have been linked with the distinctive features of this natural element since precolonial times. Thunder beings and their powers as manifested through lightning were particularly invoked by decorating a variety of items with zig-zag and wavy lines. In addition to lightning, the zig-zag motif or a wavy line was conventionally understood as the life force or power emanating from animals, human beings and any number of things. Characteristically, personal names attributed to individuals drawn in ledgers display this convention, signifying an established connection between

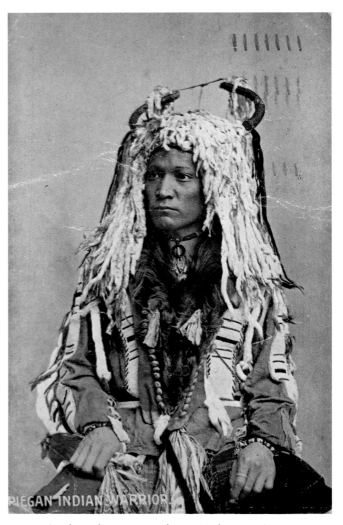

Fig. 55 *Piikani (Piegan) Warrior Acustie (Many Diving), wearing the ermine headdress of the Brave Dogs society of the Blackfoot, photograph by Frederick Steele, c. 1895. Colour postcard, H 14 cm, W 9 cm (Am,B41.20).*

Fig. 56 *Headdress belonging to the Brave Dogs society (Blackfoot), 1887. Textile, skin, metal, horn, glass, fur and feather, L 64 cm, W 20 cm (Am1887,1208.6). Ribbons, metal studs and red cloth enhanced the visual impact of such powerful items.*

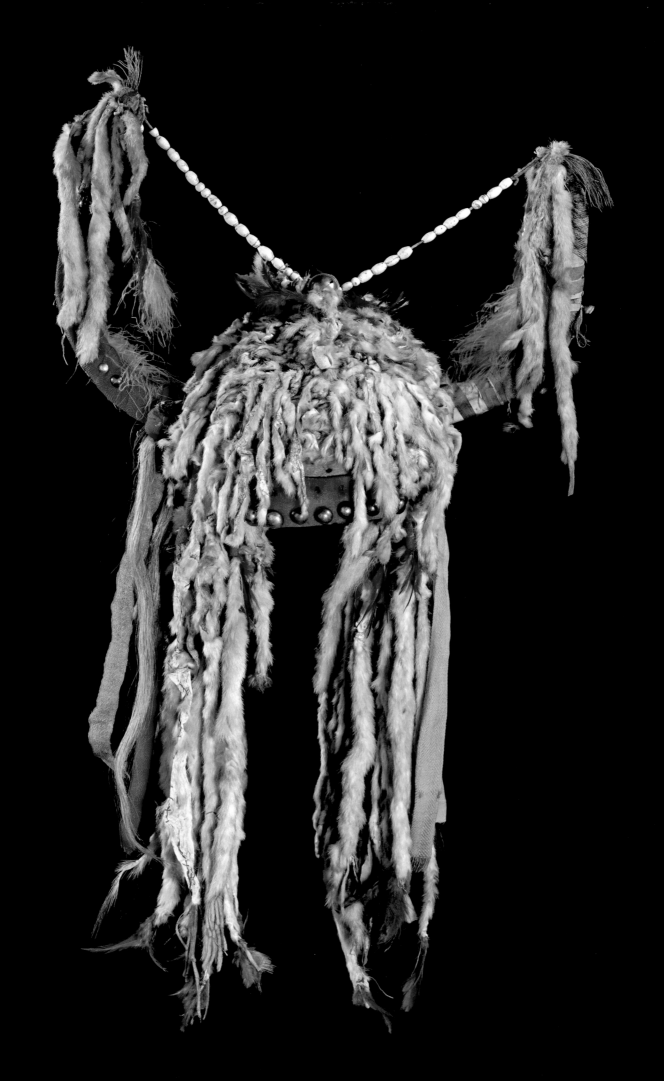

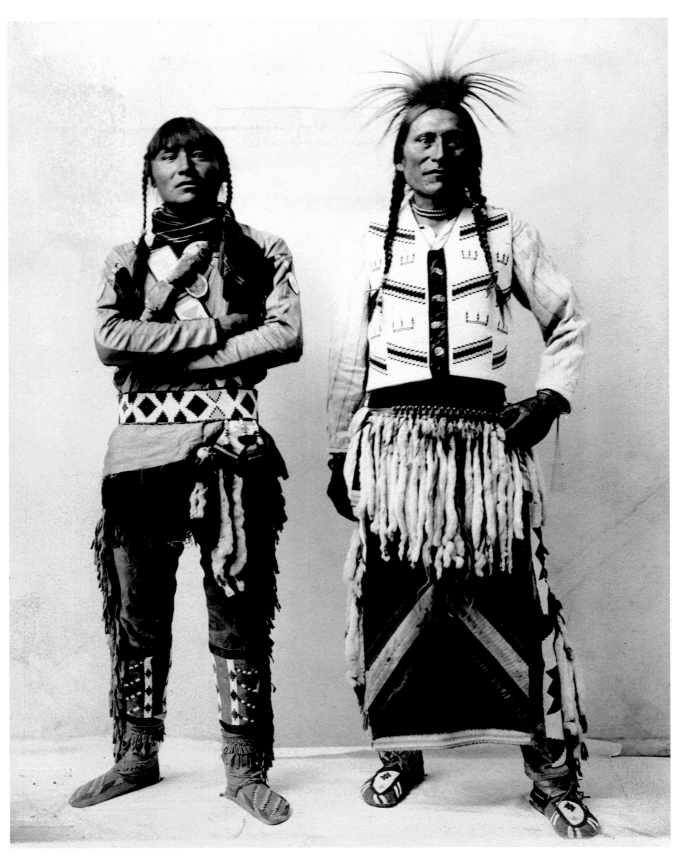

Fig. 57 *Studio photograph by Geraldine Moodie, Canada, mid–late 1800s. Albumen print, H 22.5, W 17.4 cm (Am,B42.8 Donated by Geraldine Moodie).* These Assiniboine men wear weasel tails on their belts. The central part of the animal's skin that ended with the black tipped tail was cut to produce a tubular tassel that decorated items of great prestige.

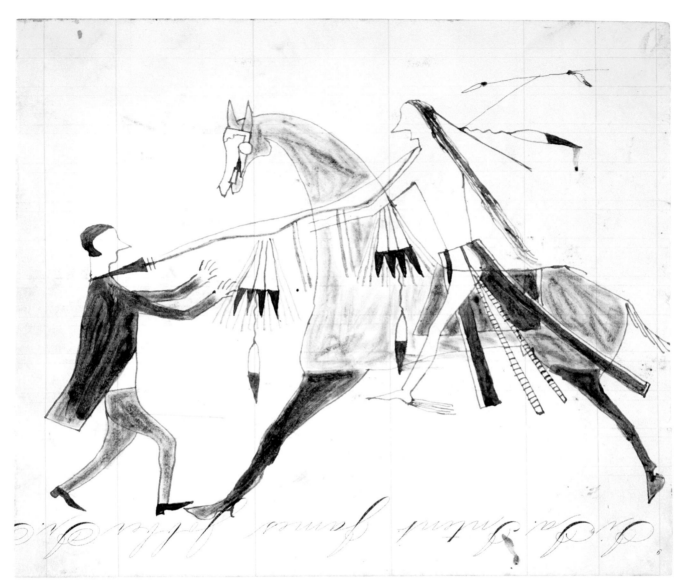

Fig. 58 *Ledger drawing by Tall Bear, Sioux (Oglala Lakota), 1874. Pencil or crayon on paper, H 17.5, W 21 cm (Am2006,Drg.13).*

A warrior, identified by the name Lance, is shown counting coup with a bow-spear on a white man. As a rule bow spears were not used to kill.

the person and the powers contained in his name. Jagged or wavy lines can also be found decorating arrow shafts and bone whistles as well as shields and shirts, but were most dramatically materialized in the use of a special type of bow lance and ceremonial whips and quirts (see Figs 62 and 105).

Bow lances, alternatively called 'thunder bows', consistently appear in Plains Indian visual representations. Rock art, pictographic art and ledger art show the use of this weapon or insignia by warriors of different societies since prehistory (Keyser 2008a). In historic times this item was distinctive of the Kit-Fox society among the Hidatsa, Arikara, Sioux Oglala and Cheyenne (Lowie 1916: p. 907), although other societies included this weapon among their prized, sacred and protective insignia: for example, the Lumpwood and Half-Shaved Heads of the Hidatsa (Lowie 1913a: pp. 263, 273), the Crazy Horse of the Arikara (Lowie

1915b: p. 670), and possibly the Assiniboine (Lowie 1909: 28). Several depictions of thunder bow owners appear in the British Museum Plains Indian collections (Fig. 58). The use of thunder bow spears among the Dakota is probably very old, given the recorded evidence of thunder-related themes in the warrior expressive culture of Siouan-speaking peoples such as the Omaha, Ponca and Kansa, descendants from precolonial Mississippian chiefdoms (Wooley and Horse Capture 1993). Significantly, Dakota bow spear bearers wore robes with designs representing spider webs whose shape is closely reminiscent of the hourglass motif developed by woodlands tribes to represent the thunder beings. In historic Dakota thought and iconography, spider and thunder were closely related and their iconographic renditions were systematically used to ensure protection (Wissler 1907). Among the Algic-speaking Cheyenne especially, bow lance bearers were a

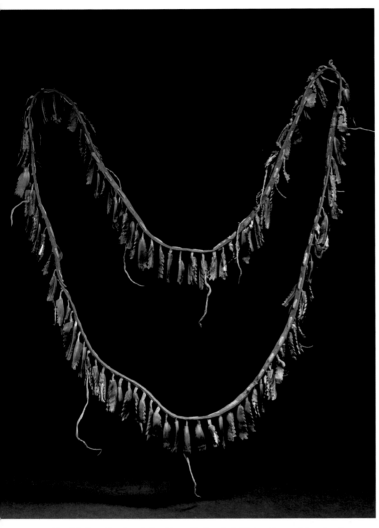

Fig. 59 *Dewclaw bandolier, Sioux (Dakota), 1889. Leather and deer hoof, D 50 cm (Am,+.4645 Donated by Sir Augustus Wollaston Franks).* Dewclaw bandoliers of this kind were used by the Sioux as baldrics or necklaces. Such objects were frequently smeared with red or yellow pigment for additional protection.

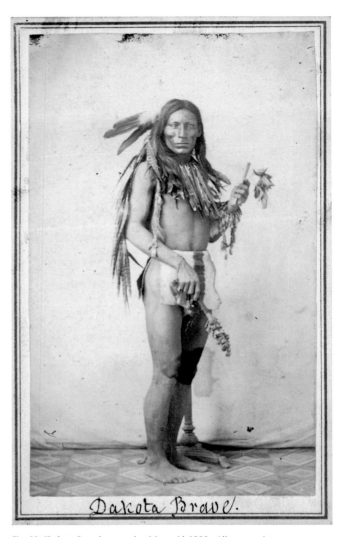

Fig. 60 *'Dakota Brave', carte-de-visite, mid-1800s. Albumen print, H 8.7 cm, W 5.7 cm (Am,B35.33).* This mid-nineteenth-century photograph of a Sioux man in ceremonial regalia may represent a member of the *Miwatani* society attired for ceremony. The deer hoof rattles he is holding were the distinctive badge of the society.

unique feature of the contraries, a class of people who had a particular relationship with thunder. The bow spears of Cheyenne contraries were believed to have been brought to the tribe by Sweet Medicine, the tribal hero and mystic prophet who established the nation's most sacred rites. Much in the same way as among the Dakota, this association testifies to the antiquity of a weapon that may have originated before the tribe's migration from Minnesota's woodlands on to the Plains prior to the 1680s.

Thunder beings were so prevalent in war-related activities that references to them, both realistically rendered and esoterically conveyed via geometric designs, are ubiquitous. Warriors, for example, invoked thunder beings and their protection by way of rattles, and in particular, dewclaw-decorated items such as sashes (Fig. 59). More specifically, dewclaw rattles were used by societies such as the Dog society of the Gros Ventre, the Dog Men of the Arapaho, the Mandan

Dog Soldiers and the Dakota Tall Ones (*Miwatani*), one of the tribe's most exclusive clubs for accomplished warriors (Fig. 60). A man wearing the characteristic sash is depicted carrying one such rattle in a battle scene represented on a robe in the British Museum (Fig. 61). Interestingly, these rattles present similarities to objects used by woodlands peoples in ceremonies in which thunder beings feature prominently. Woodlands thunder rattles were made by hanging deer hoofs from notched sticks whose wavy or zig-zag lines and shapes traditionally represented thunder beings by means of their power (lightning). A similarly carved object was universally included among warrior societies' distinctive insignias: the whip. Whips and quirts were commonly used across the Plains by special whip bearers in rituals and dance festivals to usher dancers in to take part in the celebrations, but occasionally they could be carried to battle. They almost exclusively display one notched side, or were distinctively cut in the characteristic

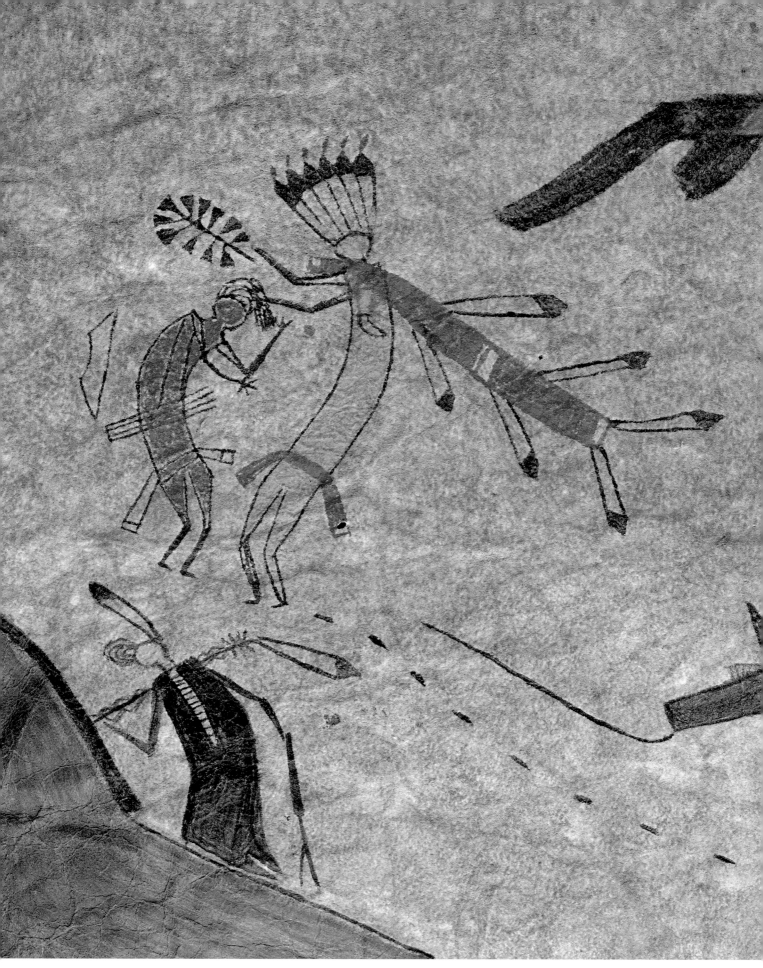

Fig. 61 *Detail of painted robe, see Fig. 99.*
In this detail of a painted robe a warrior identified as belonging to the *Miwatani* society of the Sioux is wearing the red no-retreat sash while brandishing a dewclaw rattle.

Fig. 62 *Dance quirt, Blackfoot (Kainai), late 1800s–early 1900s. Wood, feathers, natural pigments, cotton thread, brass and glass, L 105 cm, W 50 cm (Am1903,-.102).* This Blackfoot dance quirt is associated with the leader Little Shield. It is decorated with images of men and horses in vibrant colours. It has a fur handle, feathers, and is tipped with a whip.

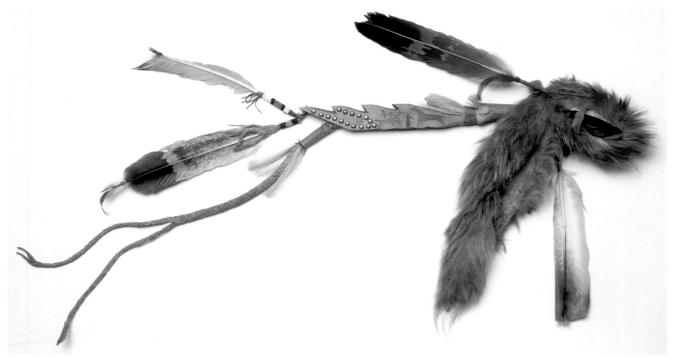

zig-zag lightning pattern such as the Blackfoot dance whip now in the British Museum collections (Fig. 62). Among the Comanche, similar items were a badge of prestige for accomplished warriors who carried into battle their precious 'big whips' in which converged war honours and medicine power (Kavanagh 1996: p. 31).

Feather headdresses were undeniably warrior societies' most impressive and recognizable items. The crown of feathers is a typical symbol of male valour and potency which probably originated among eastern tribes. It encodes a series of symbolic messages conveyed by the metaphorical and connotative aspects of shapes and materials used in its construction. The very arrangement of individual feathers around a circular band replicates the sun with its energy-bestowing rays, a powerful emblem of masculine generative potential and strength. Not coincidentally, in more recent years feathered circular bustles were elected as warriors' preferred dance outfits in substitution for the more rare feather headdresses traditionally bestowed only upon selected successful warriors (see Figs 141 and 142). Each warrior society developed its own idiosyncratic variation of the feather bonnet. Blackfoot and their intermontane neighbours such as the Nez Perce, generally not mentioned among Plains peoples, adopted the straight-up bonnet, a tall cylinder of feathers pointing upwards mounted on a strip that fitted like a crown (Fig. 63). Variations on the crown theme were developed by other tribes in a multiplicity of guises. The most common was the loose crown, purposefully made to enhance the weaving motion of horse-hair tipped feathers in the wind. The Sioux are credited for having introduced this type of headdress to other northern Plains tribes, but the origins are uncertain. Comanche, Arapaho, Cheyenne, Kiowa and southern Plains tribes used this type of headdress too (Fig. 64). Some military societies adopted a feather headdress with trailing rows of feathers. Warrior society headdresses could be decorated with horns and ermine tails fixed at the sides of the temples, or were distinctly arranged in fringed layers cascading from the top of the skull. Horned headdresses were common among many tribes. A version of this was typical of the Dakota *Cante Tinza* warrior society, also known as the Brave Hearts. A warrior wearing one such headdress is depicted in the ledger drawings made by Tall Bear in 1874, now in the British

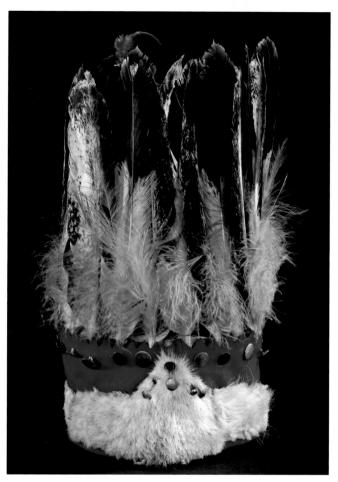

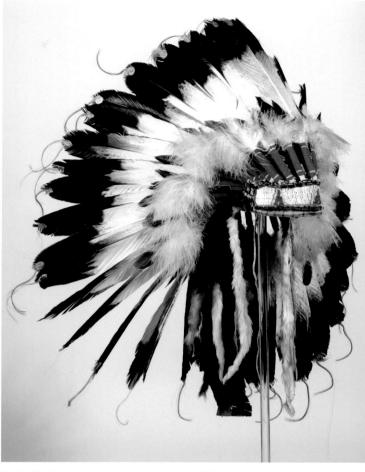

Fig. 63 *Straight up headdress (Blackfoot), mid–late 1800s. Eagle feather, hair, glass, fur, cotton and brass, H 46 cm, D 23 cm (Am1887,1208.7).*

Fig. 64 *Headdress that once belonged to Yellow Calf (Arapaho), early 1900s. Feathers, horse hair, glass, skin and cotton, H 75 cm (Am1939,22.1 Donated by Gregory M. Matthews).*

Museum (Fig. 65). Contrary to popular belief, war bonnets of this type were only occasionally worn by prominent warriors, who normally wore very simple clothes. Diplomatic and ceremonial occasions and warrior society meetings were the contexts in which sacred regalia such as feather headdresses were worn (Fig. 66). Feather headdresses and other special items were only appropriate for those occasions when public recognition of the warrior's achievements resulted in social standing and wealth in the form of horses and other valuables. The prestige and honour of warriors were publicly sanctioned during these collective events, which simultaneously offered an opportunity to establish social bonds and co-operation among tribal members while re-enforcing ethnic identity via the seductive intensity of seasonal ceremonies and rituals that marked the yearly calendar.

Warriors, dances, rituals and ceremonies

Every aspect of Plains Indian life has historically been marked by dancing and singing. Today these activities still constitute a prominent aspect of Plains peoples' ceremonial and ritual life, just as they did when warrior societies were active. Since early contact, European eyewitnesses have reported with excitement the sight of warriors dancing in preparation for war or after their return from a war raid.

However, these were not the only occasions at which warriors danced. Warriors generally danced along with their society comrades in communal festivities and celebrations. Warrior societies held dances for the appointment of new members, simple amusement, transfer of rights, or to mark a particular event. Each occasion was characterized by specific types of dances and rituals. Some warrior societies held regular social meetings that included dancing and singing primarily for the enjoyment of their members. Even in secular activities such as social dances, strict ceremonial procedures were followed. The positions taken by society members around the dance arena or in the ceremonial lodge were conventionally determined by their position in the society ranks. All society members were required to attend these private meetings. Should they not participate, they might incur sanctions, such as tearing their tipi and clothes, or receiving a severe public humiliation by the society whipman.

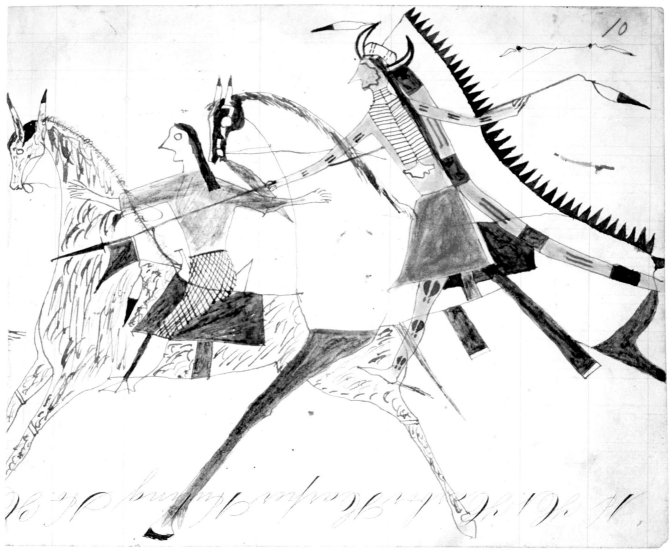

Fig. 65 *Ledger drawing by Tall Bear, Sioux (Oglala Lakota), 1874. Pencil or crayon on paper, H 17.5 cm, W 21 cm (Am2006,Drg.15).*

This man is wearing a split horn headdress of the Dog Soldiers. The scene represents Lance, a prominent warrior of this society, counting coup on a riding woman.

Many warrior societies of the nineteenth century were linked in various ways to larger tribal ceremonials that structured religious life both practically and symbolically. Religious symbols and imagery derived from the natural world, such as animals, lightning or wind, frequently emphasized martial aspects. Equally, the same symbols were used in warrior societies' regalia to ensure guidance and supernatural sanction. This mutually informing co-dependence underpinned the general notion that rituals offered protection to the tribe as much as warriors did. This concept is at the very core of Plains Indian thinking and it is still referred to by contemporary Plains Indian soldiers in relation to their involvement in the military. Such interdependence between religion and war can be seen in virtually all major tribal ceremonies and in the individual rituals and motions that characterize liturgies and conventional ritual performances.

Ethno-historical sources reveal that warrior dances and rituals were associated with tribal Sun Dances, Calumet Dances and bundle ceremonies, a fact that testifies to the direct link between warrior societies and larger tribal religious complexes rooted in past warfare ideologies. The success of Cheyenne warriors, for example, was dependent on the periodic renewal of their sacred arrows every time blood was spilled in the tribe (Powell 1969: p. 45). War themes also underpinned many of the performances and rituals associated with seasonal ceremonies that renewed tribal strength and prosperity among other Plains groups. Because community well-being depended as much on the protection provided by warriors as on their hunting skills, even the most important tribal effigies, bundles and religious items reflected an intimate relationship between religion, community identity and warrior ethos. Materials and symbolism used in religious rituals called upon spiritual forces and simultaneously employed warriors' very actions

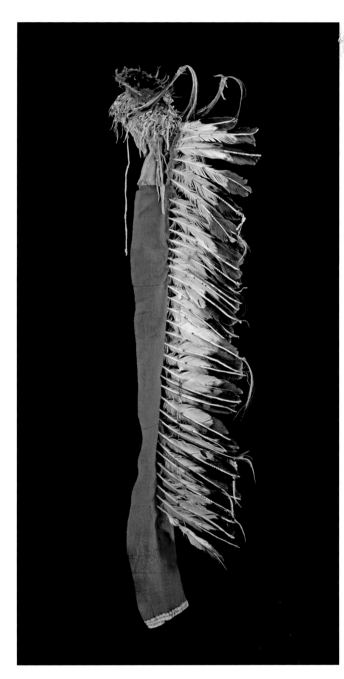

and behaviour. Rituals devised for the correct handling of important religious items were replete with martial symbolism and were often directed by prominent warriors, who had the privilege and duty of correctly co-ordinating the activities that ensured the proper conduct of ceremonies. Among many Plains tribes, warriors engaged to cut the central pole of the Sun Dance treated it as a fallen enemy on which they counted coup. Among the Omaha the Sacred Pole, symbol of tribal unity and religious integration, was intentionally made to resemble a man complete with hair scalp and a bowstring shield, indicating the simultaneous role as protector and provider (Ridington and Hastings 1997). Significantly, this effigy was called 'that which has the power to bestow honour and distinction', attributes of both a morally irreprehensible person and a valiant warrior (Fletcher and La Flesche 1911: p. 225).

Interestingly, among several tribes, warrior society dances and ceremonies were staged at the time of large tribal reunions. Although warrior societies' dances were not always part of the large complexes such as the Sun Dance or similarly important tribal ceremonies, the participation of warrior society members in the preparation and liturgy of some phases of these events was mandatory, due to the powers associated with the materials handled in their rituals. Again among the Cheyenne, Kit-Fox society members were the special guardians of the sacred tribal arrows. Members of this society had to preside over their periodic renewal because these items were traditionally kept in a kit-fox skin quiver (Powell 1969: p. 518, n. 2).

Religious meanings attributed to the dances and ceremonies of warrior societies may have been frequently over-emphasized by some anthropologists; nevertheless, even occasions on which warrior societies performed dances for social reasons retained some implicit connection to animal

Fig. 66 *Headdress, Plains peoples, early 1800s. Horn, feathers, wool, leather and porcupine quill, H 193 cm (Am.7478 Donated by Henry Christy).*
Split horn feather bonnets were used by many warrior societies with local variations on a similar theme.

Fig. 67 *Society dance belt (Blackfoot), late 1800s. Fur, feathers and hide, L 97 cm, W 23 cm (Am1903, -.95).*

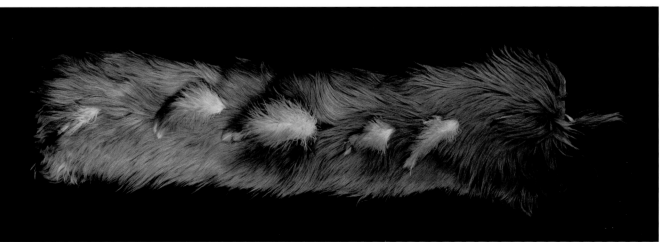

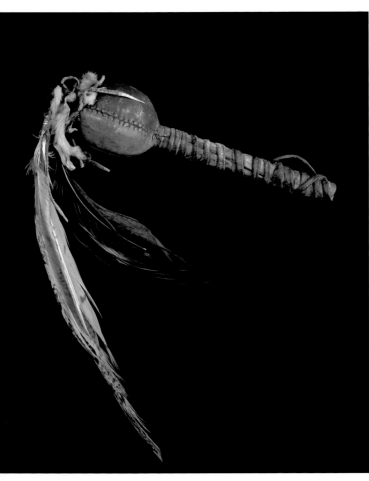

protectors, spiritual sponsors, heroes and guides that presided over society activities. Because all warrior societies originated in dreams or in the actions of culture heroes, their rituals and ceremonies had various degrees of association with spiritual meanings that required ritual and ceremonial procedures in the handling of their accoutrements and regalia. Over the centuries, some of these religious meanings may have been lost or downplayed in favour of social aspects, which became increasingly prominent as warrior societies declined. In particular, after the establishment of reserves and reservations in the early twentieth century, the death of leaders and keepers meant that much of the knowledge about warrior society items was irretrievably lost, although among some tribes, society items such as some dance bustles still today retain a quasi-religious character (Meadows 2010: pp. 293–6).

Among historical Plains tribes each society had dances and songs that accompanied the use of special accoutrements. Although differences between a society's items might be minimal, they were nonetheless significant. Among the Blackfoot, for example, a dog or a bear fur belt could signify belonging to either the lower or higher ranks of the Pigeons society (Fig. 67). Rattles or drums, usually of the same shape, differed in the colours used to decorate them and the feathers and other appendages attached to them; juxtaposed with one another, these elements constituted a complex convergence of meanings. For example, small hide hand rattles associated with Blackfoot warrior societies were used only to accompany special dances and could be handled only by selected members during the various phases of ceremonies related to society

Fig. 68 *Rattle, Blackfoot (Kainai), late 1800s. Leather, wood, seeds, fur and feathers, L 36 cm, W 10 cm, H 4 cm (Am1903,-.101).*

Fig. 69 *Drum with Thunderbird (Plains Cree (?), late 1800s. Skin stretched on a wooden hoop-like frame, D 28 cm (Am1949,22.145).*
Drums with sacred images were often used in both personal and public ceremonies. Ritual specialists and healers would paint meaningful designs on their healing drums. This one is associated with the Ghost Dance popular among Plains peoples in the latter part of the nineteenth century.

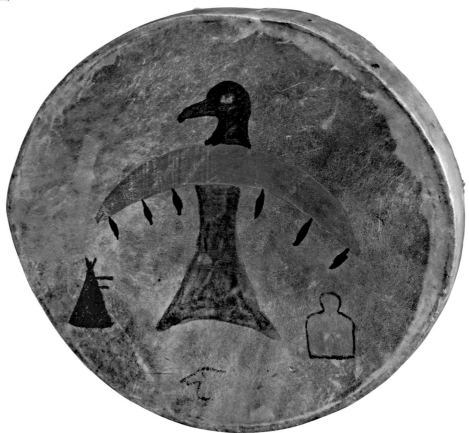

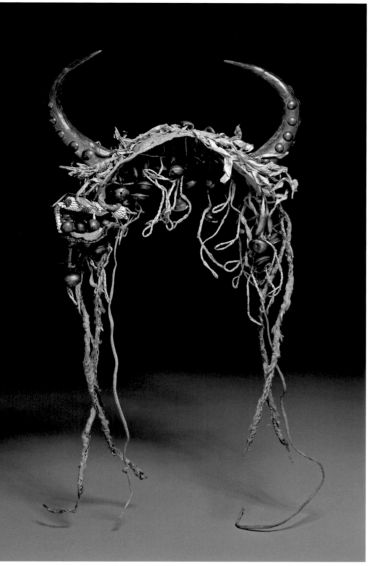

Fig. 70 *Headdress of the All-Brave-Dogs society of the Blackfoot, late 1800s. Skin, brass, hooves, horn, glass and textile, W 20 cm (Am1900,-.243 Donated by Rev Selwyn C Freer).*
Other specimens of this kind of headdress are known with longer tails.

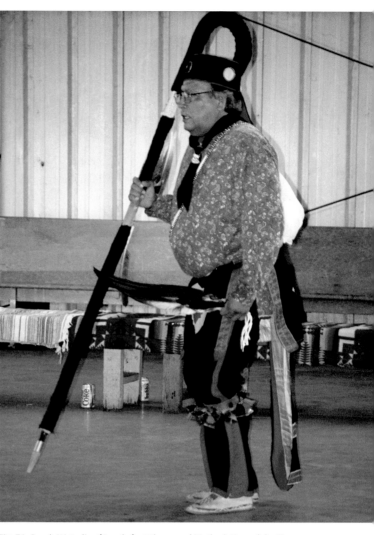

Fig. 71 *Boody Wetseline (Apache), at the annual Mother's Day celebration of the American War Mothers Kiowa Chapter 18, at the Kiowa Tribal Complex in Carnegie, Oklahoma. Photography by Milton Paddlety, Kiowa, 1990s (Am,Paddlety,F.N.2058 Donated by Milton Paddlety).*
Otter-tail headgear is used among many tribes of the eastern Plains. The typology with the long trail has been identified in ancient rock art and is associated with the Osage. The trailing tail of this headdress is often decorated with a warrior's insignia, which dangle from the wearer's back.

activities. The All-Brave Dogs society of the Blackfoot had in its kit twenty-five rattles of round and doughnut shape, two of warrior societies' most common variants (Wissler 1913: p. 387) (Fig. 68).

Similarly, hand drums that belonged to individual bundles could only be played by the official society drummers (Fig. 69). Some of these drums featured special figures associated with animals or beings that protected the society, such as the bird representing the voice of thunder painted on the Kiowa Ohoma society drums from the late nineteenth century (Harris 1989: p. 80). Larger drums that accompanied community dances are said to have been imported from eastern woodlands Algonquian tribes, where such drums were extensively used in medicine society rituals, for example in the Potawatomi's Dream Dance (Wissler 1916).

Headgear was as important an element of warrior societies' dances and ceremonies as bundle-related items such as drums, rattles, shirts and feather headdresses (Fig. 70). Pre-Columbian depictions of warrior dances carved on shell excavated in the regions east of the Great Plains show the extensive use of headgear, typically associated with particular classes of warriors. For instance, otter-skin trails, headbands and turbans were used by most Midwestern tribes such as the Osage, Otoe and Iowa. On these trails, hanging from the back of a circular headband tightly fitting the wearer's head, were displayed war honours represented by bird scalps, bills, feathers and shells. These highly regarded headdresses were only used on ceremonial occasions by prominent warriors who acted as priests in religious rituals of these tribes. The use of these items still

remains largely limited to southern Plains tribes, where they have become emblematic of the so-called 'Southern style' dancers participating in powwows (Fig. 71). Mandan Dog society dancers had a very distinctive and impressive headdress constituted by an elaborate, fully feathered cap that covered the whole skull. Such a headdress was used when dancing with the common 'no-retreat' sash denoting the highest ranks of warrior societies' bravest men. Distinguished warriors wore a sash over one or both shoulders in battle to signal that they could only move from their position after all their comrades had withdrawn. Interestingly, the bone whistle used during Dog society dances resembles the eagle bone whistles ritually blown by dancers during the Sun Dance.

The hair ornament known among Siouan-speakers as *wapehnaga* was popular among Plains Indian warriors. It is generally constituted of hide strips of variable length wrapped in quillwork with feather and horse-hair tails (Fig. 72). It seems to have originated among the Missouri River tribes. It was used in the dances of the Half-Shaved Heads society of the Mandan, for instance, and was later adopted by other northern and central Plains tribes. Its use was also reported among the Cheyenne and the Arapaho who, at the time Kroeber collected his data, no longer employed it as a required item in warrior society dances. Whether or not this ornament had originally been used by the Arapaho as part of a warrior society kit is not clear, but the very fact that Kroeber reports that it was used on occasions when warrior regalia were not prescribed shows that items otherwise considered warrior societies' special accoutrements were sometimes integrated into tribal traditions, with new purposes that resulted in historical changes affecting many warrior societies' dance-related items (Kroeber 1902–7: p. 52). Although changes inevitably occurred over time, some continuity with past ideologies may have been retained in the symbolism embedded in some of these objects (see pp. 80–1) The specimen in the British Museum is of particular interest in this respect because the materials used in it suggest intriguing connections with old cosmologies. The upright feathers decorating the top part of the ornament are fixed at the base with a round shell button on which a rattlesnake's rattle is attached. While feathers are often the central element of this type of object, the other materials are not. The presence of sky (birds' feathers), water (shell) and earth (rattlesnake's rattle) on this *wapehnaga* must have had a particular significance for the owner. What is more, this particular combination of elements prompts a direct comparison with the three-tiered cosmos that ordered Mississippians' universe and was frequently represented by the juxtaposition of abstract rattlesnakes and water beings on shell ornaments used by elite warriors (Fig. 73).

Fig. 72 Right and detail oppostite top: *Wapehnaga (Sioux), early–mid-1800s. Skin, porcupine quills, abalone shell, rattlesnake rattle, feathers and horse hair, L 12 cm (Am1944,02.247 Donated by Irene Marguerite Beasley).*

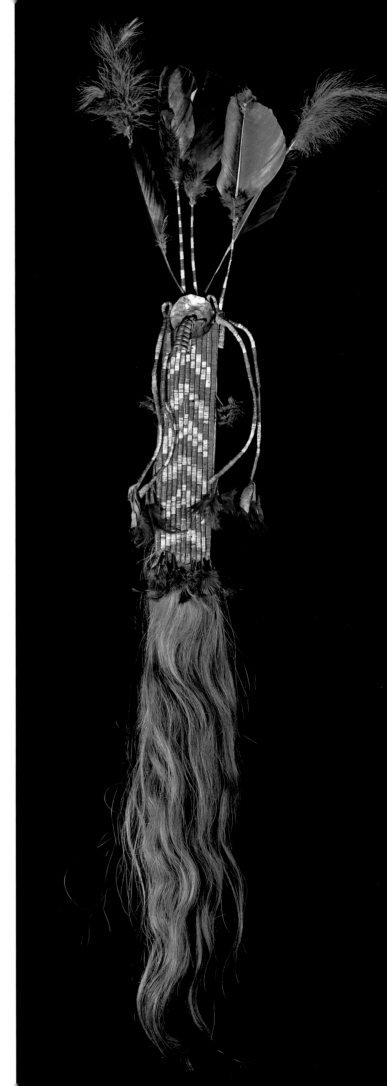

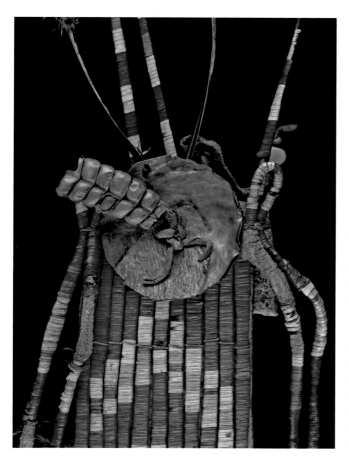

Specific items such as bustles and belts that were only used in particular warrior societies' dances and public events would be transferred as part of the society kit should the associated dances be sold to another tribe. Sashes, belts, rattles and sticks were among the most common objects transferred along with the specific warrior society's rights. Even among tribes that did not have warrior societies, dance bustles and headgear were two items of the warrior's dancing outfit that were considered some of the most distinctive items used in dances. Such items were adapted over time by the tribe that received them as part of exchange or purchase. The popular dance bustle called 'the crow' is a case in point. Originally given to the Pawnee by a powerful medicine man during mythical times, this long trail decorated with feathers and skins was associated with fire medicine, typically interpreted as the destructive power of lightning that annihilates enemies. Interestingly, among the Omaha who received it from the Pawnee in the early nineteenth century, this belt became part of the *Hethus'shka* society, which was protected and guided by the power of thunder. Among them, the crow belt was worn at the back fastened at hip level (Fig. 76). Feathers pinned on the fabric represented the dead enemies on the field, and the upward projecting sticks symbolized the fatal arrows that killed them (Fletcher and La Flesche 1911: pp. 441–6). The main leader of the *Hethus'shka* wore this belt, whereas other members would wear grass bunches in substitution for the scalps of older times. The

Fig. 73 *Citico- or rattlesnake-style gorget, Mississippian period (AD 1000–1700). Shell, diam. 11 cm (Am1884,0101.1 Donated by William Bragge).*
These objects were suspended on the chest as breastplates as markers of leadership and authority. A stylized rattlesnake is visible coiled within the shell.

Thunder symbolism in art

Returning the Gaze is a portrait of Assiniboine powwow dancer Kevin Haywahe made by the Iroquois (Onondaga) photographer and curator Jeff Thomas in 2005 (Fig. 74). Kevin's look forces the observer to reconsider who is actively doing the looking, a reflection that addresses historical power imbalances between Native North Americans as the objects of photographic intrusion and Euro-Americans as the subjects of knowledge production. This portrait also epitomizes the role played by custom among contemporary Native North Americans. Tradition is visible in the face paint worn by the dancer. The so-called 'weeping eye' motif that decorates his left cheek has direct references to historic Assiniboine Fool Dancers who took their power from thunder beings. They had the power to heal eye ailments because lightning was believed to be generated by the thunderbird's gaze. Fool Dancers' connection with lightning powers entitled them to paint zig-zag symbols on their arms, a motif also found on many objects used by Plains warriors. The face pattern worn by Fool Dancers on their masks was a variation of the 'forked eye' motif that stems from ancient iconographies related to war. From pots to ceremonial copper breastplates, carvings on shells, petroglyphs and ear ornaments, this motif has been linked to Siouan-speaking peoples of the eastern and northeastern Plains such as the Assiniboine and tribes such as those of the Dhegihan branch (Kansa, Ponca, Osage, Quapaw and Omaha), those of the Chiwere division (Iowa, Otoe, Missouri) and the related Ho-Chunk (once known as Winnebago). Some of these tribes directly descend from the archaeological tradition known as Oneota (AD 1150–1600) which left a wealth of iconography linking lightning to war-related beliefs. Of particular relevance are Oneota whelk shell engravings that may have been used as either masks or chest decorations. They feature eyes from which lightning bolts stream like tears. Analogous motifs appear in the rock art made by various groups, especially in the northwestern Plains (Keyser 2004: pp. 66, 112). Several meanings converge in these designs. Images depicting streaming tears, for example, were a sign of spiritual rapture, most notably experienced during warriors' fasts and vision-seeking periods of seclusion (Wildschut and Ewers 1959: p. 28). The association between eyes, lightning and warfare can be also found among the Omaha, whose Sky moiety's name was 'Flashing eyes' (Fletcher and La Fleshe 1911: p. 185) and was related to male sky rituals and thunder's power to give and take life.

Fig. 74 *Returning the Gaze by Jeff Thomas, 1991. Photograph, H 86 cm, W 60 cm (Am,Lge.1)*
This arresting image of a northern Plains powwow champion in his full regalia shows how ancient iconography, painted on his face, is widely used today by dancers who refer to old symbols that may still play a part in contemporary belief.

In other cases the eyes on these shell masks are circled by a forked motif that is also found on copper repoussé plates from the Mississippian period (*c.* AD 1000–1700). Four specimens from the Heimdal mounds in North Dakota show the forked motif and the lightning or streaking tears motif joined on the same whelk shell masks. The iconographic association between these two themes reflects ideological correlations between storms and destruction, generally embodied in the figure of the thunderbird. Its destructive powers in turn were manifested in the hawk's force and swiftness. The characteristic dark pattern around the eyes of the hawk (*Falco peregrinus*) inspired the forked eye motif. Hawks were frequently included in war bundles alongside shells and other sacred objects. Kansa war bundles, for example, might either contain shell gorgets or mummified hawks (Dorsey 1885; Howard 1956). Hawks' raptorial nature and warlike qualities were further symbolized in the clawed talons of the Hopewellian (*c.* AD 1–400) and Mississippian cultures. Interestingly, raptorial talons also occasionally appear at the end of zig-zag lines in pictorial representations by Lakota, Gros Ventre and Crow warriors and visionaries

of the nineteenth century (Berlo 2000; Pohrt and Pohrt 2003; Wildschut and Ewers 1960) (see Fig. 17). Eagle and hawk talons are often used today by powwow performers to decorate the tips of their dance wands.

A rare combination of the thunderbird and stylized face with flashing eyes on the same item can be seen on a rattle that is now part of the British Museum's North American collections (Fig. 75). This ritual object, produced by Algic-speaking Cheyenne, reveals the spread and significance of thunderbird and lightning symbolism. Though this tribe associated thunderbirds with the eagle, its designs resonate with iconographies produced among historic peoples from different linguistic groups. The juxtaposition of the thunderbird with flashing eyes on the two sides of this ritual object powerfully condenses the multiplicity of associations established between the destructive and protective actions of lightning, its bird messengers and spiritual sanction. Significantly, it testifies to the resilience of old ideas about cosmic forces and natural elements and belief in the role of humans in redressing cosmic equilibrium through ritual action and war-related activities accompanied by dancing and singing.

Fig. 75 *Rattle (front and back) (Cheyenne), late 1800s. Hide, animal tail and feathers, L (excluding feather and tail) 23 cm (Am1930,-.61).*

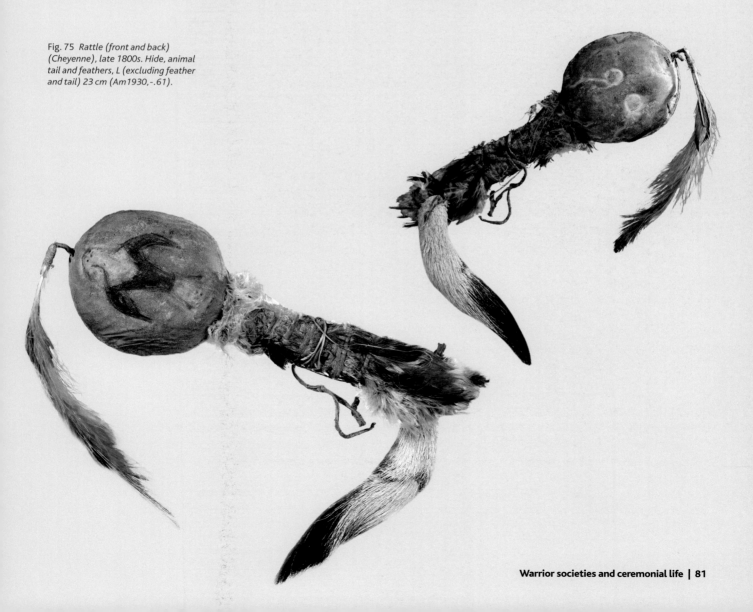

Fig. 76 *Sioux (Yankton) man,
photograph by A. Zeno Shindler and
Alexander Gardner, 1868. Albumen
print, H 18.5 cm, W 12.5 cm
(RAI 1102).*
This man is wearing an old-style Crow
belt. Today variations of this item are
worn at powwows by dancers that
compete in the Traditional category.

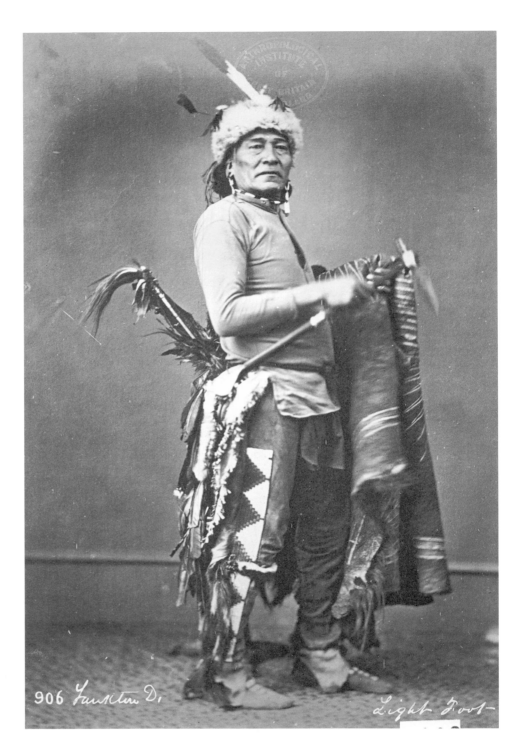

practice of dancing with scalps is very ancient and it is amply
recorded in pre-Columbian iconography (Brown 2007).
When it reached other tribes in the mid- to late nineteenth
century this practice gave the corresponding Grass Dance its
name. A version of it is known as such today (Fletcher and La
Flesche 1911: p. 461) (Fig. 77).

Changes in warrior societies' outfits parallel the historical
erosion of spiritual meaning associated with ceremonial
dancing, once at the core of warrior societies' social and ritual
life. These changes are partially the result of postcolonial
coercive measures that banned dancing and ceremonies

until the mid-twentieth century. Governmental assimilation
policies aimed at limiting Plains Indians' cultural expression
directly targeted religious ceremonies, but significantly they
included banning all those activities such as communal dances
that potentially allowed indigenous people to relapse into
customary practices and that distracted them from engaging
with mainstream lifestyles. Tribal agents employed by both
Canadian and the United States governments vigorously
enforced such policies by withholding rations and other
benefits from those known to have participated in ceremonial
gatherings, or worse yet, who organized customary

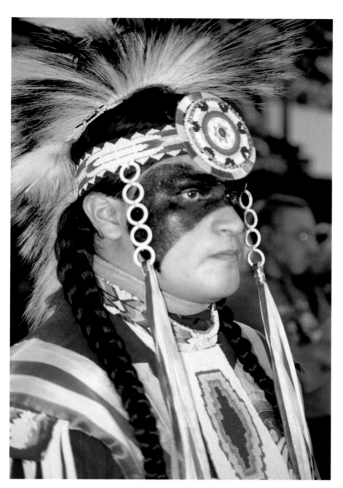

meetings of a ritual nature. In Canada prohibitions of Indian ceremonies and dances established with amendments to the Indian Act in 1906 were not repealed until the 1950s. In the United States public displays of religious activities were prohibited until the Religious Freedom Act of 1976 lifted the ban. Such repressive policies coincided with the historical demise of warrior society activities and their members' covert involvement in the social and religious activities of their respective tribes.

During this period, the adaptation of performances to new audiences may have encouraged a focus on the folkloristic aspects of warrior dances and attire, but the religious meanings most deeply associated with many ceremonial items retained their relevance for the performers, who transmitted them through the generations by way of songs, oral traditions and the implicit meanings embedded in their materials and symbols (Fig. 78).

Fig. 77 *Grass dancer at a powwow in Oklahoma, photograph by Milton Paddlety, Kiowa, 1990s (Am,Paddlety,F.N.1594 Donated by Milton Paddlety).*
Grass dancers compete in separate categories at powwows and have developed particular types of regalia that often include copious use of woollen fringes, which enhance the dancers' syncopated movements.

Fig. 78 *One Horn society of the Blackfoot of Canada, early 1900s. Colour postcard, H 14 cm, W 9 cm (Am,B41.17).*
Audiences unfamiliar with the symbols and meanings attributed to society regalia simply saw them as curious costumes from a bygone era. However, examples such as those depicted in this commercial postcard contributed to the continuation of old meanings and traditions through dancing.

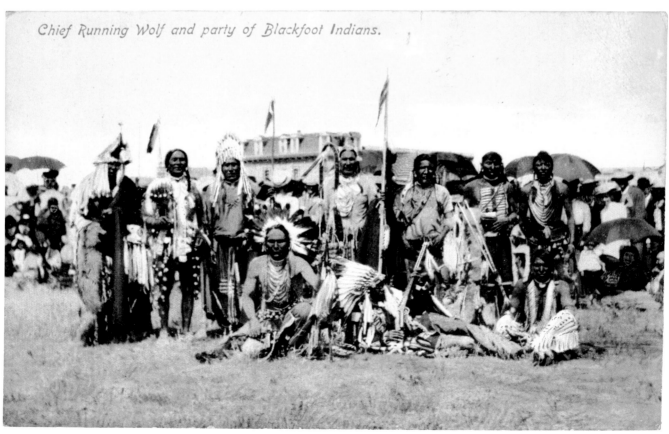

Chief Running Wolf and party of Blackfoot Indians.

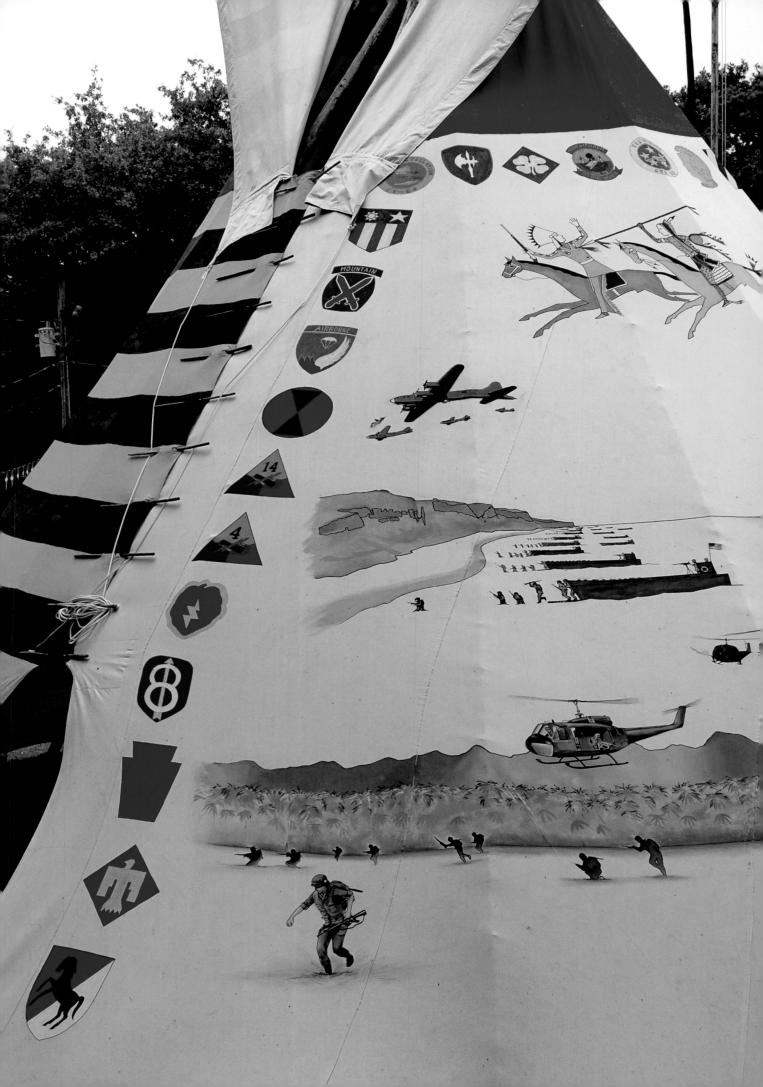

Chapter 4

Warriors and the technologies of warfare

Tangible and intangible power

In historical Plains cultures a warrior's success depended on his spiritual power as much as on his bravery and technical prowess with the bow, and on the horse. Insomuch as objects and animals were thought to be endowed with spiritual power, possession or any other association with them by means of rituals and ceremonies enabled a direct connection between man and the unseen forces of the cosmos, and this was crucial for maintaining a balance between tangible and intangible realities. Whereas sacred objects owned by a tribe or society were inalienable due to the power accumulated in renewal rituals over the years, there were also classes of items valued because of their inherent power that could be bought and sold. Anyone seeking to enhance their personal power could purchase or acquire articles that would help them achieve this goal. The number of such items that a man owned cumulatively made up his power, but this could be lost, depleted or neutralized by more potent forces. For centuries, this constant preoccupation with the accumulation of power had a substantial role in shaping interpersonal, intergroup and intertribal relations. Conflicts and alliances reflected shifts in power exchange that were materialized in the value accorded to objects, animals, humans and the transactions that mutually connected them.

Power manifested itself in manifold ways over a man's lifetime. Some men had the ability to cure and heal, some could predict future events, but the majority displayed power in their fighting abilities. Some people might use power with bad intentions, for example to harm others outside fighting contexts. Power had to be used wisely and managed carefully in order to preserve it, because power was believed to be limited and it withered with time. As we have seen in Chapter 2, among

nineteenth-century Plains Indians power renewal ceremonies were a ritual necessity that ensured community well-being and the continuation of society. Similarly, individual power and vital energies periodically dwindled and required constant replenishment, much like the natural life cycle of plants and seasons. Whether in old age or during his warrior career, every man was warned never to misuse his power and to store his energies in anticipation of battles and war raids.

In the context of war, the many manifestations of power were translated into individual abilities that often gave a warrior a distinct reputation, resulting in the attribution of a new name. Names were believed to contain a person's essence and often great warriors had so-called 'medicine names' that were kept secret to retain their potency. Whereas some men were known for their capacity to become invisible or to avoid fatal blows by running fast, others had the ability to defend themselves and their comrades effectively, take home a large booty, horses or prisoners, or to inflict great losses upon the enemies (Fig. 80). By and large, a man was considered to be a great warrior if he displayed all these characteristics. A warrior's physical strength and combat abilities were believed to depend on the amount of power he had. Each warrior therefore sought ways to enhance his power through visions and dreams or looked for supernatural signs that could help him to carry out successful raids and war expeditions. A warrior's reputation was determined by his actions, but his actions were ultimately determined by the protection he gained through communicating with invisible beings and various other manifestations of the all-permeating cosmic energy that inhabits everything in creation.

Finding one's individual power was a prerequisite to becoming a warrior. This was most efficiently achieved by seeking a vision. Visions instructed prospective warriors to make their personal protective medicines and paint themselves in a particular fashion, transferred them the rights to spiritual songs and, importantly, gave them rights to make sacred items. War medicine was most generally contained in charms made of a variety of materials, most often stuffed animal skins, entire pelts, birds' bills and talons, feathers

Fig. 79 *Kiowa War tipi pitched in the Anadarko ceremonial grounds during veteran celebrations, photograph by Ian Taylor, 2009.*
Modern and ancient themes are represented in the artwork that decorates half of the surface of this tipi. The other half is painted in yellow and black stripes in honour of prominent nineteenth-century leader Little Bluff. This style was revived by veteran and artist Dixon Palmer in the 1970s.

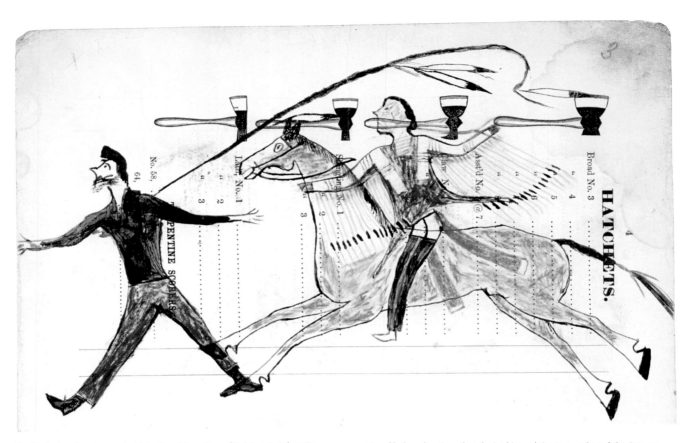

Fig. 80 *Ledger drawing, probably by Good Bear, Sioux (Oglala Lakota), 1874. Pencil or crayon on paper, H 14.2 cm, W 22.4 cm (Am2006,Drg.19).* Good Bear, a Sioux warrior, lived in the mid-nineteenth century and produced a series of ledger drawings that depict his exploits as member of the Strong Hearts society. Note how the author has intentionally used the hatchet on the ledger to convey the idea of attacking the American soldier.

and stones. Otter pelts were a popular war medicine among peoples of the northern and northwestern Plains such as Plains Cree, Tsuu T'ina, Crow and Blackfoot. Among Algic- and Siouan-speaking peoples in particular, otter symbolism is very ancient. Skins and pelts of this animal were used to contain sacred medicines such as shells used in healing ceremonies because the otter had protective and curing properties associated with water. Famous Mandan chief Four Bears, who lived in the first half of the nineteenth century, is said to have recovered from battle wounds with otter-skin power administered to him while in the water by holy man Cherry Necklace (Bowers 1950: pp. 256–7). In the past, part of the skin of this animal could be used as a bandolier worn across the chest and shoulders, or alternatively the whole skin might be worn as a poncho decorated with shells (Figs 81 and 145). This war medicine may be the predecessor of the type of otter harness decorated with round mirrors that became popular across the Plains in the second half of the nineteenth century (Raczka 2003; Sager 2000). Some war medicines were intended to protect whole war parties and even entire villages. The Cheyenne's effigy of mystic hero Sweet Medicine that supported the Sacred Wheel Lance made by blind prophet Box Elder was reputed to have saved warriors from the American army's bullets during a famous battle in 1876 (Powell 1969: p. 451).

Visions established a warrior's association with particular animal and spirit protectors that each man needed to lead a healthy and successful life, but also gave him specific instructions about his future behaviour as a warrior. Supernatural mandates might give the warrior songs that had to accompany specific ritual procedures to do with his charms. They might also indicate places where he could find his protective materials, or require that he radically change his behaviour, such as in the case of contraries, whose compulsion to act in reverse was supernaturally imposed during revelations uttered by culture heroes or ancient prophets.

Dreams and visions of particular natural elements, for instance the moon among the Omaha, or spirit beings such as the mythical Deer Woman among the Sioux, would cause a man to act like women. These men were compelled to take on the roles and responsibilities of the female sex if so instructed. These individuals could still go to war and were often recognized as valiant fighters (Roscoe 1990). Collectively they did not constitute a separate warrior society but, as reported among the Cheyenne, they danced together alongside the women at the return of warriors, holding the scalps they had taken in battle (Grinnell 1972, II: pp. 39, 41).

Unseen forces appeared in dreams and visions either personified or as talking animals to guide a man in his pursuits. Vision quests, self-inflicted cuts and flesh offerings, or ritual

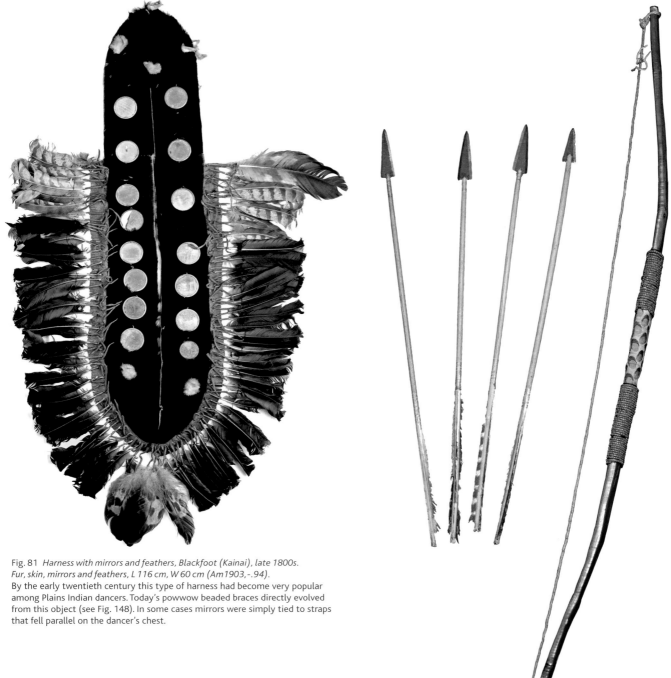

Fig. 81 *Harness with mirrors and feathers, Blackfoot (Kainai), late 1800s.*
Fur, skin, mirrors and feathers, L 116 cm, W 60 cm (Am1903,-.94).
By the early twentieth century this type of harness had become very popular
among Plains Indian dancers. Today's powwow beaded braces directly evolved
from this object (see Fig. 148). In some cases mirrors were simply tied to straps
that fell parallel on the dancer's chest.

Fig. 82 *Bow and arrows, Hidatsa, mid-1800s. Bone, sinew and glass, L 95 cm*
(Am.5207 Donated by Sir Augustus Wollaston Franks).
Bows differed according to tribal tradition. Mounted warriors of the Plains
preferred short and light bows, but tribes living on the marshy coastal plains of
Texas, used bows for fishing that were as tall as a human.

seclusion were often practised by Plains warriors before
going to war as a means of purification and to achieve clarity
of mind, as well as to obtain answers about the fate of war
parties. Should omens not be encouraging, warriors might
abstain from fighting because of the risks involved in opposing
supernatural indications. Warriors followed to the letter the
supernatural guidance and prescriptions received in dreams
and visions. Strict taboos might be imposed on their person,
weapons or clothing. As a result of dreams, warriors could be
restricted in their actions; for example, they were told who and

what places they should avoid, or how they should behave with
regard to particular animals or substances. For instance, the
famous nineteenth-century Cheyenne warrior Roman Nose,
of the Crooked Lance warrior society, had been instructed
that no white man's metal should ever touch his food, lest his
bullet-proof medicine lose its power. Shortly after he ate from a
plate that had been touched by a spoon made from white man's
metal, he was shot dead by American soldiers (Powell 1969:
pp. 94–5). The premature death of this prominent warrior was
interpreted as a direct consequence of his unintentional breach

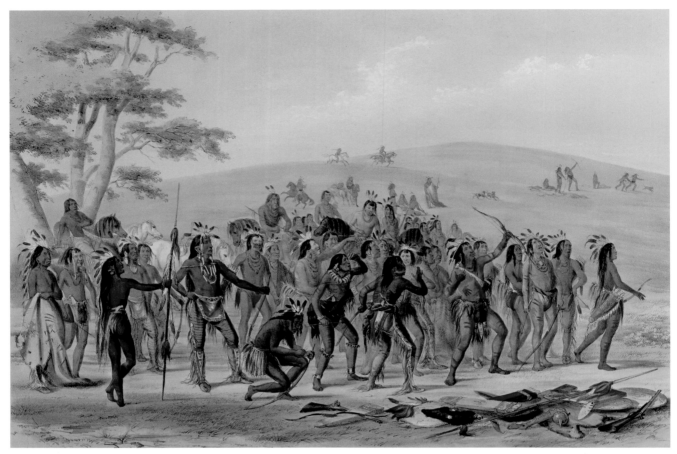

Fig. 83 The game of the arrow *from the album 'Souvenir of North American Indians' by George Catlin, 1844. Lithograph, H 31.5 cm, W 45.5 cm (AOA F Kub [Cat-] M33161, Plate 24).*

This popular contest among Indians of the upper Missouri River area impressed the painter George Catlin, who reproduced it according to conventions that owe much to the classical tradition.

of supernatural prescriptions. Belief in the causal relationship between other-worldly instructions and fatal consequences was so ingrained in nineteenth-century Plains Indian thought that episodes like these confirmed the tangible effects of intangible powers on all aspects of reality. This incident is emblematic of the ways in which Plains Indians thought about agency, intentionality and the relationship between objects, actions and intangible forces.

Whereas visions endowed warriors with supernatural protection, games and physical exercises enabled them to improve practical skills required in battles, horse-stealing raids, one-to-one combat and horsemanship. Male engagement with warrior activities was strongly encouraged from an early age. Young boys were trained in martial arts such as spearing, throwing and archery as well as horse riding, running, swimming and fasting. Such training was highly valued because it helped build stamina and resistance to hunger, thirst and other hardships that were integral to the life of a warrior. War raids might last days or even months, during which warriors had to tolerate extreme temperatures and endure water and food shortages in hostile, often unknown territories.

Young boys were encouraged to shoot small birds and rabbits with bows and arrows to improve their techniques

(Fig. 82). While this and other practices built strength and familiarized them with technologies and skills required in battle and on the warpath, crucially they also prepared the boys for a potentially successful warrior career. The artist George Catlin witnessed in the early nineteenth century what the Mandan called the 'game of the arrows' staged among the men, and he commented on the practice as follows:

> For the successful use of the bow, as it is used through all this region of country on horseback, and that invariably at full speed, the great object of practice is to enable the bowman to draw the bow with suddenness and instant effect; and also to repeat the shots in the most rapid manner ... I scarcely think it possible that any people can be found more skilled, and capable of producing more deadly effects with the bow.
> (Catlin 1974, I: p. 142) (see Fig. 83)

European and American eyewitnesses greatly admired the skills displayed by Plains Indian warriors during both horse-mounted and hand-to-hand combat. Centuries of battles and raids carried out on foot enabled Plains Indians to perfect techniques that differed from those of nineteenth-century Europeans who, by contrast, relied heavily on their technological advantages of guns and cannons, and the invaluable horse.

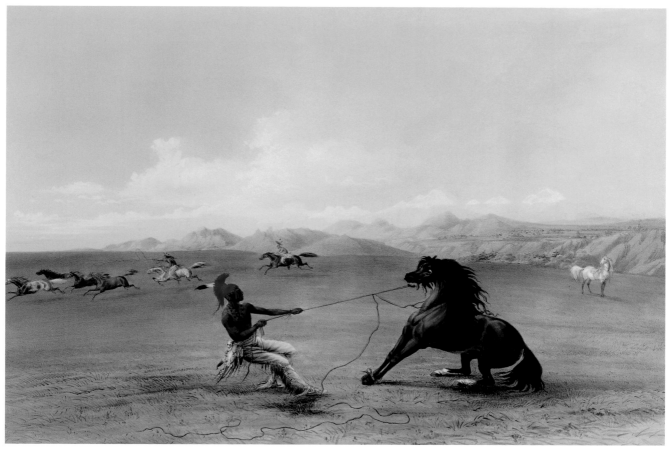

Fig. 84 *Taming a wild horse from the album 'Souvenir of North American Indians'
by George Catlin, 1844. Lithograph, H 31.5 cm, W 45.5 cm
(AOA F Kub [Cat-] M33161, Plate 4).*

Competent horsemanship was widely recognized by American visitors to the
Plains, who frequently commented on the skill and ability of Native people.

Although the horse was a relatively new animal for
Plains Indians, it quickly became a useful new technology for
transportation, scalp and war raids, expeditions and combat.
In addition to offering clear advantages over warriors on
foot, horses, like other animals, fitted well into Plains Indian
ideologies of power. In traditional Plains Indian thought,
animal-derived power was believed to ensure personal success,
and horses clearly epitomized the notion that a man's power
and status could be enhanced through the mediation of
animals. Comanche, Kiowa and other southern Plains tribes,
who were among the first to obtain the animal, soon became
renowned as skilled riders whose feats of horsemanship only
added to their widespread warlike reputation (Fig. 84). By the
age of five or six, every male child living on the Plains was a
skilful rider. After the eighteenth century horse riding skills,
whether bareback or equipped with saddle and bridle, became
paramount to pursue a warrior career. So important was the
introduction of horses among Plains-dwelling peoples that a
whole new economy developed around horse stealing, trading,
capturing, gifting and bartering. Horse stealing in particular
was one of the most common activities of a young man's early
career, helping to enhance his status and introducing him to
the ranking system of warrior societies (Fig 85).

The arrival of this new animal required adapting old-
style fighting techniques and technologies to a different kind
of warfare. One of the earliest accounts of this radical change
comes from Blackfoot oral history. In 1730 the Blackfoot
saw the horse for the first time, during a belligerent
confrontation with their westerly neighbours the Shoshone.
The Blackfoots' surprise at the animal's speed turned out to
be an advantage for Shoshone mounted warriors, who
inflicted losses upon their enemies. Alarmed about the
outcome of this ill-fated event, the Blackfoot sought assistance
among the allied Assiniboine and Plains Cree. These two
tribes had recently acquired muskets from European traders.
This new technology also surprised the Blackfoot, although
they soon adopted it as well due to its power (Ewers 1958)
(Fig. 86). Horses, muskets and later other types of guns were
seen as powerful additions to the warrior's equipment, but
their potency could be limited by his personal medicine.
Once the young man was ready to perform his first raid,
guns and horses were as important as the personal charms
he had acquired through dreams and visions. Indeed, even
the sturdiest protection such as shields and armour could be
rendered ineffective should they not have their protective
medicine.

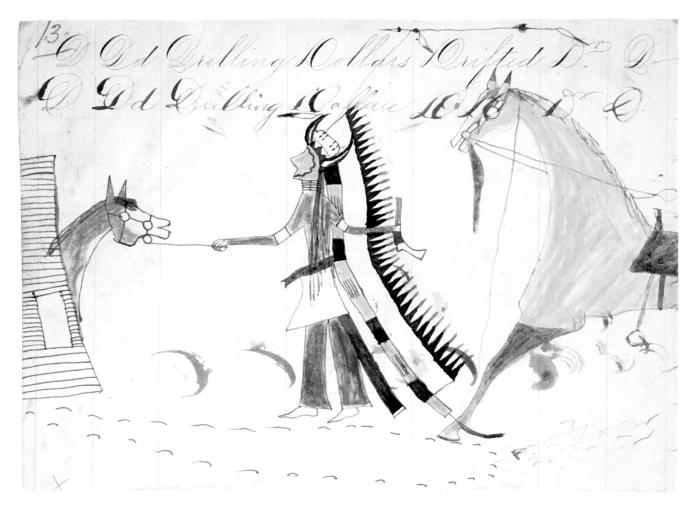

Fig. 85 *Ledger drawing by Tall Bear, Sioux (Lakota Oglala), 1874. Pencil or crayon on paper, H 17.5 cm, W 21 cm (Am2006,Drg.8).*
Here Tall Bear shows an episode from the warrior Lance's honourable career in which he appears to be capturing a horse from an American log cabin.

Fig. 86 *Powder horn, Blackfoot (Kainai), late 1800s. Wood, L 30 cm, diam. 7.2 cm (Am1903,-.121.a-d).*
Old pictographic depictions of Plains warriors show them equipped with powder horns, worn across the shoulders and chest. This essential item of a warrior's kit was discarded with the introduction of new types of guns that replaced muskets.

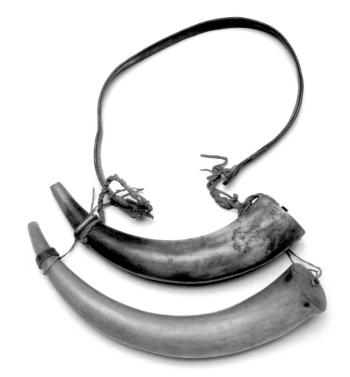

Archaeological and ethno-historical evidence reveal that armour and large leather shields were used on the Plains from the eighteenth century, and perhaps earlier. Examples of armoured horse riders are found in pictographic rock art of the northwestern Plains inhabited by Shoshonean-speaking groups. In the early equestrian period armour was employed by numerous tribes of the northern, western and southern Plains such as the Comanche, Tonkawa, Caddo, Wichita, Crow, Blackfoot, Assiniboine and Gros Ventre, among others (Ewers 1955; Gelo and Jones 2009) (Fig. 87). Armour slowly disappeared from warriors' equipment, probably as a result of the introduction of firearms. European-inspired or produced technologies and clothing, however, continued to be successfully integrated as part of Plains Indian warriors' equipment throughout the nineteenth century.

Fig. 87 *Horse armour, part of a set of two, Plains peoples, late 1700s– early 1800s. Skin and natural pigment, L 90 cm, H 60 cm (Am2003,19.6).*

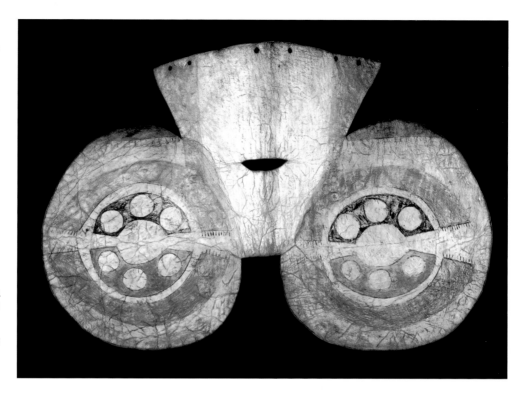

Fig. 88 *Carte-de-visite photograph by Jackson Brothers, 1800s. Albumen print, H 20 cm, W 6.2 cm (Am,A9.131).* While items of military clothing were frequently given by American and Canadian officials as diplomatic gifts to war leaders, the capture of military uniform as a form of defiance and victory over the enemy was common across the Plains.

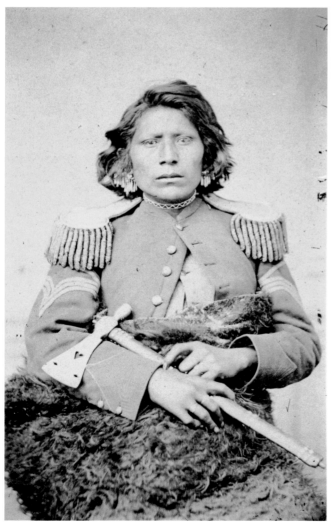

Often army hats, jackets, epaulettes, baldrics and other soldiers' regalia were worn by Plains Indian warriors as a means both to announce one's success against European, Euro-American and Canadian foes and to add the potency of the enemy to one's own (Fig. 88). Capturing the opponents' war regalia was a common feature of Plains Indian warfare, and its purpose was more than simply symbolic, as such objects were believed to contain some of the enemies' power. The significance attributed to captured army gear, muskets or swords reflects a very old ideology in which any item whose origin was exotic, obscure or mysterious had inherent spiritual value (Fig. 89). This notion has parallels in the inclusion of shells, odd-shaped stones or meteorites, whose origins were unknown, in many sacred bundles. Objects and materials that were perceived as having unusual or striking features were highly prized. Characteristics such as bright colours, transparency, light-reflecting or mirror-like effects were attributed inherent properties seen as awesome, mysterious or portentous. Among Siouan-speaking peoples in particular, mirrors had the power to attract or distract people; they could also send long-distance messages by deflecting light and, among some tribes, were used in courtship dances (Bailey and Swan 2004; Wissler 1905). With the commercial diffusion of trade goods, mirrors may have lost some of these powerful meanings, but they continued to be highly valued as decorations on dance regalia in later periods.

The symbolic and practical attributes of imported or exotic objects such as mirrors converged in weapons that were more directly used in combat. Plains Indian ideas of value were also applied to sabres, rifles and other guns, as well as the iron hatchets that were successfully introduced during the early stages of commerce with Europeans. The popularity

Fig. 89 *War shirt (Blackfoot), late 1800s. Skin, natural pigments, ermine fur, brass, glass and human hair, L. 91 cm (Am1887,1208.1).*
The watch attached to the front of this Blackfoot war shirt shows the importance that Plains Indians of the nineteenth century gave to exotic objects. As with mirrors and glass beads, watches were not available in North America before the arrival of Europeans.

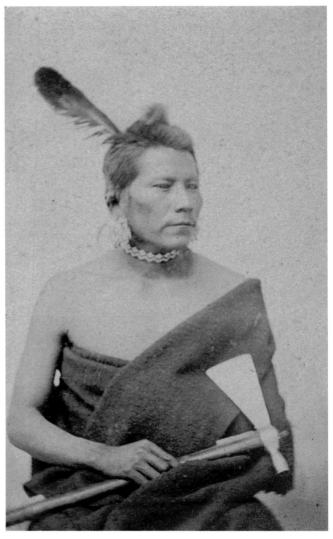

Fig. 90 *Carte-de-visite photograph of a Pawnee man by Jackson Brothers, 1868. Albumen print, H 10.1 cm, W 6.1 cm (Am,A9.131).*
Native North American leaders and warriors, such as this Pawnee brave, are often displayed holding tomahawks in a variety of poses. This convention derived as much from their desire to be recognized as warriors as from the photographer's visual repertoire derived from classical portraiture.

of such items can be explained within the context of pre-existing ideologies of religious and secular power expressed by different degrees of rank and social standing. Tomahawks, axes and celts are particularly instructive in illustrating this point.

This typology of striking weapons has been associated with chieftainship and authority since pre-Columbian times. Ritual monolithic axes recovered archaeologically from funerary kits of high-ranking individuals predating historical Plains cultures reveal a direct association with leadership. The symbolic use of axes and blades of stone or copper to denote chiefly authority almost certainly entered Plains ideologies via archaeological cultures as old as those that emerged during the Old Copper complex of Wisconsin's Late Archaic period (2000–500 BC) and the later Mississippian cultures of Oklahoma that developed under Spiro's area of influence (AD 1200–1350) (Brose *et al.* 1985). Specimens of copper and stone axes have been found in numerous locations and visual representations of warriors brandishing maces, clubs and stone celts on shells and rock art are common among cultures of the Mississippian period. Copper, in particular, has for centuries been associated with chiefs and shaman priests who managed ritual and ceremonial life. The convergence of religious and secular authority in the use of metals such as copper among Mississippian elites may have provided the ideological matrix for the successful integration of iron axes among their Prairie and Plains successors.

With the arrival of Europeans iron hatchets and axes became available to Plains Indians in large numbers. They were exchanged for local products such as pelts and skins, but were also bartered for prisoners traded from more westerly tribes. As a result, what later became known as a tomahawk (from the Algonquian 'object for cutting') soon became a universally prized implement among Plains Indian warriors

and leaders, who may have seen this new item as a substitute for earlier forms of symbolic axes made of stone and copper (Fig. 90). Iron tools and commercial hatchets and axes provided by Europeans soon replaced old-style stone axes and, in addition, their availability on the market contributed to the democratization of access to precious goods once held only by selected individuals and families. By the time Europeans arrived on the Plains, trade in copper had ceased as a result of the rapid disintegration of Mississippian chiefdoms whose elites had controlled long-distance exchanges as a means to obtain valuable commodities.

Equal access to mysterious objects and communication with intangible realities and beings are characteristics that set historical Plains Indians apart from their Mississippian predecessors, whose highly developed ranking system allowed only special classes of peoples to manage unseen forces via

rituals and ceremonies. Only the most direct descendants of Mississippian cultures, such as the Pawnee, Arikara and Osage, retained classes of warrior priests that managed tribal ceremonial life into the historic period. By contrast, other groups that emerged in the process of coalescence, following the fragmentation of Mississippian chiefdoms between the sixteenth and seventeenth centuries, rearticulated old ideologies of power in new social structures and institutions. The vision quest, central to Plains Indian life and aptly called by anthropologist Robert Lowie 'democratic shamanism', indicates that anyone could receive power and manage unseen forces without the intercession of specialized ritual experts or mediators. Echoes of former ideas about ranking and status can nonetheless be detected in the elaborate system devised by historical Plains Indians to confer merit on warriors.

Discussing valour

Among Plains Indians of the nineteenth century valour and honour were assigned to individual warriors according to deeds performed during their fighting career. Plains warrior societies classified each deed following a grading system in which some actions were more valued than others. A warrior's position in the hierarchy of valiant men was established by the quality and quantity of deeds he collected. Individuals who had returned from war expeditions, raids or battles were prompted to discuss their war accomplishments with comrades as a means to validate their worth and gain a lasting honourable reputation. Warfare experiences and exemplary events were discussed at length by warriors in long meetings during which the retellings of war party members' deeds were subject to the closest scrutiny of peers and leaders. Councils of warriors who had witnessed the man's actions could prove or disprove his tales. They assessed whatever a man claimed to have done on the battlefield in order to give him the proper recognition. Each action performed in battle had a place in the hierarchy of values assigned to warfare. Warrior roles, especially in age-graded warrior societies, could significantly change according to how the action was carried out, whether or not the warrior acted alone, or if he had faced extreme danger during a confrontation with the enemy. What constituted valour varied among tribes as well as among societies of equal grade. Tribal traditions differed substantially with regard to what they considered honourable and worth discussing publicly. In the nineteenth century, taking scalps and killing enemies were not as important for the Blackfoot as capturing their guns, for example. Scalping was not particularly valuable among the Cheyenne either, although touching an enemy ranked high in the scale of desirable war honours. Touching enemies with the bare hand was considered an act of extreme valour that raised any fighting man to the highest level of respect and admiration. Counting coup on a foe with bare hands or arms, with special sticks or small maces, was deemed to be an honourable act deserving public recognition (Fig. 91). Often horse quirts were

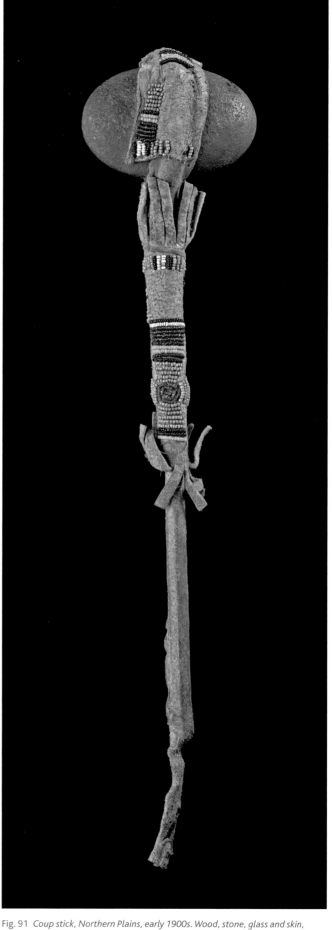

Fig. 91 *Coup stick, Northern Plains, early 1900s. Wood, stone, glass and skin, L 31 cm (Am1933,1208.1 Donated by Harry Geoffrey Beasley).*
Coup sticks could also function as convenient striking weapons. This short-handled specimen is decorated with the symbol of a star, beaded on the head and on the stem, possibly for additional protection.

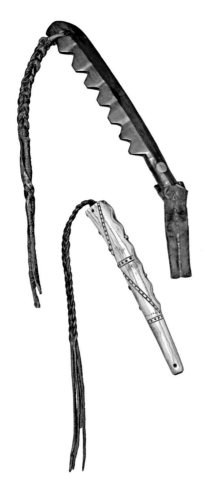

used to touch enemies in similar fashion, perhaps more as a symbolic action determined by the notched or zig-zag shape of these implements that metaphorically connected them to the striking power of lightning (Fig. 92). Striking enemies with a coup stick, a quirt or a riding whip, or having direct contact with the foe, were ranked according to who touched the opponent first. The sequence of events determined an individual's position in the ranking system and could lead to upward mobility. Leadership was socially and communally sanctioned, and people selected to be spokespersons for entire villages or societies were chosen from the most valuable men by councils of experienced warriors who had achieved the peak of a fighting career.

Having performed any valuable deed granted a man the right to add to his war regalia, such as moccasins and war shirts, particular designs or decorations that varied according to tribal tradition. Among the Crow, a man's accomplishments were advertised by the use of a set of ornaments that corresponded to the relative value given to each deed performed during combat. A coup-striker was allowed to attach wolf tails at the heels of his footwear; someone who had taken possession of a gun from an enemy's hands could hang ermine tails to his ceremonial shirt; both hair and ermine could be worn by anyone who had been a war party leader (Lowie 1983: p. 217) (Fig. 93). For the Omaha, war

Fig. 92 *Horse quirts: Above Kiowa or Comanche, 1800s. Wood and leather, L (handle) 52 cm, L (whip) 46 cm (Am.5213 Donated by Sir Augustus Wollaston Franks); Below, Omaha or Otoe, mid-1800s. Antler, leather and pigment, L (handle) 31 cm, L (whip) 41 cm (Am.5214).*
Horse quirts could be made from antler, bone or wood. Although they were mostly utilitarian, these objects were frequently decorated with studs, appendages, incisions and more rarely pictographs.

Fig. 93 *War shirt (Crow ?), late 1890s. Decorated with ermine tails, human scalps, beads and porcupine quills, L (collar to base) 73 cm, W (cuff to cuff) 159 cm (Am1944,02.201 Donated by Irene Marguerite Beasley).*
Shirts of this kind were considered to be powerful war medicine and offered protection to the wearer.

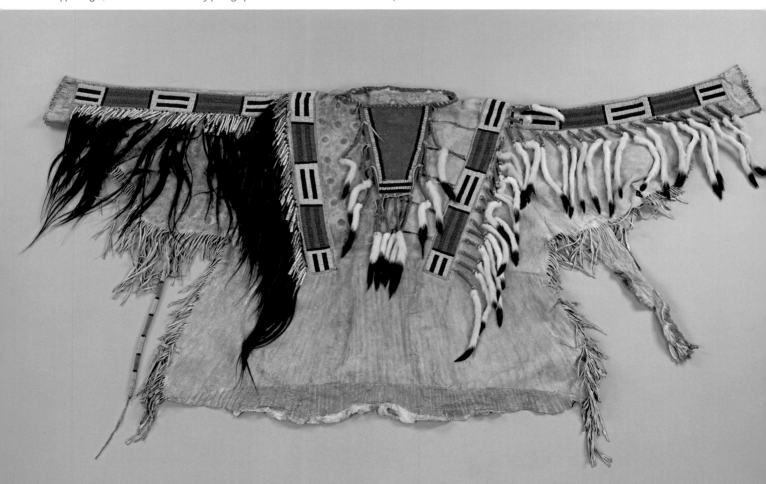

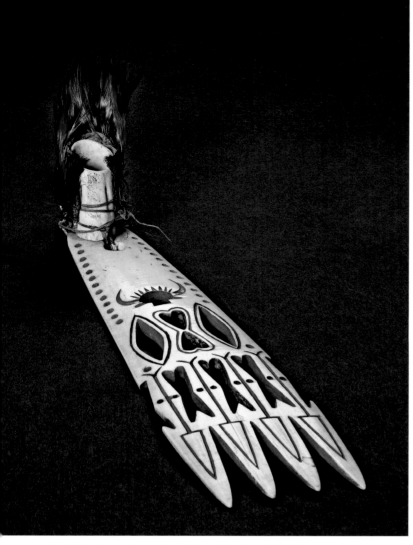

Fig. 94 *Roach spreader headdress, Sioux (Dakota), mid-1800s. Bone, natural pigments and feathers, L 24 cm, W 6 cm (Am. 5216 Donated by Sir Augustus Wollaston Franks).* Roach spreaders like this one accommodated a standing feather in the upright cylinder attached at the front end. Among tribes such as the Omaha this feather signified the warrior standing in the middle of the fire of destruction.

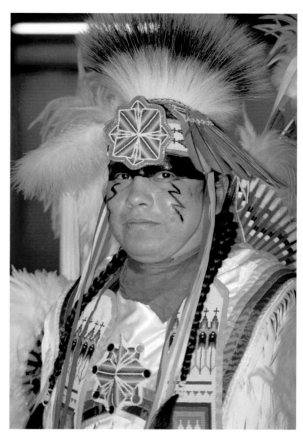

Fig. 95 *Fancy Dancer, Oklahoma, photograph by Milton Paddlety (Kiowa), 1996 (Am,Paddlety,F.N.1627 Donated by Milton Paddlety).* Originally deer hair roaches were red or yellow and were made from a single string of hide on which tufts of hair were tied to form a fringe. When looped and attached to the scalp lock this fringe stood upright gently spreading outwards in the shape of sun rays emanating from a central core. Today's roaches can be dyed in different colours to match the colours used in dance regalia, as can be seen in this photograph by Milton Paddlety.

honours were graded according to how and when one struck an enemy on the battlefield. The first grade was granted to a warrior who struck an unwounded enemy, the second grade would go to one who struck a wounded enemy, and the third grade was given to whoever struck or touched a dead enemy. A warrior who accomplished all three was allowed to wear the deer-tail headdress (roach) on ceremonial occasions (Fletcher and La Flesche 1911: pp. 438–9). This ornament was secured to the scalp lock via a spreader that kept it in place adding to it a decorative element (Fig 94) (see also pp. 40–1). This type of headdress may have originated in the practice of leaving one tuft of hair at the back of the head. The scalp lock symbolized the warrior's vital power and was decorated with personal protective charms and feathers. The importance of scalp locks in Plains Indian martial symbolism is retained in modern-day dancers' common usage of deer-tail hair roaches (Fig. 95).

So important was the collection of coups that among tribes such as the Osage, brave warriors were entitled to wear special marks of distinction tattooed on their bodies in the form of knives and pipes on the sternum, chest and shoulders (La Flesche 1914). The practice of tattooing honourable marks on the body was once also widespread among more northern tribes such as the Plains Cree, Hidatsa, Sioux and Assiniboine. Some of the most commonly tattooed marks were dark bluish or black stripes made on shoulders and arms that denoted the numbers of horses captured or people that the warrior had counted coup upon. These marks eventually became decorative elements applied on leggings and war shirts (Fig. 96).

Plains warriors' visual language of valour was complemented by more graphic forms in which conventional signs or icons were directly associated with ideas or events that happened to individuals or groups. Tallies of guns or scalps accumulated during raids and war expeditions were listed on shirts and leggings but could also be included on shields and weapons such as clubs. Clubs were the striking weapon preferred by Plains Indians, and a variety of typologies existed. Gunstock clubs, whose name derives from their shape but which may originally have been made of curved antler, and ball-headed war clubs are the oldest forms of offensive weapon recorded among Plains Indians (Fig. 97). Both these forms have eastern origins. Long maces with biconical stone heads were common, as were clubs entirely encased in a leather covering. Flail-like clubs with

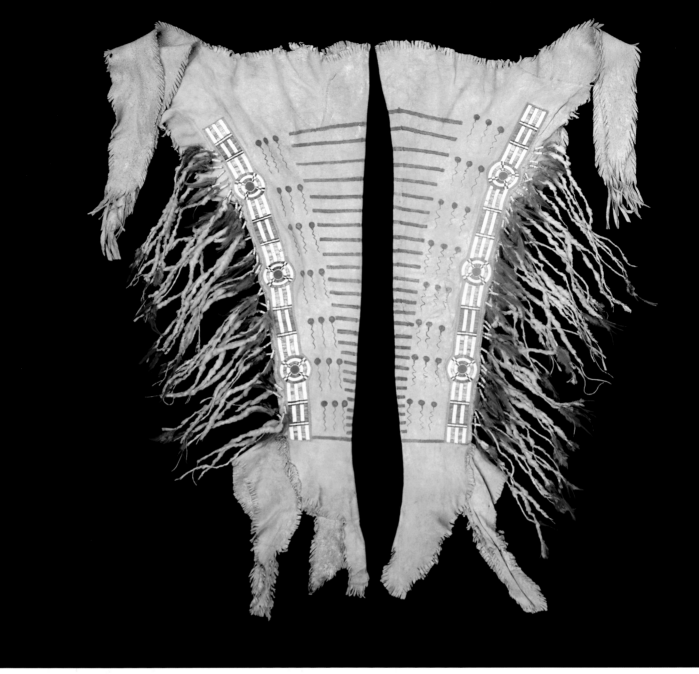

Fig. 96 *Pair of leggings, Blackfoot (Piikani), mid–late 1800s. Skin, glass, ermine tails, porcupine quills and feathers, L 114 cm (Am1972,Q.14.a-b).*
It is not unusual to find parallel lines decorating Plains Indian leggings and war shirts, which derive from body markings made on arms, chests and other visible areas. Designs may vary, but frequently they were shorthand for the wearer's accomplishment or had a protective function.

Fig. 97 *Gunstock, Eastern Plains, early 1800s. Elk antler and bone, L 38 cm (Am1987,Q.15 Donated by Wellcome Institute for the History of Medicine).*
Early forms of gunstock clubs were not equipped with blades. Warriors incised their accomplishments on the handle, much in the same way they did with shirts, shields, leggings and tipis.

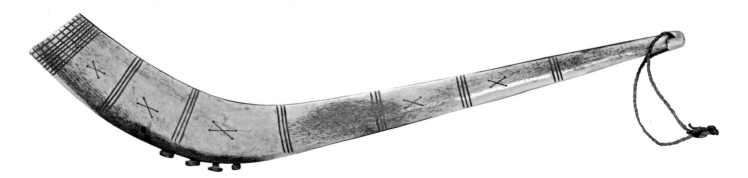

movable heads attached to the wand with a leather strip or pocket were common in the northwestern Plains (Fig. 98). Clubs and maces were highly decorated with personal charms and protective medicines such as carved animal effigies of weasels and snakes. Lightning motifs were also common, and scalps often adorned the tips of the handle. Because of their relatively wider surface, gunstock clubs frequently displayed a warrior's achievements in the form of incised tallies on the handle, much as women once marked their accomplishments by way of dots and lines on their bone hide scrapers. These marks generally referred to the number of prisoners taken, scalps and weapons accumulated, and sometimes realistic scenes of memorable events. Whether immediately accessible to a discerning public or perceived as obscure pictures by onlookers unfamiliar with Plains Indians' visual lexicon, these marks required a re-enactment of the facts associated with each symbol. The oral and performative aspect of biographies and histories associated with these icons has always been paramount to accessing the information stored in pictographic representations on shirts, clubs, hides, tipis and later canvas.

Painted hides were worn wrapped around the body to advertise one's outstanding achievements. Such robes may also have been used in oral accounts and performances to illustrate the owner's memorable deeds to attentive audiences. A hide in the British Museum, of possible Sioux origin, features several episodes in the life of a warrior consistently shown wearing a feather headdress. He can be seen holding scalps, pipes and a bow spear. He is portrayed in various episodes in which he is engaged in one-to-one combat, stealing horses, and touching or perhaps capturing a woman, all actions that may have granted him great recognition among his warrior society comrades (Fig. 99). The same pictographic style for records was also used in rock art, as on the Milk River in Alberta.

Like robes, tipis could display illustrations of significant moments in warriors' careers. Painted lodges were found across the Plains, but images found on them are more frequently associated with the owner's dreams and visions. Common decorations were animal helpers, lightning, and abstract renditions of protective elements such as Whirlwind among the Arapaho and Morning Star among the Blackfoot (Fig. 100). Tipis painted with battle scenes or biographical incidents are frequently called 'battle tipis'. Some prominent examples can be found among the Kiowa, although the Blackfoot and Sioux also produced lodges decorated with pictographic scenes that illustrated their owner's war achievements. The practice of painting battle scenes on tipis was revived among the Kiowa in the second half of the twentieth century, following an old tradition of the Black Leggings warrior society initiated by the prominent warrior Little Bluff in the 1840s. Their current society lodge is replete with military insignia and scenes of brave actions by modern soldiers which took place during recent campaigns with the United States armed forces (Fig. 79).

Plains Indian picture writing used in tipi battle scenes was a system of conventional figures that transmitted ideas, also

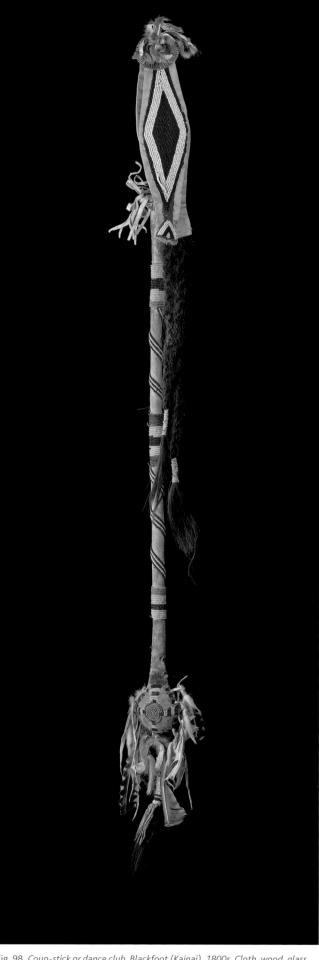

Fig. 98 *Coup-stick or dance club, Blackfoot (Kainai), 1800s. Cloth, wood, glass, buckskin, human hair and feathers, L 110 cm (Am1903,-.81).*

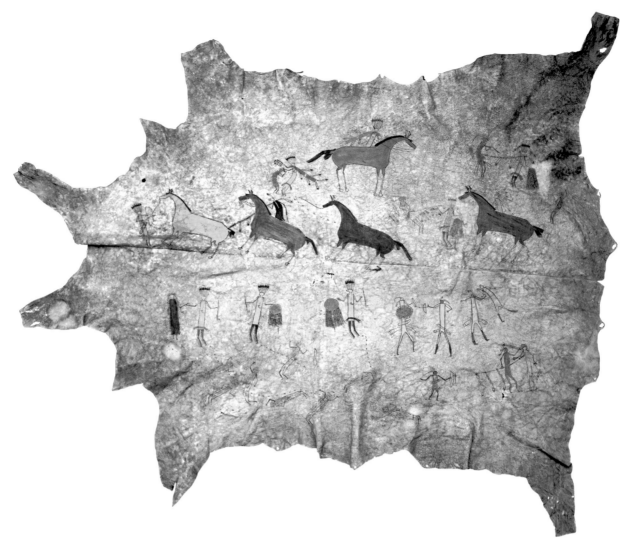

Fig. 99 *Buffalo robe with battle scenes, northern Plains, mid-1800s. Hide, natural pigments, L 220 cm, W 75 cm (Am.917 Donated by Henry Christy).*

Several episodes of the warrior's life are illustrated on this lavishly painted hide. It is possible that some parts of the robe's images may be part of a narrative, although each discrete scene may show a distinct event.

known as ideograms, which were more or less intelligible across the whole region. Although some idiosyncratic styles may have been developed by individual artists, pictures depicting specific ideas or objects conformed to a visual language shared by most Plains tribes. A wounded or killed victim was represented tilted towards one side or with an arched back, almost as if to visually convey the body's backward thrust at the impact of a shot or blow. Specific tribal fashions were recognized by all, and some diagnostic traits were employed to immediately identify the ethnicity of the figure depicted. A particular hairstyle, the manner of wearing moccasins, or whether or not the warrior was partially or wholly painted may be a clue to the ethnicity of certain figures (Fig. 101).

Pictographic renditions of warriors' nudity may also be a clue to ethnic identification. Up until the early nineteenth century male warriors of several tribes went to war entirely naked, their only protection being sacred paint, offensive weapons and personal medicines. In a rare European painting of a confrontation between Pueblo, Pawnee and Otoe from 1720 known as the Segesser hide, one can recognize some of the features generally associated with Pawnee warriors (Hotz 1970). Extensive nudity and body paint, as well as the

use of a star as a protective sacred symbol, are all traits that, in combination, define the ethnic identity of these subjects. Interestingly, the same traits also appear on some figures depicted on the British Museum hide in which an anonymous warrior painted some totally yellow figures, one of which is holding a wide shield decorated with stars (Fig. 102). Although without any oral commentary it is often difficult to interpret some of the events simply on the basis of certain diagnostic traits, it is nonetheless possible to reconstruct with some degree of accuracy the meaning of some of the scenes via the conventional use of particular iconographic markers. Confirmation of the propensity of some Plains Indian tribes to go to war naked is also found somewhat later in the diaries of the La Vérendryes brothers, who explored the northern Plains between 1738 and 1743. They report that Mandan warriors, much like their Assiniboine neighbours, went about only carelessly covered with a buffalo robe (Smith 1980: pp. 51, 59). This fact may explain the unmistakeable appearance of male genitalia only on certain figures as found in many pictographic depictions of battles and hand-to-hand combat (Fig 103).

Visual accounts of hand-to-hand fights are as realistic as they can be condensed in a single icon. Actions such as

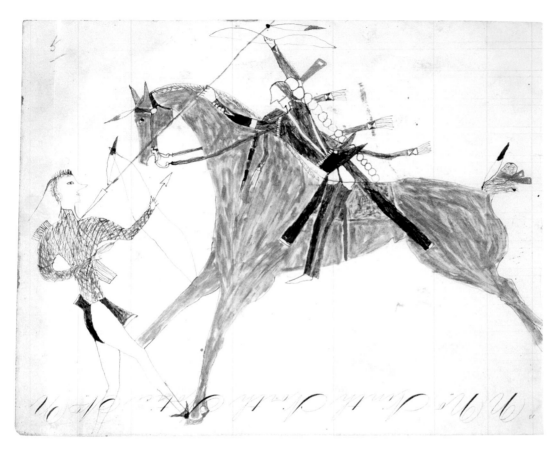

Fig. 101 *Ledger drawing by Tall Bear, Sioux (Oglala Lakota), 1874. Pencil or crayon on paper, H 17.5 cm, W 21 cm (Am2006,Drg.3).* This ledger drawing depicts a man being attacked by a mounted horseman. The upturned moccasins of the standing figure tell us that he is a Pawnee warrior. In this tribe, men wore their footwear in this style and were conventionally depicted in this fashion.

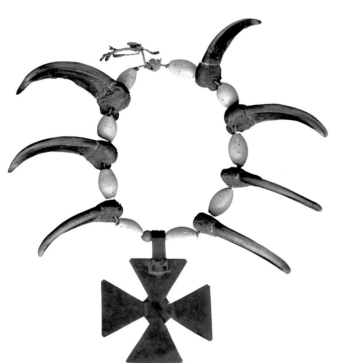

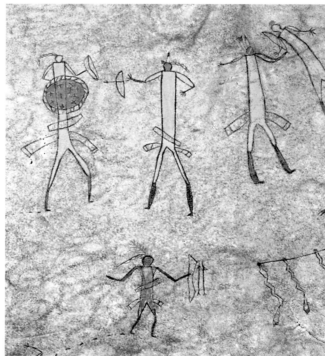

Fig. 100 *Necklace (Blackfoot ?), late 1800s–early 1900s. Metal, glass and claw, L 29 cm, W 26 cm (Am1944,02.257 Donated by Irene Marguerite Beasley).* The large beads, metal star and bear claws, which decorate this necklace, suggest that it originates from the northwestern Plains. In this area large rock circles that aligned with constellations were built for ceremonial purposes and indicate the importance of stars in the cosmology of the peoples from this region, in particular the Blackfoot.

Fig. 102 *Detail of Fig. 99.*
Stars frequently appear on Pawnee objects as protective designs or personal medicine. The shield carried by the man on the left shows several stars against a red background. It is possible that the author might have used this distinctive trait to identify this man's ethnicity.

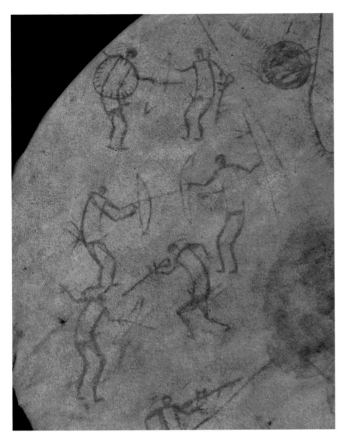

Fig. 103 *Shield cover, Pawnee, early 1800s (?). Buckskin and natural pigments, diam. 59.8 cm (Am.5202.b Donated by Sir Augustus Wollaston Franks).* Naked figures of men with erect phalluses engaging in hand-to hand combat are visible on the cover of this Pawnee shield. It is not yet clear why only some warriors display this convention, which appears in numerous pictorial representations of men in combat.

biographic narratives painted on hides required extensive elaboration on the images associated with particular events. Ideograms may give a clue to what happened and who was involved, but details transmitted orally were crucial to fully appreciating the intricacies of the story. The whole experience may have included repeating the motions as if to re-enact what had taken place in the past. The simple aesthetic appreciation of pictograms and ideograms as discrete forms of artistic expression does not do justice to the combination of kinaesthetic, oral and visual stimuli engendered by these performances, which were intended to complement and complete the images by engaging the listeners' emotions.

Before the introduction of Western-style schooling, Plains Indians had developed a highly sophisticated system of knowledge transmission that made full use of the complementary technologies of writing, oral narration and performance to convey meanings from the ideologies upon which their cultures rested. As well as being a useful means for delivering immediate messages, such as what happened when in a particular circumstance, picture writing communicated to its most immediate audiences at entirely different levels of comprehension. The totality of signs and images associated with honourable actions, such as tallies carved or painted and realistic vignettes drawn on hide and later paper, visually quantified the amount of intangible power a man possessed. Such icons not only literally translated facts into visual records, but also proved a man's spiritual potential. In this sense, picture writing can be legitimately considered a technology of the intangible, as it renders manifest what could not otherwise be seen or experienced.

touching an enemy were generally translated into pictures of men stretching their arm towards a figure, but sometimes the icon of a single hand would suffice to deliver the message. A hand juxtaposed to a weapon may signify having captured it from an enemy, whereas figures with no hands may have signified the helplessness of captives (Mallery 1893). Body parts, such as a head linked to another symbol by a wavy line, consistently stand for personal names of persons whose power directly derived from the icon with which it was associated. Additional icons juxtaposed to figures of heads signified that particular individuals were involved in events which, not infrequently, can be difficult to interpret without appropriate oral explanations or notes written on the margins. What is clear is that whatever the icon near a head may mean, the two images have a causal relationship. The person whose name is visually rendered as a head may have been the victim or the agent in a specific event. This convention was particularly used in nineteenth-century winter counts and censuses carried out among Plains peoples in newly established reservations (Mallery 1886, 1893) (see Fig. 46).

Ideograms condensed in one image the essence of the event, but additional details were required to complete the whole picture and this was generally done orally. The regular retelling of personal and tribal histories via winter counts or

Diplomacy and war

As we have seen, spiritual sanction and supernatural protection were paramount in nineteenth-century Plains Indian warfare. The significant role played by the ceremonial and ritual management of supernatural forces legitimately locates warfare practices on a seamless continuum between religion and politics. This intimate relationship between these two seemingly unrelated contexts has been examined with regard to war medicines, charms and tribal and personal fetishes. However, the objects that best epitomize the convergence of religion and politics with reference to warfare are the pipes used in warfare ceremonialism and inter-ethnic relations (Fig 104). Among nineteenth-century Plains Indians, both peaceful negotiations and war ceremonials involved extensive use of pipes. This practice should be understood in the broader ideological framework of ritual exchanges and notions of reciprocity at the core of mourning, adoption and vengeance practices that have ancient roots in eastern woodlands and Midwestern archaeological cultures.

The use of pipes among North American peoples dates back to prehistoric times when crude clay tubes may have been used for curing, possibly by blowing smoke on patients in healing sessions. Pipes were used to smoke tobacco from the genus *Nicotiana rustica* that is powerful enough to induce

hallucinations. Archaeologists have therefore suggested that the original function of pipes was in shamanic rites during which contact was sought with supernatural forces. More elaborate forms of pipes appear among the Adena and Hopewell complexes developed in the Woodland period between 1000 BC and AD 1000 (Fig. 105). Known as effigy pipes, stone and clay versions of this popular object that represented humans and animals are believed to have been associated with tutelary spirits, protective beings or totemic ancestors. While smaller specimens may have been included in personal medicine bundles, larger stone bowls were likely used in communal rituals developed within the context of the ceremonialism of Mississippian chiefdoms. Although the use of

Fig. 104 *Pipe stem (front and back), Sioux (Santee ?), 1840s. Wood and dyed porcupine quills, L 96 cm, W 2.1 cm (Am1949,22.155).*
Thunder and underwater beings appear on the porcupine quill decoration tightly wrapped around this flat-stemmed pipe of northeastern Plains origin. The thunderbird is rendered here in the red hourglass figure, whereas the *piasa* or mythical underwater panther can be seen encircled by its long tail. The two figures are intentionally juxtaposed to signify the mediatory role that humans play in keeping the universe balanced through prayers and invocations that make use of the pipe.

Fig. 105 *Smoking pipe, Chillicothe mound, Ohio, Hopewell culture, c. AD 1–400. Stone, L 12 cm (Am,S.315).*
Composite beings, such as the one represented in this pipe from the Hopewellian period, suggest a state of transformation from bird to man or vice versa. Alternatively, this effigy may be an anthropomorphized version of a thunder being, as indicated by the wavy lines on the wings, reminiscent of later zig-zag motifs.

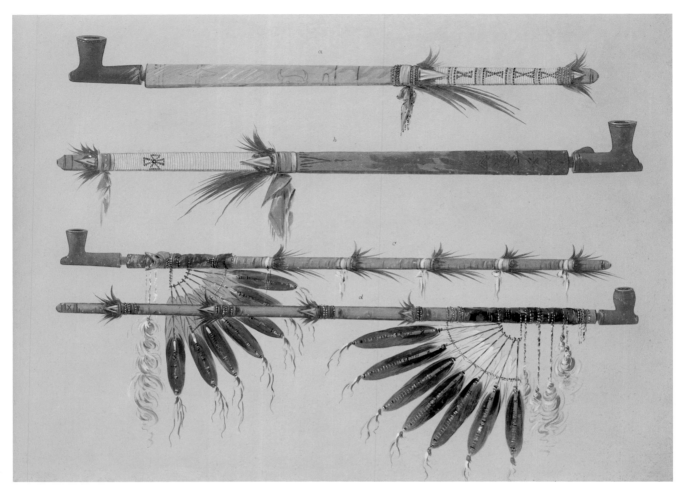

Fig. 106 *Portfolio of Pipes, by George Catlin, 1852. Oil on cardboard, H 44.3 cm, W 57.8 cm (Am2006,Ptg.25).*
Although some details of the pipes painted by George Catlin may be embellishments, they are close enough to real specimens collected during that period. Tufts and porcupine quill decorations are quasi-realistic, and so are the mallard head on the third pipe and the feather fans normally used in calumet ceremonies.

effigy pipes continued well into the proto-historic and historic periods with the production of personalized red clay catlinite carvings of birds, mammals and humans, solid geometric bowl forms prevailed in the production of ceremonial pipes (Ewers 1987).

Plains peoples developed a specific type of pipe ceremonialism perhaps as early as the fourteenth century. Archaeological finds have proved that there is a direct link between old forms of stone pipes and the nineteenth-century pipe bowls used in what came to be known as 'calumet ceremonies'. These ceremonies established diplomatic relations, sealed pacts and consecrated adoptions between two individuals or tribes (Blakeslee 1981). Caddoan-speakers such as the Pawnee, Arikara and Wichita are credited with having originated the calumet ceremony as part of the liturgy established for adoption rituals (Murie 1981). Historically, however, the ceremony also belongs to the Omaha, Osage and other Siouan-speaking peoples whose ancestors occupied the vacant quarter left at the fragmentation of Mississippian chiefdoms at the confluence of the Mississippi, Ohio and Missouri rivers after the fourteenth century (Bray 2003). Trading centres established in the permanent villages of people later known as Omaha may have been important diffusion points for some of the ancient ideas that underpinned historical adoption ceremonies involving the use of calumets, for example, among the Arikara and northern Sioux groups such as the Hunkpapa (Fig. 106). These ceremonies were generally associated with mourning the loss of tribal members and their replacement via integration of captives and prisoners into the tribe.

The origins of the calumet ceremony have been explained in relation to the widespread notion and practice of the 'making of relatives'. This is a ceremonial process by which two people, families or larger groups become related via symbolic kinship-like bonds that establish reciprocal obligations of respect, friendship and mutual support. Entire tribes could be symbolically adopted with the same calumet ceremony that replaced a dead relative or a warrior lost in battle with a child or a prisoner. It is symptomatic that tribes such as the Iowa, closely related to the Otoe, had a pipe ceremony in which the distinct relationship between mourning and adoption was clearly expressed by the sequence of laments for lost friends and the welcoming songs dedicated to newly made acquaintances (Skinner 1915b: pp. 700–1).

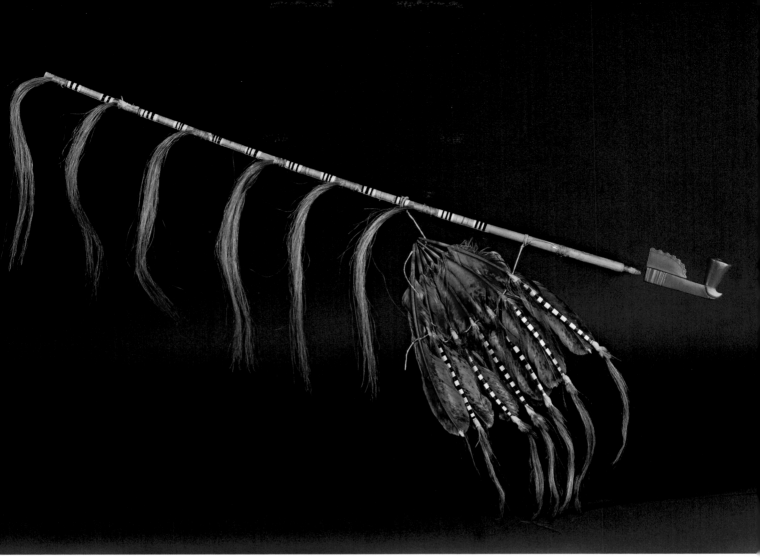

Fig. 107 *Pipe stem with feather fan and pipe bowl, Northern Plains, c. 1825. Wood, feathers, horse hair, dyed porcupine quills and catlinite, L 113 cm, H 7 cm (Am.5200.a Donated by Sir Augustus Wollaston Franks).* This early calumet-style pipe from the northern Plains can be compared to Catlin's rendition opposite. This typology of pipe was used exclusively for ceremonial occasions. Bundle pipes may be made of a single piece of stone, have a flat circular bowl, or have special decorations that made them appropriate only for particular ritual usage.

A similar idea was expressed in the *hunka* adoption ceremony of the Sioux, which bore a striking resemblance to calumet ceremonies found among southern tribes. In this version of the ritual making of relatives, the adoptee first was treated as an enemy being counted upon and was then ceremonially bound to his adopter under the solemn oath whereby should one of them be killed the other had to seek revenge in order to appease the spirit of the deceased. The ceremonial connection made between a dead person and his substitute not only established a seamless continuum between two distinct realms of existence, but also suggests an ideological analogy between a notion of appeasing the spirits of unavenged dead individuals and making peace with potential enemies by ritually integrating them into the tribe.

Ceremonial pipes used in adoption rituals seem to have derived from ancient forms of ritual rods that could not blow smoke. This is a typology of objects that was used in the Pawnee *hako* and Omaha *wa'wan* ceremonies (Fig. 107). These ceremonial rods were replete with cosmological symbolism transmitted via the materials, colours and shape of the object. Echoes of martial symbolism in later developments of flat-stemmed pipes may be detected in the similarities between their shape and that of ancient spear throwers (Fig. 108). Originally, this archaic weapon may have been used to hold in place ceremonial stone bowls for burning tobacco in the hole destined to accommodate the index finger while ejecting the dart (Hall 1997: p. 118).

Many early European observers underwent long and elaborate calumet ceremonies among the Native groups inclined to establish peaceful relations with them. Such ceremonies aimed at making the newcomers adoptees. The symbolic integration of Europeans or foreigners into the tribe created relationships of reciprocity that entailed mutual obligations and aid. Marriages between indigenous women and European settlers, for example, significantly facilitated diplomacy and were often encouraged in order to establish peaceful inter-ethnic relations (Wischmann 2004). Plains Indians' notion of reciprocity included exchange of goods as generally entertained between kinsfolk, because newly established relationships were considered analogous to kinship ties. Symptomatically, adopters and adoptees were distinctively regarded as father and son or brothers, in accordance to the relative positioning of power implicitly recognized in the transaction. Understandably, these

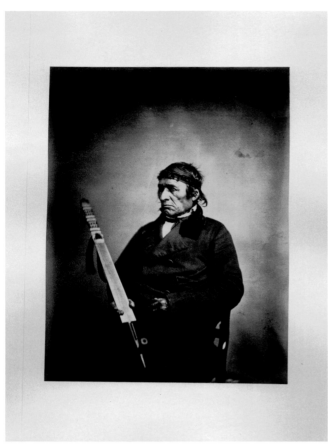

Fig. 108 *Sioux leader Sha-kpi (Six), Sioux (Mdewakanton Dakota), on a diplomatic visit to Washington holding a flat-stemmed pipe, 1858. Albumen print, H 16.2 cm, W 12.1 cm (Am,A30.12).*
Plains pipes can be flat, tubular and with an intricately carved stem called puzzle-type because the smoke channel does not run in a straight line from the mouth to the bowl.

ceremonially sanctioned relationships drew together political, economic and religious meanings that were extremely important for Plains Indians' intra and inter-ethnic relations. Europeans, on the other hand, perceived these transactions as primarily economic and political agreements. These two different perspectives resulted in almost diametrically opposed ways of managing diplomatic relations between nations. Whereas Europeans' adoption of the idiom of kinship became an artificial necessity in political negotiations with indigenous peoples, Native North Americans' metaphorical usage of kinship terms had connotations of deeper social ties that implied more than what Europeans simply interpreted as economic or political stipulations.

Diplomatic encounters between nations were marked by the use of pipes whether or not in the context of ritualized calumet ceremonies. In any case, the use of pipes was meant to unite symbolically under a sacred oath two individuals or factions through the invocations to unseen forces via the sacred smoke from tobacco (Figs 109, 110). Also, while it opened a relationship between strangers, it established a channel of communication with supernatural realms. Pipes were used extensively for both individual and communal

rituals and they were universally included in tribal, society and personal bundles. The sacred war pack of the Omaha, for example, kept in the tent of war, contained two war pipes that were smoked before an aggressive war party set off with more than a hundred warriors (Fletcher and La Flesche 1911: pp. 411–15).

Whether large or small, a war party always included a pipe in portable altars carried to perform all the ritual prescriptions required before going to war. War parties were not always large, however, and before the nineteenth century at least, consisted of no more than a few dozen men. With the increase of population movements triggered by the colonization of North America, the need for bigger and stronger mobilization became more common. War parties typically consisted of warriors and their leader, scouts, horses and helpers. Younger or inexperienced men took charge of looking after the animals, fetching water and wood, and cooking for the warriors, while the scouts explored the surrounding territory to alert the party of possible dangers. Party leaders were responsible for the whole group, but their executive decisions about strategies and tactics were not always followed by all. Some war parties set off as a result of dreams, but those that were organized in retaliation for previous attacks also had to have spiritual sanction. Prayers, invocations and sweat baths were necessary preconditions to setting off on the warpath and a great deal of ritual activity took place before, during and after the expeditions, whether or not they entailed actual fighting. War, captive or death songs, in particular, constituted an important part of the warfare preparations that infused courage and offered additional protection to individual warriors who may have received them during a vision quest. Ritual life extended into the realm of war and the battlefield because Plains Indians perceived war to be an aspect of human activity that was as regulated by spiritual agency as any other. This is why ritual rules were as relevant to what we may perceive as daily life as they were for war and diplomacy.

Implementing taboos, burning ceremonial incense and smoking tobacco were among the most common ritual procedures associated with warfare. It is significant that party leaders were also known as 'pipe carriers' or 'pipe keepers', that is, they were in charge of the sacred pipe that accompanied the war expedition. Pipe keepers and lance bearers were among the most important functions that were only given to highly respected society members during a war expedition. The pipe keeper's responsibility was to perform rituals of protection and purification for his comrades before, during and after the war raid. It is possible to identify a pipe keeper performing a series of war-related actions in the imagery of a robe in the British Museum (Fig. 111). He is consistently depicted holding a pipe. This convention simultaneously marks him as the leader of the group and enables him to stand out among the other figures.

In historic studio photographs leaders are often seen carrying pipes as well as the ubiquitous tobacco bags that contained the sacred tobacco. These items were insignia of their status as warriors but also signified that they had been

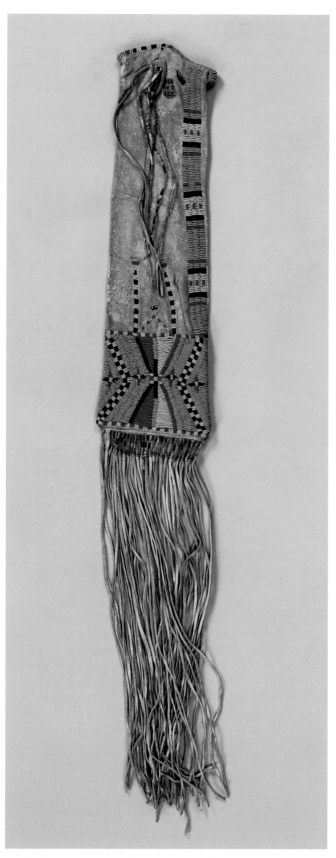

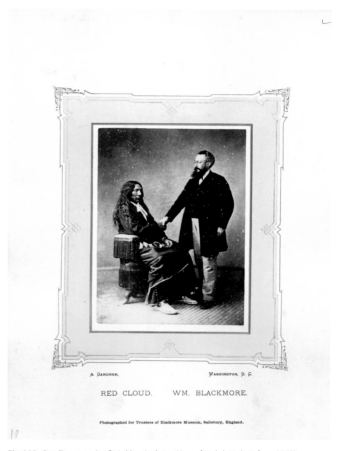

Fig.110 *Studio portrait of Makhpyia-luta, Sioux (Oglala Lakota) and William Henry Blackmore (1827–1909) by Alexander Garner, 1872. Albumen print, H 13.3 cm, W 9.6 cm (Am,A1.37).*
Prominent Sioux leader Makhpyia-luta is shown here in an amicable handshake with philanthropist and collector William Henry Blackmore. After achieving numerous victories against the American army, Makhpyia-luta signed the Treaty of Fort Laramie in 1868.

Fig. 109 *Pipe bag associated with prominent Sioux (Oglala Lakota) leader Makhpyia-luta, known among Americans as Red Cloud (1822–1909), mid-1800s. Skin, glass, porcupine quills, L 95 cm, W 12 cm (Am1944,02.223 Donated by Irene Marguerite Beasley).*

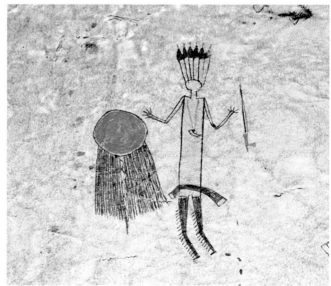

Fig. 111 *Detail of Fig. 99.*
The man in this scene is identified as the pipe carrier of a war expedition. The image shows him carrying a pipe in his left hand, and also signals that he took a scalp, here represented with a red circle. Drops of blood are visible on the flowing hair.

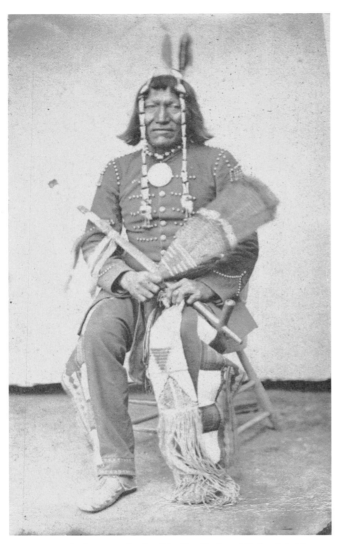

Fig. 112 *Portrait of Two Bear, leader of the Sioux Yanktonai (Dakota), holding a pipe and his personal tobacco bag, photograph by William Henry Blackmore, 1800s. Albumen print, H 10.2 cm, W 6.2 cm (Am,A9.75).*

The use of pipe bags can be seen as an extension of the practice of carrying on the person protective medicines in pouches and small leather wrappings. Tobacco was, and still is, regarded as a powerful medicine and one of the most sacred plants in North America. Its leaves were smoked alone or in combination with a variety of herbs, barks and roots. Tobacco is not only smoked on ceremonial occasions but serves many other purposes in ritual contexts. It can be offered as a prayer in small sachets that hang from tree branches, and it can be used as food for ceremonial objects such as drums, when their surface is smeared with the sacred plant in order to sanctify the instrument before a ritual singing.

Tobacco and pipes were recognized as symbols of peace and friendship across North America. They were, in fact, the counterpart to offensive weapons such as clubs and tomahawks that were used to kill. In the early colonial period, peace negotiations often included the burying of hatchets and tomahawks to signify the cessation of hostilities between two opposing factions. This practice was also common in treaty negotiations with colonial powers. With the increase in diplomatic relations between indigenous nations and Europeans, the recognition of the symbolic importance of pipes and tomahawks led to the invention of a new typology of objects that combined the characteristics of both items: a blade and a bowl (Fig. 115). This new form of pipe-tomahawk soon became a successful trade item that simultaneously conveyed the dual, complementary role of diplomacy at the crossroads between peace and war, distinctly signified by the elements that typically characterize each object. Pipe-tomahawks may have been invented by the English, who saw potential in marketing this new item to the indigenous Native nations. Two types of pipe-tomahawks became particularly popular among Plains tribes: one with the axe blade and the other with a spontoon. This latter typology derived its shape from the pole arms used by European foot soldiers during the eighteenth century. These spontoon-shaped blades often resemble the shape of the *fleur de lys* and may have been introduced to the Plains tribes by the French among their trading partners such as the Osage (Fig. 116). Sometimes blades display motifs cut in the shape of hearts. Owners of pipe-tomahawks also added personal touches on

photographed during diplomatic visits, which normally required the use of the pipe for sealing pacts and alliances. Personal pipes were stored alongside large tobacco bags decorated with quill and beadwork (Fig. 112). The shapes and styles of tobacco bags varied according to tribal and individual taste and sometimes included a case to store the pipe. Plains tobacco bags generally follow a distinctive rectangular cut. The bottom is heavily decorated with leather fringes and strips wrapped with dyed porcupine quills. In some cases the body of the bag may be smeared with coloured pigments, but this characteristic is mostly limited to southern Plains tribes such as Comanche and Kiowa, and central Plains groups such as southern Cheyenne and Arapaho (Fig. 113). By the beginning of the twentieth century tobacco bags could be almost entirely decorated with figures derived from the elaborate and vibrant lexicon of picture writing. This style became so popular among the Sioux that during the early twentieth century women started to produce all sorts of garments with completely decorated surfaces (Fig. 114).

Fig. 113 *Tobacco bags (from left to right): Sioux (?), Cheyenne, Cheyenne and Sioux (Dakota), all 1800s. Skin, glass and dyed porcupine quills, approx. L 100, W 18 cm (Am1930,0409.41 Donated by Lady Maud Wood, Am1948,17.3, Am1944,02.215 Donated by Irene Marguerite Beasley, Am1935,0710.3.a Donated by Miss Dollman Am1930,-.37).*
Note the separate case for the pipe in the fourth specimen from the left.

Fig. 114 *Beaded waistcoat (front and back), Sioux (Dakota), early 1900s. Skin, glass and textile, L 54 cm, W 60 cm (Am1954,05.947 Donated by Wellcome Institute for the History of Medicine).*
Entirely beaded items such as this Sioux waistcoat became popular in the late nineteenth century. The decorative motif visible on the front of this item (right detail) shows bullet holes with streaming blood placed symmetrically. On the back, the wearer is depicted fighting. Shots have been conventionally conveyed by the lines at the end of the guns and scalps can be seen hanging from the horses' bridles.

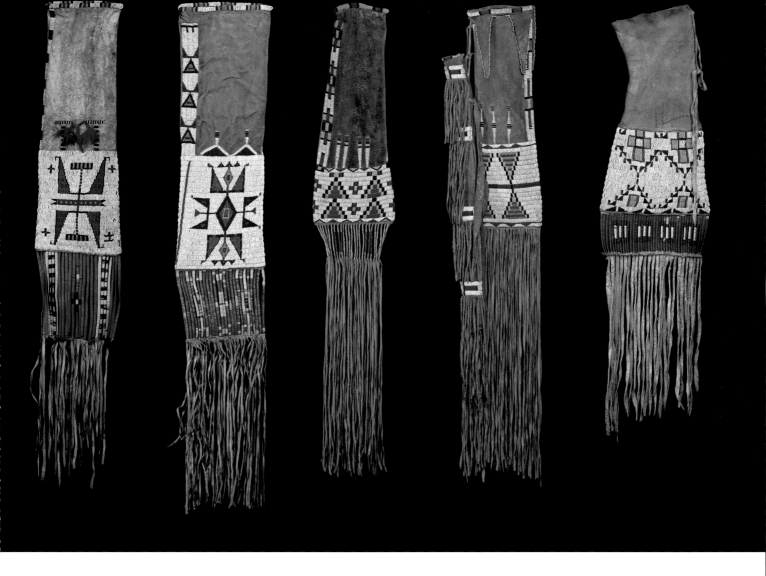

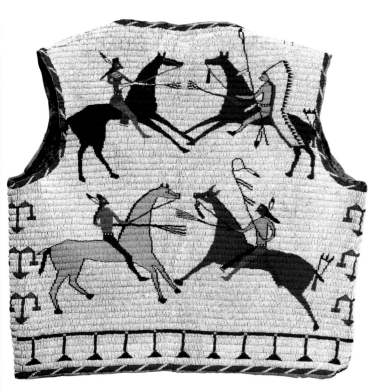

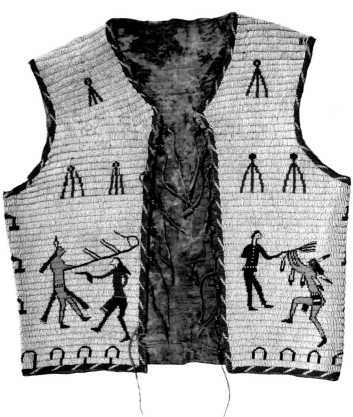

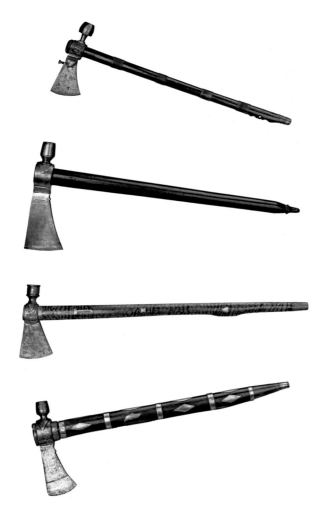

Fig. 115 *Tomahawk pipes (from left to right), Plains peoples, 1800s. Iron, brass and wood, approx. L 55 cm, W 8 cm (from top: Am,Dc.69.a, Am,Dc.72.a, Am,Dc.74.a-b, Am,Dc.75).*
The stems on tomahawk pipes could be customized according to taste with studs, metal plaques and brass rings.

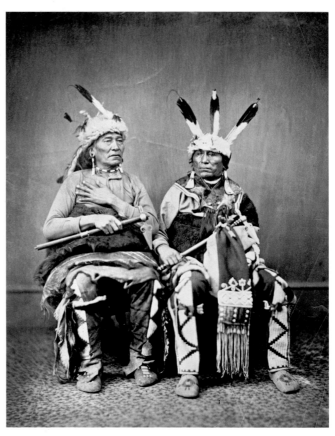

Fig. 116 *Sioux leaders holding spontoon-type tomahawks, left: Si-ha-han-ska (Long Foot), Sioux (Yankton or Yanktonai), right: unidentified man, Sioux (Yankton-Yanktonai), photograph by Alexander Gardner, Washington, DC, 1868. Albumen print, approx. H 16.3 cm, W 21 cm (Am,A13.5).*

Fig. 117 *Ceremonial pipe-tomahawk with beaded tab, Blackfoot (Kainai), 1800s. Wood, brass, dyed horse hair, fur, glass and skin, L 93 cm, W 37 cm (Am1903,-.82)* Tomahawks were prized possessions, which warriors decorated with hair locks, fur or beaded appendages attached to the stem.

the stems and tips, most notably scalps, decorated handles and beaded drops. The use of pipe-tomahawks was almost exclusively symbolic, in contrast to other types of hatchets and axes that were used as weapons on the warpath (Fig. 117).

In addition to the ubiquitous clubs, iron-bladed tomahawks and shields, weapons used in indigenous warfare included bows and arrows, lances, knives, pistols and rifles. Apart from imported powder-operated technologies that reached the Plains in the late historic period, arrows and lances included non-indigenously produced elements such as blades and arrow points. The prehistoric indigenous manufacture of copper blades did not survive the many changes that resulted in the development of historic Plains tribes. Consequently, for centuries until the arrival of European goods, ceremonial, projectile and offensive points for spear thrower darts, lances, spears and arrows were made of chert, obsidian, quartzite and other local stones.

Spear throwers were the most common weapons in North America until the first half of the first millennium AD, when bows and arrow became increasingly diffused. The

new technology, imported from Asia, revolutionized North American hunting and warfare techniques and resulted in more effective long-distance combat. Arrows were endowed with the swiftness associated with lightning, and in some cases their shafts were decorated with the ubiquitous zig-zag design associated with the destructive power of thunder beings. Even after muskets became universally traded among Plains tribes, bows and arrows retained some advantages. They did not take long to charge and could operate better in damp weather than the cumbersome, heavy muskets. It was only with the arrival of rifles and automatic guns that the benefits of using European technologies were recognized in full by all Plains tribes.

Lances, too, slowly incorporated iron and metal blades and points, although they were never thrown, but rather driven into the opponent's body (Fig. 118). While technological improvements were acknowledged, what was really valued among warriors was direct contact with the enemy. This was highlighted in warrior societies' codes of honour that dictated the scale of importance attributed

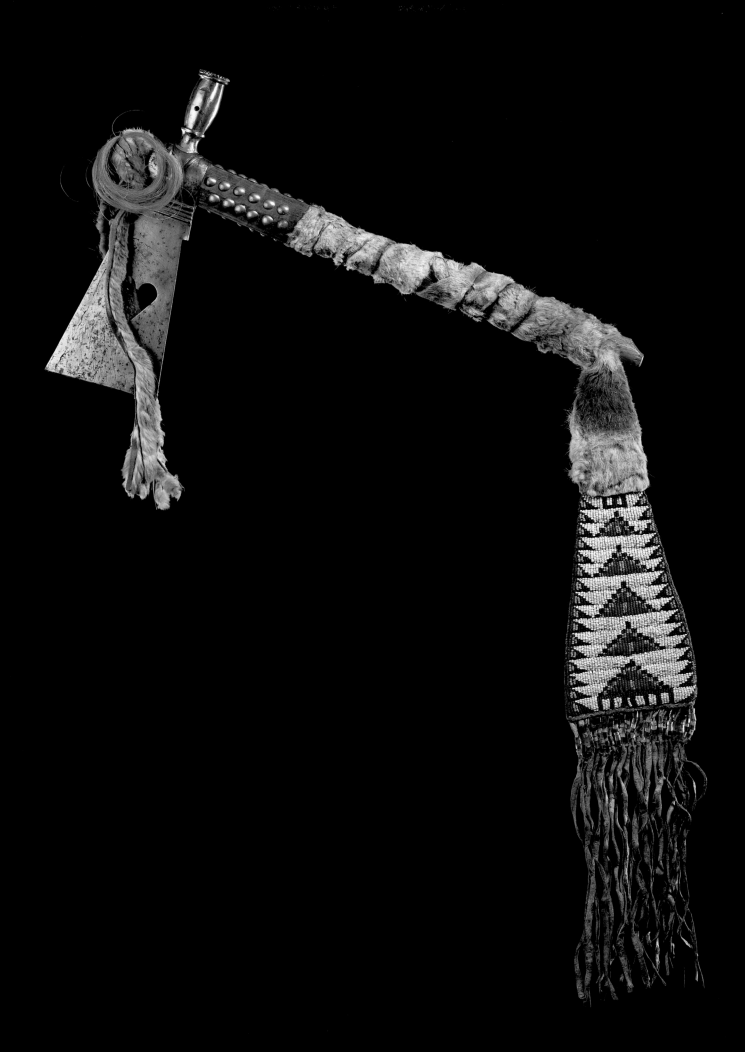

to warriors' battle deeds. The importance of hand-to-hand combat, in fact, was reflected in the universal use of weapons such as knives. In earlier times, knives were carried in triangular cases hanging around the neck. Among tribes such as the Osage and Omaha this practice was symbolically referred to in ritual tattoos that included stylistic representations of pipes diametrically flanking the central motif (Fletcher and La Flesche 1911: pp. 219–21; La Flesche 1914). These tattoos were worn by prominent warriors and may have been the original inspiration for the triangular neck flap that could be folded or applied on the front of war shirts. The blades of these early flint knives were generally symmetrical, but the introduction of iron blades of European manufacture brought to the Plains the asymmetrical knife now most commonly seen in museum collections. The bilaterally symmetric shape of knives was, however, retained in the so-called beaver-tail iron knives that were mostly popular among northern Plains tribes such as the Blackfoot and Plains Cree. Asymmetrical knives required a different type of sheath that was worn at the belt rather than at the neck (Fig. 119). Ceremonial knife sheaths included tassels and decorations generally not integral to the generic sheath design. Sioux knife sheaths, in particular, like other objects manufactured in this tribe, sometimes display rawhide plume-tipped tassels wrapped in red porcupine quills. This decoration stemmed from fringes decorating ceremonial garments. They are said to represent the blood streaming from the nose of a killed buffalo (Wissler 1904: p. 252). On the whole, the decoration and design of knife sheaths did not carry any specific symbolic meaning, unless significance was attributed to particular geometric forms most frequently found on this type of object (Wissler 1904).

Knives continued to retain their practical and symbolic importance even during the intensification of conflicts with Euro-Americans and Canadians that were mostly carried out on horseback and at a distance (see pp. 112–3). Despite

this, hand-to-hand combat sustained Plains Indians' martial values and ethos. As fighting opportunities increased following colonization, so did intertribal conflict. Pressure to occupy already inhabited territories generated by these new predicaments gave Plains warriors more chances to establish an honourable reputation through more frequent war raids. However, intertribal conflict dynamics inevitably put a strain on the delicate balance between Plains Indian political economies based on supply and demand. This eventually resulted in an increase in competition over resources, whose value and meanings became slowly shaped by the new market economy introduced by the ever more frequent exchanges with Europeans. These new transactions also brought changes in the ideologies of power, because processes of exchange and trade of imported goods tended to devalue the spiritual meanings associated with personal and tribal medicines and protection. European arms and technologies represented astonishingly powerful medicine. As a result, Plains Indians re-evaluated the meanings and values they attributed to old as well as new technologies.

Although the martial ethos of warrior societies was retained in much of the fighting and ceremonialism, some of the most radical innovations such as horses, iron and guns deeply affected Native North American ideologies and values. Above all, they contributed to the progressive erosion of traditional authorities based on the persuasive power of tribally owned spiritual symbols that, despite desperate efforts, could not protect indigenous nations from the overpowering medicine of Euro-Americans and Canadians as expressed through their military might. This proved so detrimental to the physical survival of Plains Indian nations that by 1900 they were at their lowest numbers in history. Although we have to remember that the nature and extent of violent confrontations between Native North American peoples and settlers was not the same in Canada as in the United States, the overall impact of colonization can be

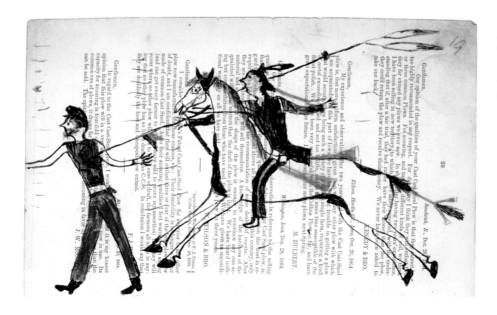

Fig. 118 *Ledger drawing, Good Bear, Sioux (Oglala Lakota), 1874. Pencil or crayon on paper, H 14.2 cm, W 22.4 cm (Am2006,Drg.39).*
Here Good Bear depicts a mounted warrior thrusting an American standard – turned into a lance – into a soldier's body.

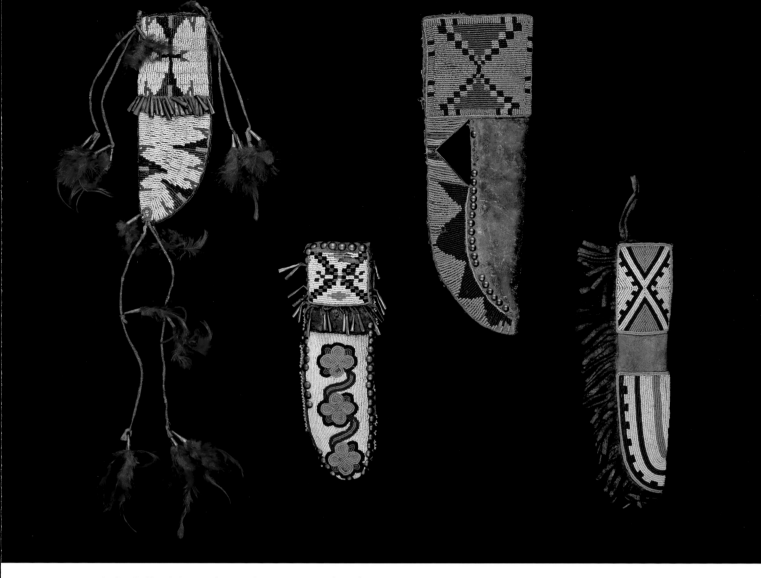

Fig. 119 *Knife-sheaths (from left to right), Sioux, Blackfoot, Blackfoot (Kainai), Assiniboine (?), 1800s. Skin, porcupine quills, brass, feathers and glass beads, approx. L 30 cm, W 10 cm (Am1948,17.8, Am1887,1208.14, Am1903,-.83, Am1949,06.26 Donated by Lt-Col W.T. Pares and Maj J. Pares).*

The variety of styles displayed by this collection of knife-sheaths shows the creative vitality of Plains Indian expressive cultures. Whereas some knife-sheaths were made to accommodate only the blade, in cases such as in the third item from the left, a large area was purposefully designed to be decorated with beads, metal cones or tassels.

seen in the effects it had on their lives. During the havoc caused by the numerous wars, diseases and starvation that plagued the Plains during the nineteenth century as a result of resettlements, boarding schools and rations, many warrior societies and their customs vanished with the deaths of the last people who retained the knowledge to carry on the traditions. Some leaders, however, managed to keep alive various traditions and practices. At the moment when the last hopes seemed to disappear under the threatening prospect of assimilation, leaders of tribal and warrior societies turned to traditional objects and their associated practices to re-establish crucial links to things and values they seemed to have abandoned in entering the new reservation era. While the Canadian and American governments and their officials made concerted efforts to stamp out every expression of former lifestyles, indigenous peoples' resilience and resistance to assimilation usefully capitalized upon the symbols that for centuries had kept them together as

nations. These were the medicine bundles, warrior regalia and weapons that had sustained Plains Indians' spiritual and material life. These symbolic objects' dormant power ultimately proved to be so great that by the second half of the twentieth century, under the impulse of struggles over cultural self-determination, new generations started engaging with the idea that continuity with the past was precisely what was needed to survive at the moment when tribes were forced to face new challenging predicaments (Dombrowski 2008; Farr 1993; Nagel 1997; Powell 1969). Objects once again began to regain their inherent spiritual strength, which although muted, was never entirely lost due to the care and respect with which they were treated by old leaders and warriors alike. It is to the power of these objects and the belief that protection would ensue from their proper handling that indigenous nations of the United States and Canada owe the exuberant resurgence of their cultures that has continued to the present day.

Plains Indian wars

Sporadic encounters between Plains Indians and Europeans started in the sixteenth century with Spanish conquistadors who made contact with southern Plains tribes such as the Wichita, Caddo, Pawnee, Apache and Jumano. French explorers and traders encountered northern tribes such as the Plains Cree, Sioux, Gros Ventre and Assiniboine living on the north-northeastern borders of the Plains. These first contacts were rarely violent. Apart from rare exceptions involving occasional killings, no sustained conflict between Native nations and settlers erupted on the Great Plains before the establishment of the new frontier. American president Andrew Jackson's creation of the Indian Territory in what is now Oklahoma in the early 1830s triggered increased interest from settlers in the colonization of the Plains. Frontier violence became reality for many southern nations such as the Comanche and Kiowa during the 1840s, when they were caught between Mexico and Texas, each of which claimed as their own territories that until then had been under Native control. Nomadic tribes living in these southern territories saw their pastures invaded, and pressures to share land with newcomers resulted in mounting animosities which, in many cases, resulted in fully-fledged wars across the whole region. When California became part of the Union in 1848 following the defeat of Mexico, crossing the Great Plains was the only route west from Oklahoma. As a consequence of the California Gold Rush, most Plains tribes became involved in wars and battles with American armies throughout the nineteenth century. These conflicts, and less violent episodes such as retaliations and raiding, are generally known collectively as the Plains Indian Wars. While some tribes were more involved than others in such conflicts, no Native nation was left unaffected by these major upheavals. One of the earliest episodes of the Plains Indian Wars was the so-called Minnesota Uprising, led by Santee Sioux leader Little Crow (1810–63). The retaliation against Indian attacks on American settlers following broken treaties between the nations ended with the mass hanging of thirty-eight warriors in Mankato, Minnesota in 1862. Teton Sioux and their Cheyenne and Arapaho allies fought under Sioux Red Cloud (Oglala Lakota, 1822–1909) in the war for the Bozeman Trail (1866–8). A later war that involved Arapaho, Comanche and Kiowa broke out in the southern Plains (1868–9), and Comanche clashed with the American army under Quanah Parker (c. 1845–1911) in the Red River War (1874–5).

Although treaties were stipulated between Native nations and government armies, pioneers and marauders often ignored territorial boundaries established for the protection of settlers and Indian tribes alike. The first Treaty of Fort Laramie of 1851, for example, was signed to ensure pioneers' safe journey to Oregon across the Plains, but despite promises and negotiations, tribes who agreed to the treaty's conditions eventually lost the area corresponding to the current states of Colorado, Kansas, South Dakota, North Dakota, Montana, Nebraska and Wyoming (Figs 120, 121). Confrontations between the American army and nations living in the northern

Fig.120 *Sioux leader Sinte Gleska (Spotted Tail, 1830–1881), Sioux (Lakota), by Zeno Schindler 1870–5. Oil on canvas, H 91.5 cm, W 74 cm (Am2006,Ptg.7).*

Plains, such as the Sioux, Cheyenne and Arapaho, eventually culminated in the famous battle of Little Bighorn in Montana (1876). Some 7,000 Indians, strategically led by experienced Sioux leaders such as Sitting Bull (Hunkpapa Lakota, 1831–90), Crazy Horse (Oglala Lakota, 1842–77) and Gall (Hunkpapa Lakota, 1840–94), defeated the Seventh Cavalry under Colonel George Armstrong Custer (1839–76). It was the Plains Indians' last military victory in the history of the Plains Indian Wars.

In Canada, Plains tribes' frustration about cases of unfair treatment following treaty signing led to rebellions, but these were significantly less violent confrontations than those experienced by neighbouring Native American tribes. Leaders such as Blackfoot Red Crow (Kainai, c. 1830–90) and Crowfoot (Siksika, c. 1830–90) and Plains Cree leader Poundmaker (1842–66) rose to prominence among those who entertained negotiations between Canadian authorities and Plains tribes. These men and many other Native leaders conducted diplomatic exchanges and acted on behalf of their tribes with pragmatism and determination. Their names have reached us through official versions of history. Many other historical narratives exist, however. To the many warriors who experienced wars, battles and conflict, history appeared differently because their perception of their own role in combat was filtered through long-held beliefs in spiritual powers and intangible protection. These narratives, often drawn on ledgers, muslin or paper, offer useful Native perspectives. These can enhance our understanding not only of facts and historical dynamics from a Native viewpoint, but also of the cultural elements that each warrior found significant in retrospective evaluations of his own agency in past actions and events.

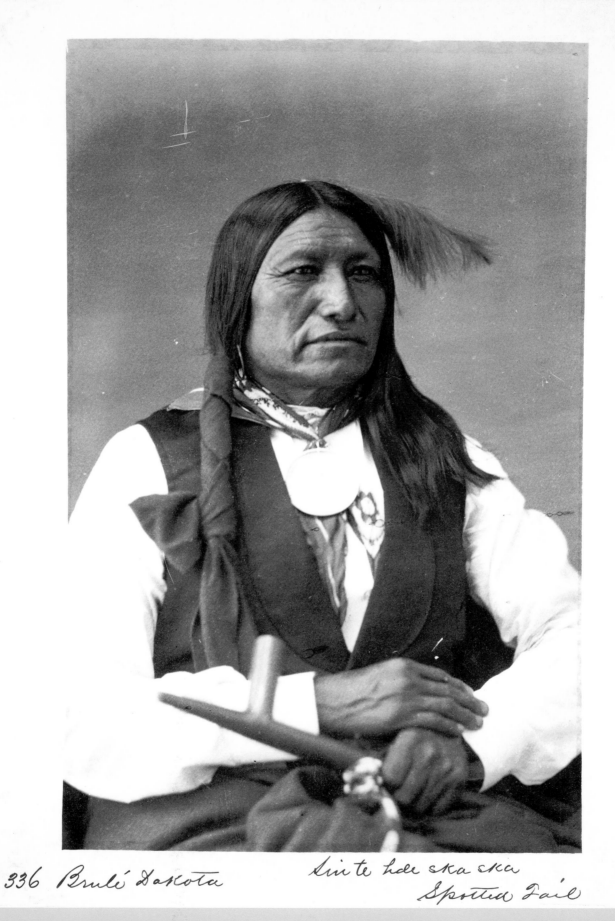

336 Brulé Dakota

Sin te hda ska ska
Spotted Tail

Fig. 121 *Sinte Gleska, photograph by Alexander Gardner, 1872. Albumen print, H 18.5 cm, W 12.5 cm (RAI 973).*
Sinte Gleska was a prominent leader of the Brule division of the Lakota, part of the Sioux confederacy. He was one of the first men to sign the second Treaty of Fort Laramie of 1868, which followed an unsuccessful series of American army campaigns against Sioux and Cheyenne on the northern Plains.

Chapter 5

Continuity and change in the warrior tradition

Warriors without wars

With the closure of the colonial frontier much of the Plains Indians' traditional life, especially hunting, came to an abrupt end by the last decade of the nineteenth century. On both sides of the international boundary between Canada and the United States, indigenous nations signed treaties that established new tribal territories (reservations in the United States and reserves in Canada) and their new legal statuses and rights. By the second half of the nineteenth century both Canada and the United States had passed legislation that effectively made indigenous peoples wards of the state after the establishment of reserves and reservations. In the United States Native American tribes are considered domestic dependent nations. Under the doctrine of wardship indigenous peoples were expected to assimilate into mainstream culture, leaving behind ancient customs and beliefs once associated with warrior-centred lifestyles and ideologies. Legislation that either restricted or directly prohibited indigenous cultural expressions severely affected Plains Indians' collective morale, which was already worn down by the humiliation of having been defeated after long and exhausting wars and having suffered illness and starvation. Former warrior nations that until recently had been led by valiant leaders and fighters were forced to become subordinate followers of government policies that offered their people no other option than to reminisce about old-time glories. The socio-economic climate in this era of cultural assimilation forced Plains Indians to find ways to survive as people with a common culture and values while adapting to a rapidly changing world (see insert pp. 112–3).

Between the last decade of the nineteenth century and the first half of the twentieth century new social realities were created by life on the reservations, Anglophone education, religious conversion, international conflicts and physical relocation, often away from their traditional territories.

Fig. 122 *Feather bustle hanging against the background of an American flag at the Red Earth Festival in Oklahoma City, July 2010, photograph by the author. Native American and United States symbols sit side by side and epitomize the sense of national pride shared by many Plains people.*

All these contributed to the appearance of a new sense of collective identity that was based as much on these shared experiences as it was on the retention of distinctly local features. The complex interplay of adaptation and resistance, overt conformity and covert disregard of rules, fuelled the creation of new modalities of expression that, to this day, continue to evolve in original combinations of old and new references and different sources of inspiration. Cultural ferment articulated on these premises led to what has been variously called 'cultural revival', 'cultural regeneration' and 'cultural renaissance'; all terms that correspond to a period of indigenous North American population increase during the first part of the twentieth century.

Much of the cultural revitalization experienced by Plains Indians and other Native peoples in North America during this period was shaped by the mutually intertwining ceremonial and martial aspects of the warrior tradition. While these evolved as two facets of the same phenomenon, they overlapped in a number of multifaceted formations. The process of rearticulation of old meanings into new contexts culminated in cultural expressions that today are germane for maintaining a shared sense of identity among Plains Indian peoples. On one side, the ceremonial aspects of warrior societies were instrumental in the reconstruction of cultural identities suppressed by assimilation policies and religious conversion. On the other side, the martial ethos and fighting opportunities generated by the outbreak of major world conflicts fuelled an unprecedented emergence of forms of national and ethnic consciousness among members of all Native North American tribes.

By the late nineteenth century, the cessation of hostilities between Plains Indians and government armies decreed the end of the majority of warrior societies and their war-related activities. Some of the most popular warrior societies' social meetings were nonetheless tolerated, under the suspicious supervision of missionaries and agents. Warrior society dances continued to be performed during annual fairs, memorials, parades and national festivities such as the Fourth of July. Fourth of July celebrations, in particular, became the substitute for Sun Dances, which had been prohibited

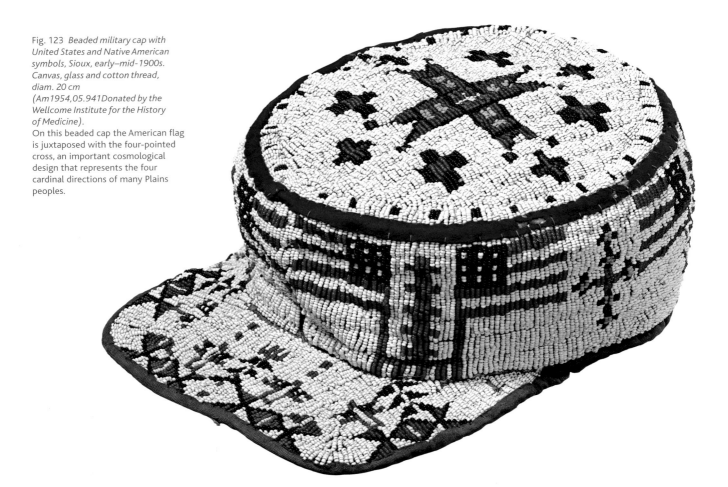

Fig. 123 *Beaded military cap with United States and Native American symbols, Sioux, early–mid-1900s. Canvas, glass and cotton thread, diam. 20 cm (Am1954,05.941Donated by the Wellcome Institute for the History of Medicine).*
On this beaded cap the American flag is juxtaposed with the four-pointed cross, an important cosmological design that represents the four cardinal directions of many Plains peoples.

in the United States under the 'Rules Governing the Court of Indian Offences' of 1882 (Prucha 1984) and in Canada under the Indian Act of 1876 (Pettipas 1994). Old warriors who participated in the last Indian Wars recounted their deeds at these public occasions and, as a result, religious and political meanings came together in the iconographies and emblems used in dances and performances. These had both a nationalistic flavour and a traditional character. Collective dances performed by Plains peoples during these celebrations featured a juxtaposition of Anglo–American, Canadian and indigenous symbols that reveal a conscious effort to appear to co-operate with their respective governments. Early experiences of loss of lands, genocidal attempts and residential confinement in reservations left a permanent scar in the collective consciousness of Plains Indians at the turn of the century. Indigenous peoples' exhaustion as a result of all these ordeals required the strategic use of symbols that could convey peaceful intent to a non-indigenous public.

Symptomatically, after the last massacre experienced by the Sioux at Wounded Knee in 1890, women started producing work that displayed the American flag and the bald eagle in unprecedented numbers. The sheer volume of flags that appear in Sioux beadwork of this period shows the desire to be perceived as amicable allies of the American government. Whereas the use of the American flag in anniversary celebrations or in beadwork could be seen as a demonstration

of patriotism, it also implicitly showed the unease and discomfort at having witnessed the annihilation of their own people under those flags they had seen as peace guarantors (Fig. 123). Interestingly, the use of flags is not limited to Sioux nineteenth-century beadwork. Flags can be found on a variety of decorated objects produced by other tribes and, in some cases, they are often purposefully depicted upside down as a sign of obvious disagreement with government policies. Inverted flags, in fact, continued to be used time and again during all the political demonstrations staged through the first part of the twentieth century by militant groups that supported indigenous rights across North America.

Like symbols everywhere, flags among Plains peoples at the turn of the century conveyed multiple and often contrasting meanings. In addition to being signs of friendship or distress, the sustained use of flags during anniversary celebrations contributed to keeping alive the fighting spirit of Plains peoples. Flags became the symbol of the lands they had defended during the Indian Wars, but also of the country they fought to protect in major world conflicts (Asepermy 2010; Palmer D. 2010; Palmer L. 2010; Ringlero 2010; Tselie M.S. 2010; Tselie, N. 2010). With time, memorials and celebrations at which dances were performed reinforced Plains Indians' warrior ethos whose cohesive power cemented a sense of common purpose and identity in spite of regular prohibitions and bans (Logan and Schmittou 2007; Pohrt

1976; Schmittou and Logan 2002). Flags today continue to be used in a number of circumstances but they are particularly important in powwows. American, Canadian and tribal flags always open powwow celebrations. They are carried by prominent personages from the organizing community such as war veterans or community leaders who have performed honourable actions in battle (Fig. 124).

That Plains Indians' warrior traditions managed to survive into the twentieth century is due to a number of concomitant factors. Popular demand for historic re-enactments was an important element in the preservation of warriors' memories that endured official proscriptions against cultural expressions throughout the pre-First World War period. Paradoxically, official obstruction of explicit displays of indigenous identity was paralleled by a public appetite for live performances in which historic battles and so-called 'war dances' were played in front of thrilled audiences. American and Canadian middle classes eagerly attended these events to have a first-hand experience with those whom they perceived as nothing more than tamed savages. While these popular performances generated excitement and anticipation, they safely placed Plains Indians in romanticized scenarios with nostalgic colonialist undertones whose echoes can still be detected in the present fascination with the stereotype of the Plains Indian 'chief'.

During the latter part of the nineteenth century several former warriors found employment in circuses, pageants and travelling shows (Fig. 125). Only nine years after the impressive victory over the 7th Cavalry in the 1876 battle of Little Bighorn, the famous Sioux leader Sitting Bull joined Buffalo Bill's *Wild West Show*. Like other shrewd entrepreneurs, Buffalo Bill capitalized on the burgeoning myth of the Western frontier that swept across North America and Europe (Durham *et al.* 2005; Moses 1996). On the surface these performance might seem detrimental to the self-esteem of their indigenous participants, but not only did they shape non-Native views of Plains Indians they also sustained the self-perception of their participants as warriors. Although they were not employed to fight in real battles, sham fights and re-enactments at least partially retained a superficial veneer of warriors' past glories.

At home on the reservations, on the other hand, former warriors maintained, often covertly, some of their customary functions as dance leaders, bundle keepers, ritual specialists, historians and artists. Direct links with past traditions were sustained through the preservation of oral traditions, songs, stories and dances, but also through family heirlooms and the continued production of objects once central to a warrior's life. This occupation was often encouraged by Canadian and American patrons and agents as a means to generate a minimal yet much needed income. The reservation period marked the end of lifestyles that were largely based on the buffalo hunt. Aside from the difficulty of re-inventing themselves as settled agriculturists after centuries of nomadic life, Plains Indians found that these newly imposed economies were not sufficient to yield enough products to sustain even

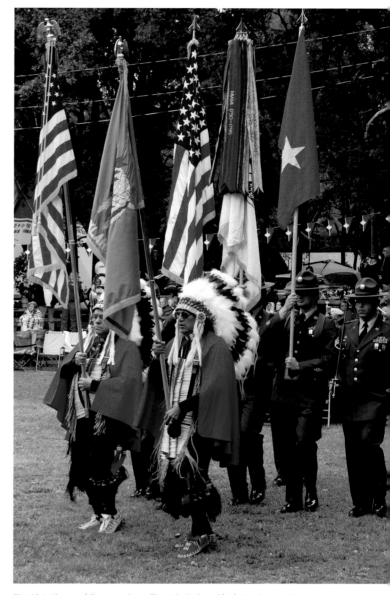

Fig. 124 *Kiowa soldiers carrying military insignia at Black Leggings society celebrations, Anadarko ceremonial grounds, Oklahoma, 2009, photograph by Ian Taylor.*
Parading flags and military banners has become a common practice in both military celebrations and powwows across North America.

greatly reduced populations. Indigenous economies and subsistence means became obsolete if not impossible to carry out under the new regime. As a result, over the nineteenth century indigenous peoples became increasingly dependent on their respective governments for rations. In these dire economic predicaments many families saw no better alternative than selling their most valuable possessions such as shields, weapons and clothing to American and Canadian collectors due to financial need. Despite this, large numbers of objects were still kept as important mementos of past lifestyles that inspired a sense of pride, even among those who had never fought a real battle. Much of the dance regalia collected by Canadians, Americans and Europeans during the first years of the twentieth century were probably never used in combat. In fact, many of the items were produced for use in pageants,

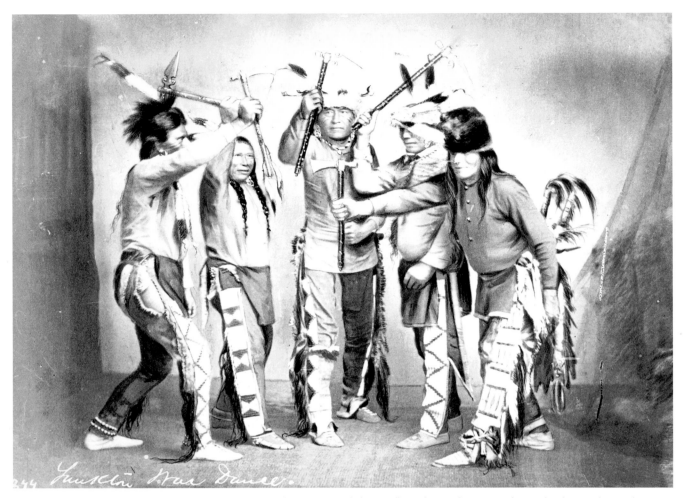

Fig. 125 *Group of performing warriors, photograph by A. Zeno Shindler, 1867. Albumen print, H 12.5 cm, W 12.5 cm (RAI 1086).*
This group of men are posing for a staged picture in which they act out a belligerent gesture. Interestingly, the figure on the far right wears a Crow belt normally used in Omaha, or Grass dances. The photograph was taken in the transitional period when the former martial nature of warrior societies was turned into a spectacle for Euro-American and Canadian audiences before it reclaimed its military character.

travelling shows and other public celebrations. They were nonetheless inspired by ancient models, albeit manufactured with new materials such as cotton muslin, cowhide and commercially available pigments (Fig. 126).

The incorporation of exotic supplies into the production of material culture has been a constant feature of North American indigenous peoples' resilience and adaptation to novelty; crayons, coloured pencils and watercolours were no exception. They were extensively used in drawings made on ledgers and notebooks in keeping with the old pictographic tradition. What changed in this new form of art were the scenes and modes of expression that, in contrast to older conventions, incorporated perspective, backgrounds, frontal and back views and other visual principles that reflected the encounter with novel representational styles. Many former warriors began to use pencils and paper to depict scenes of old-time village life, hunting, battles scenes and their own experiences of assimilation.

Since the early nineteenth century, ledgers, trade catalogues and writing pads had become available to Plains Indians, who found this new technology an efficient substitute for hide, which until then had been used to record warrior deeds and show off their prowess. Visual depictions on paper of warriors' honourable actions show the intimate relationship that existed between Plains Indians, the war ethos and the military, even after the end of the Indian Wars. Often produced to illustrate life in captivity, during military campaigns, or on reservations, ledger drawings also include a vast array of representations of daily and ceremonial life between the end of nomadism and the First World War. This form of expressive culture became popular among Euro-Americans once Plains Indians started becoming scouts, such as among the Crow and Pawnee, or prisoners of war between the last years of the nineteenth century and the first decades of the twentieth century. Many individual artists emerged during this period. To cite a few, Cheyenne Howling Wolf visually rendered his experiences of residential schools; Sioux Amos Bad Heart Bull recorded local historical events; and Kiowa Wohaw represented emblematic images of Plains Indians between two worlds (Afton *et al*. 2000; Bad Heart Bull *et al*. 1967; Berlo 2000; Greene 2004; Keyser 2000; Petersen 1971; Szabo 1994a, 2007) (Fig. 127).

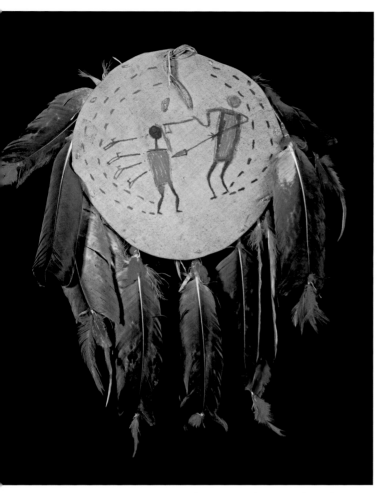

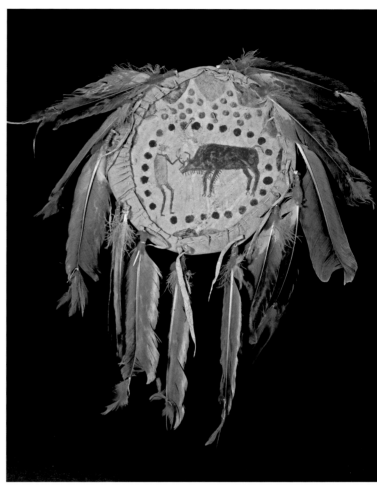

Fig. 126 *Dance shield with feathers (front and back), Blackfoot (Kainai), late 1800s–early 1900s. Hide, muslin, commercial paint and feathers, D 90 cm (Am1903,-.93).*
In the nineteenth century dance items were still made following old principles and techniques. In this dance shield we see a battle scene and the warrior's encounter with a supernatural animal. Putting sacred designs and substances in hidden places like at the back of a protective object, such as a shield, is consistent with old beliefs.

Ledger drawings presented a version of Plains Indian history and culture that has been instrumental in preserving the memory of events, people and past lifestyles in a format that was also acceptable among the non-indigenous majority. Indeed, as with other types of Native artefacts, Euro-Americans frequently encouraged those who incited warriors to produce drawings for sale. The emergence of a market for these drawings re-ignited Plains Indian men's pride that by then had been muted by the lack of fighting opportunities. This new expressive form encouraged individualism and the emergence of the figure of the artist among Native North Americans. For Native men engaged in the production of ledger drawings, individualism resonated with old practices because it was consistent with the pictographic tradition of personal exploits and memorial actions whose expressive roots go back to prehistoric and proto-historic times. Plains Indian warriors have used picture writing in different ways that, despite the variety of media, conveyed similar messages. The evolution of new forms of expression managed to retain the immediacy of the action and the vitality of lived experience that characterized the oral accounts of which these images were complements. In contemporary culture biographic art traditions such as picture writing and ledger art have continued to adapt to new circumstances by including new forms of expression that maintain an open dialogue with past customs (see Figs 18, 19).

If, by the early twentieth century, ledger drawings enabled Plains Indian warriors to retain pride in individual achievements and personal honour, the prestige and social standing once derived from war exploits and horses had turned into a show of material wealth that coincided with a renewed sense of confidence generated by public demand for Indian pageants. Wealth was mostly symbolized in the abundant display of ceremonial regalia exhibited during anniversary parades and formal ceremonies. Heavily decorated horse trappings, saddle blankets, cruppers, horse masks and bridles became a popular means to demonstrate one's status publicly. In line with past customs, social recognition of a warrior's ranking still largely focused on the horse, with the only difference being that in the reservation period it was used for parades and pageants instead of war expeditions. Horse ornaments such as Plains Cree, Crow

Fig. 127 *Ledger drawing by Good Bear, Sioux (Oglala Lakota), 1874. Pencil or crayon on paper H 14.1 cm, W 22.4 cm (Am2006,Drg.24).* Many Plains artists, such as Good Bear (pictured here), concentrated on personal war exploits, which cannot be identified as specific events. This is in contrast to more recognizable experiences of individuals associated with the famous battles of internment camps.

and Blackfoot parade saddles produced between the last decade of the nineteenth century and the first part of the twentieth century are richly embroidered with elaborate multicoloured bead designs, and feature wool thread, ribbons and commercial cloth (Fig. 128). These exuberantly decorated items not only testify to an aesthetic sensibility guided by the desire to impress, but also by a new form of ethnic pride solicited by participation in public shows. During the first decade of the twentieth century, Plains Indians' warrior identity was limited to cultural displays in which references to warfare and its ceremonialism only appeared in the form of iconographic testimony to a bygone era.

The possibility to fight nevertheless became again reality with the onset of the First World War. Plains Indians saw in this major conflict a perfect opportunity to revive the combative character of old-time warriors that, although dormant for several decades, had never been forgotten among them. Men could prove once again that they were as valiant warriors as their predecessors. The language of pride, honour and tradition fuelled the eagerness with which thousands of Plains Indians joined Canadian and United States armed forces during this conflict. While economic incentives and the apathy of reservation life may have been contributing factors to this widespread phenomenon, Plains Indian men also found in this world conflict the chance to reinvigorate a masculine sense of self-frustrated by the mortification of a settled life that for a long time had suppressed their fighting spirit.

Plains Indians and modern conflicts

Indigenous participation in government armies did not start with the world wars. Tactical choices, factionalism and parochial interests are some of the reasons that variously motivated tribes from all over North America to take part in virtually all the conflicts entertained by European and colonial North American powers since colonization began. Individuals from Plains nations, like those from tribes in other parts of the continent, engaged with American and Canadian armies as scouts and guides, but also as troops and tribal guards after the establishment of reserves and reservations. Native men frequently formed distinct regiments, and entire tribes or sub-tribes provided unofficial and irregular tactical support to their respective allies. Decisions about allegiances and collaborations with American or Canadian armies were often guided by the necessity of looking after tribal welfare, and strategic pacts were often struck with different factions in order to prevent fatal consequences.

Plains Indians, in particular, were active in European colonial wars on the North American continent since the

Fig. 128 *Parade Saddle, Blackfoot or Plains Cree, late 1800s–early 1900s (?). Leather, wool, glass and wood, L 47 cm, H 27 cm (Am1983,Q.254).* The exuberant creativity that characterizes this parade saddle shows the skill and patience of Plains Indian women. Settled life freed women from other activities such as time-consuming hide-tanning common in earlier times. They could dedicate more time to beading and embroidering and expressed inventiveness and originality.

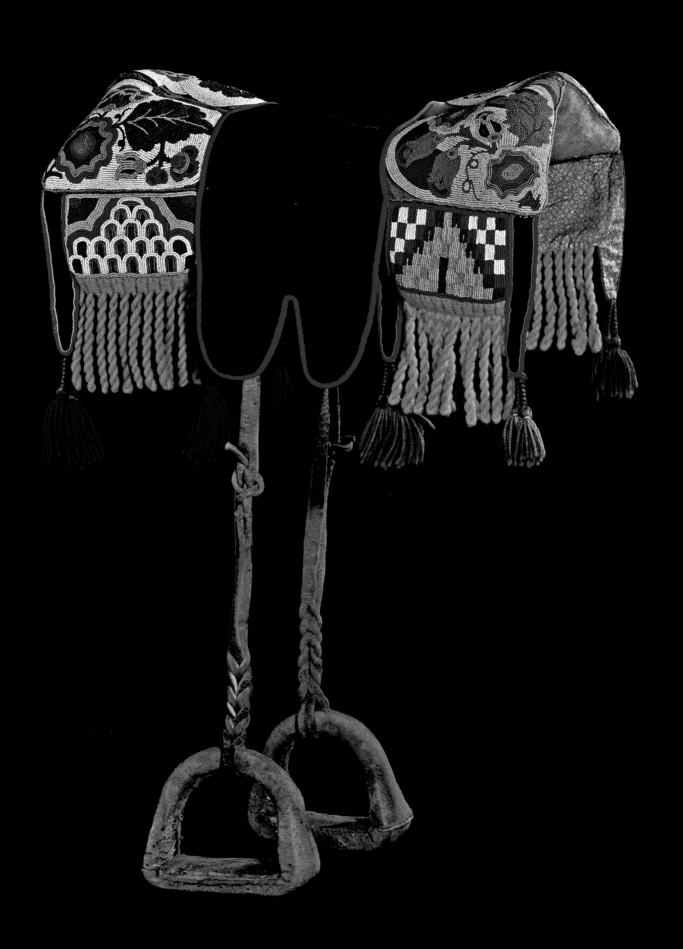

earliest stages of colonization. Eighteenth-century Spanish-French rivalries frequently relied on the aid of Indian troops to achieve their desired goals in exchange for protection and trading incentives. One of the earliest visual renditions of such mutually beneficial collaborations is depicted in the famous painting called the 'Segesser hide' that shows Otoe and Pawnee auxiliaries engaged in a fierce fight between the French and Spanish during Pedro de Villasur's expedition to New Mexico in 1720 (Hotz 1970). Co-operation between Plains Indians and European, Euro-American or Canadian armies continued to different degrees of involvement well into the nineteenth century due to convenience and necessity.

During the American Civil War (1861–5), territories west of the Mississippi under the Confederate army's jurisdiction included sections of the southern Plains occupied by tribes such as the Kiowa, Comanche, Kiowa-Apache, Wichita, Osage and Caddo. These tribes were unwillingly caught up in the conflict, and only partially and indirectly sustained the Confederates' causes. Comanche and Kiowa, although never a separate subdivision of the Confederate army, were supplied with ammunition to raid Union posts so as to prevent them attacking their providers' territories. Oklahoma tribes such as the Cherokee, Choctaw, Creek and Chickasaw, which had been relocated from east of the Mississippi in the early 1830s, fought as distinct divisions in active support of the Confederate army, whereas southern Plains tribes such as the Osage, Quapaw, Caddo and Wichita mostly supplied scouts who served under Indian commanders (Gibson 1985).

Between the end of the Civil War and the First World War, Indian scouts were an important component of the American army and were especially employed to serve in the several military campaigns against Plains tribes who had yet to sign peace treaties. Auxiliary forces such as scouts became obsolete at the end of the Indian Wars, when there was no more need to spot enemies' encampments and detect war parties. During this interim period, recollection of historical battles was still fresh in the older generations' memories. Former warriors recounted their deeds on public occasions, and some of them collaborated with American, European and Canadian authors in publishing their biographies (Brumble 1988; Dempsey 1972; Liberty and Stands in Timber 1998; Marshall and Standing Bear 2006; Nabokov and Two Leggings 1967; Schmidt-Pauli and White Horse Eagle 1931; Vestal 1962). North American and European publics eagerly consumed these books that further complemented popular images of Indian warriors generated by travelling pageants and shows in which Indians took part.

The outbreak of the First World War (1914–18) once again offered a new opportunity to fight. The painful memories of defeat in the Indian Wars did not stop Plains Indian men, and to a lesser degree women from United States tribes, from taking part in this major conflict; on the contrary, it fuelled their desire to defend a long-standing reputation for being valued and honourable warriors. In 1918 one third of all Native American males had voluntarily registered to fight overseas; more than 6,500 men were enlisted in the army, 1,000 in the navy and 500 in auxiliary work (Barsh 1991; Densmore 1934). This unexpected phenomenon triggered a heated dispute that centred round issues of citizenship, civil duties and political responsibilities of American Indians. Native intellectuals, members of the newly formed Society of American Indians (SAI), clashed over whether or not Native Americans should be allowed to have independent regiments or should fight alongside other soldiers. There were public debates about the assimilation of indigenous peoples in mainstream culture. Native American men eventually entered integrated regiments alongside Euro-American soldiers, unlike African-Americans who fought in separate divisions (Fiorentino 1998).

Bureaucrats and politicians believed that drafting Indians into the military would have helped in acculturation efforts endorsed by the federal government via the Dawes Act of 1887. The public generally agreed that only if Native Americans relinquished their tribal identity could they finally become American citizens. Until the First World War, citizenship had been denied to members of indigenous nations. The debate continued well after the end of the conflict. It was the deaths of large numbers of Native American soldiers and the return of veterans that eventually led the United States federal government to grant citizenship to all American Indians in 1924 as recognition of their service to the nation. Euro–Americans perceived this phenomenon in terms of patriotism and nationalism, but motivations that pushed Native Americans to join the army were diverse, and so was their sense of allegiance to their respective governments.

Ironically, indigenous men who took part in the First World War and women who participated in different capacities did not see either their involvement or the fighting as a move towards integration and assimilation; they saw it as a means to maintain continuity with past lifestyles. Consistent with customary values that posited the protection of land and family as paramount, Plains Indians enlisted voluntarily in the army to defend their country and what was left of their tribal territories, reduced by aggressive allotment policies implemented by their governments. If, on the one hand, this meant reaffirming former fighting traditions, on the other the proximity of men from different tribal backgrounds in the army contributed to a sense of widely felt national pride rooted in common tribal values and warfare ideologies.

Traditional practices associated with warfare activities such as dances and songs continued to mark victories while new meanings and content were integrated with old-style expressions. Much in the same way as past warriors, soldiers prepared for battle by staging war dances. Texts from songs collected among Plains Indian soldiers on their return from the First World War clearly show the sustained importance of filtering new experiences through indigenous languages and traditions in line with customary attitudes towards war, valour and death. Themes central to such songs were the combatants' bravery and honour, the capture of enemies' war emblems, taunting of foes, and rejoicing ceremonies at the return of brave soldiers (Powers 1998b). According to ethnomusicologist Frances Densmore, who collected war

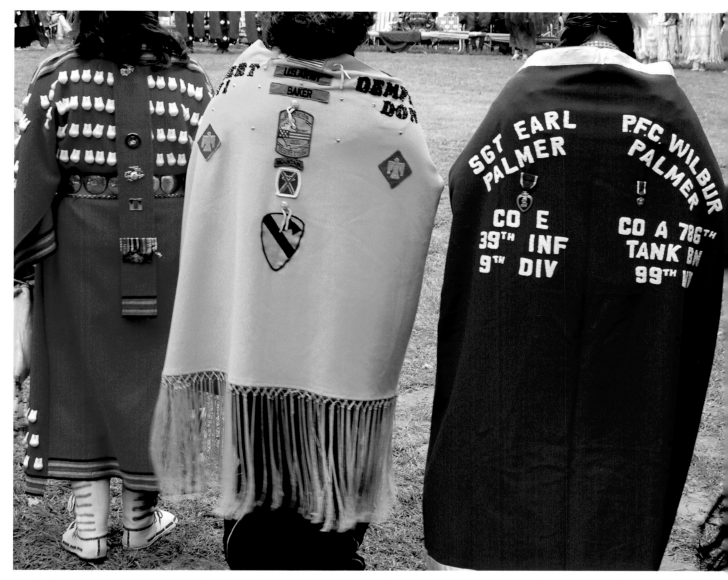

Fig. 129 *Women honouring family members during veteran celebrations at the Anadarko ceremonial grounds, Oklahoma, 2009, photograph by Ian Taylor.*

Today military insignia are sewn onto shawls that women wear at festive occasions, much in the same way as they did in the past.

songs among First World War Native American soldiers, long-held customs such as displays of war trophies, dancing, singing and gift-giving continued to be prominent practices among Plains Indian men returning from the battlefield. The new notion of being a soldier effectively overlapped with the idea of being a warrior, and men who participated in the conflict were treated in similar fashion as old-style victorious combatants. When special songs were sung in praise of particular soldiers during homecoming celebrations, they stood up and danced while their mothers carried mementos such as helmets, knives, bayonets and other objects captured in enemy territory on long poles as in pre-reservation victory dances (Densmore 1934; Ellis 1999).

Women played an essential part in sustaining Plains Indian military traditions in the postwar period. Soldiers interviewed between the world wars often stated that it was their mothers and spouses who had pushed them to enlist

in the army. Women continued to play this important role during and after the Second World War. After this second world conflict, associations of mothers whose sons and husbands had been in battle were born. These voluntary clubs were collectively called associations of 'War Mothers'. Their activities and dances were subsequently integrated into powwow preparations and celebrations held at the return of soldiers from foreign lands. Cheyenne, Kiowa, Pawnee and Otoe started such clubs in charitable support of war veterans, and to this day they provide moral and material sustenance to returning soldiers.

Customarily Plains Indian women showed moral support for warriors by wearing their insignia, weapons and headdress in festive dances staged at their return from war raids (Carocci 1999). This practice continued unaltered throughout the world wars. After the First World War, one Kiowa woman was even reported to have made a dress of a flag captured from

Fig. 130 *Car number plate, photograph by the author, 2009.*
The achievements of veterans returning from war campaigns are celebrated by the production of number plates, t-shirts, baseball caps and other items of clothing.

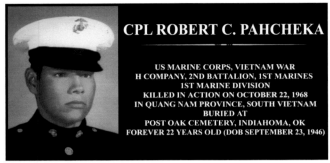

Fig. 131 *Commemorative plaque, still from video In the Tradition of the Warrior: a History of Modern-day Comanche Veterans (Comanche Nation of Oklahoma, Bill Curls Video Productions: 2009).*
Native North American men and women who lost their lives in battle are considered to be warriors and are given the highest honours for serving their tribe and country.

an enemy. Following this tradition, Kiowa and Comanche women today wear a 'battle dress' as a special gesture in recognition of fallen warriors and returning veterans during scalp, honouring and victory dances (Jennings 2004). Dresses and leggings worn by Kiowa women from prominent warrior families display martial symbolism, such as coup marks, army emblems and colours traditionally associated with victory: red and black. War regalia, feather headdresses and weapons feature prominently in today's women's dances, in which women carry their husbands' and fiancés' insignia to honour their accomplishments as they did in the past. War Mothers and women who participated in war campaigns in various capacities dance simply wearing a shawl with badges of the regiments and army corps of which they or their kinsfolk were part (Fig. 129) (Tselie, M.S. 2010).

Plains Indian women and men participated in all the major conflicts of the twentieth century. American Indians ranked among the highest of ethnic minorities who served in the military forces in the Second World War (1939–45) (Bernstein 1991). By 1942, nearly 9,000 Native American men had voluntarily joined the army, and at the end of the war more than 24,000 tribal people had served in the armed forces (Bennett and Holm 2008). In the military Indian soldiers were treated like any of their comrades, but individually and among their tribal communities Native combatants retained many of the former practices and beliefs distinctive of their cultures. Personally, individual soldiers might carry protective medicines in battle, seek spiritual comfort in old prayers and invocations and, most publicly, adapt drumming and singing to impromptu performances overseas (Pyle 1945).

The Korean War (1950–53) and the Vietnam War (1955–75) also attracted indigenous North Americans and, just as in the past, returning veterans were given the highest military honours in their tribes (Figs 130, 131). Postwar homecomings held in the 1950s often revolved around symbols of tribal unity such as medicine bundles and other sacred items (Anderson 1956). Speeches and honouring dances that accompanied these celebrations contributed to the reaffirmation of tribal values that led to a process of energetic cultural revival and

reinvigoration of indigenous identities. The second half of the twentieth century marked a period of renovation of old ceremonies and the re-establishment of moribund customs and institutions such as warrior societies.

After the 1950s old-style warrior societies were revived among a number of tribes, notably the Kiowa, Apache and Comanche (Meadows 1999) (Fig. 132). That this old social institution should become so prominent in the cultural revitalization process among Plains tribes is not coincidental, however. Warrior societies offered Plains Indian men the opportunity to match their wartime experiences with old martial customs in an efficient, culturally appropriate way that, at least partially, resolved the apparent contradiction of being an indigenous person in a modern world. The regular celebration of returning soldiers as modern warriors reflected a transformed world, one in which customary practices and beliefs still had a significant function in spite of efforts to eradicate them. Military societies became a way to turn customary practice into a valuable ethnic signature of contemporary experiences. In the new version, warrior societies effectively turned into military clubs that helped to maintain social identity and cohesion while revealing the contribution tribal people made to both their communities and mainstream society. The re-establishment of warrior societies among Plains peoples contingently resolved identity conflicts engendered by incongruities and contradictions experienced in reconciling what, until then, were seen as opposing values and ideologies. It is indicative that characteristics such as fierceness, courage and disdain for death, once considered by the mainstream majority as the epitome of Indian backwardness, in the postwar period turned into indigenous fighters' most positive assets that forever marked them as patriotic heroes (Bernstein 1991). Military societies followed in a revised form the structure of old-time warrior clubs, for example, in allowing youngsters and individuals who had never taken part in a real battle to participate in some of the dances. They generally kept their celebrations separate from other tribal events. Their function was primarily to honour publicly soldiers and veterans with dances, speeches and

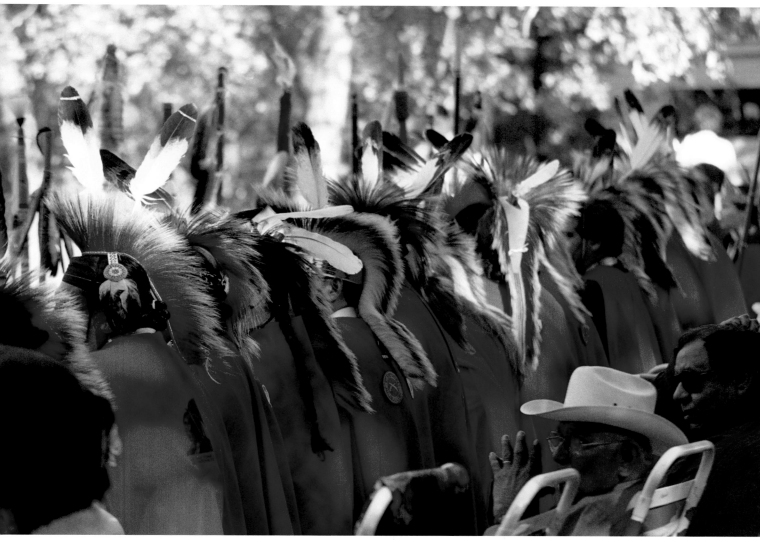

Fig. 132 *Kiowa Black Leggings members watching veteran celebrations at the Anadarko ceremonial grounds, Oklahoma, photograph by Milton Paddlety, Kiowa 1996 (Am,Paddlety,F.N.2329 Donated by Milton Paddlety).*

The distinctive red cape of the Black Leggings was adopted as one of the distinguishing items of the society when a young warrior captured this Mexican army insignia in the nineteenth century.

prayers. The performance of old-time dances, however, also contributed to a sense of tribal cohesion and community identity through the practice of old customs that paralleled intertribal cultural expressions such as the powwow.

In the new revived military societies, old warrior regalia re-entered the dancing arenas. Tribal craft specialists faithfully reproduced items once used by warriors following traditional motifs, colours and designs, yet integrated new materials in line with the ever-adapting fluid character of Plains Indian cultures (Fig. 136). Bone hairpipe breastplates, once used by prominent warriors, were replaced with easily obtainable plastic facsimiles (Fig. 137). Old-time hide leggings were made from commercially available fabrics, and acrylic paint, cotton thread and wool often replaced traditional raw materials such as buffalo sinew thread, bone-derived glues and natural pigments. Warrior regalia, headdresses, standards and other emblems effectively became visual links to the old times that highlighted the importance of the martial legacy for the great

majority of Native North Americans. In so doing, these objects not only materialized a historical legacy but reaffirmed the values that brought communities together around the cultural significance of warrior traditions (see pp. 126–7).

Today military societies' ceremonials always include religious elements that complement the strict martial focus of dances and regalia, and their leaders are keen to highlight the spiritual aspect implicit in the movements, objects and meanings in some of the performances and ceremonies that accompany their gatherings. Among some tribes, for instance, some warrior dances have replaced large seasonal gatherings such as the Sun Dance that were once forbidden by the authorities. Special societies, such as the ones formed by the so-called Gourd Dancers, now popular both locally and intertribally, have dances and songs that effectively perform some of the same functions that large seasonal rituals once had.

The Gourd Dance encapsulates both secular and spiritual meanings in one ceremony. Gourd societies and dances were

Interview with Lyndreth L. Palmer

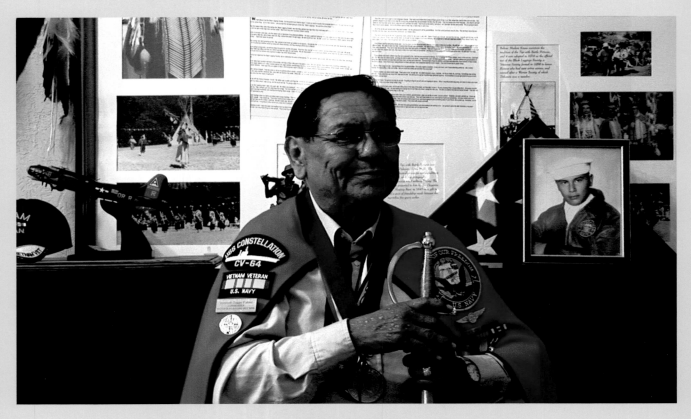

My name is Lyndreth L. Palmer … and I belong to the Kiowa tribe of Oklahoma. Not only am I a Roman Catholic, I belong to the Kiowa Native American Church in which we pray in a tipi all night. I am also a Vietnam veteran. I am the commander, or *Pahtok'i*, of the Kiowa Black Leggings warrior society of which I am wearing the cape. It means 'the centre of [the] Sun Dance' (the pole). The Black Leggings warrior society originated two … maybe three hundred years ago, we don't know. They were an organization made up of Kiowa warriors … who protected the Kiowa people … from other tribes … or … settlers who came to this new country. In 1958 my father, Gus Palmer Senior, was … elected as the commander [of the Black Leggings] … which I am because my father passed away in 2006. I represent all the Black Leggings, all the veterans of the Kiowa tribe, and women veterans … who served in the armed forces. The Black Leggings were called the *Tokogaut* … I was told that back in the olden days they used to burn those pastures … and there were no horses back then, so we would get black [legs from] the coals. But as the time went on they said 'we are going to have black leggings', which we wear [today] ….

Fig. 133 *Kiowa Black Leggings commander Lyndreth L. Palmer telling his war experiences during the shooting of the film* For my land I fight *by Max Carocci and Simona Piantieri, 2011. Photograph by Simona Piantieri, 2011.*

Fig. 134 Páubôn, *the crooked lance of the Kiowa Black Leggings, part of the replica warrior society regalia belonging to Gus Palmer Senior, by Vanessa and Carl Jenkins, Kiowa (see Fig. 136). Wood, iron, synthetic fur, dyed turkey feathers and cotton string, L 250 cm (2009,2038.1.a).* The hook of the *Páubôn* is said to represent the tail of a bull buffalo when it is angry and ready to attack, a sign of the martial nature of the society.

Fig. 135 *Memorial bust of Set-tainte (Satanta, 1820–1878), Kiowa, at the Anadarko Native American wall of fame. Photograph by Simona Piantieri, 2010.* Set-tainte became known as 'the orator' for his eloquence and articulate rhetoric, which made him famous with the American army after the Treaty of Medicine Lodge in 1868.

About regalia

This [ceremonial staff (Fig. 134)] is called a *Páubôn*…. It's a lance, really, the main warrior takes this. It's got a crook. If you ever make a buffalo [angry], even a female buffalo, their tail will always be [crooked] like that. Buffaloes were mighty animals. The buffalo was food … It was part of our medicine with which we doctor our people. This [sword] would signify the cavalry of the new settlers…. This is worn, or given to officers of the United States Army. I am so privileged that a commanding officer of Fort Sill, Oklahoma in 2008 had given this to me. I am an officer, I am a commander, I am a *Pahtok'i*. So this would represent a modern-day warrior. This is what the United States government gave me. [This is from] Vietnam, a good conduct medal, and a national defense medal for my mother country, the United States. This represents the four corners of the earth and … inside that it has got my lance. A warrior and a soldier in this day and age are synonymous …. When you put on a military uniform … colour has no factor because you are fighting a war. If there was a Black man [or] Italian … I know that if I should fall, he will pick me up, take me to safety…. If he fell, it would be the same for me. That's what we learn … and this is synonymous with the old Indian warrior. We protect one another in our tribe ….

About war

… I would go to war because of my status as a Black Legging …. Now … the other side of my very spirit … [tells me that] war … is bad, it takes lives, it breaks up families …. But war, to a Native American, is part of us. We have always volunteered to any service of the United States …. Kiowas … would go to war for our people … to protect our mother country…. My upbringing came from my uncles, my father (and the seven brothers who served in the Second World War), plus my great-great-grandfathers who were mighty chief warriors [(Fig. 135)]…. Being in the military is a very, very honorable thing for me. I have [had] to distinguish myself to become a *Pahtok'i* for my people…. Wearing that uniform [means that] you are a real warrior. [When you do] you go back in time when we were on the prairies…. Now we go through all that training to become a mighty warrior…. My people [and] my relatives have fought and died for [the] … flag of the United States…. This means so much to the Native American veterans especially. And when we pass on this flag is laid over our coffin because we were warriors, a true warrior …. Every time I see a flag I go back to all the men who fought in the various wars (the First and Second World Wars, Vietnam, Korea, Guam, Desert Storm, Operation Freedom). They went in, no questions asked…. I am proud of this flag and the many men and women who lost their lives for their mother country. This signifies freedom of our people …. This is why I love this flag … and I am proud that I could serve. … If Uncle Sam says 'Lyndreth L. Palmer, we need help', I will say, 'Yes sir, I am ready!', even at this age…. Native Americans … are warriors. They will fight, any time … that's what we are made of: we are never afraid.

Afterthoughts

[2010 will be] our fifty-second year of the ceremonial. [It] is going to be the first [time] we are going to designate a Saturday to recognize women veterans because … they have distinguished themselves too…. Things have changed …. We are equal now … younger … Kiowa men and women need to learn our dances, our songs, and the very meanings … that have been passed on from generation to generation … if those Kiowa songs are lost, our people will be lost …. We have our own dances, we have our own songs … the only one thing that we have that is meaningful to the warrior, and to the Kiowa … tribe …. When I am gone … my prayer … will be … that you … teach the other generations for years and years to come…. Make it meaningful, and above all respect … our people…. Native Americans … are very kind, loving, we have a lot of pride …. I give … my prayers, to … people of Europe, [so] that you get a better understanding of my people…. The more you learn about us, the better the understanding …. Movies and Hollywood [are] fine to get [you] all excited, but we are not that…. I want to thank you very much for interviewing me. I have been wanting to do this for the next generations…. Always love, always care, and respect one another … and you will never go wrong. *Aho*, thank you.

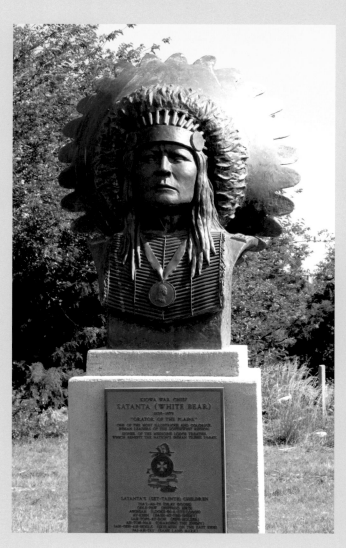

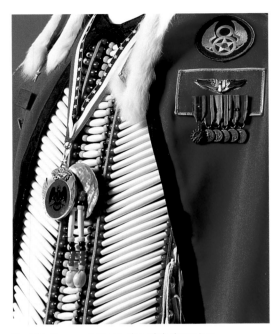

Fig. 136 Above and right *Replica of Black Leggings regalia worn by Gus Palmer Senior (Kiowa) (1919–2006), 2009.*
Breech cloth and beaded sash by Vanessa and Carl Jennings, Kiowa. Red cape and shawl by Lana Klinekole Palmer, Apache/Comanche. Breastplate by Allen, Kiowa and Karen Yeahquo, Cheyenne/Arapho. Belt, moccasins and cuffs by Winona Kodaseet, Kiowa. Backdrop dragger by Alice Tendooah Palmer, Kiowa. War headdress by an anonymous relative, Kiowa. Otter fur, replica eagle feathers, metal, textile, glass, leather, skin, synthetic fibre, fur and polyester, H 200 cm, W 90 cm (2009,2038.1.c–r).

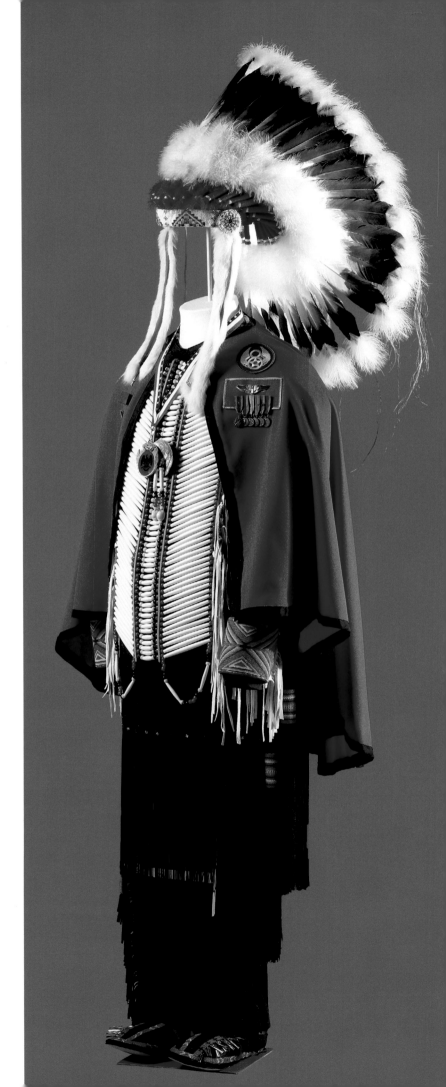

born out of martial clubs such as the Kiowa Unafraid of Death that eventually spread among Plains tribes such as the Otoe, Arapaho, Cheyenne, Osage and many others after the 1950s. While Gourd Dance society songs and ceremonies are often attributed some spiritual meaning, they do not constitute worship and therefore cannot be considered a form of religion in the same way as more structured and organized rituals such as the Sun Dance. However, although Gourd Dance ceremonies and songs are not integrated into more complex rituals and liturgies, they function as binding factors in tribal cohesion in much the same way as larger seasonal ceremonies.

Among certain tribes and in some intertribal powwows, the performance of Gourd Dances and songs precedes the dancing competitions, beauty pageants and honouring ceremonials that make up most powwows (Fig. 138). This practice is consistent with the martial origins of powwows in which warriors and soldiers featured prominently with dances, speeches and songs. In contemporary powwows, war veterans always escort the flag-bearing contingent during the grand entry, the introductory parade that opens powwow dances (Fig. 139). The order in which powwow schedules are usually structured highlights the prominent role played by soldiers and veterans in Native society in general. This gesture of respect and deference to those who have protected families and communities ties in neatly with the martial ethos embodied in former Plains warrior societies.

The transition from warrior societies to military clubs shows the sustained importance of martial imagery for Plains Indians' renewed sense of confidence in their culture. Over the years, this has often been augmented by a sense of spiritual comfort derived from revived ceremonies and dances. Since the revival of military societies, ceremonies with a martial flavour have openly acknowledged the spiritual undertones implicit in the visual and material expressions exhibited by military societies' regalia. The interplay of spiritual and martial meanings may explain military societies' success in the broader picture of Plains Indian cultural revitalization. The uninterrupted legacy of old warrior societies continues to this day in military societies' activities and celebrations, which substantially contribute to expressing Plains Indians' vitality and resilience. These are characteristics that are vibrantly articulated in the ultimate expression of their cultural renaissance: the modern powwow.

Cultural revitalization

World conflicts brought together large numbers of peoples from different tribes across Canada and the United States. That aboriginal trade networks, political configurations and migrations had already achieved this in the past is undeniable. The world wars, however, contributed to the consolidation of new forms of intertribal identities that were forged in shared experiences of residential schools. Forced education and wars similarly helped to engender a unique phenomenon in the history of Native peoples of North America; they triggered a process of identity formation that differed from other similar

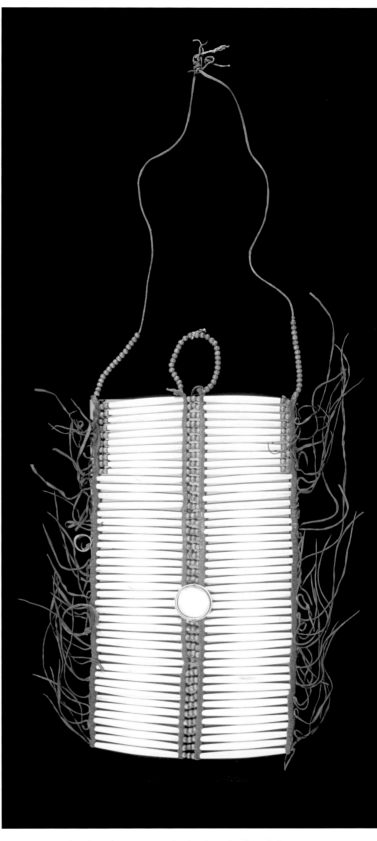

Fig. 137 *Breastplate (Sioux), 1800s. Bone, leather, brass beads, and glass, L 45 cm, W 25 cm (Am1938,0311.1).*
This breastplate is of the type called bone-pipe and was used by men in war. A version with vertical beads was more often associated with women who wore them during ceremonial occasions. This item has a brass ring attached on one side, possibly a memento or a protective charm.

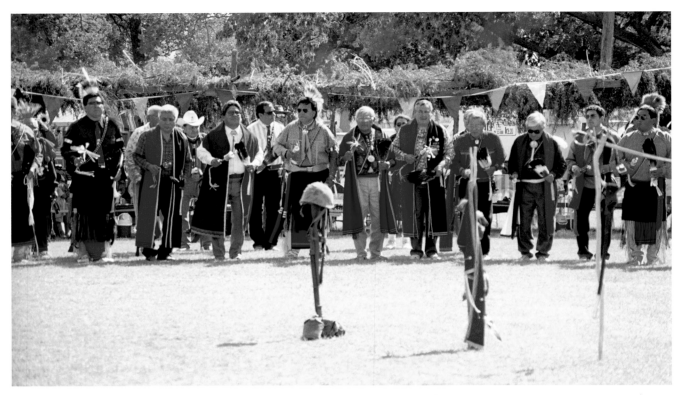

Fig. 138 *Gourd dancers singing at veterans day in Oklahoma, photograph by Milton Paddlety, Kiowa, 1996 (Am,Paddlety,F.N.2069 Donated by Milton Paddlety).* Army helmets and insignia can be seen in the foreground.

Fig. 139 *Veterans enjoying a powwow competition at the Red Earth Festival, Oklahoma City, photograph by Simona Piantieri, July 2010 .*

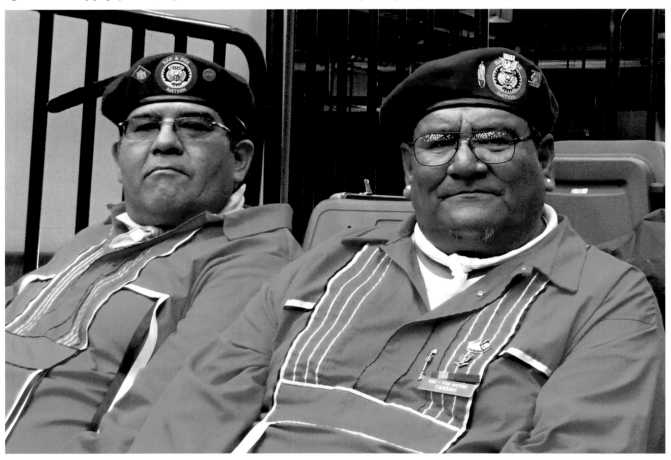

processes in scale and character. Over recent history, Plains Indians variably acted as large groups, dispersed units and small sub-tribes, or reconstituted themselves as distinct nations after processes of disintegration and coalescence. The multiplicity of alliances, trading relations and conflicts that marked the social and political development of Plains Indian historical tribes often, but not always, engendered a sense of shared purpose such as fighting against a common enemy. However, this did not generate any identification in entities larger than tribal confederations. During the Indian Wars, for example, Pawnee and Crow often allied with Americans against their historical enemies such as the Sioux. The American army frequently capitalized on age-old animosities in order to further their own aims, employing scouts from these tribes to gain intelligence about tactics and seasonal movements. No homogeneous identity was ever created among indigenous nations until the early twentieth century, when new predicaments slowly shaped Native North Americans' perception of themselves as one group with a distinct history. This was partially as the result of common experiences, but also of unifying juridical terms and the implementation of standard policies affecting all Native North American nations.

The final defeat of indigenous nations and the signing of peace treaties led to relinquishing lands and hunting rights. These events similarly affected all the Plains tribes, more or less irrespective of the level of friendliness and co-operation displayed by certain groups to Canadian and American governments in the pre-reservation era. Although retention of strong tribal identities kept communities together across the area, the terms established by treaties, legislation, congressional acts and federal policies forced them to respond as one ethnic group with shared legal and political status that were clearly marked by the unique wardship relationship with their respective governments.

The reality of aboriginal subordination became apparent with the establishment of tribal lands and the institutionalization of educational programmes via state and mission-run schools across North America. At the dawn of the twentieth century, governmental efforts to eradicate Native cultures and languages required that children be sent to institutions often very far from their homelands, for example Carlisle Indian School in Pennsylvania, or Chilocco Indian School and Bacone College in Oklahoma. In Canada, this situation was mirrored with the establishment of institutes such as the Catholic school at Q'Appelle and Battleford in Saskatchewan, or High River in Alberta, to name a few (Pettipas 1994). The traumas of boarding schools, especially in Canada, frequently engendered among indigenous students animosity and downright resistance to assimilation efforts implemented by the government. These feelings were crucial in establishing the premises for the creation of an identity that cut across tribal differences beyond the international boundary between the United States and Canada. While the emergence of this new identity was an organic process that was partially activated in response to the governments'

treatment of tribal nations as one entity, political, religious and cultural factors contributed in equal measure to construct an intertribal character that was ultimately based on the experience of being indigenous.

Part of the Plains tribes' contribution to the emergence of intertribal identity can be found in the process of cultural cross-fertilization that occurred between Plains Indian peoples precisely in the context of early twentieth-century education. The vibrant dynamism displayed by Plains cultures during this period is clearly discernible in the art produced by individual artists coming out of institutes such as Bacone College in Oklahoma, and the University of Oklahoma's non-accredited classes for Indian students established before and during the 1920s. In an effort to support local development and encourage the emergence of a class on Native American artists originally pioneered by Dorothy Dunn in the Southwest of the United States, American teachers followed in the footsteps of earlier patrons in endorsing initiatives that could help talented individuals to develop their skills and artistic abilities for economic return. Some of the most capable figures encouraged by art teachers during this era came from tribes such as the Kiowa that had a long and established pictorial tradition. James Auchiah (1906–75), Lois Bougetah (1907–81), Monroe Tsatoke (1904–37), Jack Hokeah (1902–73), Spenser Asah (1905–54) and Stephen Mopope (1898–1974) emerged as prominent painters, marking the development of a style that bridged Plains Indian visual communication and Western aesthetics and styles learned from American teachers' art classes. The cultural relevance of these artists rested in the fact that their visual representations trespassed local boundaries to produce an image of Plains Indians which reflected social realities of the period. Murals painted by Stephen Mopope for public buildings in the 1930s, for example, captured the essence of a generic Plains Indian culture that bore no specific resemblance to any of the dozen tribes at that time living in Oklahoma (Fig. 140). The inventive mélange of references and visual standardization of identity markers epitomized by these artists might have been the result of patrons' pressures to accommodate the Western public's expectations, but undoubtedly they also mirrored the increasingly strong tendency towards the mixing of distinct tribal peoples and cultural features that characterized later expressions of the intertribal phenomenon. For example, painter Acee Blue Eagle (1907–59), of Pawnee and Creek descent, inventively matched in his art elements from cultural repertoires that were generally not considered part of Plains cultures. This tendency visually conveyed the changing reality of most Plains Indian peoples, in which the adoption of customs and aesthetics from different areas was increasingly common. But importantly it also mirrored social attitudes and public discourse that treated every tribe as indistinctly 'Indian'.

In 1935 the creation of the Indian Arts and Crafts Boards under the endorsement of the United States Bureau of Indian Affairs established that in order to qualify as truly aboriginal, Native American art had to be distinctly 'traditional' and 'Indian'. Ironically, this definition made official any generic

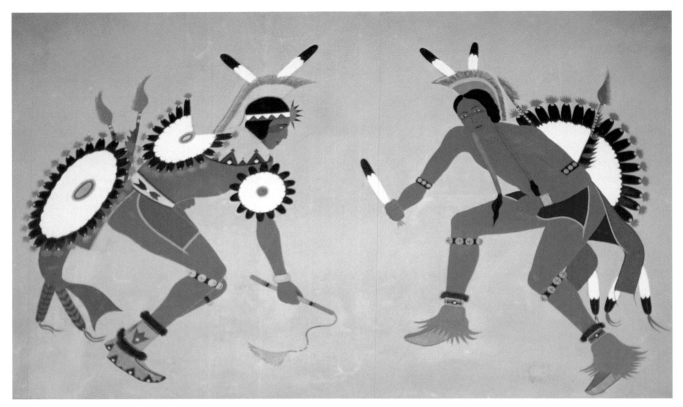

Fig. 140 *Mural by Stephen Mopope (Kiowa), early 1900s in the Anadarko post office, Oklahoma, photograph by Milton Paddlety, Kiowa, 1996 (Am,Paddlety,F.N.2946 Donated by Milton Paddlety).*

In his long artistic career Stephen Mopope painted many scenes of Plains Indian life. This early twentieth-century mural in the Anadarko main post office captures the vibrant vitality of dancers before powwow became a formalized competition and a national institution.

nondescript cultural expression that essentially eluded the unique character of local traditions because it encouraged inspiration from a variety of indigenous sources and experiences. Later prominent Plains artists such as Cheyenne Dick West (1912–96) and Sioux Oscar Howe (1915–83), who were strongly opposed to the styles promoted through mainstream art networks, turned the official definition of 'Indian' on its head to argue that although their art explicitly used non-traditional visual languages it was quintessentially indigenous because it expressed themes and concepts derived from distinct tribal traditions (Anthes 2006). This debate was crucial in establishing new parameters for further discussions about what constituted Indian art and simultaneously opened up new critical perspectives on the role played by tribal traditions in shaping new forms of cultural expression.

Intertribal culture continued to develop after the Second World War, when a further push to assimilate indigenous nations materialized in the residential relocation policies of the 1950s and 1960s aimed at the dissolution of all tribal lands and the termination of all reservations. Indigenous urban enclaves emerged as a result of a long process of rural-to-urban migration of families and individuals from distant areas encouraged by American and Canadian governments. Contrary to assimilationists' expectations, however, mainstream lifestyles did not produce acculturated indigenous individuals. On the contrary, people who relocated to cities

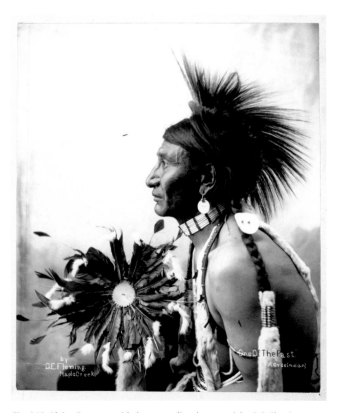

Fig. 141 *Plains Cree man with dance regalia, photograph by G.E. Fleming, 1879–1902. Silver gelatine print, H 25.4 cm, W 20.3 cm (Am,B47.3).*

such as Detroit, Chicago or Toronto under government training schemes used tribal references to supply an increasing need for indigenous role models in non-native settings. This process helped them face the social anomie generated by isolation and geographical distance from tribal lands and customs. The frequency of marriages between people of different tribal backgrounds contributed to the appearance of mixed families in which mutual influences and inspirations naturally came together in a fluid process of adaptation, negotiation or downright resistance to mainstream culture. Cultural fusion evolved from these ethnically diverse indigenous contexts and fostered the development of an intertribal culture that thrived by means of regular meetings and ceremonials, craft classes, storytelling workshops, political rallies and community gatherings.

Whereas at supra-local level the encounters of multiple tribal realities in boarding schools, educational institutions, military and urban life triggered a process of reciprocal influence resulting in intertribal cultural expressions, local people maintained a firm desire to preserve cultural distinctiveness in light of the radical changes and encroaching threats of assimilation that were rapidly eroding old values and ideologies. Former warrior societies' dances and ceremonialism have an important role in the continuation of distinct tribal traditions to this day. Though many warrior societies disappeared due to low numbers, some nevertheless

Fig. 142 *Feather bustle, Blackfoot (Kainai), late 1800s. Tin pottery, porcupine quill, feathers and brass, D 56 cm (Am1903,-.98).*
Much in the same way as today's warriors use contemporary materials to build their regalia, past dancers used whatever was at hand, as can be seen in this Blackfoot dance bustle made of feathers secured to a metal support.

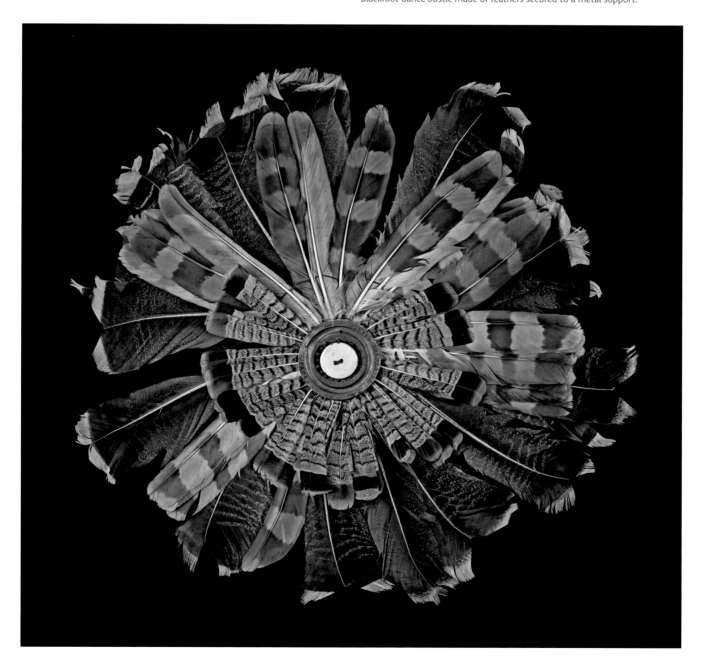

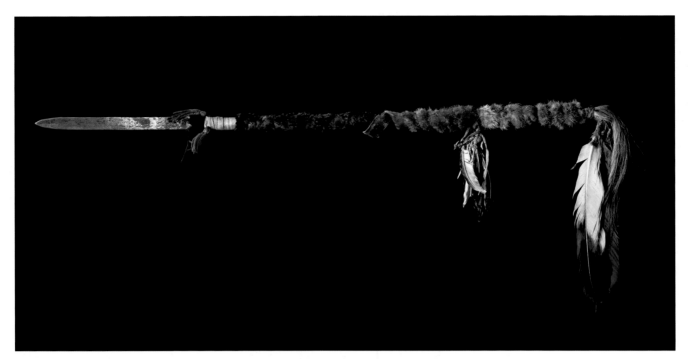

Fig. 143 *Dance spear, Blackfoot (Kainai), mid–late 1800s. Iron, wire, wood, beaver skin, feather and horse hair, L 128 cm, W 4 cm (Am1903,-.92).*

Plains peoples continue to this day to use dance spears of this kind in festivals, dances and ceremonies.

managed to retain enough members to continue to hold crucial functions in the proper management of tribal liturgies and rites that ensured communal well-being. Among the Cheyenne, Kit-Fox society warriors maintained their position as managers of the sacred arrows, one of the tribe's most important national symbols. In the Blackfoot Confederacy (Siksika, Piikani and Kainai), warrior symbols, bundles and medicines ensure community cohesion, and among the southern tribes the dances and ceremonies of military societies were instrumental in the processes of cultural preservation and revitalization. Indeed, many of the cultural roots of today's intertribal identities can be found in the historical re-elaboration of Plains Indian warrior dances and themes in a variety of celebrations largely gathered under the term powwow.

Powwow is an Algonquian word with old roots. It was first used in the eighteenth century by English colonists describing gatherings of Atlantic coast peoples led by ritual specialists for healing purposes. With time the term became applied to most Indian gatherings with a ceremonial and festive flavour, regardless of purpose. As a social phenomenon of cultural survival, powwow as we know it today among Plains Indians emerged at the turn of the nineteenth century from an inventive recombination of symbols and regalia with origins in the warrior dances of the Omaha, Ponca and Crow tribes. Warrior dances such as the southern Siouan-speaking tribes' *Hethus'shka* (also called Grass Dance) and the Hot Dance of the Crow, credited as the matrix of modern powwow dances, were acquired by several Plains tribes at different times (see Fig. 74). The Omaha gave the Grass Dance to the Yankton Sioux in the 1840s, and they in turn diffused it among northern tribes.

The Ponca passed the dance to the Osage, and in Canada the Assiniboine gave rights to perform the Grass Dance to Blackfoot tribes in the 1880s. The acquisition of Grass Dance rights and its most important regalia – the feather bustle and deer-tail roach – was consistent with pre-existing intertribal relationships consolidated during seasonal fairs and trading meetings.

In the latter part of the nineteenth century the diffusion of the Grass Dance and its regalia had an important role in cementing intertribal ties (Figs 141, 142). By the 1920s powwows, alongside public performances of so-called war dances, had become a regular annual fixture for many Plains nations. In tribally heterogeneous Indian schools, such as the Haskell Institute in Kansas, yearly powwows became a standard feature benevolently supported by educators and teachers strictly for entertainment purposes. Over the years, however, powwows have meant much more than simple leisure for those involved in their organization. The cultural distinction and self-worth generated by individual and collective participation in powwows contributed to the enormous popularity of this festival among Plains tribes. Song and dance helped many indigenous people to retain pride in themselves and their culture in the face of radical changes and ruptures with former lifestyles. What is more, they transmitted a body of knowledge that was embedded in the martial symbols and emblems worn by the dancers and singers.

Although in the past, participation in war dances was restricted to those who had performed socially recognized war deeds, with the popularization of these events everyone was encouraged to dance. Powwows staged in tribally integrated schools fostered a sense of intertribal cohesion that further cemented a generic 'Indian' identity, which proved to

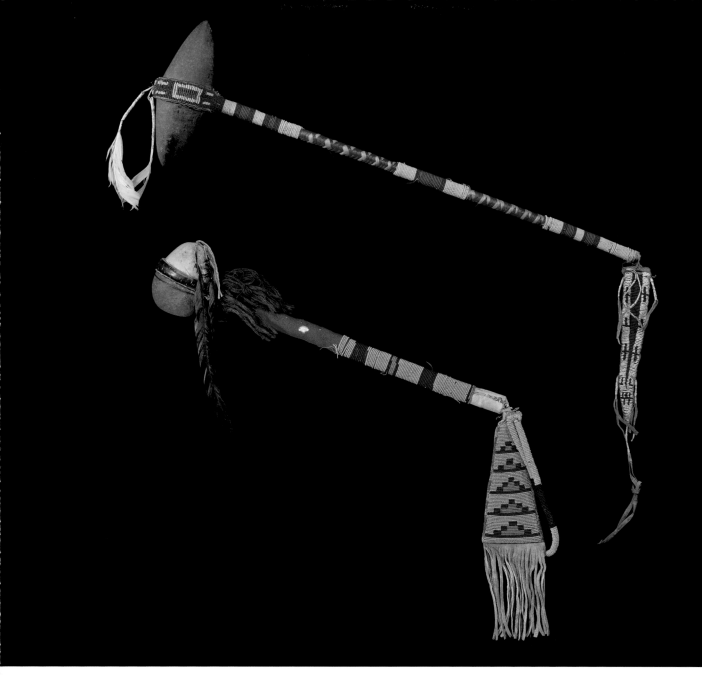

Fig. 144 Above: *Stone-headed club, Blackfoot or Sioux (?), 1870–1900. Quartzite, wood, glass, buckskin (?), horse hair, feathers and porcupine quills, L 66 cm, W 21 cm (Am1902,Loan01.50).*
Below: *stone-headed club, Blackfoot 1800s. Stone, wood, leather, glass, cotton and feathers (Am1903,-.80).*

This lavish biconical stone-headed club is decorated in a rare style popular among peoples of the northern Plains. Dyed horse hair is woven in a neat pattern around the stem, and feathers and beaded tabs hang at each end. The item below was probably never used in combat. Its owner would have used it in dances and parades, and almost certainly have carried it with him at important diplomatic meetings.

be crucial in the revitalization and further strengthening of Plains cultures. Powwows maintained explicit links to former Plains warrior traditions. Meanings conveyed through the actions and gestures performed, or implied in the objects used in the dances, clearly referred to Plains Indian warrior imagery that constituted the unique repertoire of old-time warrior societies. Food presented during ceremonial feasts was first speared as if it were an enemy by lance-handling dancers; performers continued to attach their headdresses to the scalp lock, the symbol of a warrior's vital force; and copies of warrior society insignia were regularly carried by participants during dances, as well as in parades and other public ceremonies (Figs. 143, 144).

By the mid-twentieth century powwows had become so popular that they developed into a social and cultural phenomenon responsible for shaping later forms of indigenous identity in both Canada and the United States. Powwow's forceful appeal resonated with the need to restore community values and the social, martial and religious meanings rooted in indigenous traditions. Although religious meanings were strongly opposed by authorities until the mid-twentieth century, some of the items used by dancers, such as eagle feathers, as well as choreographies, invocations, prayers and purifications included in the event, retained a semi-religious character that many today still see as a manifestation of an inherent spirituality conveyed through the intensity of

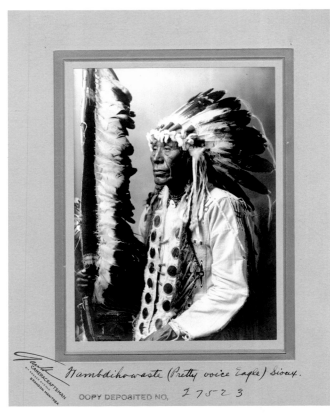

Fig. 145 *Wambdihowaste (Pretty Voice Eagle), Sioux (Dakota), photograph by Gould, 1913. Gelatine silver print, H 16.7, W 12 cm (Am,A13.22).*
In this photograph Wambdihowaste is wearing the popular harness decorated with mirrors that later developed into the braces used by powwow dancers.

wings, and sun rays radiating from a central circle, worn at the shoulders and hips respectively, have evolved from the Crow belts used in the Omaha Grass Dance and Crow Hot Dance (Figs 146, 138, 139).

Powwow dancers' use of face paint is also indicative of the old martial iconography that continues to inspire creative patterns and motifs. Discerning audiences can detect warrior features of personal body decoration, such as in the face paint of famous contemporary powwow champion Kevin Haywahe from the Assiniboine tribe. In a series of recent photographs by Iroquois photographer Jeff Thomas, he is portrayed with the so-called 'weeping eye' motif associated with hawks and the striking power of lightning. The choice of this motif is a direct reference to the masks of nineteenth-century Assiniboine Fool Dancers. These were clowns who carried a deer-hoof wand and used backward speech (Lowie 1909: pp. 62–6; 1916: p. 911). Like corresponding societies of the neighbouring Plains Cree and Plains Ojibwa, Fool Dancers shared the typical characteristic of contraries, who were also notoriously connected with thunder beings whose protection ensured successful raids (see pages 80–1) .

Distinct powwow regalia evolved from regional styles (see pages 138–9). Powwow dances are more generally divided into northern and southern styles. Within these typologies dances can vary in accordance with singing and drumming genres and are classified according to the type of regalia worn by the dancers.

New contexts

Twentieth-century historical, political and economic developments deeply changed Plains Indians' cultural life. The progressive fragmentation of social structures, an increasing erosion of customary values, and the pressure to conform to majority lifestyles imposed by governmental policies and legislation forced indigenous North Americans to engage with their traditions in strategic ways that enabled them to straddle competing ideologies and cope with asymmetrical power relations. Since the establishment of reservations new cultural expressions have emerged from ever more frequent interaction with non-indigenous worlds. New conditions of cultural production, exchange and fruition of objects and ideas created through experiences of captivity, integrated schools, military life and urbanization provided a fertile terrain for experimentation and creative output. Simultaneously triggered by the necessity to retain connection with traditions and the external pressure to assimilate, individual originality, foreign stimuli and hybridization resulted in changes in expressive cultures whose forms and meanings reflected a dynamic engagement with contrasting forces. At the same time, some former modalities of expression retained a powerful cultural resonance in the maintenance of continuity with old customs.

New cultural contexts that have appeared since the early twentieth century enabled Plains Indians and most indigenous North Americans to reflect on the role that

dancing and singing (Lassiter 1998). The inclusion of eagle feathers in dance regalia is an example of the spiritual meanings associated with dancing and the deep respect given to the military achievements of the past and to warriors and soldiers. Eagle feathers were traditionally given to warriors as proof of their accomplishments. They constituted the most common form of prestige currency for Plains Indian braves. While the public gift of an eagle feather represented the social acknowledgment of a warrior's valour, the feather also signified recognition of the deep spiritual strength that had guided and protected the warrior's actions. Because of their inherent spiritual power, eagle feathers are today still treated with the uttermost respect. In contemporary powwows, should an eagle feather fall during a dancer's acrobatic motions it can only be picked up by a veteran who has participated in real battles.

Over the years, powwow dance regalia have developed into distinct forms associated with regional variations of specific dance styles. Sashes, yokes and harnesses, feather bustles, roaches, whips, wands, shields, belts and clubs are the most common items used in different types of dances. References to warrior society regalia permeate contemporary powwow dancers' attire. The common beaded harnesses worn by so-called 'Fancy Dancers', for example, are a direct development of otter-skin braces decorated with mirrors used in the nineteenth century (Figs 145 and 81) (Sager 2000). Similarly, feather bustles in the shape of

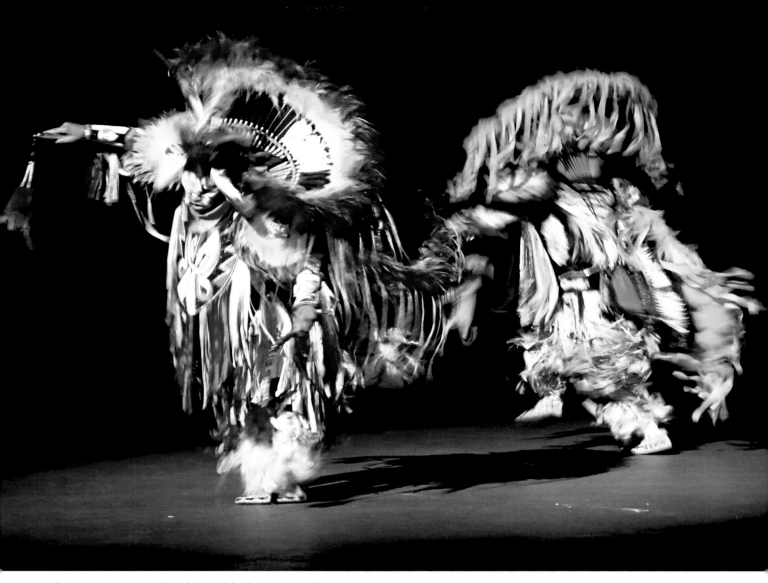

Fig. 146 *Powwow competition, photograph by Simona Piantieri, 2010.*
Powwow competitions can be dramatically enhanced by a judicious use of lighting and paring of dancers.

practices, beliefs and cultural artefacts played in their lives. Many found in the production and use of objects a helpful tool to express and contingently reframe notions of ethnic and national identity in rapidly evolving circumstances. Modes of expression developed between the late nineteenth and early twentieth century such as ledger art, or powwow dancing regalia, retained the important function of preserving meanings relevant to maturing as an indigenous person in the contemporary world. The visual language developed by Plains peoples over this period through new aesthetics, formal expressions and innovative media answered the need for expressing intangible ways of feeling that materially manifested a deeply rooted sense of spirituality and beliefs at the very core of Native North American identity.

While pre-reservation objects associated with warfare may have been more directly linked to religious beliefs, spiritual sanction and supernatural connections, mutated circumstances modified the degree to which spirituality today mediates our understanding of objects produced or used by contemporary Plains Indians. As the present foray into the cultural history of war-related objects demonstrates,

intangible spiritual qualities once attributed to weapons, personal medicines and insignia made, owned and worn by past warriors are often retained in contemporary items. While some of these objects continue to be perceived as alive because of particular spiritual energies stored in them, they cumulatively embody a collective spirit that can be aptly translated into a shared sense of community.

Objects so charged with significance retain an immense symbolic power for the many twenty-first-century Native North Americans who consciously express their indigenous identity. It is through the use of these objects that individuals come together as communities, because they embody traditions relevant to their contemporary lives. They epitomize the crucial role still fulfilled by rituals and ceremonies that transmit values and beliefs which connect the generations via symbols and actions. As repositories of moral principles and knowledge, these objects are fundamental aids to the maintenance of cohesion and continuity with the past. As much today as historically, these objects have a deep effect on reality because they shape ideas and perceptions of what is useful, admirable, relevant and valuable. As such, they can be seen as technologies of the intangible, for they transmit implicit information and

Contemporary powwow regalia

Fancy Dance regalia such as these, produced by Dennis Zotigh (Kiowa), are among the most elaborate used by men in powwow competitions (Fig 147). They are characterized by imposing feather bustles worn at the waist and shoulders, a beaded harness and belt, a hair roach, arm ornaments and knee bells. In the past, dancers only used feather bustles attached to a waist strap, but by the mid-twentieth century a shoulder bustle had been introduced for increased visual impact and arresting presence. Feather ornaments similar to waist bustles currently used by Fancy Dancers have been identified on precolonial effigies. A clear representation of a feathered ornament is visible on an anthropomorphic pipe found at the archaeological site of Adena Mound in Ohio that is dated between 500 BC and AD 1. Interestingly, the man represented on this object also displays a haircut reminiscent of the roach made of dyed deer hair used today by all powwow dancers. Although it is not possible to know exactly in what context this ancient man might have used these regalia, it is tempting to see a certain degree of historical continuity in the formal similarities between his accoutrements and the regalia of contemporary dancers.

Fancy Dance regalia differ greatly from other outfits worn at powwows. 'Traditional' dancers, for example, wear regalia made in accordance with old techniques using materials such as pelts and skins dyed with natural pigments. Dancers in this category generally avoid bright colours, dyed feathers and acrylic fabrics. Newer elements are most frequently included in regalia worn by people competing in categories such as 'Grass Dance', 'Fancy Dance' or women's 'Jingle dresses'. Dennis' Fancy Dance regalia include commercially available orange ribbons that he has used to tip the bustles' feathers to add dynamism while dancing. These ribbons substitute

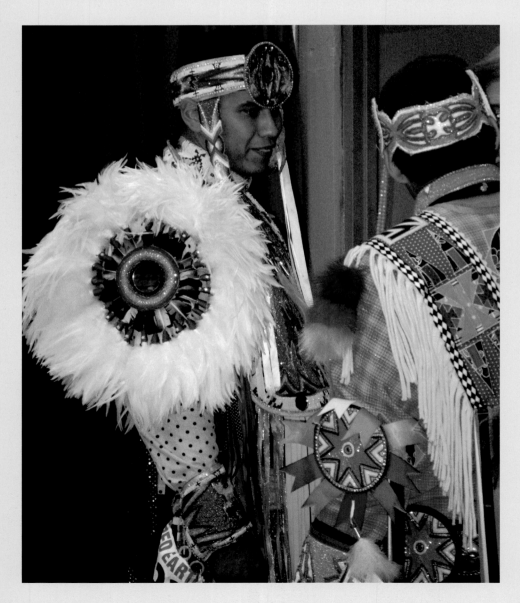

Fig. 147 *Participants at the Red Earth Festival, Oklahoma, photograph by the author, 2010.*
Participants at the annual Red Earth Festival demonstrate their inventiveness and creativity by mixing and matching new and old styles in original and highly individual fashions. The use of fluorescent ribbons, sequins, and microfibre is becoming common among young dancers.

Fig. 148 *Powwow regalia used and made by Fancy Dancer Dennis Zotigh (Kiowa), 2000–9. Twenty-eight pieces of regalia including: feathered roach, beaded bandoliers, gaiters, headband and belt, tabard and apron, feathered back and arm bustles and goatskin boots. Feathers, wood, cotton, polyester, glass, textile, deer hair, horse hair and skin, H 210 cm, W 120 cm (2010,2029.1.a-z).*

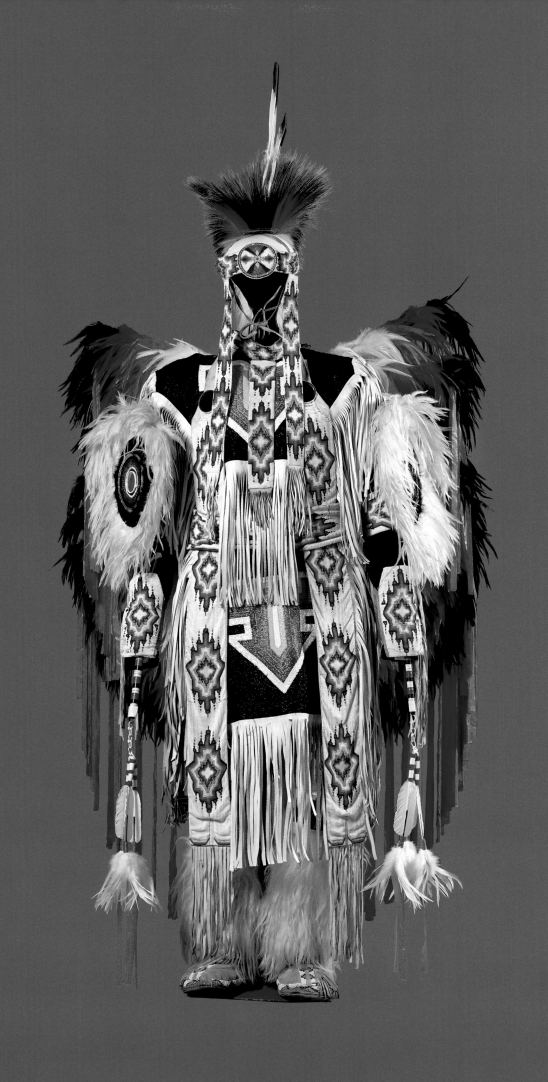

for the dyed horse hair used in the past to decorate eagle feathers and add a contemporary feel to the whole outfit. New materials and designs reflect changing trends, expressed by powwow dancers with resourcefulness and creativity (Fig 148). Regalia worn by men and youngsters in recent powwows often include references to popular culture, such as cartoon characters sewn on side flaps and breech cloths, CDs on arm bands, and graphics inspired by the aesthetics of heavy metal and rock groups reproduced in beadwork on yokes, harnesses and wrist decorations. Women may use sequins, fluorescent or translucent fabrics and acid-coloured ribbons to decorate shawls, leggings, crowns and hair ties.

Innovation on traditional themes has always characterized powwow regalia. Many of the materials used throughout history to produce both men's and women's outfits were either imported or recycled from readily available objects. Glass beads, tin cones, brass bells, mirrors and buckles, now integral parts of powwow regalia, are among the items introduced by Europeans to North America for trade and commercial purposes. In spite of all these innovations, the symbols and martial meanings associated with powwow regalia have remained constant over time. Feathers worn dangling on the side of the dancer's head are called 'scalp feathers'. Designs used to decorate dancing shields and other items often refer to powerful protective animals, such as eagles, wolves and hawks, traditionally related to warfare and warrior powers. Fire, crosses, circles and thunderbirds also appear frequently in powwow regalia decorations. Thunderbirds in particular can be discerned hidden in hatched designs that produce the hourglass patterns traditionally used to signify these mighty beings. The zig-zags, stripes and dots that decorate dancers' moccasins, side flaps, yokes and breech cloths cite pictographic conventions that historically represented bullets, tallies and various warriors' accomplishments on shirts, leggings and weapons. In addition to tributes to warrior roots expressed by individualized decorations on powwow regalia, perhaps the most visible acknowledgement of their martial legacy is the collective 'grand entry'. This is the parade that starts every event, in which flags and military insignia are carried by soldiers, veterans, elders and other distinguished members of the sponsoring community. This sombre opening, during which all participants are required to stand in respect for national and tribal symbols and their bearers, is frequently followed by Gourd Dancers, generally veterans themselves, who begin singing traditional songs before starting off the dance competition (Fig. 149). The inclusion of this repertoire reiterates the customary nature of the event while highlighting its military origins. Powwows clearly reveal historical continuity in themes and motifs that stress the cultural significance of the warrior tradition among contemporary Plains peoples.

Fig. 149 *Powwow competitor, J. J. Lone Lodge, Kiowa/Wichita, in the Fancy Dance category at the American Indian Exposition in Anadarko, Oklahoma, photograph by Milton Paddlety, Kiowa, 1994 (Am,Paddlety,F.N.1790 Donated by Milton Paddlety).*

enable invisible connections between past and present. The emotional responses of the Native delegates during the British Museum exhibition to the sight of ancestral warriors' objects indicate that, irrespective of the contexts in which they operate, the objects provide links with fundamental principles for the continuation of indigenous identities (Fig 150).

The contextual reading of warfare-related objects provided here resonates with Native ways of understanding and conceptualizing a world in which things and actions should be understood as integrated wholes. This holistic perspective ultimately reveals the level to which religious and martial aspects implicit in these Plains Indian objects mutually inform each other's meanings and, in turn, the cultural practices of which they are an essential part. Indeed, these objects can neither be seen solely as warfare objects nor can they be understood only as religious items because, in most cases, they are both. On the contrary, religious and martial meanings together give significance to these objects even if, as in more contemporary contexts, they may be perceived as either solely ritual or simply military. When veterans enter the powwow arena wearing their feather bonnets and soldiers' insignia, they are simultaneously invoking symbols and meanings that work at different levels. Although the military aspects may be more clearly stated, they work in tandem with the references to spirituality associated with sacred objects carried in parade and the respect for the values they represent. The complex interplay of spiritual and martial cross-referencing eludes any simple classification of these items as art objects, crafts or soldier's insignia. While undoubtedly Native North Americans recognize in them the aesthetic properties that potentially locate these objects in the language of art or craft, a pure appreciation of their formal qualities, technical execution and composition may hinder a complete comprehension of their cultural role among those who produce and use them. In order to achieve a fuller picture of their local relevance among Native North Americans, it would perhaps be more appropriate to see these features as expressions of principles and values that go beyond the immediate appreciation of their beauty and the skills of their makers. Truly, objects cannot be divorced from their contexts of fruition, as perceptions of them among different audiences change within the conditions of representation. Irrespective of context, however, it is important to highlight the various elements that render these objects not only examples of technical accomplishment, taste and cultural finesse, but also exuberant agents of cultural continuity, identity maintenance and social cohesion. This perhaps is the main quality that continues to characterize warfare-related objects produced by Native Americans of the Great Plains over their rich and dynamic history.

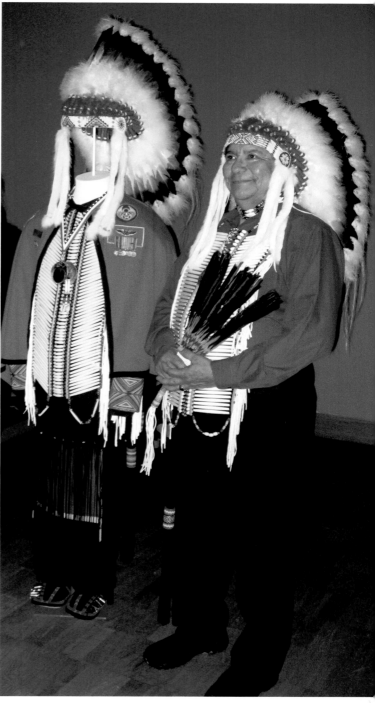

Fig. 150 *Lyndreth L. Palmer after the blessing ceremony in the exhibition hall of* Warriors of the Plains *(British Museum January–April 2010), photograph by the author, 2010.*

Bibliography

Abel, Annie Heloise 1939, *Tabeau's Narrative of Loisel's Expedition to the Upper Missouri*, Norman: University of Oklahoma Press

Adams, Jim 2004a, 'OutKast's GRAMMY Performance Offends Many', *Indian Country Today*, 18 February: A1, A3

Adams, Jim 2004b, 'Miss USA's Costume Offends Native Viewers', *Indian Country Today*, 9 June: B1

Afton, Jane, Andrew E. Masich, Richard N. Ellis and David Fridtjof Halaas 2000, *Cheyenne Dog Soldiers: A Ledger Book History of Coups and Combat*, Boulder: University of Colorado Department of Fine Arts

Albers, Patricia 1971, 'The Plains Vision Experience: A Study of Power and Privilege', *Southwestern Journal of Anthropology* 27 (3): 203–33

Albers, Patricia 1993, 'Symbiosis, Merger, and War: Contrasting Forms of Intertribal Relationship among Historic Plains Indians', pp. 94–132 in John H. Moore (ed.), *The Political Economy of North American Indians*, Norman: University of Oklahoma Press

Albers, Patricia and Beatrice Medicine (eds) 1983, *The Hidden Half: Studies of Plains Indian Women*, Lanham, MD: University Press of America

Anderson, Jeffrey D. 2000, 'The Motion-Shape of Whirlwind Woman in Arapaho Women's Quillwork Art', *European Review of Native American Studies* 14 (1): 11–21

Anderson, Robert 1956, 'The Northern Cheyenne War Mothers', *Anthropological Quarterly* 29 (4): 82–90

Anthes, Bill 2006, *Native Moderns: American Indian Painting, 1940-1960*, Durham and London: Duke University Press

Appadurai, Arjun (ed.) 1986, *The Social Life of Things*, Cambridge: Cambridge University Press

Applegate Krouse, Susan 2009, *North American Indians in the Great War*, Lincoln: University of Nebraska Press

Archambault, JoAllyn 2001, 'Sun Dance', pp. 983–95 in *Handbook of North American Indians*, vol. 13, pt 2, Washington, DC: Smithsonian Institution

Axtell, James and William C. Sturtevant 1980, 'The Unkindest Cut, or Who Invented Scalping', *William and Mary Quarterly* 37 (3): 451–72

Bad Heart Bull, Amos, Helen H. Blish and Mari Sandoz 1967, *A Pictographic History of the Oglala Sioux*, Lincoln: University of Nebraska Press

Bailey, Garrick 2004, 'Continuity and Change in Mississippian Civilization', pp. 83–91 in Richard Townsend (ed.), *Hero, Hawk, and Open Hand: American Indian Art of the Ancient Midwest and South*, New Haven and Chicago: Yale University Press and The Art Institute of Chicago

Bailey, Garrick and Daniel C. Swan 2004, *Art of the Osage*, Seattle and London: Saint Louis Art Museum and University of Washington Press

Barr, Juliana 2007, *Peace Came in the Form of a Woman: Indians and Spaniards in the Texas Borderlands*, Chapel Hill: University of North Carolina Press

Barsh, Russell Lawrence 1991, 'American Indians in the Great War', *Ethnohistory* 38 (3): 276–303

Bennett, Pamela and Tom Holm 2008, 'Indians in the Military', pp. 10–18 in *Handbook of North American Indians*, vol. 2, Washington, DC: Smithsonian Institution

Berlo, Janet Catherine 2000, *Spirit Beings and Sun Dancers: Black Hawk's Vision of the Lakota World*, New York: George Braziller

Berlo, Janet C. and Ruth Phillips 1998, *Native North American Art*, Oxford: Oxford University Press

Bernstein, Alison R. 1991, *American Indians and World War II: Toward a New Era in Indian Affairs*, Norman: University of Oklahoma Press

Biolsi, Thomas (ed.) 2008, *A Companion to the Anthropology of American Indians*, Oxford: Blackwell

Bishop Franco, Jere 1999, *Crossing the Pond: The Native American Effort in World War II*, Denton: University of North Texas Press

Blakeslee, Donald J. 1981, 'The Origin and Spread of the Calumet Ceremony', *American Antiquity* 46 (4): 759–68

Bowers, Alfred W. 1950, *Mandan Social and Ceremonial Organization*, Chicago: University of Chicago Press

Bowers, Alfred W. 1992 [1965], *Hidatsa Social and Ceremonial Organization*, Lincoln: University of Nebraska Press

Bray, Kingsley 2003, 'Omaha Rendezvous: Ethnogenesis and Warfare at a Plains Indian Trade Center', pp. 40–52 in Colin F. Taylor and Hugh A. Dempsey (eds), *The Plains Indians of North America: Military Art, Warfare, and Change. Essays in Honor of John C. Ewers*, Wyk auf Foehr: Tatanka Press

Britten, Thomas A. 1997, *American Indians in World War I: At War and at Home*, Albuquerque: University of New Mexico Press

Brizee Bowen, Sandra L. 2002, *For All to See: The Little Bighorn Battle in Plains Indian Art*, Glendale, California: Arthur H. Clark

Brose, David S., James A. Brown and David W. Penney 1985, *Ancient Art of the American Woodland Indians*, New York: Harry N. Abrams

Brown, James 2007, 'On the Identity of the Birdman within Mississippian Period Art and Iconography', pp. 56–106 in F. Kent Reilly III and James F. Garber (eds), *Ancient Objects and Sacred Realms: Interpretations of Mississippian Iconography*, Austin: University of Texas Press

Brownstone, Arni 1993, *War Paint: Blackfoot and Sarcee Painted Buffalo Robes in the Royal Ontario Museum*, Toronto: Royal Ontario Museum

Brownstone, Arni 2002, 'Completing the Circle', pp. 10–13 in Jonathan C.H. King and W. Raymond Wood (eds), *Ákaitapiiwa Ancestors*, Lethbridge, Alberta: Sir Alexander Galt Museum and Archives

Brumble, H. David III 1988, *American Indian Autobiography*, Berkeley: University of California Press

Buchli, Victor (ed.) 2002, *The Material Culture Reader*, Oxford: Berg

Buffalohead, Eric 2004, 'Dhegihan History: A Personal Journey', *Plains Anthropologist Memoir 36*, 49 (192): 327–43

Butler, Lorinda T. 1994, 'World War I and the Native American', *Whispering Wind* 27 (1): 12–19

Carocci, Massimiliano 1995, 'Limits of the Concept of Culture Areas in the Development of a New Anthropology of American Indians', pp. 277–84 in K. Versluys (ed.), *The Insular Dream: Obsession and Resistance*, Amsterdam: VU University Press

Carocci, Massimiliano 1997a, 'Role Change in Northern Plains Women's Societies after the Introduction of Horse Related Economy', pp. 165–76 in Susan Castillo and Victor M.P. Da Rosa (eds), *Native American Women in Literature and Culture*, Porto: Edições Universidade Fernando Pessoa

Carocci, Massimiliano 1997b, 'Rain' [exhibition review], *European Review of Native American Studies* 11 (1): 53

Carocci, Massimiliano 1999, 'Women, Temporary Liminality and Two-Spirits: The Staging of Community in the Plains Indians Scalp Dance's Gender Masquerade', *Journal of Ritual Studies* 13 (2): 12–25

Carocci, Max 2009, 'Visualizing Gender Variability in Plains Indian Pictographic Art', *American Indian Culture and Research Journal* 33 (1): 1–22

Carroll, Al 2008, *Medicine Bags and Dog Tags: American Indian Veterans from Colonial Times to the Second Iraq War*, Lincoln: University of Nebraska Press

Catlin, George 1974 [1844], *Letters and Notes on the Manners, Customs, and Conditions of the North American Indians Written During Eight Years' Travels (1832–1839) amongst the Wildest Tribes of Indians of North America*, vols I and II, New York: Dover

Chacon, Richard J. and David H. Dye (eds), 2007, *The Taking and Displaying of Human Body Parts as Trophies by Amerindians*, London: Springer

Clerici, Naila 1998, 'War Fighters and Peace Keepers: An American Indian Perspective', *Rivista di Studi Anglo-Americani* 9 (11): 478–90

Clifford, James 1992, 'Four Northwest Coast Museums: Travel Reflections', pp. 212–54 in Ivan Karp and Steven D. Levine (eds), *Exhibiting Cultures: The Poetics and Politics of Museum Display*, Washington, DC: Smithsonian Institution Press

Cobb, Amanda J. (ed.) 2005, 'The National Museum of the American Indian', *American Indian Quarterly* [special issue] 29 (3–4)

Coleman, Winfield 1998, 'Art as Cosmology: Cheyenne Women's Rawhide Painting', *World of Tribal Arts* 5 (1): 48–60

Coleman, Winfield 2003, 'Feeding Scalps to Thunder: Shamanic Symbolism in the Art of the Cheyenne Berdache', pp. 98–113 in Colin F. Taylor and Hugh A. Dempsey (eds), *The Plains Indians of North America: Military Art, Warfare, and Change. Essays in Honor of John C. Ewers*, Wyk auf Foehr: Tatanka Press

Coleman, Winfield 2004, 'Blinded by the Sun: Shamanism and Warfare in the Little Shield Ledger', *European Review of Native American Studies* 18 (1): 31–40

DeMallie, Raymond J. 1983, 'Male and Female in Traditional Lakota Culture', pp. 237–65 in Patricia Albers and Beatrice Medicine (eds), *The Hidden Half: Studies of Plains Indian Women*, Lanham, MD: University Press of America

DeMallie, Raymond J. 2001, 'Introduction', pp. 1–13 in Raymond DeMallie (ed.), *Handbook of North American Indians*, vol. 13, pt 1, *Plains*, Washington, DC: Smithsonian Institution

DeMallie, Raymond J. and Douglas R. Parks 2003, 'Plains Indian Warfare', pp. 66–76 in Colin F. Taylor and Hugh A. Dempsey (eds), *Military Art, Warfare, and Change: Essays in Honor of John C. Ewers*, Wyk auf Foehr: Tatanka Press

Dempsey, Hugh Aylmer 1972, *Crowfoot, Chief of the Blackfoot*, Norman and London: University of Oklahoma Press

Dempsey, James 2007, *Blackfoot War Art: Pictographs of the Reservation Period, 1880–2000*, Norman: University of Oklahoma Press

Denig, Edwin T. 1930, 'Indian Tribes of the Upper Missouri', pp. 375–628 in J.N.B. Hewitt (ed.), *46th Annual Report of the Bureau of American Ethnology 1928–1929*, Washington, DC: Smithsonian Institution

Densmore, Frances 1934, 'The Songs of Indian Soldiers During the World War', *The Musical Quarterly* 20 (4): 419–25

Dobkins, Rebecca J. 2008, 'Art', pp. 212–28 in Thomas Biolsi (ed.), *A Companion to the Anthropology of American Indians*, Oxford: Blackwell

Dombrowski, Kirk 2008, 'The Politics of Native Culture', pp. 360–82 in Thomas Biolsi (ed.), *A Companion to the Anthropology of American Indians*, Oxford: Blackwell

Donald, Leland 1997, *Aboriginal Slavery on the Northwest Coast of North America*, Berkeley: University of California Press

Dorsey, James O. 1885, 'Mourning and War Customs of the Kansas', *The American Naturalist* 19 (7): 670–80

Dorsey, James O. 1894, 'A Study of Siouan Cults', *11th Annual Report of the Bureau of American Ethnology 1889–1890*, Washington, DC: Smithsonian Institution

Driver, Harold 1962, 'The Contributions of A.L. Kroeber to Culture Area Theory and Practice', *Indiana University Publications in Anthropology and Linguistics* 18, Bloomington

Durham, Jimmie, Richard William Hill, Jean Fisher, Bonnie Fultz, Jen Budney and Simon Ortiz 2005, *The American West*, Compton Verney and Peter Moores Foundation

Durrett, Deanne 2009, *Unsung Heroes of World War II: The Story of the Navajo Code Talkers*, Lincoln: University of Nebraska Press

Dye, David H. 2004, 'Art, Ritual, and Chiefly Warfare in the Mississippian World', pp.190–205 in Richard Townsend (ed.), *Hero, Hawk, and Open Hand: American Indian Art of the Ancient Midwest and South*, New Haven and Chicago: Yale University Press and The Art Institute of Chicago

Earenfight, Phillip (ed.) 2007, *A Kiowa's Odyssey: A Sketchbook from Fort Marion*, Seattle: University of Washington Press

Eckberg, Carl J. 2007, *Stealing Indian Women: Native Slavery in the Illinois Country*, Urbana and Chicago: University of Illinois Press

Ellis, Clyde 1999 '"We Don't Want Your Rations, We Want This Dance": the Changing Use of Song and Dance on the Southern Plains' *Western Historical Quarterly* 30(2):133–154

Errington, Shelley 1998, *The Death of Authentic Primitive Arts and Other Tales of Progress*, Berkeley: University of California Press

Ewers, John C. 1939, *Plains Indian Painting: A Description of a Native American Art*, Palo Alto: Stanford University Press

Ewers, John C. 1955, 'The Horse in Blackfoot Indian Culture: with Comparative Material from Other Western Tribes', *Bureau of American Ethnology Bulletin 159*, Smithsonian Institution, Washington, DC: United States Government Printing Office

Ewers, John C. 1957, 'Early White Influence upon Plains Indian Painting: George Catlin and Karl Bodmer among the Mandan', *Smithsonian Miscellaneous Collections* 137 (7): 1–11

Ewers, John C. 1958, *The Blackfeet, Raiders of the Northwestern Plains*, Norman: University of Oklahoma Press

Ewers, John C. 1964, 'The Emergence of the Plains Indian as the Symbol of the North American Indian', *Annual Report of the Smithsonian Institution*, Washington, DC: Smithsonian Institution

Ewers, John C. (ed.) 1969, *The Indians of Texas in 1830 by Jean Louis Berlandier*, Washington, DC: Smithsonian Institution Press

Ewers, John C. 1977, 'Notes on the Weasel in Historic Plains Indian Culture', *Plains Anthropologist* 22 (1): 253–62

Ewers, John C. 1978, *Murals in the Round: Painted Tipis of the Kiowa and Kiowa-Apache Indians*, Washington, DC: Smithsonian Institution Press

Ewers, John C. 1987, *Plains Indian Sculpture: A Traditional Art from America's Heartland*, Washington, DC: Smithsonian Institution Press

Ewers, John C. 1997, *Plains Indian History and Culture: Essays on Continuity and Change*, Norman and London: University of Oklahoma Press

Ewers, John C. 2003, 'Military Art of the Plains Indians', pp. 24–37 in Colin F. Taylor and Hugh A. Dempsey (eds), *Military Art, Warfare, and Change: Essays in Honor of John C. Ewers*, Wyk auf Foehr: Tatanka Press

Fagan, Brian M. 1995, *Ancient North America: The Archaeology of a Continent*, London and New York: Thames & Hudson

Farr, William E. 1993, 'Troubled Bundles, Troubled Blackfeet: The Travail of Cultural and Religious Renewal', *Montana: The Magazine of Western History* 43 (4): 2–17

Feest, Christian F. 1999, *Native Arts of North America* [updated edn], London and New York: Thames & Hudson

Fiorentino, Daniele 1998, 'Between Tradition and Assimilation: The Debate on the American Indians' Participation in World War I', *Rivista di Studi Anglo-Americani* 9 (11): 269–675

Fitzgerald, Michael Owen and Yellowtail 1991, *Yellowtail: Crow Medicine Man and Sun Dance Chief*, Norman and London: University of Oklahoma Press

Fletcher, Alice and Francis La Flesche 1911, 'The Omaha Tribe', *27th Annual Report of the Bureau of American Ethnology 1904–1906*, Washington, DC: Smithsonian Institution

Fossati, Angelo Eugenio, James D. Keyser and David A. Kaiser 2010, 'Flags and Banners in Warrior Rock Art: Ethnographic Comparison for Valcamonica and Bear Gulch Rock Art', *American Indian Rock Art* (36): 109–24

Gell, Alfred 1996, 'Vogel's Net: Traps as Artworks and Artworks as Traps', *Journal of Material Culture* 1 (1): 15–38

Gell, Alfred 1998, *Art and Agency: An Anthropological Theory*, Oxford: Clarendon Press

Gelo, Daniel J. and Lawrence T. Jones III 2009, 'Photographic Evidence for Southern Plains Armor', *Visual Anthropology Review* 25 (1): 49–65

Gibbs, Peter 1982, 'Duke Wilhelm Collection in the British Museum', *American Indian Art Magazine* 7 (3): 52–61

Gibson, Arrell Morgan 1985, 'Native Americans and the Civil War', *American Indian Quarterly* 9 (4): 385–410

Gilbert, Ed 2008, *Native American Code Talker in World War II*, Oxford: Osprey Publishing

Goddard, Ives (ed.) 1996, 'Languages', *Handbook of American Indians*, vol. 17, Washington, DC: Smithsonian Institution

Greene, Candace S. 2004, 'From Bison Robes to Ledgers: Changing Contexts in Plains Drawings', *European Review of Native American Studies* 18 (1): 21–40

Greene, Candace and Russell Thornton 2007, *The Year the Stars Fell: Lakota Winter Counts at the Smithsonian*, Lincoln: University of Nebraska Press

Greene, Jerome 2007, *Indian War Veterans: Memories of Army Life and Campaigns in the West, 1864—1898*, Lincoln: University of Nebraska Press

Greer, Melissa and James D. Keyser 2008, 'Women among Warriors: Female Figures in Bear Gulch Rock Art', *American Indian Rock Art* (34): 89–103

Grinnell, George B. 1972 [1923], *The Cheyenne Indians: Their History and Way of Life*, vols I and II, Lincoln: University of Nebraska Press

Haines, Francis 1976, *The Plains Indians*, New York: Thomas Y. Cromwell

Hall, Robert L. 1997, *An Archaeology of the Soul: North American Indian Belief and Ritual*, Urbana: University of Illinois Press

Hämäläinen, Pekka 2003, 'The Rise and Fall of Plains Indian Horse Cultures', *Journal of American History* 90 (3): 833–62

Hanson, Emma I. 2008, *Memory and Vision: Arts, Cultures and Lives of Plains Indian Peoples*, Seattle: University of Washington Press

Hanson, Jeffrey R. 1988, 'Ages-set Theory and Plains Indian Age-grading: A Critical Review and Revision', *American Ethnologist* (15): 349–64

Harris, Moira F. 1989, *Between Two Cultures: Kiowa Art from Fort Marion*, Saint Paul: Pogo Press

Harrod, Howard L. 1995, *Becoming and Remaining a People: Native American Religions on the Northern Plains*, Tucson: University of Arizona Press

Hassrick, Royal B. 1964, *The Sioux: Life and Customs of a Warrior Society*, Norman and London: University of Oklahoma Press

Hennepin, Louis 1903 [1698], *A New Discovery of a Vast Country in America*, Reuben Gold Thwaites (ed.), Chicago: McClurg

Her Many Horses, Emil 2007, *Identity by Design: Tradition, Change, and Celebration in Native Women's Dresses*, Washington, DC: Smithsonian Institution, National Museum of the American Indian and Harper Collins

Her Many Horses, Emil and George Horse Capture (eds) 2006, *Song for the Horse Nation: Horses in Native American Cultures*, Golden, CO: Fulcrum Publishing

Heth, Charlotte (ed.) 1992, *Native American Dance: Ceremonies and Social Traditions*, Washington, DC: National Museum of the American Indian

Hill, Richard 1994a, 'Introduction', pp. 6–7 in *Akwe:kon* [special issue]: *Native American Expressive Culture*

Hill, Richard 1994b, 'The Old and the New: Different Forms of the Same Message', pp. 74–83 in *Akwe:kon* [special issue]: *Native American Expressive Culture*

Hill, Tom and Richard W. Hill Sr (eds) 1994, *Creation's Journey: Native American Identity and Belief*, Washington, DC: Smithsonian Institution Press

Hoebel, E. Adamson 1978 [1906], *The Cheyenne, Indians of the Great Plains*, New York: Harcourt Brace College Publishers

Holder, Preston 1970, *The Hoe and the Horse on the Plains: A Study of Cultural Development among North American Indians*, Lincoln: University of Nebraska Press

Horse Capture, George P., Anne Vitart, Michael Waldberg and Richard West Jr 1993, *Robes of Splendor: Native North American Painted Buffalo Hides*, New York: The New Press

Horse Capture, Joseph D. and George P. Horse Capture 2001, *Beauty, Honor, and Tradition: The Legacy of Plains Indian Shirts*, Washington, DC and Minneapolis: National Museum of the American Indian and Minneapolis Institute of Arts

Hotz, Gottfried 1970, *Indian Skin Paintings from the American Southwest: Two Representations of Border Conflicts between Mexico and the Missouri in the Early Eighteenth Century*, Norman: University of Oklahoma Press

Howard, James H. 1951, 'Notes on the Dakota Grass Dance', *Southwestern Journal of Anthropology* (7): 82–5

Howard, James H. 1953, 'The Southern Cult in the Northern Plains', *American Antiquity*, 19 (2): 130–38

Howard, James H. 1956, 'The Persistence of Southern Cult Gorgets among the Historic Kansa', *American Antiquity*, 21(3): 301–3

Hultkrantz, Åke 1980, *The Religions of the American Indians*, Berkeley: University of California Press

Ingold, Tim 1988, 'Living Arctic at the Museum of Mankind' [exhibition review], *Anthropology Today* 4 (4): 14–17

Iverson, Peter (ed.) 1985, *The Plains Indians of the Twentieth Century*, Norman: University of Oklahoma Press

Jablow, Joseph 1951, *The Cheyennes in Plains Indian Trade Relations, 1795–1840*, Lincoln: University of Nebraska Press

Jennings, Vanessa 2004, 'The Tradition of the Kiowa Battle Dress', *Whispering Wind* 32 (3): 8–16

Jessup, Lynda and Shannon Bagg (eds) 2002, *On Aboriginal Representation in the Gallery*, Hull: Canadian Museum of Civilization

Kaiser, David A., James D. Keyser, Amanda K. Derby and John Greer 2010, 'The Bear Gulch Shield Bearing Warrior: Defining a Cultural Type', *American Indian Rock Art* (36): 37–52

Kampen O'Riley, Michael 2002, *Art Beyond the West*, New York: Harry N. Abrams

Kavanagh, Thomas W. 1996, *The Comanches: A History, 1706–1875*, Lincoln and London: University of Nebraska Press

Kehoe, Alice B. 1970, 'The Function of Ceremonial Sexual Intercourse among the Northern Plains Indians', *Plains Anthropologist*, 15 (47): 99–103

Kehoe, Alice B. 2004, 'The Rush Mat of the Wa-Xo'-Be: Wrapping the Osage within the Cosmos', *Cosmos* (20): 2–16

Kehoe, Alice B. 2007, 'Osage Texts and Cahokia Data', pp. 246–61 in F. Kent Reilly III and James F. Garber (eds), *Ancient Objects and Sacred Realms: Interpretations of Mississippian Iconography*, Austin: University of Texas Press

Keyser, James D. 1977, 'Writing-on-Stone: Rock Art on the Northwestern Plains', *Canadian Journal of Archaeology* (1): 15–79

Keyser, James D. 1991, 'A Thing to Tie to the Halter: An Addition to the Plains Rock Art Lexicon', *Plains Anthropologist* 36 (136): 261–7

Keyser, James D. 2000, *The Five Crows Ledger: Biographic Warrior Art of the Flathead Indians*, Salt Lake City: University of Utah Press

Keyser, James D. 2004, *The Art of the Warrior*, Salt Lake City: University of Utah Press

Keyser, James D. 2007, 'The Warrior as Wolf: War Symbolism in Prehistoric Montana Rock Art', *American Indian Art Magazine* 32 (3): 62–89

Keyser, James D. 2008a, 'Prehistoric Antecedents of the Plains Bow-Spear', *American Indian Art Magazine* 33 (2): 60–73, 92

Keyser, James D. 2008b, '"These Curious Appendages": Medicine Bundles in Bear Gulch Rock Art', *American Indian Rock Art* (34): 61–72

Keyser, James D. 2010, 'Size Really Does Matter: Dating Plains Rock Art Shields', *American Indian Rock Art* (36): 85–102

Keyser, James D. and Michael A. Klassen 2001, *Plains Indian Rock Art*, Seattle: University of Washington Press

Keyser, James D., Linea Sundstrom and George Poetschat 2006, 'Women in War: Gender in Plains Biographic Rock Art', *Plains Anthropologist* 51 (197): 51–70

King, Jonathan C.H. 1986, 'Tradition in Native American Art', pp. 64–92 in Edwin L. Wade and Carol Haralson (eds), *The Arts of the North American Indian: Native Traditions in Evolution*, New York: Hudson Hills Press and Philbrook Art Center

King, Jonathan C.H. 1999, *First Peoples, First Contacts*, London: British Museum Press

King, Jonathan C.H. 2001, 'Writing Biographies: A Northern Plains War Record Robe at the British Museum', *American Indian Art Magazine* 26 (3): 72–7

King, Jonathan C.H. 2005, 'Marketing Native North America: The Promotion and Sale of Art and Design', *European Review of Native American Studies* 19 (1): 5–12

King, Jonathan C.H. and JoAllyn Archambault 2003, *Native American Art: Irish American Trade. The Stonyhurst Mullanphy Collection*, London: British Museum Press

Klein, Alan M. 1980, 'Plains Economic Analysis: The Marxist Complement', pp. 129–40 in W. Raymond Wood and Margot Liberty (eds), *Anthropology on the Great Plains*, Lincoln: University of Nebraska Press

Klein, Alan M. 1983, 'The Political Economy of Gender: A 19th Century Plains Indian Case Study', pp. 143–65 in Patricia Albers and Beatrice Medicine (eds), *The Hidden Half: Studies of Plains Indian Women*, Lanham, MD: University Press of America

Klein, Alan M. 1993, 'Political Economy of the Buffalo Hide Trade: Race and Class on the Plains', pp. 133–60 in John H. Moore (ed.), *The Political Economy of North American Indians*, Norman: University of Oklahoma Press

Koch, Ronald P. 1977, *Dress Clothing of the Plains Indians*, Norman and London: University of Oklahoma Press

Kostelnik, Michael 2009, 'Cheyenne Moccasins with Thunderbird Designs', *Whispering Wind* 38 (3): 12–17

Kroeber, Alfred L. 1901, 'Decorative Symbolism of the Arapaho', *American Anthropologist* 3 (2): 308–36

Kroeber, Alfred L. 1902–7, 'The Arapaho', *Bulletin of the American Museum of Natural History* (XVIII): part I, 3–35 and 36–150; part II, 151–229; part IV: 279–454

Kroeber, Alfred L. 1907, 'The Ceremonial Organization of the Plains Indians of North America', *Congrès International des Américanistes*, XVe session (2): 53–63

Kroeber, Alfred L. 1939, 'Cultural and Natural Areas of Native North America', *University of California. Publications in American Archaeology and Ethnology* 38, Berkeley: University of California Press

Krupat, Arnold 1992, *Ethnocriticism: Ethnography, History, Literature*, Berkeley: University of California Press

La Flesche, Francis 1914, 'Ceremonies and Rituals of the Osage', *Explorations and Fieldwork of the Smithsonian Institution. Smithsonian Miscellaneous Collections* 63 (8): 66–9

La Flesche, Francis 1939, 'War Ceremony and Peace Ceremony of the Osage Indians', *Bureau of American Ethnology Bulletin 101*, Smithsonian Institution, Washington, DC: United States Government Printing Office

Landes, Ruth 1968, *The Mystic Lake Sioux*, Madison: University of Wisconsin Press

Lang, Sabine 1998, *Men as Women, Women as Men: Changing Genders in Native American Cultures*, Austin: University of Texas Press

Lassiter, Eric 1998, *The Power of Kiowa Song*, Tucson: University of Arizona Press

Laubin, Reginald and Gladys Laubin 1977, *Indian Dances of North America*, Norman: University of Oklahoma Press

Laurencich Minelli, Laura 1992, 'Indiani delle Grandi Pianure nella Raccolta di Antonio Spagni', *Cataloghi dei Civici Musei* 14, Reggio Emilia

Lee, Molly and Nelson Graburn 1988, 'The Living Arctic, Hunters of the Canadian North: An Exhibit at the Museum of Mankind', *American Indian Art Magazine* (14): 54–9

Lessard, F. Dennis 1992, 'Plains Pictographic Art: A Source of Ethnographic Information', *American Indian Art Magazine* 17 (2): 62–69, 90

Lewis, Meriwether and William Clark 1905 [1814], *History of the Expedition under the Command of Captains Lewis and Clark to the Sources of the Missouri, thence across the Rocky Mountains and down the River Columbia to the Pacific Ocean, performed During the Years 1804–5–6, by Order of the Government of the United States*, London: Nutt

Lewis, Oscar 1941, 'Manly-Hearted Women among the North Piegan', *American Anthropologist* (43): 173–87

Liberty, Margot and John Stands in Timber 1998, *Cheyenne Memories*, New Haven: Yale University Press

Linderman, Frank B. 1972 [1932], *Pretty-Shield: Medicine Woman of the Crows*, Lincoln: University of Nebraska Press

Logan, Michael H. and Douglas A. Schmittou 2007, 'Inverted Flags in Plains Indian Art: A Hidden Transcript', *Plains Anthropologist* 52 (202): 209–27

Londoño Sulkin, Carlos David 2003, 'Powwow Diversified: Powwow: Performance and Nationhood in Native North America, 21–23 February 2003, British Museum', *Anthropology Today* 19 (3): 27

Lowie, Robert H. 1909, 'The Assiniboine', *Anthropological Papers of the American Museum of Natural History* 4 (1), New York: American Museum of Natural History

Lowie, Robert H. 1913a, 'Hidatsa and Mandan Societies', *Anthropological Papers of the American Museum of Natural History* (11), New York: American Museum of Natural History: 143–358

Lowie, Robert H. 1913b, 'Crow Military Societies', *Anthropological Papers of the American Museum of Natural History* (11), New York: American Museum of Natural History: 143–218

Lowie, Robert H. 1915, 'Arikara Societies', *Anthropological Papers of the American Museum of Natural History* (11), New York: American Museum of Natural History: 645–678

Lowie, Robert H. 1916, 'Plains Indian Age-Societies: Historical and Comparative Summary', *Anthropological Papers of the American Museum of Natural History* (11), New York: American Museum of Natural History: 877–992

Lowie, Robert H. 1954, *Indians of the Plains*, New York, Toronto and London: McGraw-Hill

Lowie, Robert H. 1983 [1935], *The Crow Indians*, Lincoln: University of Nebraska Press

Lyford, Carrie A. 1940, 'Quill and Beadwork of the Western Sioux', *United States Office of Indian Affairs, Indian Handicraft* 1, Lawrence, KS: Haskell Institute Printing Department

Mallery, Garrick 1886, 'Pictographs of the North American Indians', *4th Annual Report of the Bureau of American Ethnology 1882–1883*, Washington, DC: Smithsonian Institution

Mallery, Garrick 1893, 'Picture Writing of the American Indians', *10th Annual Report of the Bureau of American Ethnology 1888–1889*, Washington, DC: Smithsonian Institution

Marshall, Joseph and Luther Standing Bear 2006, *Land of the Spotted Eagle*, Lincoln: University of Nebraska Press

McClintock, Walter 1937, 'Blackfoot Warrior Societies', *Southwest Museum Leaflets* 8, Los Angeles: Southwest Museum

McCoy, Ronald 1992, 'Short Bull: Lakota Visionary, Historian and Artist', *American Indian Art Magazine* 17 (3): 54–65

McCoy, Ronald 1994, 'Swift Dog: Hunkpapa Warrior, Artist and Historian', *American Indian Art Magazine* 19 (3): 68–75

McCoy, Ron 2003a, '"A Shield to Help you through Life": Kiowa Shield Designs and Origin Stories Collected by James Mooney, 1891–1906', *American Indian Art Magazine* 28 (3): 70–81

McCoy, Ron 2003b, '"I Have a Mysterious Way": Kiowa Shield Designs and Origin Stories Collected by James Mooney, 1891–1906', *American Indian Art Magazine* 29 (1): 64–75

McCoy, Ron 2004, 'The Art of History: Lakota Winter Counts', *American Indian Art Magazine* 30 (1): 78–89

McLaughlin, Castle 2003, *Art of Diplomacy: Lewis and Clark's Indian Collection*, Seattle and London: University of Washington Press

McMaster, Gerald 1999, 'Towards an Aboriginal Art History', pp. 81–96 in W. Jackson Rushing III (ed.), *Native American Art in the Twentieth Century: Makers, Meanings, Histories*, London and New York: Routledge

Mails, Thomas E. 1973, *Dog Soldiers, Bear Men and Buffalo Women*, New York: Prentice Hall

Meadows, William C. 1999, *Kiowa, Apache, and Comanche Military Societies*, Austin: University of Texas Press

Meadows, William C. 2010, *Kiowa Military Societies: Ethnohistory and Ritual*, Norman: University of Oklahoma Press

Meadows, William C. and Gus Palmer Sr 1992, 'Tonkonga: The Kiowa Black Legs Military Society', pp. 116–17 in Charlotte Heth (ed.), *Native American Dance: Ceremonies and Social Traditions*, Washington, DC: National Museum of the American Indian

Medicine, Beatrice 1983, '"Warrior Women" – Sex Role Alternatives for Plains Indian Women', pp. 267–79 in Patricia Albers and Beatrice Medicine (eds), *The Hidden Half: Studies of Plains Indian Women*, Lanham, MD: University Press of America

Medicine Crow, Joseph 2003, 'Counting Coup and Capturing Horses (1920–1940)', pp. 168–72 in Colin F. Taylor and Hugh A. Dempsey (eds), *Military Art, Warfare, and Change: Essays in Honor of John C. Ewers*, Wyk auf Foehr: Tatanka Press

Miller, Elizabeth 1994, 'Evidence for Prehistoric Scalping in Northeastern Nebraska', *Plains Anthropologist* 39 (148): 211–19

Milloy, John S. 1988, *The Plains Cree: Trade, Diplomacy, and War, 1790 to 1870*, Winnipeg: University of Manitoba Press

Mithlo, Nancy Marie 2004a, '"Red Man's Burden": The Politics of Inclusion in Museum Settings', *American Indian Art Quarterly* 28 (3/4): 743–63

Mithlo, Nancy Marie 2004b, '"We Have All Been Colonized": Subordination and Resistance on a Global Arts Stage', *Visual Anthropology* (17): 229–45

Moses, Lester George 1996, *Wild West Shows and the Images of American Indians, 1883–1933*, Albuquerque: University of New Mexico Press

Murie, James 1914, 'Pawnee Indian Societies', *Anthropological Papers of the American Museum of Natural History* (11), New York: American Museum of Natural History

Murie, James 1981 [1921], 'Ceremonies of the Pawnee', *Smithsonian Contributions to Anthropology* (27), Washington, DC: Smithsonian Institution Press

Nabokov, Peter and Two Leggings 1967, *Two Leggings: The Making of a Crow Warrior*, New York: Thomas Y. Crowell

Nagel, Joane 1997, *American Indian Ethnic Renewal: Red Power and the Resurgence of Identity and Culture*, Oxford: Oxford University Press

Nagy, Imre 1994, 'A Typology of Cheyenne Shields', *Plains Anthropologist* 39 (147): 5–36

Neumann, Georg K. 1940, 'Evidence for the Antiquity of Scalping in Central Illinois', *American Antiquity* 5 (4): 287–9

Nielsen, Axel E. and William H. Walker (eds) 2009, *Warfare in Cultural Context: Practice, Agency and the Archaeology of Violence*, Tucson: University of Arizona Press

Oberholtzer, Cath 2000, 'First Peoples, First Contacts: Tangible Records', *Museum Anthropology* 102 (1): 139–52

Pauketat, Timothy R. 2008, 'Founders Cults and the Archaeologies of Wa-kan-da', pp. 61–80 in B.J. Mills and W.H. Walker (eds), *Memory Work: The Archaeologies of Material Practice*, Santa Fe: School of American Research

Pauketat, Timothy R. 2009, 'Wars, Rumors of Wars and the production of Violence', pp. 246–61 in Axel E. Nielsen and William H. Walker (eds), *Warfare in Cultural Context: Practice, Agency and the Archaeology of Violence*, Tucson: University of Arizona Press

Pauketat, Timothy R. and Thomas E. Emerson 2008, 'Star Performance and Cosmic Clutter', *Cambridge Archaeological Journal* 18 (1): 78–85

Peers, Laura 2000, 'Native Americans in Museums: A Review of the Chase Manhattan Gallery of North America', *Anthropology Today* 16 (6): 8–13

Peers, Laura and Alison Brown (Eds.) 2003 *Museums and Source Communities: a Routledge Reader* London and New York: Routledge

Penney, David W. 2004, *North American Indian Art*, London: Thames & Hudson

Peterson, Harold L. 1965, 'American Indian Tomahawks', *Contributions from the Museum of the American Indian Heye Foundation*, vol. 19

Petersen, Karen Daniels 1971, *Plains Indian Art from Fort Marion*, Norman: University of Oklahoma Press

Pettipas, Katherine 1994, *Severing the Ties that Bind: Government Repression of Indigenous Religious Ceremonies on the Prairies*, Winnipeg: University of Manitoba Press

Phillips, Ruth B. 1994, 'Fielding Culture: Dialogues between Art History and Anthropology', *Museum Anthropology* 18 (1): 39–46

Pohrt, Richard 1976, 'The Indian and the American Flag', *American Indian Art Magazine* 1 (2): 42–8

Pohrt, Richard and Richard A. Pohrt Jr 2003, 'A Gros Ventre Painted Lodge', pp. 157–60 in Colin F. Taylor and Hugh A. Dempsey (eds), *The Plains Indians of North America: Military Art, Warfare, and Change. Essays in Honor of John C. Ewers*, Wyk auf Foehr: Tatanka Press

Powell, Peter J. 1969, *Sweet Medicine*, Norman: University of Oklahoma Press

Powell, Peter J. 2002, 'Bearers of the Sacred Thunder Bow' (pt 2), *American Indian Art Magazine* 27 (4): 56–65

Powers, Marla 1998 'Lakota Women in War' *Rivista di Studi Anglo-Americani* 9(11): 687–95

Powers, William K. 1982, *Oglala Religion*, Lincoln and London: University of Nebraska Press

Powers, William K. 1998a, 'Lakota Terms for Dance Costumes', *Whispering Wind* 29 (2): 16–26

Powers, William K. 1998b, 'The Continuing Warrior Tradition: Lakota Song Texts from Over There', *Rivista di Studi Anglo-Americani* 9 (11): 657–68

Prucha, Paul 1984, *The Great Father: The United States Government and the American Indians*, Lincoln: University of Nebraska Press

Pyle, Ernie 1945, 'Ceremonial Dances in the Pacific', pp. 12–13 in *Indians in the War*, United States Department of Interior – Office of Indian Affairs, Chicago: Haskell Institute Printing Department

Raczka, Paul 1992, 'Sacred Robes of the Blackfoot and Other Northern Plains Tribes', *American Indian Art Magazine* 17 (3): 66–73

Raczka, Paul 2003, 'War Medicines of the Northwest Plains', pp. 130–38 in Colin F. Taylor and Hugh A. Dempsey (eds), *Military Art, Warfare, and Change: Essays in Honor of John C. Ewers*, Wyk auf Foehr: Tatanka Press

Ray, Melissa Marie 2008, 'The Shield Bearing Warriors of Bear Gulch: A Look at Prehistoric Identity in Rock Art', *American Indian Rock Art* (34): 23–35

Reilly, F. Kent III and James F. Garber (eds) 2007, *Ancient Objects and Sacred Realms: Interpretations of Mississippian Iconography*, Austin: University of Texas Press

Rickard, Jolene 2007, 'Absorbing or Obscuring the Absence of a Critical Space in the Americas for Indigeneity: The Smithsonian's National Museum of the American Indian', *Res* (52): 85–92

Ridington, Robin and Dennis Hastings (In'aska) 1997, *Blessing for a Long Time: The Sacred Pole of the Omaha Tribe*, Lincoln: University of Nebraska Press

Riggs, Stephen Return 1893, 'Dakota Grammar, Texts, and Ethnography', *Contributions to North American Ethnology* (9), Washington DC: Geographical and Geological Survey of the Rocky Mountain Region

Risch, Barbara 2003, 'Wife, Mother, Provider, Defender, God: Women in Lakota Winter Counts', *American Indian Culture and Research Journal* 27 (3): 1–30

Roscoe, Will 1990, '"That is My Road": The Life and Times of a Crow Berdache', *Montana: The Magazine of Western History*, pp. 46–55

Roscoe, Will 1998, *The Changing Ones: Third and Fourth Genders in Native North America*, London: Macmillan

Rosoff, Nancy B. 2011, *Tipi: Heritage of the Great Plains*, Seattle: University of Washington Press

Sager, Dave 2000, 'Northern Beadwork Harnesses: Possible Beginnings', *Whispering Wind* 30 (6): 4–13

Santos-Granero, Fernando (ed.) 2009, *The Occult Life of Things: Native Amazonian Theories of Materiality and Personhood*, Tucson: University of Arizona Press

Schiffer, Michael Brian 1999, *The Material Life of Human Beings: Artifacts, Behaviour and Communication*, London and New York: Routledge

Schmidt-Pauli, Edgar von and White Horse Eagle 1931, *We Indians: The Passing of a Great Race. Being the Recollections of the Last of the Great Indian Chiefs, Big Chief White Horse Eagle, as told to Edgar von Schmidt-Pauli*, Christopher Turner (trans.), London: Thornton Butterworth

Schmittou, Douglas A. and Michael H. Logan 2002, 'Fluidity of Meaning: Flag Imagery in Plains Indian Art', *American Indian Quarterly* (26): 559–604

Scriver, Bob 1990, *The Blackfeet: Artists of the Northern Plains*, Kansas City: Lowell Press

Skinner, Alanson 1915a, 'Kansa Organizations', pp. 741–75 in Clark Wissler (ed.), 'Societies of the Plains Indians', *Anthropological Papers of the American Museum of Natural History* (11), 1912–16, New York: American Museum of Natural History

Skinner, Alanson 1915b, 'Iowa Societies', pp. 679–740 in Clark Wissler (ed.), 'Societies of the Plains Indians', *Anthropological Papers of the American Museum of Natural History* (11), 1912–16, New York: American Museum of Natural History

Smith, G. Hubert 1980, *The Explorations of the La Vérendryes in the Northern Plains, 1738–43*, W. Raymond Wood (ed.), Lincoln: University of Nebraska Press

Smith, Marian W. 1938, 'The War Complex of the Plains Indians', *Proceedings of the American Philosophical Society* 78 (3): 425–64

Soop, Louis/Piitaikiihtsipiimi/Spotted Eagle 2002, 'Humour and Respect', pp. 14–16 in Jonathan C.H. King and W. Raymond Wood (eds), *Ákaitapiiwa Ancestors*, Lethbridge, Alta: Sir Alexander Galt Museum and Archives

Sundstrom, Linea 2004, *Storied in Stone: Indian Rock Art in the Black Hills Country*, Norman: University of Oklahoma Press

Sundstrom, Linea 2008, 'Buffalo Gals: Images of Women in Northern Great Plains Rock Art', *American Indian Rock Art* (34): 167–79

Szabo, Joyce M. 1994a, *Howling Wolf and the History of Ledger Art*, Albuquerque: University of New Mexico Press

Szabo, Joyce M. 1994b, 'Shields and Lodges, Warriors and Chiefs: Kiowa Drawings as Historical Records', *Ethnohistory* 41 (1): 1–24

Szabo, Joyce M. 2007, *Art from Fort Marion: The Silberman Collection*, Norman: University of Oklahoma Press

Taylor, Colin F. 1994, *Wapa'ha: The Plains Feather Head-dress*, Wyk auf Foehr: Verlag für Amerikanistik

Taylor, Colin F. 1996, *Catlin's O-kee-pa*, Wyk auf Foehr: Verlag für Amerikanistik

Taylor, Colin F. 1999, *Saam: The Symbolic Content of Early Northern Plains Ceremonial Regalia*, Wyk auf Foehr: Verlag für Amerikanistik

Taylor, Colin F. 2004, 'The "Tall Bear" Drawings in the William Blackmore Collection at the British Museum', *European Review of Native American Studies* 18 (2): 1–12

Taylor, Colin F. and Hugh A. Dempsey (eds) 2003, *The Plains Indians of North America: Military Art, Warfare, and Change. Essays in Honor of John C. Ewers*, Wyk auf Foehr: Tatanka Press

Thomas, Davis and Karin Ronnefeldt (eds) 1976, *People of the First Man: Life among the Plains Indians in their Final Days of Glory. The First Hand Account of Prince Maximilian's Expedition up the Missouri River, 1833–34*, New York: Dutton

Thomas, Nicholas 1999, *Possessions: Indigenous Art/Colonial Culture*, London: Thames & Hudson

Thomas, Rodney G. 2000, 'Daughters of the Lance: Native American Women Warriors', *Journal of the Indian Wars* 1 (3): 147–54

Thornton, Russell 2002, 'A Rosebud Reservation Winter Count Circa 1751–1752 to 1886–1887, *Ethnohistory* 49 (4): 723–41

Thwaites, Reuben Gold 1904–5, *Original Journals of the Lewis and Clark Expedition, 1804–1806*, 8 vols, New York: Dodd, Mead

Thwaites, Reuben Gold (ed.) 1906, *Early Western Travels 1748–1846*, Cleveland: Arthur H. Clark

Tilley, Christopher 1999, *Metaphor and Material Culture*, Oxford: Blackwell

Torrence, Gaylord 1994, *The American Indian Parfleche: A Tradition of Abstract Painting*, Seattle: University of Washington Press

Townsend, Richard 2004 (ed.), *Hero, Hawk, and Open Hand: American Indian Art of the Ancient Midwest and South*, New Haven and Chicago: Yale University Press and The Art Institute of Chicago

Tuhiwai Smith, Linda 1999, *Decolonizing Methodologies: Research and Indigenous Peoples*, London: Zed Books

Turner Strong, Pauline and Barrik van Winkle 1993, 'Tribe and Nation: American Indians and American Nationalism', *Social Analysis* (33): 9–26

Utley, Robert M. and Wilcomb Washburn 1977, *Indian Wars*, Boston: Houghton Mifflin

Venbrux, Eric, Pamela Sheffield Rosi and Robert L. Welsch (eds) 2006, *Exploring World Arts*, Long Grove, IL: Waveland Press

Vestal, Stanley 1962 [1934], *Warpath: The True Story of the Fighting Sioux Told in a Biography of Chief White Bull*, Lincoln and London: University of Nebraska Press

Wagner, Glendolin Damon, William Allen and Plenty Coups 1987 [1933], *Blankets and Moccasins: Plenty Coups and his People, the Crow*, Lincoln and London: University of Nebraska Press

Walker, James R. 1980, *Lakota Belief and Ritual*, Lincoln: University of Nebraska Press

Walters, Anna Lee 1989, *The Spirit of Native America: Beauty and Mysticism in American Indian Art*, San Francisco: Chronicle Books

Wedel, Mildred Mott 1973, 'The Identity of La Salle's Pana Slave', *Plains Anthropologist* 18 (61): 203–17

West, Ian M. 1978, 'Plains Indian Horse Sticks', *American Indian Art Magazine* 3 (2): 58–67

Wied-Neuwied, Maximilian Alexander Philipp, prince von 1843, H. Evans Lloyd (trans.), *Travels in the Interior of North America*, London: Ackermann

Wiegers, Robert P. 1988, 'A Proposal for Indian Slave Trading in the Mississippian Valley and its Impact on the Osage', *Plains Anthropologist* 33 (180): 187–202

Wildschut, William and John C. Ewers 1959, 'Crow Indian Beadwork: A Descriptive and Historical Study', *Contributions from the Museum of the American Indian Heye Foundation*, vol. 16

Wildschut, William and John C. Ewers 1960, 'Crow Indian Medicine Bundles', *Contributions from the Museum of the American Indian Heye Foundation*, vol. 17

Wingfield, Christopher 2007, 'Feeling the Vibes: Dealing with Intangible Heritage': – An Introduction', *Journal of Museum Ethnography* (19): 9–20

Wischmann, Lesley 2004, *Frontier Diplomats: Alexander Culbertson and Natoyist-Siksina' among the Blackfeet*, Norman: University of Oklahoma Press

Wissler, Clark 1904, 'Decorative Arts of the Sioux Indians', *Bulletin of the American Museum of Natural History* 18 (3): 231–77

Wissler, Clark 1905, 'The Whirlwind and the Elk in the Mythology of the Dakota', *Journal of American Folklore* 18 (1): 257–68

Wissler, Clark 1907, 'Some Protective Designs of the Dakota', *Anthropological Papers of the American Museum of Natural History* 1 (2): 19–53

Wissler, Clark 1912, 'Societies and Ceremonial Associations in the Oglala Division of the Teton-Dakota', pp. 1–99 in Clark Wissler (ed.), 'Societies of the Plains Indians', *Anthropological Papers of the American Museum of Natural History* (11), 1912–16, New York: American Museum of Natural History

Wissler, Clark 1913 'Societies and Dance Associations of the Blackfoot Indians', pp. 359-460 in Clark Wissler (ed.) 'Societies of the Plains Indians' *Anthropological Papers of the American Museum of Natural History* (11) 1912–16. New York: American Museum of Natural History

Wissler, Clark 1916, 'General Discussion of Shamanistic and Dancing Societies', pp. 853–76 in Clark Wissler (ed.), 'Societies of the Plains Indians', *Anthropological Papers of the American Museum of Natural History* (11), 1912–16, New York: American Museum of Natural History

Wissler, Clark (ed.) 1912–16, 'Societies of the Plains Indians', *Anthropological Papers of the American Museum of Natural History* (11), New York: American Museum of Natural History

Wissler, Clark 1927, 'Distribution of Moccasin Decorations among Plains Tribes', *Anthropological Papers of the American Museum of Natural History* 19 (1): 1–23

Wood, W. Raymond 1980, 'Plains Trade in Prehistoric and Protohistoric Intertribal Relations', pp. 98–109 in W. Raymond Wood and Margot Liberty (eds), *Anthropology on the Great Plains*, Lincoln: University of Nebraska Press

Wood, W. Raymond and Margot Liberty (eds) 1980, *Anthropology on the Great Plains*, Lincoln: University of Nebraska Press

Wooley, David L. and Joseph D. Horse Capture 1993, 'Joseph No Two Horns: He Nupa Wanica', *American Indian Art Magazine* 18 (3): 32–43

Württemberg, Paul Wilhelm von Hans von Sachsen-Altenburg and Robert L. Dyer 1998, *Duke Paul of Wuerttemberg on the Missouri Frontier, 1823, 1830 and 1851*, Booneville, MS: Pekitanoui Publications

Young Man, Alfred 1991, 'Token and Taboo: Academia vs. Native Art: Problems in Teaching North American Indian Art at the post-Secondary Level', *European Review of Native American Studies* (32): 11–14

Zuyderhoudt, Lea 2002, 'Engendering Blackfoot Histories', pp. 155–78 in Barbara Saunders and Marie-Claire Foblets (eds), *Changing Genders in Intercultural Perspective*, Leuven: Leuven University Press

Interviews

Asepermy, Lenny 2010, Oklahoma (interview with the author)

Palmer, Dixon 2010, Oklahoma (interview with the author)

Palmer, Lyndreth 2010, Oklahoma (interview with the author)

Ringlero, Aleta 2010, Arizona (interview with the author)

Tselie, Mary Stevenson, 2010 Oklahoma (interview with the author)

Tselie, Nathan 2010, Oklahoma (interview with the author)

Acknowledgements

Image credits

My most sincere gratitude goes to the informants, consultants, and interviewees from the Native North American nations who generously and kindly gave time, knowledge and expertise to expand my understanding and appreciation of the historical contexts and cultural material featured in this book: Lyndreth Palmer (Kiowa), Dixon Palmer (Kiowa), Dennis Zotigh (Kiowa), Milton Paddlety (Kiowa), Allan Pard (Blackfoot), Lenny Asepermy (Comanche), Mary Stevenson Tselie (Wichita), Nathan Tselie (Apache), Aleta Ringlero (Tohono O'odham), and not least Stephanie Pratt (Dakota) whose spiritual support has accompanied me throughout the production of this book. Sincere thanks go to Alison Brown (University of Aberdeen, Anthropology), Jonathan King (Keeper of Anthropology, British Museum), and Colin McEwan (Head Curator, Americas, British Museum) for their useful comments on earlier drafts of the manuscript, and to David Shankland, (Director, Royal Anthropological Institute) for allowing me to use photographs from their collections. Further thanks go to people at the British Museum: Robert Storrie (Curator, North America) for his sound advice, Harry Persaud (Photo Archivist) for his help with archival material, Sovati Smith for her efforts in making sure that images were delivered on time, and to Morwenna Chaffe for her invaluable assistance in tidying up the records. Particular appreciation for their generosity goes to Ian Taylor for lending his beautiful shots of the Kiowa Black Leggings society, and to Simona Piantieri whose pictures grace the cover and parts of the book. Further thanks go to Laura Peers (Oxford University, Anthropology, and Pitt Rivers Museum) for her expert pastoral care, to Tressa Berman for her dedicated patience and wisdom, and to Polly Schaafsma for sharing her views on Native American warfare. Teresa Francis and Rosemary Bradley at The British Museum Press must be thanked for having believed in this book since the start; Axelle Russo managed the programme of photography of Museum objects and Susan Walby the production of the book. Special gratitude goes to the indefatigable Claudia Bloch whose editorial input was crucial in the manuscript preparation all along the way. Finally enormous, heartfelt thanks goes to my parents Adriana Benedetti and Massimo Carocci to whom this book is dedicated in recognition of their love and sustained encouragement since the day I first drew a feather.

McGill-Queen's Native and Northern Series
(In memory of Bruce G. Trigger)
Sarah Carter and Arthur J. Ray, Editors

Index